CRAFTING

IDENTITY

CRAFTING

IDENTITY

SANDRA ALFOLDY

The Development of
Professional Fine Craft
in Canada

McGill-Queen's University Press
Montreal & Kingston • London • Ithaca

© McGill-Queen's University Press
ISBN 0-7735-2860-1

Legal deposit third quarter 2005
Bibliothèque nationale du Québec

Printed in Canada on acid-free paper

This book has been published with the help of a grant from the Canadian Federation
for the Humanities and Social Sciences, through the Aid to Scholarly Publications
Programme, using funds provided by the Social Sciences and Humanities Research
Council of Canada. Funding has also been provided by a Jean A. Chalmers Fund for
the Crafts of the Canada Council for the Arts.

McGill-Queen's University Press acknowledges the support of the Canada Council
for the Arts for our publishing program. We also acknowledge the financial support
of the Government of Canada through the Book Publishing Industry Development
Program (BPIDP) for our publishing activities.

Library and Archives Canada Cataloguing in Publication

Alfoldy, Sandra, 1969–
 Crafting identity: the development of professional fine craft in Canada /
Sandra Alfoldy.

Includes bibliographical references and index.
ISBN 0-7735-2860-1

1. Handicraft – Canada – History – 20th century. 2. Decorative arts – Canada – History –
20th century.
I. Title.

TT26.A44 2005 745'.0971'09046 C2005-901225-0

Typeset in 10.5/13 Cartier Book, an updated version by Rod McDonald of Carl Dair's
Cartier. In 1966 the first proof of Cartier was published as "the first Canadian type for
text composition" to mark the Centenary of Canadian Confederation.

Book design and typesetting by Glenn Goluska.

Contents

Acknowledgments

THIS BOOK COULD NOT HAVE BEEN UNDERTAKEN WITHOUT THE GENEROUS assistance of many individuals and organizations. I am grateful to the Artisans of Crawford Bay, Gordon Barnes, Joan Chalmers, Gail Crawford, Glenn Allison, Alan Elder, Sandra Flood, Chris Freyta, Yvan Gauthier, Ricardo Gomez, Tom Hill, Stephen Inglis, Robert Jekyll, Cherryl Masters, Lois Moran, Arthur Price, Paul Smith, Marilyn Stothers, Jan Waldorf, and Peter Weinrich for their candid opinions and helpful insights. Thank you to the archivists and librarians of the American Craft Council Archives; the Archives of Ontario; the Archives of American Art; the Canadian Museum of Civilization Archives; the Metro Toronto Reference Library; the National Archives of Canada; the National Gallery of Canada Archives; the Nelson Museum and Archives; the Ontario Science Centre Archives; the Royal Ontario Museum Archives; the Thomas Fisher Rare Book Library, University of Toronto; and the York University Archives. I am particularly indebted to Margot Reid of the Canadian Museum of Civilization for making the objects come to life; to Emilie Anderson, Trish Lucy, and Mary B. Davis of the American Craft Council for being so receptive to my project and allowing me to view Aileen Osborn Webb's unpublished autobiography; and to Anne Godard and Mike Macdonald of the National Archives of Canada.

This book originated with my doctoral and postdoctoral research, and I was most fortunate in having exceptional supervisors. Thank you to Joan Acland, Janet Berlo, Lydia Sharman, and especially Catherine MacKenzie for all their patience, good humour, and insightful comments and criticism. Thank you also to my fellow craft historians Gail Crawford and Sandra Flood for reading

the entire manuscript and offering their thoughtful observations and to my great aunt Jeannette MacArthur Radley for providing me with a base from which to conduct much of my research. My craft history students at NSCAD University have provided invaluable insights into the future of craft, and for that I am grateful.

This book is grounded in archival research. The American Craft Council archives and library and the Archives of American Art have provided extensive material on Aileen Osborn Webb and the World Crafts Council. The National Archives of Canada and the Archives of Canadian Craft at the Province of Ontario Archive contained important material on the Canadian Craftsmen's Association and the Canadian Guild of Crafts. Primary material regarding exhibitions and conferences was made available through the National Gallery of Canada archive, the Royal Ontario Museum archive, the Canadian Museum of Civilization archive, York University archives and the Ontario Science Centre archive. Unfortunately, due to funding cutbacks, some of the archives of the Canadian Crafts Council are inaccessible, stored in a private individual's garage, and many of the Ontario Crafts Council archives are also in storage. A number of personal, telephone, letter, and email interviews have been used to expand upon archival material and, in particular, to compensate for those holdings that are not available for consultation.

The research for this project could not have been completed without the generous assistance of the Social Sciences and Humanities Research Council of Canada, the Canada Council for the Arts and the Fonds pour la formation de chercheurs et l'aide à la recherche (FCAR). In addition, thank you to Concordia University for providing me with support through the J.W. McConnell Memorial Graduate Fellowship.

This book is the direct result of being raised by two artists who define the term professional, Andy and Elaine Alfoldy. Thank you Mom and Dad, and also Sylvia, for your constant inspiration. And of course, thank you to my husband, Christopher, and our son, Viktor, for their love and encouragement and for the pleasant hours spent together researching and writing.

CRAFTING IDENTITY

Introduction

CONTEMPORARY PROFESSIONAL CRAFT IS THE CHILD OF LATE MODERNISM. Semantics surrounding the word craft developed in the postwar period when a system of labels based on the legacy of North American modern art were developed and applied to distinguish a new entity, professional North American craft, from its predecessor, traditional craft. The craft community has long suppressed the reality of this hierarchical organization for two reasons. First, it defeats the romanticized vision of a harmonious craft world. Second, many craftspeople and supporters believe that the presentation of a unified field of craft can ward off the perceived threat of dominance and absorption by the world of "art." Indeed, there is a reluctance to explore the lasting impact of late modernist art criticism on professional craft, and in some cases explicit refusal.[1] This has contributed to the popular misconception that craft is a non-hierarchical world, leading to the assumption that children's macaroni "craft" projects, Martha Stewart, and the objects of the winners of Canada's most prestigious craft prize, the Bronfman Award, belong to the same field. Art historians are not obliged to qualify that their scholarly publications focus on professional art, yet studies in craft history are still required to delineate between amateur and professional craft activities.

Now that it is claimed that the art/craft debate is dead, replaced by the spirit of interdisciplinarity, it is possible to recognize the multiplicity of schemata within craft.[2] Inside the complex craft world there exists an undeniably powerful professional community. It is this group who determines the institutionalized craft sanctioned by jurors, galleries, governments, universities, publications, and private funding bodies. It must be acknowledged that

professional craftspeople and administrators are quite separate from the realm of amateur or hobby craft. Although this distinction has not been emphasized in craft history, the North American notion of professional craft has been in existence from the postwar period and was developed and instituted in close collaboration with late modern art. It is this relationship that will be examined in this book.

In the 1950s, actively identifying craft as "fine" was perceived as distinguishing it from the non-professional objects that cluttered the field. Donald Buchanan made this point explicitly in his writing on Canadian craft and design and through his meaningful use of the term "fine" in his craft exhibitions at the National Gallery of Canada. For Buchanan, craft had a responsibility to work with industry, both to overcome the division between the two and to aid postwar Canada in creating a supply of well-designed, mass-produced objects to replace wartime shortages. By simply inserting the term "fine," loaded with overt references to the "fine" arts, it was believed that the crafts could be elevated. Canada was not alone in appropriating this word; the Crafts Centre of Great Britain used the term "fine craftsmanship" to develop its policy during the late 1940s, focusing as well on the need for craft to work with industry while attaining new levels of artistic self-consciousness.[3] For all concerned, fine crafts were professional crafts, poised to work with industry and fully engaged with modernist art discourses. Nowhere was this made more evident than in the United States, where the American Craft Council launched its series of *Designer-Craftsmen U.S.A.* exhibitions in the 1950s to promote this ideal. Fine craft was to cross the borders between art and industry, demonstrating the sophistication of craft.

It was during the 1960s and 1970s that the international craft community heralded Canadian craft objects, craftspeople, and exhibitions as finally attaining professional style and status. However, behind the facade of this unified achievement remained the question, what *was* professional Canadian craft? Who determined the definition, and who was included in such a concept? It was a problem that would ultimately lead to the failure and reformation of the Canadian Crafts Council, the official national organization that grew out of the 1974 amalgamation of the Canadian Handicrafts Guild, founded in 1905, and the Canadian Craftsmen's Association, founded sixty years later. Like much of Canadian craft history this central period remains largely unexplored. The period from 1964 to 1974 was a key, although deeply problematic, decade in the development of infrastructures intended to facilitate what is now a multimillion dollar annual business. The fact that the crafts in Canada are flourishing today can be directly traced to the influence of this crucial time. While there are a number of ways to approach this era,

this book focuses on the accomplishments of Canadian craftspeople and administrators, their emphasis on the ideology of professionalism, and the issue of US influences, a factor so striking it should no longer be avoided. Specifically, the goals set by and articulated through the American Craft Council and its influential sponsor, Aileen Osborn Webb, can be described as affecting Canadian efforts to establish an important place for craft in the national "consciousness." Webb's insistence on "elevating" the crafts from the level of the church fair to the art world was forcefully echoed in Canada as early as 1955. The mid-60s to mid-70s witnessed a myriad of activities designed, as Anita Aarons, an arts columnist of the time, would have it, to foster the emergence of the "genuine, contemporary craftsman" producing original work without "sentimental desire" or "traditional shackles."[4]

This period began with the impetus to create a new national craft organization, the Canadian Craftsmen's Association, following the 1964 First World Congress of Craftsmen. By 1974 the Association and the Canadian Handicrafts Guild had merged as the Canadian Crafts Council, hoping to establish a more powerful national body for the representation of professional craft activities across the country. In those ten years, many major craft exhibitions were held, new educational opportunities were structured, and Canadian craftspeople were projected onto the international stage in two "world" events – Expo 67 and the tenth World Crafts Council Congress, held in Toronto in the summer of 1974. It is the professional craft community whose voice is heralded today in North America. This group, responsible for the dissemination of professional values through its high-profile winning of national awards, inclusion in gallery and museum collections, and teaching roles at the university level, continues to advocate an ideology of craft that was established at the First World Congress of Craftsmen in 1964, when the apex of modernism with its antagonism toward craft, ornament, and the decorative arts was beginning to be called into question through postmodernism's challenging of these exclusions. The archival research undertaken for this book has revealed the impossibility of providing an absolute definition of professional craft; however, the repeated voicing of collective goals suggests that the varied views on professionalism share some commonalities.

In order to analyze these perspectives it is crucial to attempt to identify professional craft. I have turned to the field of the sociology of professionalism for help in answering this question. The study of professions can be traced to the late nineteenth century with Emile Durkheim's theories on the division of labour in society.[5] More recently, Michel Foucault's theoretical examination of the development of the authority of the medical "gaze" in *The Birth of the Clinic* looked at the "collective consciousness" of a professional

group and at the power emanating from the knowledge and language possessed by specialists.[6] Most helpful for my research has been Magali Sarfatti Larson's *The Rise of Professionalism: A Sociological Analysis*, which takes a distinctly Marxist approach to the power and prestige of professional groups.[7] According to Larson, professionals possess a specialized body of knowledge and techniques that result in the granting of rewards by society.[8] More recent scholarship on professions expands upon this definition. Keith MacDonald includes the importance of using this specialist knowledge to build a monopoly, one that works through exclusions, and Harold Perkin emphasizes the importance of the development of a bureaucratic management that organizes and supports professional expertise.[9] The professional expert is one with specialized knowledge based on education, competitive merit, and experience.[10] One of the key components agreed upon by all researchers in the field of professionalism is the privilege of self-regulation. As explored by Foucault and Larson, the ability to produce ideology is central to the status of a profession.

The North American craft community of the 1960s and 1970s witnessed the implementation of its professional status based on the acceptance of its technical, aesthetic and epistemological superiority. Craftspeople continued to develop their technologies and material aesthetics, but new to this work was the growth in the bureaucratic administration that organized and categorized the community. The development of self-regulating craft bodies started earlier in the twentieth century, with the establishment of the Canadian Handicrafts Guild in 1905 and the precursor to the American Craft Council in 1939; however, during the 1950s craft organizations shifted their regulations to focus on late modern art's agenda. Led by the American Craft Council, the technical mysteries of craft materials became interwoven with formalized language and specialized knowledge, creating a "professional" craft image with its attendant benefits.

Canadians were heavily influenced by the modernist perspectives on craft put forward at the First World Congress of Craftsmen and taken up by the American Craft Council's journal *Craft Horizons* (*American Craft*) under the editorship of Rose Slivka. The fact that the American Craft Council's conference attracted René d'Harnoncourt, director of the Museum of Modern Art, and the art critic Harold Rosenberg, associated with the abstract expressionist movement, as speakers on the "Vistas of the Arts" panel lent craft a new credibility. Rosenberg and d'Harnoncourt's message for craft was simple – professionalism, based on modernism's rules, was mandatory: "A form of work establishes itself as a profession not only through the complication of its technique – many of the ancient crafts involved more complex recipes than

their counterparts today – but through self-consciousness with regard to this technique."[11] With the formation of the World Crafts Council at the First World Congress of Craftsmen it became clear that the modernist narrative was accepted as the official credo of international craft. *Craft Horizons*, North America's longest-running craft magazine, and one widely read by Canadians, continued to disseminate modernist language and aesthetics under the banner of professionalism. Craft objects featuring references to modern art trends, for example the work of Marilyn Levine and David Gilhooly, were highlighted. Innovative interpretations that pushed boundaries while paying homage to craft materials and forms were praised. A willingness to work with architects and designers was promoted. *Craft Horizons* was not alone in encouraging this trend; in Canada the federal government initiated national craft design awards and granted commissions to craftspeople for the decoration of new federal buildings.

The existence of craft experts was a necessary component of this professionalization. The development of standardized knowledge for craft during this period was inseparable from the individual producers who applied it and from the governance and institutions that promoted it, with both contributing to the discourse of professional craft that we adhere to today.[12] These professional standards mirrored the modern art community, placing equal emphasis on the technical and the conceptual. It was no longer enough to simply be a proficient craftsperson. One had to be able to contextualize wool, clay, metal, and wood as well as manipulate them.

Of course all professional craft practice could not be reduced to this standard form. Those considered to be the privileged specialists had their vision of craft translated into ideals for the entire community, leading to tensions between the power elite and the marginalized, who remained unable to influence the direction of craft's standardization. Who were the power elite of early professional craft? During the period studied in this book, particular individuals stand out for their ability to influence professional standards. These individuals can be divided into three groups: wealthy patrons and sponsors of craft, professional bureaucrats who understood the importance of institutionalizing specific forms of craft, and outspoken craftspeople who were able to publicize their views on craft through their ability to work with these patrons and bureaucrats.

Frequently marginalized craftspeople reflected approaches to craft considered outdated, for example those who practiced and preserved traditional skills, or those who avoided neat classification, like First Nations craftspeople. Indeed, these groups continue to resist easy categorization and as a result are often written out of emerging histories of this period. The craftwork of certain

Canadian groups fell outside the rubric of "professional taste" as dictated by US influences; specifically, Native and Québécois craftspeople. (It should be noted that, in the context of this book, the term "Québécois" refers to Francophone residents of Quebec.)

The transition and perception of Native craft from souvenirs to professional art objects parallel EuroCanadian craft development. During the 1964–74 period, Canadian craft organizations were slowly made cognizant of their exclusionary practices toward contemporary Native production as evidenced through the Canadian Guild of Crafts involvement in *Canadian Indian Art/Craft '70* and *Canadian Indian Art '74*. Despite this growing awareness the majority of craft exhibitions and conferences continued to classify Native craft as either historic artifact or ethnographic specimen. This disparity can be addressed through a discussion of the importance of revising the reception of these objects that have been inscribed as "natural," "exotic" souvenirs under Western modes of production. Conversely, the ability of these objects to subvert the imperialist cultural fields surrounding them by modernizing the capital possessed by Native craftspeople provides resistance through the preservation of specific craft materials, forms, and meanings.[13] The need to be conceptually and materially articulate is one of the fundamental bases of professionalism established during this period. This requirement extended beyond the centre and impacted upon the production of First Nations craftspeople, whose growing awareness of the need for sophisticated treatments of materials led to increased self-reflexivity and to a sensitivity to the manipulations of traditional material and forms into new expressions that placed, for example, Robert Davidson, Elda Smith, and Bill Reid at the forefront of Canada's professional craftspeople. The success of the work of these craftspeople within the market, and their reflection of modern art practices, caused great confusion among professional craft organizations. Native craft training often fell outside the framework of these institutions, and the ambivalence of First Nations craftspeople about participating within these groups contributed to dissention, while challenging the vision of craft as developed by the powerful craft elite.

Quebec's longstanding dedication to professionalism, evidenced through the rigorous jurying process for acceptance into the provincial craft organization, placed Quebec in an interesting position with regard to Canada's national groups. Frequently Québécois craftspeople and administrators were frustrated by what they perceived to be the amateur, or cliquish, nature of the Canadian Guild of Crafts. This pressure proved to be divisive, as was the case with the 1969 exhibition *Craft Dimensions Canada*; however, Quebec's continued emphasis on the necessity for professional craft forced the Guild and

the newly formed Canadian Craftsmen's Association to question their own definitions of professionalism and their audience structures. As a result Canada witnessed the increasing selectivity of professional craft organizations, something that was often declared necessary for shaping the public's reception of craft.

Unlike many other professions, the crafts have concrete objects that reflect the length and quality of the training of its professionals. A system of signs was developed to denote professional craft, and during the postwar period these signs were institutionalized. These symbols include aesthetic markers, namely, a look that indicates awareness of larger conceptual concerns shared by the fine arts community or that reference the cultural position of craft as an indicator of lifestyle. Reviewing jurors' statements, examining exhibition catalogues, and observing the craft objects of this period reveal shared characteristics rooted in late modernism, including subtle ornamentation, experiments with new techniques, an emphasis on natural colouration, and increasing references to artistic trends embodied in the form of the craft objects. Many craft objects produced during the 1960s and 1970s share an aesthetic based on the rediscovery of "lost" or "foreign" techniques, such as handloom weaving, vegetable dying, enamelling, batiking, ash firing, raku, and celadon glazes. The profile of the maker as a professional was often central to the reading of these signs.

It was perceived that a conflation of hobby craft as the work of all craftspeople would ensure the stagnation of the entire field of craft. Fundamental to the separation of professional from amateur was an emphasis on standards, adopted by the Canadian Guild of Crafts and the Canadian Craftsmen's Association. Anita Aarons, a jeweller and the "Allied Arts" columnist for the *Royal Architectural Institute of Canada's Journal* (*Canadian Architecture*), was vocal in her push for increased standards in the work of Canadian craftspeople that would encourage architects to work with craftspeople on large-scale commissions. Joan Chalmers, president of the Canadian Guild of Crafts, advocated for improved standards in the business of craft, for example, display, labelling, and shipping. Distinctions between professional, self-taught, and amateur craftspeople are not based on formal education – the granting of a university degree – but rather on the sophistication of the conceptual framework within which the craftsperson is working. It is expected that professionals will possess advanced technical skills, whether they are acquired through formal or self-education; however, technical skills do not translate into erudite conceptual abilities. Professional craftspeople with degrees have been exposed to the importance of employing a theoretical approach, but there are self-taught producers who have independently

trained themselves to be conceptually adept. It is the craftspeople function-
ing outside these conceptual frameworks that are almost universally consid-
ered to be amateur. Frequently generalizations of amateur craftspeople are
gendered, with objects dismissed as women's hobbies. In reality, higher
standards of living in North America during the 1960s and 1970s meant an
increased market for craft objects. The enormous growth of government
provided an infrastructure to support craft organizations, the expansion of
higher education that resulted in increased opportunities for professional
training for craftspeople, and the incorporation of women into the profes-
sional workforce. This meant that many of the power elite within the profes-
sional craft community were women.[14]

The examination of professional precedents in mid-century North
American craft clearly reveals the crucial roles played by women. Although
women have always made substantial contributions to the field of craft, the
strict regulation of "acceptable" roles for female makers in the first part of
the twentieth century meant that they were effectively prohibited from par-
ticipating in the elements fundamental to attaining professional status.
These included full access to advanced education, the capacity to engage in
all levels of the production process, the ability to push the boundaries of
acceptable craft forms and materials beyond those deemed "ladylike" or
"feminine," and the necessity of aggressively marketing one's own work, as
well as having spaces available to introduce this work to the public. Despite
lingering accusations of dilettantism surrounding national craft organiza-
tions, by 1964 Aileen Osborn Webb, the founder and president of the
American Craft Council, was in a powerful enough position to declare herself
the leader of the World Crafts Council, and Norah McCullough was deemed
suitable for election as Canada's official representative to the Council.
Certainly both these women faced continuing gender-based challenges to
their authority, in particular McCullough, who did not possess Webb's eco-
nomic advantages. However, these trials were met with and overcome by the
tenacity of vast numbers of women who played key roles in the establish-
ment of North America's professional craft community, including Joan
Chalmers, Anita Aarons, Mary Eileen "Bunty" Muff Hogg, Bailey Leslie, Ann
Suzuki, Rose Slivka, Lenore Tawney, and Elda Smith, to name only a few
examples.

Unlike Aileen Osborn Webb, whose economic capital assured her a domi-
nant role in the shaping of professional craft, Canadian women, despite their
large numbers involved in craft activity, faced the problematic of increasing
professionalism, meaning increasingly male arbiters of taste. By no means
the least of the problems facing Canadian craft organizations, the majority

established by women, as they sought to confront the particularities of their professional goals, was the persistent need to garner support, financial and otherwise, from a variety of government bodies and fine arts institutions. Often this required foregrounding professional male "experts." Although the practical considerations of securing public funding were not as pressing to the US exemplar: Aileen Osborn Webb threw her considerable philanthropic resources behind the American Craft Council, and by 1956 had gone so far as to establish an influential exhibition venue, the Museum of Contemporary Crafts, located across the street from the Museum of Modern Art; Webb often relied on male voices to support her vision.

During the 1960s women found themselves forming the majority of the students studying craft at the university level. Following the 1964 First World Congress of Craftsmen conference, Canadians worked aggressively toward the establishment of advanced education for craftspeople, in the form of BFAs and MFAs. One of the strongest definers of professionalism is education, and Canadians had suffered from the loss of top craftspeople who had no choice but to pursue their studies in the United States and Europe. During the late 1960s and early 1970s education was a double-edged sword, for not only were craftspeople leaving Canada to study, but the need for university-educated instructors at Canadian universities and art colleges led to the importation of large numbers of Americans and Europeans. Although this practice was criticized, it was tremendously important in pushing forward the need for innovation in the definition of professional craft. The link between advanced education and conceptual art practices continues to result in debate over issues like the role of function; however, it cannot be denied that the introduction of US ideologies into Canadian craft education resulted in the training of craftspeople who have proven to be articulate with modern art sensibilities but who remain devoted to the forms and materials of craft.

Ironically, the development of professional craft, with its attendant power struggles within the field of cultural production, was actually a rebirth, for it echoed the craft guilds that operated as the first professional systems in the West as early as the twelfth century. Indeed, many of the traits attributed to contemporary professional craft grew directly from its guild precedents. In an effort to counter the effects of the feudal system many European craft guilds were established between 1100 and 1200.[15] Guilds functioned under the principle of self-organization, providing their members with "power and control over association, the workplace, the market, and the relation to the state."[16] The seemingly mysterious skills of groups of artisans held tremendous command over government bodies, but in return guilds relied on government support for their very survival:

craft guilds fought over the skill monopoly, over the market, over who could control and employ whom in the workplace. Then, as now, power of association plus power over the workplace could lead to market control – if local or national government would agree to grant it, or protect it, instead of challenging it.[17]

Just as the power of today's professional craft organizations varies, the strength of craft guilds depended on their geographic location and on the materials they represented. Within the guilds themselves there was a hierarchy of technical mastery and cohesion among artisans, and an ordered rank of makers, with master craftspeople at the top.[18] Guilds were accorded the power to create their own rules, and consequently many craft guilds fell prey to corruption. As a result of increasingly elitist control over guilds, by 1500 the rank of master craftsperson was an impossible one to achieve for most apprentices and journeymen.[19] The emergence of "free-market ideology" meant that craft guilds previously weakened by internal corruption were now easily attacked by early capitalism.[20] Certain craft guilds persisted into the nineteenth century, but by the early twentieth century most guilds had been subsumed by "the increasing subordination and alienation of industrial labor."[21] Certainly romanticized versions of guild systems were resurrected throughout the late nineteenth and early twentieth centuries, perhaps most famously C.R. Ashbee's Guild of Handicraft, a place where "the modern English workman could find that freedom and happiness" that had been lost during the factory work of the nineteenth century.[22] The links between craft guilds and alternate lifestyles during this period contributed to our notion of craftspeople as leading unconventional, often rural, existences outside the spaces of mainstream capitalist markets. Specialized craft media societies, including The Society of North American Goldsmiths (founded 1969), The Surface Design Association (founded 1977), and The National Council on Education for the Ceramic Arts (founded 1967), contributed to the definition of professional craft during the period analyzed in this book. Our contemporary craft associations mirror certain guild traits, however it must be pointed out that, like historical guild examples, modern craft is not a unified field but instead is predicated on hierarchies surrounding materials, patrons, locality, and government support.

The Canadian Handicrafts Guild was established in 1905, at the height of the return to the imagined ideal of the medieval guilds. The Guild was a philanthropist organization dedicated to the preservation of a particular type of craft – traditional, ethnic, and "threatened" with extinction. The guild model itself represented a nostalgic and fictional ideal for craftspeople, and the tra-

ditional modes of marginalized craft production promoted by the Canadian Handicrafts Guild provided the perfect partner to the guild image, encouraging communities of craftspeople while meeting market demand. During the early part of the twentieth century craft guilds occupied a marginalized role in the capitalist market. Rather than representing professional organizations, it could be argued that in a world of increasingly sophisticated mass design and production techniques they were perceived as indulgent revivals of the past glory days of craft. Why, then, did the 1960s experience an upsurge in the reorganization and the granting of power to professional craft organizations that had perhaps subconsciously adopted the professional strategies of self-government previously employed by the guilds? As this book will argue, the postwar period in North America witnessed the establishment of professional institutions for craft by the power elite, who saw the opportunity to unite as independent, self-governing bodies of craftspeople and patrons. By setting strict standards for professional craft that differentiated the "new" objects and producers from the romantic, traditional vision of craft, these organizations developed an audience for craft as professional, artistic enterprise. This postwar transition and today's thriving craft market is based on the establishment of craftspeople as specialized professionals, supported and organized by professional administrators, academics, and institutions. All members of this community use knowledge and language taken from late modern art's rules, combined with material-specific craft skills. This has led to the shift from the situation of largely anonymous, marginalized craftspeople promoted by the Canadian Handicrafts Guild early in the twentieth century to our modern conception of the individual "genius" craft expert and our dependence on name recognition to identify professionals. In other words, from "traditional collectivity" to "modern individuality."[23] The establishment of craft authorities is a necessary component of the professionalization of craft, for these roles are limited and privileged, and must remain relatively inaccessible. The resulting perception of craft as a professional enterprise replete with experts has dramatically increased market demand for all types of professional craft production.

In the late twentieth and early twenty-first centuries the reinvention of professional craft remains outside the domain of the working class due to the introduction of late modernist art discourse. Despite the economic hardships endured by many independent craftspeople struggling to earn their income exclusively from their production, today's craftspeople are not considered "working class" due to their high levels of education and conceptual abilities. Thus professional craftspeople no longer occupy the same social space as their historical guild precedents; however, modern artisans have co-opted

several important guild traditions, namely the power of self-employment, the development of a closed system of power, and a professional community that is defined through a system of exclusivity and inclusivity.[24] These professional paradigms are supplemented by a well-developed system of bureaucratization that has developed around craftspeople. Michel Foucault discusses the "collective consciousness" surrounding professions that is the result of being an autonomous movement or group.[25] The upper echelons of North America's professional craft establishment reflect this notion of collective consciousness. While there are significant numbers of craftspeople considered to be professional, the majority of these artisans are not creating within the conceptual frameworks demanded by North America's top prizes, galleries, and publications, however they appear to support these hierarchical structures (for example, the Bronfman Award). The expert jurors who determine these awards often remain unquestioned, and this ability to self-regulate is one of the indicators of the attainment of professionalism. It is undeniable, however, that professional craft activity has grown considerably in the past forty years.

Although statistics rarely tell the full story, the November 1972 Statistics Canada's "Canadian Crafts Survey and Membership Plebiscite" revealed that 1,701 full- and part-time craftspeople were working in Canada.[26] That number had increased to fifteen thousand full- and part-time craftspeople by 1991, jumping to 22,600 in 2003, and everything suggests a continuing expansion of the craft population.[27] Both the 1991 and 1996 Statistics Canada reports indicate that craftspeople form one of the most well-educated groups of workers in Canada, with 15 percent having graduated from community college, technical school, or a CEGEP, 40 percent possessing a university degree, and 8 percent holding a postgraduate degree.[28] Despite the lack of a national craft magazine in Canada, all ten provincial craft councils circulate newsletters, and Quebec, Ontario, Saskatchewan, and Alberta publish magazines. Craftspeople are not the only ones increasing their expertise in the area of craft. The public interest in purchasing crafts continues to grow; craft retail outlets and gallery spaces noted that 36 percent of the general public had purchased crafts between 1989 and 1994, while during 1999 the sale of crafts rose an additional 11.5 percent to generate an estimated 13.8 million dollars annually.[29] The 2003 Profile and Development Strategy for Craft in Canada, coordinated by the Canadian Crafts Federation, estimates that crafts generate "total output valued at $727 million, and exports approaching $100 million dollars annually."[30]

Contemporary professional craft was established on modernist precedents of innovation and its insistence on an ongoing dialogue between craft and

the concerns of modern art. It was assumed that craft would participate in postmodernity's subsequent deconstruction of these previously exclusionary dialogues. Indeed, this has happened, as is demonstrated through the thought-provoking work of Canadian craftspeople like Jeannie Mah, whose pieces in porcelain question function by employing the surface to project images engaged in a critical, occasionally biographical, reassessment of ethnicity and identity in the Canadian context. This process of questioning had been initiated earlier through the work of a large number of craftspeople, ranging from Merton Chambers's rethinking of the role of ceramic wall murals in the austere concrete spaces of modern architecture, Ely and Monica Phillip's abstract weaving based on traditional First Nations motifs, Donald Lloyd McKinley's manipulations of modern industrial materials into the realm of woodworking, and Mariette Rousseau-Vermette's willingness to push the spacial limits of fibre, to Walter Ostrom's bold reintroduction of colourful, fanciful maiolica earthenware during the heyday of stoneware with its subdued natural colours and forms.

In the past eight years Canadian historians Gail Crawford, Andrée-Anne De Sève, Sandra Flood, and Ellen Easton McLeod have published key craft histories. Apart from references to the role of privileged women, including Aileen Osborn Webb, in the marketing and promotion of North American craft, and the resistance of l'École du Meuble Director Jean-Marie Gauvreau to the importation of US ideals, none of the books focus specifically on the issue of professionalism, and none elaborate upon US influences. Recent conference proceedings that seek to redress the imbalance between the growth in Canadian craft and the relative paucity of writing on the subject are filled with useful references to William Morris and the British arts and crafts movement but contain few allusions to US craft ideologies. Alan Elder's argument that Canadian craft identity is formed "in opposition to a domination 'other' – in Canada's case, the United States," is the exception.[31] It is not surprising that any discussion of the relationship between Canada and the USA is absent in US scholarship on craft. What is surprising is that little has appeared in print on Webb and the American Craft Council.

Canadian craft history remains relatively underdeveloped and the period of the 1960s and early 1970s is largely unexplored. It is important to create a solid body of research on the whole of Canadian craft in order to broaden theoretical examinations of the issues raised within these histories. British academics have demonstrated that there is interest in such histories, and Canadian craft cannot allow itself to remain outside of current debates and writing. Such neglect impacts upon international and national perceptions of the role and importance of Canadian craft objects and craftspeople.

This book explores Canadian craft at a time when it was wrestling with the problem of how to professionalize its production and its organizational infrastructures. It is only through an examination of the activities of the 1960s and 1970s, an active time in the pursuit of a clearly demarcated place for professional craft within the field of Canadian culture, that we can broaden our understanding of how the triumphs and tensions of the period continue to impact upon contemporary craft. Indeed, although the term "craft" is historically determined, it is dangerous to assume that there exists a unified, essentialist concept of craft. In the relatively new field of craft history and theory, scholars tend to collapse craft into a homogenous entity. Depending on the author, this may stem from the need to present a unified front to combat the supposed oppressive, marginalizing forces of art or from the desire to establish a new, clearly defined scholarly field. In any case, it is essential that the realm of professional craft be studied as separate from the popular mass conceptualizations of craft.

1

Pioneering Professional Craft in Canada

THE 1960S WITNESSED THE EMERGENCE OF PROFESSIONAL CRAFT EXPERTS in Canada. While there had been significant voices for craft throughout the twentieth century, the decade of the 1960s encouraged a new approach to the crafts that emphasized innovation, interdisciplinarity, and the saw the materialization of a new organization, the Canadian Craftsmen's Association. These developments would ultimately challenge the bureaucratic management of craft previously dominated by the Canadian Handicrafts Guild. Sandra Flood has argued that the perception "'nothing happened here in craft until the late 1960s, early 1970s' with the corollary 'until the Americans arrived,'" is damaging to the establishment of a specifically Canadian craft history.[1] Although Flood is correct that Canada has long engaged with the crafts, the 1960s are noteworthy for the increasing interest paid to the crafts by the artistic elite and as a result the intensification of the process of institutionalization. Significantly, it was a US craft initiative, The First World Congress of Craftsmen, that galvanized Canadians into action. In direct opposition to the mandate of the Canadian Handicrafts Guild, the Congress echoed the US embrace of modernism, encouraging craftspeople to look forward, not backward for inspiration:

We must not allow ourselves the mistakes ... made by the William Morris movement ... If the crafts are to play a significant part in today's culture ... the craftsman ... can no longer afford to depend on experiences based on the past, but he must have an intellectual as well as an esthetic awareness of what is happening today and what will probably happen tomorrow.[2]

Florence Wyle, *Head of Norah McCullough*,
1930 C. Plaster, 57.2 × 22.9 × 15.9 cm.
Photo courtesy of the MacKenzie Art
Gallery, University of Regina Collection.

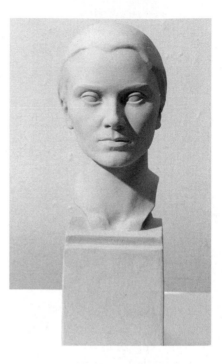

Norah McCullough responded to this challenge, setting into motion events
that would forever alter the way craft practice was perceived in Canada.

The Canadian Handicrafts Guild, formerly the cornerstone of the national
Canadian craft community and linked to the Arts and Crafts movement,
came under fire for being outdated and was forced to rethink its definition of
craft. A serious challenge to the Guild was presented in the form of the
Canadian Craftsmen's Association, based loosely on the professional ideals
put forward by Aileen Osborn Webb's American Craft Council. These ideals
supported the establishment of professional craft experts committed to rais-
ing the standards used to judge craft. In turn, these improved standards,
emphasizing originality and a strongly anti-derivative view of craft, would
result in the granting of rewards equal to those of the fine arts community
through the establishment of bureaucratic support structures. These rewards
were quickly manifested when the Canadian Craftsmen's Association was
selected by the Expo 67 Corporation to operate as the standard bearer for the
upcoming international exposition.

The formation of the Association indicated the initial stage for profession-
al craft in Canada. The main task of the group was to identify the participants
and to publicly state their shared similarities and goals. As evidenced by the

February 1965 conference that established the Association, articulating agreed upon definitions of craft for the group proved to be challenging; ultimately, however, a small group of elite craft experts emerged to implement the Association's vision of professional craft. Although many of the revisions undertaken by the organization would reiterate what had been evolving in the United States for years and would often be influenced by an awareness of the ideologies and activities of members of the American Craft Council, the professional craft community in Canada was an independent and, in its own right, internationally significant group. The Canadian Craftsmen's Association assisted in the crystallization of a "professional" Canadian craft ideology, a concept that continues to influence the Canadian craft world.

What is remarkable about this period of transition, shifting power from the Canadian Handicrafts Guild to the Canadian Craftsmen's Association, was that women spearheaded it. Norah McCullough, founder of the Association, embraced modernism and was intimately associated with the Canadian art scene. Anita Aarons, an exceptionally vocal supporter of tough new professional standards for craft, was dedicated to reforming traditional approaches to craft. Between them, McCullough and Aarons ushered in a new era for professional craft in Canada. Unfortunately, it was not their voices that were heard during the establishment of the Canadian Craftsmen's Association. Although they had proven themselves to be experts in the new field of professional craft, with the exception of Aaron's "Allied Arts" column, it was the voices of men that made public these new ideologies.

Socially Enfranchised Women

Florence Wyle's 1930 plaster portrait of Norah McCullough is a stylized, early modernist depiction of the then twenty-five-year-old: smooth, expressionless eyes, a strong nose, full lips, and high cheekbones. During the period from 1928 to 1930, when Wyle created this plaster bust, as well as a bronze sculpture of McCullough, the two were both participants in Toronto's dynamic art scene, where they shared acquaintances with Group of Seven members including Arthur Lismer, McCullough's boss at the Art Gallery of Toronto, and the prominent ethnologist Marius Barbeau. Florence Wyle and her partner Frances Loring have been established within the Canadian art historical canon as "the first ladies of Canadian sculpture"[3]; however, Norah McCullough remains relatively unknown despite her involvement with the Art Gallery of Toronto, the Saskatchewan Arts Board, the National Gallery of Canada, the World Crafts Council, and the Canadian Craftsmen's Association.

While her work on the Beaver Hall Group and the watercolours of Arthur Lismer has garnered recognition,[4] her role in the establishment of professional, contemporary Canadian craft, perhaps her greatest contribution, remains unrecognized.

Born in Ontario in 1903, Norah McCullough was the daughter of Dr John W.S. McCullough, appointed in 1912 as the Provincial Officer of Health for Ontario and Chief Medical Officer. In 1925 she graduated from the Ontario College of Art with an honours degree in painting and three years later was in the employ of the Art Gallery of Toronto (now the Art Gallery of Ontario), where she assisted Arthur Lismer in teaching children's art classes. Like Lismer, McCullough benefited from Carnegie Foundation money, "To broaden my view, I was sent in 1934 to the Courtauld Institute, London, and enabled through a number of other Carnegie grants to survey educational programs at the Cleveland Museum of Modern Art, the Metropolitan Museum, and the Boston Museum of Fine Art."[5] While attending the Courtauld Institute she took courses in embroidery, textiles, English furniture, pottery and porcelain, glass, the history of gold and silversmithing, and the art of William Morris.[6]

In 1938 Lismer selected McCullough to head to Pretoria, South Africa, to help organize an art school, a venture again funded by the Carnegie Foundation. McCullough spent nearly a decade in South Africa and was celebrated by Pearl McCarthy in the *Globe and Mail* for bringing honour to Toronto by being selected for the task.[7] McCullough's independence and fearlessness were featured in a 1946 *Star Weekly* article titled "A Girl against the Veldt." There, her ability to adapt to the cultural and natural "exoticism" of South Africa was highlighted through stories of stumbling across a native initiation ceremony and accidentally mistaking crocodiles for logs while swimming in the Zambesi River.[8] The Canadian press was writing McCullough as an independent woman, able to lead in the public sphere, yet contained within the domestic expectations for women in the arts through her involvement with art education and the study of crafts.

By 1936, when McCullough was starting her work as a professional in the arts and crafts, May Phillips and Alice Peck, the founders of Canada's only national craft organization, the Canadian Handicrafts Guild, were exiting the craft scene. In her book, *In Good Hands: The Women of the Canadian Handicrafts Guild*, Ellen Easton McLeod offers a clear picture of the women involved in the establishment of the Guild. Alice Peck was from a comfortably upper-middle-class Montreal family, had been educated in England, and had travelled extensively in Europe. Mary (May) Phillips was the daughter of a Montreal lawyer who had died while she was young, leaving the family in

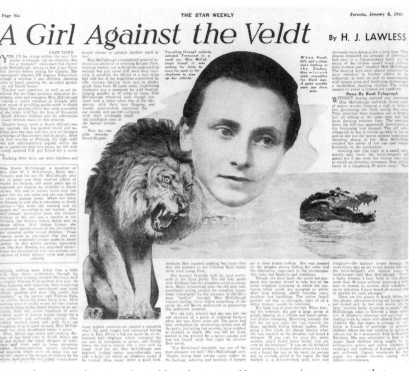

H.J. Lawless, "A Girl against the Veldt," *The Star Weekly*, Toronto (5 January 1946): 6.
Photo courtesy of the Toronto Reference Library.

debt. Although she possessed less economic capital than Peck, Phillips and her wealthier associate were involved in the same upper-class Montreal social circles.

Funding herself through teaching, Phillips trained as an artist in New York City at the New York Art Students League from 1884 to 1889, and after her return to Montreal she began an extensive exhibition schedule before becoming the co-principal of the Victoria School of Art, Montreal, in 1892. By 1895 Phillips was the principal of the renamed School of Applied Art and Design. From 1903 to 1904 Phillips travelled the world, an undertaking that gave her increased cultural capital in the Montreal social scene and assisted her in establishing the Canadian Handicrafts Guild.[9] McLeod argues that Peck and Phillips became respected cultural leaders due to their status as recently enfranchised women, yet their privileged economic position was equally important.[10] Noting that the women involved in the Guild were operating from a sense that their privilege entailed responsibility, McLeod is

careful to outline the social constraints that were placed upon their proper role in a public organization, which included the inability to be voting members in most organizations or to incorporate the Guild without the assistance of a male sponsor.[11]

Once the Guild was established, it was able to offer a certain amount of economic support to Canada's craftspeople through its shops, which reflected a dedication to the preservation of traditional skills through the sales of crafts produced by new settlers in Canada, as well as by members of the First Nations. During the depression, both the federal and provincial governments perceived craft as a viable economic support to depressed areas. Unlike the centralized Works Progress Administration in the United States, Canada's craft programs were never united into a central organization. While the Guild supported the view of the governments in providing economic support through the crafts, it felt threatened by the concept of a national craft program and the potential loss of the Guild's artistic ideals.[12]

Alice Peck and May Phillips were comfortable relating to the small-scale economy of rural craftspeople. Their positions in the field of cultural production were powerful relative to the rural craftspeople, while their economic and cultural capital permitted them to convince the middle and upper class markets of the value of these craft objects; a value that was created due to symbolic recognition. It may be argued that wealthy, well-educated women in the early twentieth century operated outside the restricted gender realm of other women. In spite of this, the majority of women were limited in terms of their gender roles within certain aspects of the economic power relations of the early twentieth century, but they were nonetheless able to act as individual agents in their role as consumers who recognized crafts as valuable. Pierre Bourdieu identifies the men and women in these privileged positions as the "most favoured agents in cultural production ... sufficiently secure to be able ... to take on the risks of an occupation which is not a job."[13]

Ellen McLeod relates the difficulties faced by the Guild as men increasingly became the public authorities on craft, building on the work originally done by the women of the Guild. This shift was related to the growing awareness of the need for increased standards for the crafts, and the desire to integrate crafts into fine arts, fuelled by the writings of men like Marius Barbeau.[14] The earlier female leaders of Canadian craft were thought of as amateurs as the emergence of the image of professional artist-craftspeople reintroduced certain gender biases. May Phillips and Alice Peck believed that economic privilege entailed social responsibility through the crafts. Due to the growing socially enfranchised position of North American women, McCullough represented a new generation, able to pursue her interest in the crafts as part of an

economically independent career. McCullough's economic capital had been preconditioned by her position within the middle-class professional world of Anglophone "Central Canada," which might have prevented her from being sympathetic toward women producing crafts who remained voiceless; however, her consistent desire for inclusion in the crafts indicates that she remained aware of social class positions other than her own. In later letters, she reflects on her election to the position of Canadian representative to the World Crafts Council as being unrelated to ability and more to the "problem [of] who could *afford* to go" to the international meetings.[15] Her links to Arthur Lismer and the Carnegie Foundation enabled McCullough to possess the necessary artistic assets to be perceived as an expert on art education and craft history.

The Influence of Marius Barbeau

Upon her return to Canada, McCullough worked for the extension services department of the National Gallery of Canada, leaving Ottawa for Regina, Saskatchewan, in 1947 to work as the only paid employee of the Saskatchewan Arts Board.[16] During her time in Regina, from 1947 to 1958, she retained links to the National Gallery and was able to bring her knowledge and connections to Central Canada. One of McCullough's first projects in Saskatchewan was to organize a "home industries" program after she had seen this succeed in Quebec and had consulted Marius Barbeau.[17]

An ethnologist at the Museum of Man (now the Museum of Civilization), Barbeau was trying to preserve Quebec's handicraft tradition, based on an exclusive lineage relating back to the noblest of the first settlers.[18] His ideas contributed to the strong provincial funding of craft projects in Quebec, where Canada's first schools dedicated to craft and design training were established, in particular L'École du Meuble in 1930. Sandra Flood argues that Barbeau's craft ideals embraced the rural romanticism promoted by the Canadian Handicrafts Guild, whose board he served on during the 1930s.[19] These ideas influenced a "relatively small, predominantly Anglophone circle centred in Montreal who with Marius Barbeau in Ottawa dominated the field."[20] Arthur Lismer and A.Y. Jackson accompanied Barbeau on his first trips in 1925 to Île d'Orléans and Île aux Coudres to collect examples of authentic Quebec crafts, and it is probable that McCullough met Barbeau through Lismer.

In her first project specifically focusing on the crafts in Saskatchewan, McCullough established a centre at Fort Qu'Appelle where craftspeople lived

and produced pottery on a full-time, professional basis.[21] In her description of the project, which was intended to be a heritage site as well as a craft centre, she was sure to delineate the type of craft objects being produced, which were "carefully vetted to underline originality of hand work rather than handywork."[22] Despite her emphasis on professional crafts, McCullough was nevertheless dedicated to the preservation and promotion of many types of craft activity. In her 1950 presentation to the Massey Commission on behalf of the Saskatchewan Arts Board, she makes her position clear: "This province has in addition to its indigenous groups many cultural heritages which would be a great loss to the pattern of Canadian culture ... [I would suggest] a survey undertaken by the National Museum to investigate closely what exists in the way of handmade arts by indigenous and ethnic groups in Canada and to gather up fine and typical examples in the various traditions for a permanent collection ... in this way, the traditional crafts would receive the care and appreciation they warrant, the craftsman would be encouraged and the public would receive constant inspiration."[23]

The Initial Push for Professionalism

McCullough's interest in craft expanded when she received the Canadian Government Overseas Awards Fellowship in 1956 to study "home industries" in Europe. She set out to investigate the relationship of artists to craftsmen, citing in her proposal the example of Picasso and the potteries; she hoped to use the insight gained for her development of a provincial handicraft program. From 1956 to 1958 McCullough travelled in Europe, studying the regional variations in craft, the different materials in craft production and methods of marketing. In her letters to friends and family, McCullough detailed her observations about European craft, in particular the respect for Scandinavian crafts she had begun to develop when in 1955 she had hired Swedish-trained David Ross as the potter for her Fort Qu'Appelle project.[24] The example of Denmark, she argued, could suggest new approaches to Canadian craft:

The handicraft associations have become so involved in sales promotion that taste and quality have been sacrificed. Dr. Marius Barbeau, the recognized authority on French-Canadian handicraft, once said that over-commercialism had damaged the unique qualities of Quebec crafts. In comparison to Denmark ... although not such a closely-knit national group, we have our rich and varied ethnic mixtures to call upon our leisure and affluence. It seems apparent that good taste and skills develop well

where large numbers of people engage in the practice of handicraft under the direction of imaginative people. Therefore, it seems timely to suggest that a national handicraft council be established in Canada.[25]

McCullough's observations on taste and quality reflected her preference for professional, educated craft production; however, her emphasis on inclusion and the use of crafts to unite the many cultures of Canada remained a focus throughout her career. Her exposure to the professional craftspeople of Europe had a lasting impact, and upon her return to Canada she set about introducing Canadians to the work of European artists by staging small-scale travelling craft exhibitions through the National Gallery of Canada where she served as the liaison officer for Western Canada from 1958 to 1968.

McCullough's comment on the sacrificing of taste and quality for sales promotion was an indirect reference to the Canadian Handicraft Guild, an organization then under scrutiny from Canadian craftspeople and administrators who were better educated and increasingly professional in their approach to the crafts. The retail outlets established by the Guild branches in Montreal, Toronto, Winnipeg, and Yellowknife (in addition to their associated retailers and summer outlets) had provided important sources of income for all levels of craftspeople and were recognized by many Canadians as the key source for crafts. Mary Walpole's "Around the Town" column in the *Globe and Mail* that appealed to the middle-class female consumer, frequently featured items at the Guild shop: "Your look might start with an attractive but classic suit in spring navy and then have it suddenly come to life with a pure silk Batik scarf ... with a pin of hand hammered silver in the pocket ... We saw this happen with a decided dash at The Guild Shop recently and discovered that the accessories were from our top Canadian craftsmen."[26]

The Decline of the Canadian Handicrafts Guild

By 1963 the situation of the Guild was problematic enough to capture the attention of the magazine *Canadian Art*, which published design writer Sandra Gwyn's article "Guild at The Crossroads." Gwyn honoured the long history of the Guild, but also pointed out the division within its supporters between the senior members' desire for tradition and the younger members' need for change and new directions. Like McCullough, Gwyn's respect for the increasing number of educated, professional craftspeople took precedence over a need to adhere to the past: "But in 1963, when the home arts are all but moribund, when the *habitant* woodcarver, the Maritime hooker of rugs,

H.W. Kielman, Silver Teapot, Jack and Lorraine Herman, Nativity Set, Stoneware, Sandra Gwyn, "Guild at the Crossroads," *Canadian Art* 20/5 (September/October 1963): 276. Photo courtesy of the Toronto Reference Library.

the country cabinet-maker have all given way to the sophisticated, art-school-trained fine craftsman, and, less fortunately, to the 'do-it-yourselfer' with his cut-price craft kit, the Guild's confused organization and outdated structure put it at an almost hopeless disadvantage."[27] Gwyn praised the Quebec chapter of the Guild as leading the way for a modernization of the organization with its spring 1963 exhibition, *The Arts and Crafts of Canada.* This national show was the first to be rigorously juried and restricted to fine crafts, defined by Gwyn as the sophisticated products of art-school-trained fine craftspeople.

Norah McCullough served as the only woman on the three-person jury, where she was able to apply her aesthetic preference for fine crafts.[28] In an effort to embrace the Guild's policy of inclusiveness, the jury did not restrict the exhibition to the works of artist-craftspeople only. Instead, they based their judgments on the quality of the pieces not the conceptual content; as Gwyn noted, the Canadian Handicrafts Guild maintained its dedication to

the traditional crafts of Canada's indigenous peoples: "And the show was by no means confined to the works of the avant-garde big-city craftsmen. Included as well were pieces like delicate, embroidered Indian slippers, an exquisite sampler from Yellowknife, and a porcupine quill box made by Teresa Thomas, who lives on a Micmac reservation in Nova Scotia."[29]

The presence of McCullough on the jury for the Guild was important in terms of her cultural capital. It signified her role in the Canadian craft world as an expert, a woman who possessed legitimate authority in terms of judging what qualified as tasteful, high-quality craft while validating the exhibition. In the 1963 spring exhibition McCullough's standards were put forward as a national starting point for future shows. The new selectivity of the Guild show frightened some of the regular craftspeople away, a point Gwyn counters by arguing that some of the best Canadian craftspeople were persuaded to enter for the first time. The final entries clearly indicated an art focus that excluded the untrained amateur. This approach was not new to Quebec, where since its inception in 1949 the Association professionnelle des artisans du Québec had limited membership to professional craftspeople selected by a jury of peers.[30]

Despite the careful selection of pieces for the show, the display itself was considered to have been poor. Gwyn complained of haphazard exhibits, battered showcases, and poor labelling, all of which contributed to the perception of craft exhibitions as less professional due to their hasty organization. As Ellen McLeod observes, by 1963 the Guild was suffering from financial restraints, necessitating a program focused mainly on retail sales. The undertaking of large-scale exhibitions was beyond their scope in terms of physical display, shipping, publicity, and curatorial staff.

Although the display was imperfect, the Quebec chapter of the Guild was able to hire a public-relations consultant who emphasized the high standard of craft objects to the Montreal press, which sent art critics from both the English and French language newspapers to cover the exhibition. While the expertise of Norah McCullough was established through her involvement as a juror in the exhibition, the Canadian Handicrafts Guild turned to the United States for its symbolic capital in the form of Mrs Vanderbilt Webb, the founder of the American Craft Council. Her visit to Montreal to open the spring exhibition of the Guild was part of a larger plan to form an active liaison between the Guild and the American Craftsmen's Council. In an effort to persuade the American Craft Council to sponsor joint workshops and the publication of articles on Canadian craft in their magazine *Craft Horizons,* the national president of the Guild, Harold Burnham, had been communicating with Webb regarding North American craft cooperation. During her Montreal

visit Webb met with Guild representatives to discuss the liaison, but as Gwyn reported in her article, the confused organization, lack of funding, and ineffectual maintenance of standards by the Guild were providing major barriers to forming a strong partnership with the American Craft Council. This was followed by further setbacks faced at the Canadian Conference of the Arts "Seminar 65" in January 1965. The purpose of the conference was to outline funding opportunities for cultural organizations. Different groups presented briefs to support their requests for monetary support. The Canadian Handicrafts Guild found themselves questioned as to their validity as the exclusive national craft organization.[31]

The First World Congress of Craftsmen

Margaret Patch spent 1960 travelling the world on behalf of the American Craft Council.[32] A weaver from Massachusetts and founder of the Massachusetts Weavers Guild, Patch had been a member of the American Craft Council since the early 1950s and had become a close friend of Aileen Osborn Webb, its founder and sponsor. Webb was impressed with Patch's "great belief in organization and statistics,"[33] and had entrusted her with undertaking an international survey of craftspeople. After visiting craftspeople on every continent, Patch returned to New York to inform Webb of the intense interest she had encountered for the idea of designing an international craft project. Her findings aligned neatly with Webb's vision of contributing to world peace by uniting the craftspeople of the world. The 23,500 individual members belonging to the American Craft Council in 1964 regarded Webb as being responsible for the shift in perception of US crafts from rural hobbies to objects forming part of the New York art scene. Now she planned to take on the same task for the rest of the world.

Webb's visit to Montreal to open the spring exhibition of the Canadian Handicrafts Guild enabled her to promote her most ambitious craft project yet, the First World Congress of Craftsmen, to her Canadian counterparts. Webb and Patch confidently set about organizing what was to become the First World Congress of Craftsmen, during which they also planned to present a proposal for a world's craft council.[34] The American Craft Council had already scheduled a national gathering for New York City during the 1964 World's Fair; after Patch's positive reception by those deemed to represent the world's craftspeople, it was decided simply to convert the national conference into an international one. Delegates from many nations attended, but perhaps none were affected as strongly as those from Canada.

Margaret Patch, left, and
Aileen Osborn Webb, right.
Jacqueline Rice, ed. *The First
World Congress of Craftsmen*,
8–19 June 1964, New York:
American Craftsmen's
Educational Council, 1964,
175. Photo courtesy of the
American Craft Council
Archives.

The First World Congress of Craftsmen was held 8–19 June 1964 at Columbia University. Aileen Osborn Webb, the independently wealthy philanthropist who sponsored the American Craft Council, envisioned the event as contributing to world peace by uniting the world's craftspeople. The conference attracted 942 conferees from forty-seven countries. Some craftspeople undoubtedly took advantage of Aileen Osborn Webb's offer to find free board and lodging for the two-week period, but the cost of travel still meant that the Congress was dominated by Americans: 692 were in attendance. The second largest delegation, comprised of thirty people, was from Canada.[35] Seven represented the Canadian Handicrafts Guild, three were from the Canadian Guild of Potters, one attended on behalf of Les métiers d'art de Québec, and the remainder were from various arts groups and galleries across the country, including Norah McCullough, the representative from the National Gallery of Canada.[36] Most regions of Canada were touched upon, although with the exception of Ellis Roulston of Halifax, the absence of anyone else from the Atlantic Provinces was striking.

The booklet "A Short Guide to World Crafts" was distributed to delegates, and contained revealing statistics and surveys of the crafts of each country represented. The US section provided extensive listings of craft organizations, universities, art schools offering professional training for craftspeople, and successful artists who worked in various craft media. "It is of interest to note

American Craft Museum,
New York City. Photo
courtesy of author.

here," wrote the Education Department of the American Craft Council, "that
the approach to craftsmanship in America is that of the individual artist,
working most often alone as both designer and producer, and creating one-
of-a-kind prestige pieces."[37]

This contrasted greatly to the approach to crafts stressed in the other
writeups, including the section on Canada. While the Canadian entry noted a
revival of interest in the crafts, the anonymous author of the Canadian sec-
tion confessed to the lack of schools or institutions in Canada offering full
instruction in crafts and to the hobbyist focus of provincial craft programs,
leading to "the major drawback that confronts all craftsmen ... little of the
work done is recognized as art."[38] The advancing position of US craft within
the recognized hierarchy of the arts was thus contrasted to the struggles of
Canadian crafts to occupy the same professional space. Lois Moran, current
editor of *American Craft*, believes that "Canadians could see what was happen-
ing in the United States and wanted to fill that gap in their own country."[39]

The American Craft Council had achieved its artistic aims for craft through a number of initiatives funded by Webb. America House, a successful retail outlet for the Council, was established in 1940, followed by the launch of the publication *Craft Horizons* in 1942, with a professional editor and a distribution of 3,500 copies.[40] In 1946 the Council established the School for American Craftsmen, part of the Fine and Hand Arts Division of the Liberal Arts College of Alfred University, later an affiliate of the Rochester Institute of Technology. This affiliation with the university milieu was considered to be important for the status of crafts in the United States. Following a 1954 conference on "Craftsmen and Museum Relations" at the Art Institute of Chicago, Webb sponsored the Museum of Contemporary Crafts, which opened in September 1956.[41] In addition to the economic capital Aileen Osborn Webb invested in hosting the First World Congress of Craftsmen, her cultural and symbolic capital came into play in terms of the presenters who agreed to participate in the numerous conference panels and workshops held over twelve days.

Modernism and the Definition of Professionalism

Among the presenters at the First World Congress of Craftsmen were two extremely influential Americans, René d'Harnoncourt, director of the Museum of Modern Art, New York, and the critic Harold Rosenberg. Rosenberg had achieved critical fame through his essay on the Abstract Expressionist movement, "American Action Painters" (1952), as well as his books, *The Tradition of the New* (1962) and *The Anxious Object: Art Today and Its Audiences* (1964). Unlike his contemporary Clement Greenberg, who focused on the avant-garde at the expense of craft concerns, Rosenberg was careful to note the links between art and craft. In *The Tradition of the New*, Rosenberg argued for the self-reflexivity that was developing in the US craft scene: "A form of work establishes itself as a profession not only through the complication of its technique – many of the ancient crafts involved more complex recipes than their counterparts today – but through self-consciousness with regard to this technique."[42]

Acting as the opening speaker for the "Vistas in the Arts" panel of the conference, Rosenberg reiterated the important connections existing between the crafts and the fine arts, "the fine artist and the inventive craftsman are indistinguishable from each other. It is regrettable that an inherited hierarchy of terms makes it more desirable to be called an artist than an artisan," but was careful to maintain the modernist emphasis on the self-reflexive object: "... what defines art as craft is placing the emphasis on the object and

its qualities to the exclusion of the personality of the artist, his uniqueness, his dilemmas. The ideal vista for the future is clear. It is that self-development shall be the motive of all work."[43] In his paper in the panel "The Contemporary Scene," d'Harnoncourt agreed with Rosenberg on the validity of crafts as fine art, but approached the question of identity from a different angle, contending instead that the desire of craftspeople to be given the same prestige as sculpture was disturbing. "It seemed to me then, as it seems to me now," he stated "that the crafts have a dignity and distinction of their own and need not try to borrow status from anything else."[44] Like Rosenberg, d'Harnoncourt's comments excluded the non-professional: "This is a time of rapid change in the arts as well as in any other field of human endeavor. Old classifications are apt to become obsolete overnight. As folk art declines and individual craftsmanship gains in importance, the line dividing craftwork from sculpture often becomes very vague."[45] As evidenced by the enthusiasm for Rosenberg's and d'Harnoncourt's assessments of craft as art, the American Craft Council and the World Crafts Council sought to institutionalize the modernist narrative while making it the official narrative of the international craft world. With over six hundred representatives from the United States present at the conference, the dominance of US concerns over the status of craft as valid art was not surprising. The American Craft Council had a modernist agenda that included the physical placement of the Museum for Contemporary Crafts beside the Museum of Modern Art, the use of art language in the journal *Craft Horizons*, and the presence of René d'Harnoncourt and Harold Rosenberg at American Craft Council events. These institutionalization strategies employed by the Council succeeded in positioning craft within the fine arts establishment.[46]

An analysis of the primary research material for this period reveals several "rules" that craftspeople had to adhere to in order to be considered professional: higher education, business acumen, urban-based practice, sophisticated treatment of traditional materials, innovative use of non-traditional materials, willingness to employ an interdisciplinary approach (to work with industrial design and architecture), and the use of references to modern art trends: "Hitherto the craft field, so called, has been the province of the adult educator or the leisure time dilettante and preserve of archaic custom. This orientation made it of little use to the architect. However, the new group, while not excluding these other activities, has forced attention on the changing nature and growing body of artist-designers who defy categorization and means by education and professional practice to elevate their status to one of economic reality and social responsibility."[47] Anita Aarons, the "Allied Arts" columnist for the journal *Canadian Architecture*, was careful to appear inclusive

of non-professional craftspeople in her definition quoted above; however, the "new group" was of a particular, exclusive nature.

The Formation of the Canadian Craftsmen's Association

Many of the Canadian representatives attending the First World Congress of Craftsmen were influenced by the fine art focus of the panels, and by the end of the event a serious rift had developed between the conferees. Those attending on behalf of the Canadian Handicrafts Guild headed to New York assuming that their president, Harold B. Burnham, would act as the primary Canadian representative to any future body arising from the Congress. A March 1964 Canadian Handicrafts Guild bulletin clearly stated the case: "Our president, Mr. Harold B. Burnham, who is also president of the national guild, is to be the official Canadian delegate."[48] It therefore came as a shock to many when Norah McCullough of the National Gallery of Canada was elected to be the Canadian representative on the executive board of the newly formed World Crafts Council, winning a surprise victory over Harold Burnham. The younger members of the Canadian delegation had broken rank by appointing McCullough, a full-time professional craft administrator who was quick to seize on the opportunity to make dramatic changes within the institutional structures for the crafts in Canada. Many of these changes would echo what had been evolving in the United States for years and would often be "supervised" by members of the American Craft Council, including Aileen Osborn Webb.

In 1969, Gordon Barnes, a National Board member of the Canadian Handicrafts Guild, wrote about the chaos created by the election of McCullough. He described the division in the Canadian craft community at the New York conference as "the traditional youthful rebellion against the 'establishment.' This rebellion surfaced on the occasion of the founding meeting of the World Crafts Council, hosted by Mrs. A.O. Webb ... Initial contact and pre-conference correspondence was with the Guild as it was the only Canadian crafts organization. A group of those attending the meeting from Canada, led by the youthful members, caucused and selected Miss Nora McCulluh [sic], the Western Representative of the National Gallery of Canada to be the Canadian Representative to the World Crafts Council, in preference to the National President of the Guild."[49]

McCullough may have represented a shift toward the "new professionals" with their emphasis on formal art school or university training and acceptance of "fine arts" ideals, but she was neither particularly young, nor unaware

of certain components of the "establishment" Canadian cultural scene.[50] She was also aware of the professional standards that were admired by many Canadian craftspeople.

Following her return to Regina from New York, McCullough was sought out by the Guild, whose members debated the advantages of including her in their organization. Wilson Mellen, president of the Quebec chapter of the Guild, brought up the possibility of appointing McCullough as the new national president of the Guild, replacing Burnham, but believed like many others that she would be too busy as liaison officer at the National Gallery of Canada.[51] The interest in McCullough increased when she proved to be quick to use her new position to begin instituting major changes in the structure of Canadian crafts; changes that challenged the very existence of the Canadian Handicrafts Guild.

McCullough was aware that the position of Aileen Osborn Webb as the president of the World Crafts Council and the body's push for regional development (demonstrated through their insistence that every participating country belong to a larger regional group), indicated that Americans had decided to take on the leadership of North American crafts. Canada was in a weak position due to the lack of an effective craft council. McCullough decided to rectify this situation. Her first step was to collect a list of the names of all Canadian craftspeople, thereby creating what was purported to be a national mailing list. Unlike the Guild, which had separate provincial branches, some stronger than others, this list represented craftspeople from every part of Canada. While McCullough sought an inclusive list, the names were submitted to her by the other Canadian representatives present in New York and were therefore limited to those craftspeople recognized by this largely professional core group. A newsletter written by McCullough from the Saskatchewan Arts Board was sent out on 26 June 1964, encouraging Canadian craftspeople to respect the urgent need for a national organization to work with the World Crafts Council. No mention of the Canadian Handicrafts Guild serving as this organization was made. After McCullough had received more than seven hundred names and addresses of craftspeople, a detailed "Newsletter to the Craftsmen of Canada from Miss Norah McCullough" was mailed on 16 September 1964. McCullough presented suggestions for a meeting regarding the possibility of establishing a new national organization that would be centered on two key questions: structure and membership.

Basing her argument on the importance of unity of purpose and intercommunication, McCullough asked craftspeople if a new organization was necessary, or if the existing associations formed "an exceedingly valuable

framework and it would seem desirable that a CRAFTS COUNCIL should embrace, not compete with them." More important to McCullough than the structure of a new organization was the issue of membership. Recalling debates over exclusivity and membership at the New York congress, where delegates agreed on the importance of international communication and development and the limitations of restricted membership, she urged her fellow Canadians to consider keeping the organization open. One of her chief concerns regarding membership was the need to include non-practicing individuals such as Aileen Osborn Webb, who "could be exceedingly helpful, Mrs. Vanderbilt Webb herself being a notable example."[52] Members of an ideal national craft organization would be composed of artist-designers, rural and folk designers, amateurs as well as enthusiastic laymen. McCullough's next step was to use her suggestions to form the basis of her biggest project yet, the first national gathering of Canadian craftspeople.

Having received almost 100 percent response to her newsletter, with the majority in favour of the formation of a new organization, McCullough planned a conference to take place at the Department of Architecture and Interior Design, University of Manitoba, Winnipeg, 5–7 February 1965. More than forty government officials, university professors, individual crafts-people, and representatives of major craft organizations attended the meet-ing, bringing with them a diversity of backgrounds and approaches to the crafts. The North American studio craft movement's emphasis on individual artist-craftspeople had been increasing in popularity, following a shift from group crafting and craft education activities such as the Works Progress Administration in the United States, or the Searle Grain Company project in Canada.[53] Despite the increased emphasis on individual practice, McCullough received an overwhelmingly positive response to her call for the formation of a united group. This indicated that Canadian craftspeople were not only aware of the increased opportunities for funding available through organiza-tions involved in planning the events of the centennial year but they wanted to meet other craftspeople from across the country in order to exchange ideas and information.

Government officials took advantage of the Winnipeg conference to announce new funding initiatives that would benefit Canadian craft and design. The Department of Industry along with the National Design Council unveiled Canadian Design '67, a program intended to promote good design for manufacture. The Minister of Public Works announced a commitment to set aside one percentage of the cost of new federal government buildings for works of art.[54] This was positive news for the craftspeople attending, for it indicated the federal government's financial support for art and design,

particularly in the rush to prepare Canada for the celebrations of 1967. Crafts-people found their work being considered under both art and design cate-gorizations. The fear of missing out on these opportunities, as a result of geographical location, exclusions through standards, or lack of symbolic or cultural capital, provided the incentive to engage in collective action.

Absent from the Winnipeg conference were Aileen Osborn Webb and members of the American Craft Council. In order to develop a truly Canadian craft organization, nurtured independently of the United States, invitations had not been extended. In the final report of the Conference of Canadian Craftsmen, item eleven stated "although the American Craftsmen's Council was an exemplary institution, we should create our own Canadian pattern."[55] Even if Webb and the American Craft Council were not present, there was an awareness of their role in the instigation of the meeting and the need for strong Canadian representation in the North American section of the World Crafts Council. A few months after the Winnipeg conference the perceived strengths of this organization continued to highlight the deficiencies in the existing Canadian craft groups:

Handcraft in the USA is big business. This is due to the indefatigable devotion of a dynamic entrepreneur, Mrs. Vanderbilt Webb and her organization, the American Craftsmen's Council. With her vision and untiring effort (plus the use of personal for-tune) she and her craftsmen supporters have elevated the handcrafts of America well above the sentimental preservation of cottage craft, or the promotion of the indige-nous native artifacts as perpetual souvenirs. A well organized body of contemporary trained craftsmen is producing highly original, well crafted products in any media. They expect, and do, earn a good professional income disposing of their products to all branches of society, independent of the tourist industry.[56]

Eight panels were featured at the Winnipeg conference; sessions examined structure, membership, education, legal, marketing, liaison, and affiliation with the World Crafts Council, but the official name and the issues of struc-ture, membership, and standards proved to be of greatest concern. The Quebec Handicrafts Guild sent Mrs Louis E. Johnson and Mlle Françoise Brais, and the Ontario Canadian Handicrafts Guild chose Harold Burnham, Mary Eileen Muff, and Merton Chambers as their official representatives. The Guild was aware of their increasingly negative image, especially in Western Canada. Following the embarrassment of New York, Burnham had been busy discussing new directions for the Guild, and he arrived in Winnipeg as even the name of his organization was being reconsidered.[57] In late 1964 the Guild had initiated a questionnaire to craftsmen in an effort to identify their poten-tial membership base. Questions were aimed at professional, amateur, semi-

professional, and student craftspeople and focused on concerns over stan-
dards, exhibitions, craft supplies, and marketing. Following the question-
naire, Adelaide Marriott, a long-time Canadian Handicrafts Guild member
and former manager of the Ontario Guild's retail sales, suggested to Burn-
ham a motion be put forward that "a newly reorganized and expanded
Canadian Handicrafts Guild – under a new name with a full-time organizing
director and suitable staff – be made the recognized official organization for
Canadian craftsmen – to implement the constitution and work in co-opera-
tion with the World Crafts Council."[58]

The question was not settled in time for the Winnipeg conference.

Merton Chambers, Harold Burnham, and the Semantics of Craft

The Women's Committee of the Ontario chapter of the Guild urged the
selection of a professional craftsperson to represent the interests of the
organization and funded the trip to Winnipeg for professional potter Merton
Chambers. Toronto-based Chambers worked mainly in ceramics but also cre-
ated batik and block-printed fabrics. He was one of the only Canadian potters
specializing in architectural ceramics and was praised for producing versatile
work of a very high standard.[59] Following his graduation from the Ontario
College of Art and Design in 1957, where he majored in ceramics, Merton
Chambers won a scholarship to study overseas with Dora Billington, head
of the Pottery Department at London's Central School of Arts and Crafts.
Although Billington had suffered from a stroke, forcing Chambers to study
under her assistant, he was influenced by her aesthetic. Billington empha-
sized the European tradition of handbuilt, tin-glazed earthenware, in opposi-
tion to the oriental aesthetic of Bernard Leach. Her book, *The Art of the Potter*,
published in 1937, was one of the first to encourage the blending of ceramic
history with technical information. She persuaded her students to make one-
off pieces rather than production series.[60] While Chambers was at the Central
School he met Lucie Rie and went to visit Bernard Leach and Shoiji Hamada.
He was particularly influenced by the industrial techniques practiced in
Great Britain, which he perceived as forming the vital bases for all ceramic
work, "All that stabilizing and tradition was a good influence on me. The
Americans threw it all out with the dishwater and lost some of the reason for
validity in what they were doing ... So we got the teapot that was no longer
a teapot."[61]

Billington's students included Nicholas Vergette, who produced ceramic
murals and figurative works for architectural settings during the 1950s and
1960s, and Ruth Duckworth, famous for her ceramic murals.[62] Following his

return to Canada, Chambers began to explore the possibilities for ceramics within architecture: "When I came back my mind simply expanded because we were into a great construction period then of brute concrete, and I could see there was another area in which clay could be used."[63] His interest in the relationship between clay and architecture resulted in a large number of public commissions during the 1960s including pieces for the provincial government of Ontario, synagogues, banks, and schools. His relationship with Anita Aarons, a vocal proponent for the integration of craft into architectural spaces, was helpful in promoting his work. Her exhibitions, including 1967's *Crafts For Architecture* at the University of Toronto, demonstrated the tremendous popularity surrounding the use of craft within modernist structures: "It was one of the top exhibitions ... so popular that the firemen regulated the crowds going through."[64]

Chambers's commissions were highlighted in Aarons's regular "Allied Arts" column in the *Royal Architectural Institute of Canada Journal*. A series of his ceramic planters for the National Trust Building in Toronto were illustrated in the May 1965 *Journal*. These large square planters supported on delicate tall bases featured high-relief patterns of various geometrical shapes. The unglazed relief work was left rough to reflect the quality of the earth. According to Gail Crawford's June 2002 interview with Chambers, commissions like these planters were less interesting to him than his mural work. "Other than murals, the works that I did were containers for something and therefore that something was far more important than the container. Things like bowls had to have a lip and the interior was much more interesting than the exterior. If it were a larger piece, the simple form itself was more important representing, in the case of planters, a rather earthy feel. The plant itself was more interesting and was a vehicle to make the container more interesting."[65]

Chambers designed his murals to offset the modernist architecture of the period, which he describes as depressing "heavy brute concrete."[66] His large figurative mural for Toronto's Education Centre reflects his desire to break up plain interiors with colourful, dynamic surfaces. The illustration shows Chambers at the far left examining his work, which was composed of pieces of clay hung on various sections of the wall. The repeating motif of the circle is used to form the faces of the children, who appear to be singing in a large choir, as well as in more abstracted round outlines. These shapes remind the viewer of musical instruments while simultaneously pulling the eye away into abstracted forms. Delicate Paul Klee-like linework on the surface of the flat ceramic puzzle pieces provide active connections from one end of the large mural to the other, which is punctuated by the groupings of children's faces, mouths open in song. This piece is reflective of Chambers's desire to

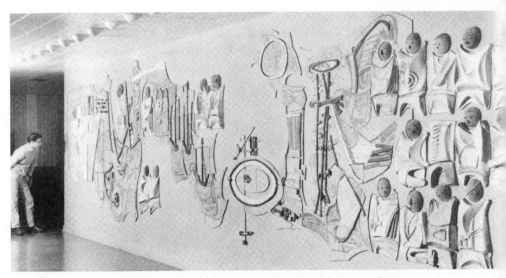

Merton Chambers examining his Education Centre Mural. *Royal Architectural Institute Journal* 42/3 (March 1965): 22. Photo courtesy of the Toronto Reference Library.

break up the "long corridors which were deathly" and threatened to "turn the staff into zombies."[67]

The Women's Committee of the Guild, many of whom were familiar with his work, was convinced that Chambers would give the Guild a modern, professional voice at the Winnipeg conference.[68] Burnham, who also attended the Winnipeg conference, believed, like many members of the Guild, that the establishment of a new Canadian crafts council would permanently harm the Guild.[69] However, it had become apparent to members that it was necessary for the Guild to approach the possibility of a new organization on friendly terms, prepared for full cooperation, for "if we do not, we shall be superseded in every activity and remain a benevolent, kindly, rather old-fashioned organization."[70] At the start of the conference Burnham made the position of the Guild clear: "I had the opportunity to state that the representatives of the Canadian Handicrafts Guild, who were attending the meeting, had come in the fullest spirit of cooperation ... and that it was prepared to expand its services, if desired, to act as the Canadian branch of the recently formed World Crafts Council."[71]

Burnham had been carefully developing his view on the Guild's relationship with crafts. In a 1965 article in the Guild publication *The Craftsman/ L'Artisan*, he attributed the difficulties facing the Guild to the problem of definition. Reducing craft production to "craft as art" versus craft as "manual

skill," Burnham argued that while this "clash of meanings" led to the need for a name change within the Guild, it had no impact upon the status of craftspeople. Burnham dismissed the issue of naming, about to be foregrounded at the Winnipeg conference, as irrelevant, "Several attempts have been made in recent years to give added stature to the craftsmen in our community by referring to fine crafts, designer-craftsmen, and artist-craftsmen. Like most compound terms in English, all these are clumsy. 'Fine crafts,' like 'fine arts,' carries the seeds of ambiguity and could lead to a segregation of work on a bold scale. Designer-Craftsman is a misnomer: the person who designs objects for the skilled artisan, or handicraftsman, remains a designer. Artistcraftsman is a redundancy. Let us accept the fact that the craftsman who produces original work is an artist, good or bad."[72] In Merton Chambers, the Women's Committee of the Guild had elected to send to Winnipeg a representative very different from Burnham. Whereas Burnham desired equal status for craftspeople irrespective of name, Chambers was convinced that titles were central to the public's perception of professional crafts.

Chambers perceived Canadian craft as consisting of three major elements: 1) native handcrafts based on tribal imagery; 2) pioneer craft skills preserved by talented amateurs; 3) products produced and distributed by contemporary craftsmen. Chambers subdivided the third category into adult amateurs collecting part-time skills and professionally trained artist craftsmen, products of art schools able to work in the various fields of art, architecture, and design for industry. Chambers's focus was on the final category of professional craftspeople, which he further classified as: [1] artisan-craftsmen, who execute traditional designs or the designs of others; [2] artist-craftsmen or designer-craftsmen, who are capable of originating and executing their own designs and who exhibit and sell under their own name; [3] designers in the craft field, who know the techniques in a given media but prefer to design work for others rather than execute it themselves.[73]

The opposing views of Burnham and Chambers came into the open during the Winnipeg conference. Chambers was nominated to chair the session on "structure" and asked Burnham to be a member of the committee. This was the key issue at the conference for members of the Canadian Guild of Crafts, for it would determine whether the Guild was maintained as the only national craft organization, or if there would be a new craft council developed. As the committee discussions developed, Chambers did not put forward the Women's Committee recommendation to continue using the Guild as a revamped umbrella organization. Instead, George Shaw, who worked with Norah McCullough at the Saskatchewan Arts Board, moved that a new organization be formed. A vote was held, with nine in favour, four against,

and one abstention. A new crafts council was born. This incensed Burnham, who perceived the reign of the Canadian Handicrafts Guild as having come to an end, in part through the betrayal of the session chair. Chambers, in contrast, believed that a new organization would be able to present a unified front to the World Crafts Council: "Provincial disunity and dissatisfaction as previously displayed in the First World Congress of Craftsmen, would have been intolerable at this juncture to present to a wider sphere."[74] For many of those attending the Winnipeg meeting a new organization indicated a new image and a perception of Canadian craft as modern and professional.

What had begun as a conference focusing on crafts ended up creating, as McCullough undoubtedly had intended, a new organization dedicated to "all those forms designed for use in man's environment, either hand-made or designed for large-scale industrial production."[75] Delegates to the Winnipeg meeting had agreed that there would be room for "jewelry, pottery, weaving, enamelling, sculpture and murals or, for other artifacts that can be industrially produced from well-designed prototypes such as printed textiles, ceramic garden planters or furniture."[76] Arnold Rockman, the editor of *Canadian Art*, and contributing art critic for a variety of Canadian newspapers, suggested the name Canadian Council for the Environmental Arts (Francophone representatives approved of the name, which was easily translatable into French as "Conseil Canadien pour les arts de l'espace"[77]), which was accepted by the delegates. Rockman argued that this name embraced far more than craft and would benefit craftspeople far into the future. For Burnham and the other members of the Canadian Handicrafts Guild, the name indicated a problematic shift away from craft concerns toward a broader concern with craft, design, architecture, and art. Mary Eileen Muff, a special delegate for the Ontario Guild, reported her negative vote for the new name, observing that, "the ideas expressed by many of those present indicated that they considered that they worked in a field which could not be called a craft. Some of these were typographers, industrial and interior designers, architects, potters and jewelry makers. Therefore they did not want the word 'craft' in the name. As the vote indicated sympathy towards this group, it would seem that this new organization cannot hope to assist the craftsmen for quite some time due to the course it now seems bound to follow, that of establishing a highly professional group, embracing all that is visual."[78]

This surprise focus of the Canadian Council for the Environmental Arts left an opening for the Guild to continue as the only true representative of the crafts in Canada, Muff argued. She recommended they keep the name Canadian Handicrafts Guild and concentrate on raising the standard of their image. Meanwhile Rockman was elated at the shift in focus during the

Winnipeg meeting. In his editorial for *Canadian Art,* he took a swipe at the Guild and praised the new organization: "In the opinion of many of those present at the conference, the Canadian Handicrafts Guild had become a stagnant organization which did little to raise the standards of handmade craft objects and was to all intents and purposes merely a retail selling organization ... Perhaps this latest development within the hitherto narrow world of Canadian crafts suggests that our craftsmen are now ready to abandon their stubborn adherence to the ideology of the handmade object."[79]

Chambers echoed Rockman's sentiments in his article on the Canadian Council for the Environmental Arts published in the *Royal Architectural Institute of Canada Journal*, concerning himself with the issue of standards. Chambers took the opportunity to highlight the deficiencies of the Canadian Handicrafts Guild, stating that Canadian craftspeople were aware of the "unsatisfactory and ambiguous nature of the handicrafts organizations," which were not always operating in the best interest of the contemporary artist-craftsperson. Chambers very pointedly acknowledged the role and the current pre-eminence of the Americans: "the American Craftsmen's Council gave the lead to form the World Crafts Council, and to use the methods and experience gained by them plus proper consideration of local geographic conditions. Despite their leadership role, no plans as yet exist to form a professional society of the standing of the American Craftsmen's Council. It is hoped in time this will follow."[80] Chambers expressed excitement over the ability of the new organization to raise the standards of Canadian craft, calling the Canadian Council for the Environmental Arts primarily a "standard setter." The conference agenda, he reported, had been dominated by discussions surrounding "the raising and maintaining of high standards" and the expected "standards in education and promotion."[81]

The standards set by the new organization reflected the habitus, or lifestyle, of its constituents. Those who were present in Winnipeg represented administrators and craftspeople who possessed the cultural and economic capital to make large-scale changes to the definition of craft, as well as the certainty that they were qualified to make such reforms. The name, suggested by Rockman, a leading force in disseminating ideas regarding what was acceptable art in *Canadian Art*, shifted away from the Canadian Handicrafts Guild, as well as from amateurs and consequently the women, rural poor and immigrant populations who were creating craft without formal education. While crafts had traditionally been the domain of women, by the early 1960s male producers and administrators formed a growing part of the audience for craft. Those wishing to dictate good taste and proper standards in craft were hoping to perpetuate value systems and ideological constructions they

held as important. The craft objects designated as precious and selected by specialists could operate as agents for the transmission of an effective dominant culture.

The government officials present at the Winnipeg conference recognized the power of the new organization to operate as a standard-setting body. While the Expo 67 Corporation officially demanded evidence from the Council that it could speak as a national organization for the majority of Canadian craftspeople and designers, Jean-Claude Delorme, the secretary-general of Expo, had attended the Winnipeg meetings and had already decided that the new Council held a set of standards high enough for the Canadian Government.[82] The new organization and its leaders had been officially sanctioned as the gatekeepers of Canada's craft culture. The Francophone representatives supported the new Council, with its focus on high standards, as their provincial organizations had been setting such stringent standards since 1949.

Yvan Gauthier, the former executive director of the Conseil des métiers d'art du Québec, argues that Quebec had always made the distinction between professional and amateur craftspeople, unlike English Canada, which retained ideological links to the Arts and Crafts movement's philosophy of joy for everyone in craft labour. While the other provinces had been romanticizing the amateur, the Quebec Government had recognized the ability of its professional craftspeople to affect cultural and language developments and had been generous in granting money to Quebec's craft organizations. Quebec had been looking toward the United States for leadership, rather than toward the Canadian Guild of Handicrafts. Gauthier stresses the importance of the United States on the development of Quebec's craft council, which adopted the emphasis on crafts as business and the importance of university education in craft. In 1955, Quebec started the first large-scale professional craft fair in Canada, the Salon des métiers d'art, which was strictly juried and well-publicized and hired a number of permanent employees.[83]

Earlier connections with the American Craft Council had been successful as well. In the 1942 first edition of the journal *Craft Horizons*, the Province of Quebec's director of handcrafts (a position under the auspices of the Ministry of Agriculture), Oscar Beriau, published an article on the "Craft Revival in Quebec," where he discussed the involvement of American instructors at the School of Handicrafts he helped to found in 1930.[84] Beriau became friends with Aileen Osborn Webb, and he met with her on his trips to New York to study the organization of the Council.[85] In turn, Beriau influenced American craft organizations through the exhibitions of Quebec craft work he sent to the New England states.[86] The Government of Ontario was impressed with

Beriau's professional approach to craft development and in 1946 formally requested his assistance in establishing a craft organization in Ontario, a project that Beriau accepted but was unable to complete due to his death in 1947. Ellen McLeod argues in *In Good Hands* that the appointment of men like Beriau to professionalize Quebec crafts was inherently sexist, as they replicated many of the activities of the women in the Canadian Handicrafts Guild but were perceived as authorities in comparison to Phillips, Peck, and their supporters.[87] Be that as it may, Quebec had been leading the way in terms of professional crafts, and their delegates in Winnipeg were enthusiastic about a national project that pursued the same aims by introducing strict standards.

Anita Aarons: A Vocal Critic

As we have seen, Chambers's position in Canada as a professional potter allowed him to vocalize concerns over the issue of poor standards in craft production. Chambers's life partner, Anita Aarons, who arrived in Canada from Australia in 1964 and proceeded to shake up the Canadian craft scene, helped to amplify his voice. Aarons was a jeweller, sculptor, and critic who had worked as head lecturer in sculpture at Caulfield College in Melbourne. She had helped to found the Society of Sculptors and Associates in Australia, an organization that provided a liaison between sculptors, designers, and architects. In 1963, Aarons worked as a demonstrator and teacher under the influential British art critic Sir Herbert Read at the "International Education Through Art" seminar in England.[88] Read began his career in the Department of Ceramics at the Victoria and Albert Museum, where he developed the view that, while sculpture was imitative, pottery was "plastic art in the most abstract form."[89] His vision of modernism included ceramics, which he felt embraced the abstraction that was crucial to the avant-garde. By 1965 the American Craft Council's Museum of Contemporary Craft was also a follower of this view, staging exhibitions of the work of California ceramist Peter Voulkos, who was famed for his non-utilitarian clay forms. The Canadian Council for the Environmental Arts believed it could make a difference by demonstrating that the crafts were indeed a professional practice unrestrained by the confines of utility, an outlook promoted by Anita Aarons.

Anita Aarons's own jewellery production exhibited many of the aesthetic ideals she urged through her writing. She favoured large, bold designs referencing natural forms that betrayed her sculptural training. Like other jewellers practicing at the time, most notably Walter Schleup, Aaron's work reflects her awareness of modern artistic trends. While Schluep produced

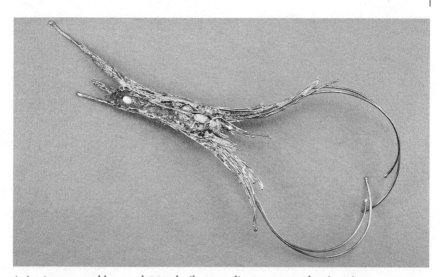

Anita Aarons, necklace, n.d. Metal, silver, sterling, stone, opal, 4.6 × 36.5 × 15.4 cm.
Photo courtesy of the Canadian Museum of Civilization.

work directly reminding viewers of these artistic sensibilities, including pop-art rings bearing cartoon-like flags of the United States, Aarons's manipulation of materials and willingness to push beyond traditional jewellery forms set her work apart from many of her contemporaries. Her necklace, selected as one of the Canadian entries for the 1974 exhibition *In Praise of Hands,* demonstrates Aarons's ability as a professional art-craft jeweller. The piece features a stylized piece of bark, formed from fused silver wire of various weights. Referencing the surfaces found in ceramics and textiles, an organic, natural look for the bark is achieved through the nubbly, rough, texture that she applied to the surface of the work. The knotholes on the bark are highlighted though oval white opals set in a diagonal line. Aarons draws the viewer's eye down and away from the opals by extending one strong, textured, wire, which she balances by drawing the eye back up to a series of other wires creating the top ring for the neck. Her interest in the relationship between architecture and craft mirrors her concern for the ergonomics of the wearers of her jewellery designs. Her heavy, bold necklace was composed of protruding wires engineered to be worn without interfering with the wearer's comfort.

By the time she arrived in Canada, Aarons was convinced of the importance of good education and professional standards, as well as affiliations with architecture and fine arts, in developing Canadian craft, a view she strongly expressed in her "Allied Arts" column in the *Royal Architectural*

Institute of Canada Journal (later *Canadian Architecture*). Not present at the Winnipeg conference, she supported the new group throughout the 1960s with positive reviews in her column. Like Rockman and Chambers, Aarons publicly applauded the professional focus on improving standards, applying the possibilities to architecture, "Hitherto the craft field, so called, has been the province of the adult educator or the leisure time dilettante and preserve of archaic custom. This orientation made it of little use to the architect. However, the new group, while not excluding these other activities, has forced attention on the changing nature and growing body of artist-designers who defy categorization and means by education and professional practice to elevate their status to one of economic reality and social responsibility."[90] Aarons was an outspoken critic of what she perceived to be the poor quality of Canadian craft. Her international experience and confidence garnered the attention of Canadian craftspeople, and her strongly expressed opinions appeared in many different publications. A year after the Winnipeg conference she used the journal of the Canadian Handicrafts Guild to issue a contentious challenge to craftspeople, openly mocking the Guild and praising the American Craft Council. Central to the development of a successful Canadian craft scene were sound education and good business practice, Aarons contended, goals she felt were lacking in the Guild due to the involvement of amateur members. Although she praised the enthusiasm of amateurs for their role in developing the contemporary craft movement in Canada, she was convinced "the amateur has become a dead albatross tied around the neck of the practicing craftsman." Aarons critiqued the Canadian National Exhibition show, used by the Guild since 1932 to display examples of Canadian craft, as "hysterically funny with the numerous prizes, even for tea cosies." Aarons suggested Canadians follow the example of the American Craft Council, with their elevation of the crafts to "professional and businesslike status without loss of creative energy," chiding Canadians for their negativity and fear of becoming well-organized and aggressive in the promotion of their craft work.[91]

Along with Rockman and Chambers, Aarons believed she knew which standards were necessary for improving craft. This confidence betrayed their social and personal backgrounds, which gave them accredited tools for aesthetic selection and, more important to the classification of professional craft, aesthetic elimination. McCullough's early strategy of inclusion was lost in the push for improved standards, which necessitated that the craft field become dominated by members who possessed the cultural and economic capital believed to belong to the "proper" type of craft. The new organization, name and members were credited with the potential to overcome the

traditional in deference to the intellectual connections available in the material activity of craft production by, as Pierre Bourdieu states, "abandoning the popular aesthetic, the affirmation of continuity between art and life, which implies the subordination of form to function."[92] Norah McCullough was a friend of Merton Chambers and Anita Aarons, who were strong supporters of her belief in the advantages of a new Canadian craft organization, free from the "dead albatross" of the Canadian Handicrafts Guild.[93]

While Rockman, Chambers, and Aarons condemned the Canadian Handicrafts Guild, long-time Guild members opposed their views by writing a number of Guild histories that highlighted the important role the Guild had played in Canadian craft. Adelaide Marriott wrote a history of the Canadian Guild of Handicrafts, published in the Guild's journal, stressing the importance of retail sales to the survival of the Guild as well as many craftspeople. The contributions of the T. Eaton Company in providing retail space, the involvement of Floyd Chambers and Mr Cole, the Canadian trade commissioner, in arranging the participation of the Guild in a 1939 international exhibition at Madison Square Garden, New York, and the role of the American Craft Council's America House in promoting Canadian crafts through exhibitions were outlined by Marriott. She argued that while all of these initiatives were related to the goal of increasing sales, they also played a vigorous role in elevating the status of Canadian craft.[94] Both sides, it seems, could use the American Craft Council for validation.

Alice Lighthall's history, published for the Guild, was careful to mention the Guild's inspiration from the craft revival in Great Britain, and she noted the many disadvantaged groups, which had been assisted by the Guild's efforts. Beginning with Mary Phillips's and Alice Pecks's initial desire to prevent the disappearance of "the country arts," Lighthall went on to praise the Indian and Eskimo Committee, which intended to preserve what was left of the Indian arts "for the good of the People." Further, the Guild's series of "New Canadians Exhibitions" were started following the Second World War in an effort to help "displaced persons who sought our shelter with only the skill of their hands as capital."[95]

The attempts by Marriott and Lighthall to inspire faith in the Guild by referring to its illustrious history were not completely successful. There remained difficulties in reconciling the founding and organization of the Guild by women perceived as "dilettantes" with the desire for professional membership. This was an issue of gender as much as class and education. Aileen Osborn Webb had overcome this potential problem by remaining the economic lifeforce of the American Craft Council, while allowing younger members to play an active role in the selection and promotion of crafts.

Although there was reverence for Marriott and Lighthall, long-time administrators and supporters of the Guild, they were not considered to be key players in the emerging debates over professionalism. The new women who were occupying leadership roles in the Canadian craft scene, such as McCullough and Aarons, were promoting themselves as career women, therefore lifting the crafts out of the domestic realm and forcing the education of craftspeople into the public sphere. Oscar Beriau's romantic vision of women teaching their children the domestic arts of spinning and weaving by the hearth was simply no longer applicable.

The attacks on the Guild by the "rebellious" and "youthful" members of the Canadian Council for the Environmental Arts were considered to be attacks on the disadvantaged and amateur craftspeople who had been most benefited by the Guild's program. Indeed, craft practices perceived as outside the classification of fine art were not part of the new council's agenda. Rockman's name and the general agreement to widen the parameters of craft led directly back into the hierarchy of traditional art, a categorization dependent upon the tastes of many non-practicing art administrators. However, the mandate of the Council reflected a concern with exclusion, despite the strong push for professionalization. Item six stated that it was "necessary to clear up the existing confusion between the professional designer and the hobbyist," while item nine reminded members that "attention and assistance be directed towards the ethnic minorities, including new comers to Canada, to improve production and prevent the debasing of skills and exploitation."[96] Prior to the Winnipeg meeting the Guild had made an effort to distill its history while indicating their readiness for modernization and change. An article published in the *Junior League Magazine* reached North American audiences with the message that "the Canadian Handicrafts Guild ... is in a reorganizing period. Its function and operation are being retranslated in the light of today's opportunities and needs. There is tremendous ferment in the field of crafts today, which must be directed, particularly in the matter of standards."[97] As the election of Norah McCullough in New York and the agreement to form a new craft organization in Winnipeg demonstrated, the Guild's message had come too late, at least for the immediate future.

Following the Winnipeg meeting, the new organization undertook the momentous task of uniting Canada's craftspeople, designers, and architects. The executive committee consisted of Norah McCullough as chair, Françoise Brais as vice-chair, and George Shaw as secretary-treasurer. In Burnham's official report on the conference he offered his sympathy to this group, stating "the problems faced by this executive council are of the greatest magnitude."[98] Based in Regina, considered to be outside the dominant Toronto–

Ottawa–Montreal power base of Central Canada, the group held greater appeal in the west than the Guild, but soon the official address was moved to Ottawa in the hopes of securing government funding. By the summer of 1965 it was becoming obvious to the executive that they could not retain the name Canadian Council for the Environmental Arts and receive funding from the Department of the Secretary of State, which felt that there were too many organizations with the terms "Canadian Council" in their title.[99] The executive committee began searching for a new name, aware that their choice had to embrace the goals set for the group at the Winnipeg conference, "the problem is that the word design does not translate into French. There has been some strong feeling about including words like "professional,' and excluding words like Guild, and we did not want to call it by a name too closely emulating the American one, the American Craftsmen's Council."[100] After a great deal of discussion among McCullough and the Association's executive and lawyers, the group was renamed the Canadian Craftsmen's Association, identifying the organization specifically with crafts, and thus abandoning Rockman's desire to encompass a wider variety of arts. A further blow to the organization occurred when Norah McCullough resigned from the position of chair in order to curate a large exhibition of Canadian crafts she was starting to organize for the National Gallery of Canada during the centennial year.

George Shaw, the new chair of the Association, began to seek the approval of the Expo 67 Corporation to have his organization set the standards for crafts sold and exhibited at the World's Fair. It was helpful that Sheila Stiven, a member of the new Association, was also on the Centennial Commission. Even more helpful was the Canadian Government's eagerness to establish strong, unified cultural groups across the country in time for 1967. Funds were available through the Secretary of State, the Centennial Commission and the Canada Council to initiate cultural events; the Canadian Craftsmen's Association had determined to professionalize the image of Canadian crafts and improve standards just in time for the international spotlight that would focus on Canada in 1967.[101]

Aileen Osborn Webb was busy with World Crafts Council commitments throughout 1965, including a worldwide tour with Margaret Patch, during which they visited all Council representatives. Although not invited to the Winnipeg meeting in February, Webb returned to Canada in April as the keynote speaker at another major conference on the crafts, this time for the craftspeople of Ontario. Webb had been corresponding with several of the Canadian delegates to the First World Congress of Craftsmen, as well as Canadian craftspeople who had written to the American Craft Council and

Webb for advice and guidance on issues they felt were important. Letters in the Canadian and American craft archives show that Webb was careful to send out many personalized replies to Canadian letters, many of which were concerned with the lack of formal educational opportunities in craft in Canada.[102]

Canadian craft administrators were also being approached regarding the problem of education, an issue that had been highlighted at the January 1965 meeting of the Canadian Conference of the Arts, where the delegates unanimously agreed that new schools were needed, as well as funds to employ teachers who were leaders in their fields. Galt Durnfurd of the Quebec Branch of the Canadian Handicrafts Guild received a letter from Mary E. Black of Nova Scotia; it read, "Of late I have been greatly concerned over the lack of a school in Canada for the training of our Canadian craftsmen, English speaking that is, as I understand there are handcraft schools for the French speaking student."[103] Taking up the banner, Anita Aarons condemned the education of Canadian craftspeople: "Miss Aarons feels the manner in which art is taught to teachers is the source of much of the problem ... Miss Aarons points out that there are good schools in some parts of the United States, such as Rochester Craft School, Pratt, Cranbrook. 'You are so close it should be simple to send teachers over there to experience new thinking.'"[104]

Aarons undertook to correct the lack of liaison between architects and craftspeople by designing a full colour *Allied Arts Catalogue*, which listed Canadian craftspeople capable of working on architectural projects, citing their backgrounds and qualifications and showing examples of their work. She received a $9,000 grant from the Canada Council for the project, which she promoted through the journal *Architecture Canada*. She made no apologies for the varying skills presented in the work of the artists featured, stating "If it's not good enough, all I can say is it's the best Canada's got."[105] Critics condemned the catalogue, including Robert Fulford, who claimed that it was "... appalling. Again and again, on page after page, Mrs. [sic] Aarons presents us with art that is stillborn ... you cannot examine it without wincing."[106] By fuelling, through a succession of texts, the debate erupting from the quality of standards displayed by the work in the catalogue, Aarons had succeeded in highlighting the need for better education for Canadian craftspeople.

The Ontario Crafts Conference

Mary Eileen "Bunty" Muff Hogg, a craft advisor at the Department of Education, Community Recreation Branch, Ontario, approached the problem of

lack of education by organizing another craft conference less than three months after McCullough's Winnipeg meeting. Muff Hogg had been with the Department of Education since 1949, when she was hired as a Home Weaving Service instructor and consultant, after she had completed a general crafts course at Macdonald College, McGill, taken a six-month apprenticeship at Karen Bulow's weaving studio in Montreal, and practiced weaving at the Gaelic Foundation in Cape Breton. Muff Hogg had been instrumental in organizing weaving guilds throughout Ontario, helping to found the Ontario Handweavers and Spinners Guild in 1956 and the Ontario Rug Hookers Guild in 1960. She also was a member of the Ontario branch of the Canadian Handicrafts Guild.[107] Utilizing her connections to the Department of Education and to William Davis, Minister of Education, Muff Hogg set about organizing the first Ontario Crafts Conference.

Ontario government officials were aware of the increasing popularity of crafts in Canada. The 1964 Province of Ontario Conference on the Arts attributed the rapid growth of interest and activity in the crafts to increased leisure time, the rising cost of consumer products, the press, new Canadians, and a search for an understanding of Canada's past.[108] The debate over standards emerging within the Canadian Handicrafts Guild and the new Canadian Craftsmen's Association and the new interest in craft indicated to administrators and craftspeople the need for guidance in terms of good taste. The Ontario Crafts Conference took place at Geneva Park, Lake Couchiching, 23–25 April 1965. The conference featured international speakers and an attendance of more than one hundred delegates. The issues addressed were similar to those raised in Winnipeg: increasing standards and professionalizing craft. Press releases surrounding the conference focused on successful examples of craft promotion, primarily in Quebec, "In the province of Quebec, crafts today are a thriving industry. Twenty-two full-time salesmen travel extensively in Europe and Asia as well as North America, promoting crafts manufactured in Quebec ... Quebec handicrafts have achieved first-rate status, highlighted by numerous exhibitions in Canada and abroad."[109]

Ontario's attempts in the 1940s to learn from such Quebec's craft leaders as Oscar Beriau were revisited at the Lake Couchiching conference, where Jacques Garnier, Gaétan Beaudin, and Bernard Chaudron, president of the Association professionnelle des artisans du Québec, were brought in as distinguished guests. William G. Davis, Minister of Education for Ontario, opened the conference by pledging provincial support for the crafts in his province. Alluding to the 1964 World Crafts Council meeting, Davis predicted that the conference could revive craftsmanship within Ontario, placing the province in the forefront of the international craft movement. Cyril Wood,

the director of the Craft Council of Great Britain, newly formed in 1964, was one of the two keynote speakers. Wood praised the Government of Ontario for its interest in funding a craft organization, stating that "My government ... gives nothing to the crafts. The word 'craft' has fallen into disrepute in my country. The situation here in Canada is happily much brighter and the arts and crafts are put together."[110]

Mrs Vanderbilt Webb's visit to the conference had been well publicized, and in her keynote speech she, like Cyril Wood, praised the efforts of the Ontario Government. In contrast to Wood, she offered to assist the Canadian delegates in establishing new craft programs and spoke of a day when national boundaries would be entirely permeable: "I want you to know how happy I am to have been asked to come to this conference. If there is anything that I or the American Craftsmen's Council can do to help I hope that you will call on us. I think that Americans and Canadians should be able to come very much closer together from the point of view of the crafts than they are ... I hope that some day we will all be brothers in the crafts and sisters in the crafts, rather than Canadians and Americans."[111] Following the lead of the Canadian Council for the Environmental Arts, the Lake Couchiching conference resulted in the formation of the Ontario Craft Foundation. By November 1965 Davis had approved funds to begin investigating the formation of a specialized craft training centre, the central project of the Ontario Craft Foundation. The result of this scheme was the establishment of the Sheridan College of Crafts and Design, specializing in craft education.

Webb and members of the American Craft Council had met informally with Canadian craftspeople and administrators prior to the conference to discuss strategies regarding improving public taste for crafts and better education for craftspeople.[112] A central issue in those talks, raised again by Webb in her keynote address, was the difficulty of customs duties, which she felt indicated the lack of support from both federal governments. The Canadian Craftsmen's Association addressed Webb's concerns over the difficulty of craft exchanges between Canada and the United States. In November 1965 George Shaw prepared a brief to the federal government to request relief for artists from the federal sales and excise tax, requesting that the Department of National Revenue declassify artists as small manufacturers, thereby relieving them of an 11 percent excise tax.[113]

McCullough's initial desire for wide membership within the Canadian Council for Environmental Arts had been replaced by an emphasis on professionalism and the raising of standards. Craft standards were important not for economic but for qualitative reasons, measured by international perceptions of excellence. The American Craft Council and now the Canadian

Craftsmen's Association were in position to create a cultural hegemony of crafts recognized as part of high culture. This approach would also influence the hegemonic structures surrounding international craft production and consumption. Entry into this canon was dependent upon the producing structures in place, structures stratified along class, gender and race lines. McCullough's desire to unify all Canadian craftspeople whether professional or amateur, was in the spirit of the World Crafts Council; however, just as World Crafts Council members required the proper cultural, economic, and symbolic capital to join, so too did members of the Canadian Craftsmen's Association.

A profound shift in Canadian craft ideology was signaled by the emphasis on professionalism that emerged during the formation of the Canadian Craftsmen's Association. Standards reflecting a sound education in the conceptual art concerns of modernism, a willingness to open up one's craft practice to other visual genres, and the institutionalization of these concerns meant the loss of amateur practitioners who were frustrated by this new direction, ultimately leading to the consolidation and self-regulation of Canada's craft organizations by newly declared professionals. Canadian craftspeople, administrators, and patrons demonstrated their readiness to engage with professional craft based on modernism's rules, thus completing the initial stage in the development of professional craft – the formation of an exclusive group with shared goals, language and standards. The adoption of this professional approach (which included an emphasis on high-profile craft exhibitions and support for postsecondary craft education) by the Canadian Guild of Crafts, a group suffering from accusations of being "an organization made up of old fogey Sunday dilettante do-gooders," reinforced the importance of these new sensibilities.[114] Although Canadian craft professionals played an important role in North American craft culture, there remained an awareness of the omnipresent shadow of Aileen Osborn Webb and her American Craft Council and their successful propagation of a fine craft milieu that was widely accepted by modernist art supporters.

Norah McCullough recognized the need for a craft organization that embraced an epistemology emphasizing the ideals linked to late modernist art. As a member of Canada's cultural community, McCullough was open to the call for increasing self-consciousness in craft outlined by René d'Harnoncourt and Harold Rosenberg at the First World Congress of Craftsmen. Through her extensive connections, in particular her links to the National Gallery of Canada, McCullough had the professional authority to translate this vision into reality for an elite group of Canadian craftspeople and administrators. Although the Guild could recognize the need for this

shift, many of its members resisted, fearing that technical proficiency and the traditional identity of craft would be compromised. The Canadian Handicrafts Guild had dominated craft in Anglophone Canada since the beginning of the century. Now, and very suddenly, its achievements seemed to have been cast aside. Not only did craftspeople perform the unexpected through their choice of Norah McCullough as the official Canadian representative to the new World Crafts Council, many of the thirty delegates returned to Canada more determined than ever to "professionalize" the field of craft, looking to the future described by modernism rather than the past glories of craft. Thus the initial stage of establishing a professional group for craft in Canada was completed. While these debates raged in Canada, the American Craft Council continued to consolidate its monopoly over professional craft, a position that hugely impacted upon its northern neighbours. In understanding the seminal moments in the establishment of a professional craft presence in Canada it is essential to examine how Webb was able to garner support and recognition for craft in the United States, moving it from a social cause to an artistic enterprise.

2

Aileen Osborn Webb and the American Craft Council: Establishing a Professional Craft Ideology

THE UNITED STATES PROVIDED LEADERSHIP IN CRAFT DISCOURSE DURING THE 1940s and 1950s, paralleling the shift in artistic power from Europe to New York during the same period. Under the direction of Aileen Osborn Webb, the New York-based American Craft Council financed and supported a new ideological openness for crafts, one which recognized the need for the support of the powerful elite within modernist art circles. Webb was knowledgeable of, and intimate with, many key players in this New York scene, including René d'Harnoncourt, director of the Museum of Modern Art. Her awareness of modernist aesthetics led to the financial support of a unique approach to making within the US craft community, one that stressed innovation, technical experimentation, and the privileging of the conceptual over the traditional and the utilitarian. The result for craftspeople willing to engage in this methodology was the granting of rewards usually reserved for the art world – high-profile gallery exhibitions, increased prices for their work, and recognition as artists. Webb's decision to effect these changes for craft on the world stage through her 1964 First World Congress of Craftsmen directly influenced the Canadian delegates, as well as the many non-attending Canadian craftspeople and administrators who could clearly see the exciting developments resulting from this new approach to the crafts.

The impact of the New York gathering can only be understood by first considering the nature of the American Craft Council, which had given rise to the new "international" organization, the cultural "authority" of Aileen Osborn Webb who had founded both bodies, and the degree to which the Canadian craft community had already been made receptive to US notions of

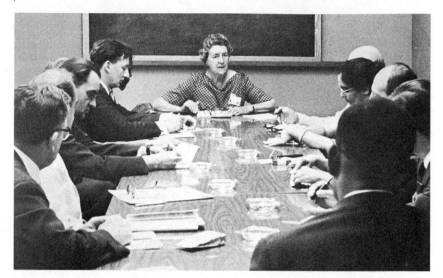

Aileen Osborn Webb chairing inaugural meeting of the World Crafts Council, New York, June 1964. Jacqueline Rice, ed. *The First World Congress of Craftsmen*, 8–19 June 1964, New York: American Craftsmen's Educational Council, 1964, 203. Photo courtesy of the American Craft Council Archives.

professionalism through its awareness of the American Craft Council and its sponsor.[1] It was this vision of professional craft that impacted most heavily on Canada's emerging elite.

Although she began by supporting rural, subsistence craft during the depression, Webb remained dedicated to the social cause of craft while radically professionalizing the field. Under Webb's leadership the American Craft Council established the first of each type of North America's professional institutions for craft, including the retail outlet America House (1940), the journal *Craft Horizons* (1942), the School for American Craftsmen (1946), and the Museum of Contemporary Craft (1956). What distinguished these enterprises from similar concerns was the cultural authority they were able to grant craft, and the level of self-regulation that they enjoyed. Craftspeople trained at the university level, written about in the conceptually articulate pages of *Craft Horizons*, and popularized through the American Craft Council's Museum and associated conferences found that their work had a ready market through America House.

The characteristics of craft materials were drastically expanded upon during this period. Technical innovations merged new materials with old and, as a result of experiments in cross-cultural appropriation, with the exotic. The

American Craft Council encouraged craftspeople to concern themselves with design, an approach made exciting by the abundance of creative materials now available. Descriptions of objects in the Council's *Designer-Craftsmen USA 1960* exhibition included textile pieces composed of "monofilement with orlon, linen and Celanese"; weavings with grass, plastic, rayon, viscose, and mohair; wood entries featuring tropical woods, Genisero, and teakwood; and a proliferation of stoneware.[2] While these materials enjoyed a variety of forms, many of them were biomorphic, blending organic shapes with the still-popular geometric patterning of modernism. As well, the conventional sizes of craft objects, smallish to fit interior domestic spaces, were subverted by the new avant-garde opportunities for craft – things became dramatically larger.

It was during this postwar period that the American Craft Council was able to establish its monopoly over professional craft, and therefore its market control. It was the standard setting agency and the birthplace of North America's craft experts. The language and ideology espoused through these institutions impacted directly on a wide range of craftspeople, educators, bureaucrats, patrons, and collectors. It was to Webb's credit that she was confident enough in her cultural authority to welcome the input of modernism's leading voices in New York and to allow new craft experts to flourish under this system, thus widening the net of expertise accredited to the Council.

The Establishment of the American Craft Council

In 1940 Aileen Osborn Webb founded the Handcraft Cooperative League of America, an organization through which she intended to elevate standards in craft production. The architect David Campbell, a Harvard graduate and, since 1938, director of the New Hampshire League of Arts and Crafts, collaborated with Webb on setting an agenda for the League.[3] Campbell, according to Webb, "gave up a very promising career in architecture because he became so obsessed with the conviction that the creative use of the hands was one of the things which the world needed."[4] Webb and Campbell agreed that the first step the Handcraft Cooperative League should take in its national battle to have designer-craftspeople accepted as artists was to hire a professional to develop a program. Frances Caroe, the daughter of Frank Lloyd Wright, was thus hired and brought to the League, constituting an important link to established cultural capital in the United States. Webb respected Caroe, whom she described as strong-minded, bold and imaginative, with a "vision of the future of the crafts ... far ahead of mine."[5] In 1940, under the direction of Caroe, a cooperative retail shop operated by the League was

established as America House.[6] The chief mandate of America House was to ensure the quality and perfection of production. Caroe and Webb were confident they would be able to create markets if they offered a high standard of craft objects.

During this time the Handcraft Cooperative League of America faced competition from an organization with similar aims, the American Handicraft Council, founded in 1939. Anne Morgan, the daughter of the financier John Pierpont Morgan, headed the Council. Allen Eaton, famous for his books on US craft, and Holger Cahill, head of the craft program of the Works Progress Administration, were members of its powerful board of trustees.[7] In 1942 the two organizations merged into the American Craftsmen's Cooperative Council, Inc., an act that has been formally acknowledged as an agreement between Morgan and Webb to eliminate the duplication of efforts. According to Webb's autobiography, a contributing factor to the merger was Anne Morgan's reluctance to provide large amounts of financial support to the group, her money going instead to a variety of different causes.[8] Webb was not so reticent, and, with a single national craft organization operating in the United States, America House was now able to provide the only large-scale merchandising of high-quality crafts and thus a solid foundation from which to build a future for US crafts.

Emerging from the success of America House was the American Craftsmen's Cooperative Council Inc.'s publication, *Craft Horizons*. The journal was originally published in 1941 as a newsletter addressing problems of marketing for the groups soon to be participating in the Council. Webb met with two Council trustees, the poet Mary Duryea and Horace Jayne of the Metropolitan Museum, who agreed the sheet should be transformed into a professional publication. Webb put her financial support behind the project, and, through contacts at the magazine *Antiques*, an office for *Craft Horizons* was set up in its headquarters.[9] The first issue of *Craft Horizons* in its magazine format was published in May 1942, with a distribution of 3,500 copies and a professional editor.[10]

The interest in crafts produced by US craftspeople was steadily increasing. America House continued to operate profitably, moving in 1943 to a prestigious Madison Avenue location purchased by Webb. This allowed the operations at America House to expand to include the new Educational Council, whose activities encompassed educational workshops, craft exhibitions, and the publishing of periodicals, books, and pamphlets on crafts.

In her memoirs, Webb recounts a 1943 meeting with a soldier that had convinced her of the importance of providing craft education. The soldier entered America House and urged Webb to purchase a large plantation in

School for American Craftsmen, Rochester, New York, circa 1950. Photo courtesy of the American Craft Council Archives.

the US South and start a craft school for returning veterans.[11] Again, Webb's connections provided the possibility of establishing such a school. Owen D. Young, the chairman of the New York State Board of Regents and "warm friend" of Webb's father, wrote to her suggesting that the school consider becoming part of Alfred University in western New York State.[12] As a result the School for American Craftsmen was formed. The School was initially located at Dartmouth College, New Hampshire, but moved in 1946 to become part of the Fine and Hand Arts Division of the Liberal Arts College of Alfred University, moving again in 1949 to become an affiliate of the Rochester Institute of Technology. This affiliation with the university milieu was considered to be important for the status of crafts in the United States: "The significance of the invitation to the School for American Craftsman on the part of the Trustees of Alfred University is very great. In one step it lifts the educational status of the Hand Arts from that of vocational training, on a par with radar or refrigerators, to training on the Liberal Arts level. The focus will thus be changed from mere technical ability to that of creative art. Once again, craftsmen will be considered as artists rather than artisans."[13]

Expanded facilities at America House allowed for individual artists to be given featured shows, increasing both the visibility of US craftspeople and the increasing standard of quality and design of products. A formal gallery at America House was opened in 1949, and the Educational Council organized large-scale exhibitions. Sponsored and organized by the Council, *Craftsmanship in the United States 1952* was displayed at the Metropolitan Museum of Art, New York City, while *Designer Craftsmen U.S.A. 1953* travelled to ten major US museums. Following a 1954 conference on "Craftsmen and Museum Relations" at the Art Institute of Chicago, Aileen Osborn Webb and David Campbell set to work designing the Museum of Contemporary Crafts, which opened in September 1956.[14]

Webb's Cultural Capital

It was fitting that the first large exhibition of US craft premiered at the Metropolitan Museum in New York; Aileen Osborn Webb's father, William Church Osborn, had been the president of the board of trustees from 1941 to 1948 and her maternal grandfather had been an earlier member. As the mention of the names Frances Caroe, Anne Morgan, and Owen D. Young already betrays, Webb brought to her support of the American Craft Council the benefits of a privileged upbringing. Webb's philanthropy was predicated upon her social, economic, and cultural position within the upper echelons of New York Society. Webb had access to all three types of capital defined by Bourdieu: economic, symbolic, and cultural. Agents within the cultural field occupy positions dependant upon the distribution of capital and the recognition of this capital. As a result of her advantaged childhood, Webb understood the power relations contributing to the position she occupied as a cultural agent. Her interest in world equality for craftspeople was predicated upon the reformist tendencies and internationalist orientation of her family.

Born in 1892 in Garrison, New York, to William Church and Alice Dodge Osborn, Aileen entered a family described by the *New York Herald Tribune* as "the public-spirited family of Osborn."[15] Both her maternal Dodge and paternal Osborn families were considered US "royalty," possessing independent fortunes, involved in New York and federal politics, and playing prominent roles in the development of Princeton University.[16]

Her maternal background was especially strong. Webb's mother was the granddaughter of William Earl Dodge, who had amassed a large fortune through his company, Phelps, Dodge and Co., North America's largest metal importer.[17] Upon his death in 1883 Dodge was revered not so much for his

fortune as for his charitable works. Like the famous US philanthropist Andrew Carnegie, Dodge was a devout Christian, and in his roles as vice-president, then president, of the American Chamber of Commerce from 1858 to 1880 he encouraged other business people to contribute generously to charities. An estimated fortune of $6 million was divided among his seven sons, who continued their father's philanthropy.[18]

Webb's mother was the daughter of one of those sons, William Earl Dodge Jr., a prosperous New York merchant. She was involved with a number of charities, in particular the New York Children's Aid Society. A more prominent force in philanthropy was her eldest sister, Grace Hoadley Dodge, a well-known social reformer who, especially concerned with the situation of women in the United States, founded the first Working Girls Society in 1881. She was a principal benefactor of Teachers College at Columbia University, the Industrial Education Association, the Young Women's Christian Association, the New York Travelers' Aid Society, and the American Social Hygiene Association.[19] It is estimated that Grace Hoadley Dodge donated $1,500,000 to her various causes.[20] Alice and Grace Dodge's brothers, Cleveland H. Dodge and D. Stuart Dodge, were involved in the establishment of the American University of Beirut. Cleveland H. Dodge cultivated his international connections, serving as a trustee of Robert College in Istanbul and directing the United War Work Campaign during the First World War, which raised funds for the YMCA, the Red Cross, and for the relief of war victims in the Near East.[21] It was thus a developed sense of social responsibility that Alice Dodge Osborn took into her marriage with a fellow philanthropist, William Church Osborn. He was a graduate of Princeton and the Harvard Law School, with interests in mining companies, railroads, and real estate. Described as "full of good works," he acted as president of the Children's Aid Society, and trustee for the Ruptured and Crippled Hospital. William Church Osborn was interested in art, serving not only as president of the Metropolitan Museum until his death in 1951,[22] but also bequeathing his extensive art collection to the institution (reserving several works by Monet and Van Gogh for his children).[23]

Aileen Osborn began her own philanthropic activity through the Junior League, started in 1907 by Mary Harriman, Dorothy Whitney, and Frederica Webb, the older sister of Aileen Osborn's future husband Vanderbilt Webb. "They called a meeting every autumn of carefully handpicked, and socially eligible girls, elected a president and vice-president and turned them loose to run a play or pageant to make money for charity," recalled Webb, who became president of the Junior League in 1910.[24] Her social ideals were heavily influenced by the Democratic politics embraced by her family[25]: William Church Osborn having served as the New York Democratic State Chair from

1914 to 1916 and run as the alternate candidate in the Democratic primary for governor of New York in 1918.[26] Her maternal uncle Cleveland H. Dodge was the largest single contributor to Democratic candidate Woodrow Wilson's presidential campaigns in both 1912 and 1916.[27]

Aileen Osborn Webb was active in politics herself and early on made some interesting acquaintances. Vice-president of the Women's Democratic Committee in Putnam County around 1912, she hosted a Democratic picnic where Eleanor Roosevelt was the speaker: "I think it was the first political speech that Eleanor Roosevelt ever made."[28] Roosevelt played a role in Webb's later interest in social assistance through the crafts, as Roosevelt and her friends Marion Dickerman and Nancy Cook had generated the idea of Val-Kill Industries in 1927. Val-Kill was an arts and crafts colony producing colonial revival crafts, inspired by the Roosevelt "cottage" located on their Springwood, New York, estate near the Val-Kill stream.[29] Webb and her friends Nancy Campbell and Ernestine Baker emulated this initiative when in 1929 they set up Putnam County Products in Garrison, New York, to market local crafts.[30] Webb recalls that the women had expected the local people to arrive ready to sell "string beans and eggs" and were instead delighted when the women produced needlecrafts and the men woodwork, demonstrating "the latent art consciousness in people."[31]

By 1936 President Roosevelt had established the New Deal, perceived by some as a source of national pride during economic hard times. Federally funded art programs under the title of the Works Progress Administration (WPA) provided marketing and financial assistance to craftspeople along the same lines as Eleanor Roosevelt's Val-Kill Industries and Aileen Osborn Webb's Putnam County Products. Holger Cahill who would participate in Anne Morgan's American Handcraft Council, was appointed to head this program. The WPA sponsored more than three thousand projects and exhibitions of craft, and, through the Farm Security Administration, experiments in handicraft production and craft fairs were carried out in nearly every state.[32] Cahill's largest project was the Index of American Design, intended to "pioneer the appreciation of Americana" by employing five hundred painters in thirty-two states to produce over twenty-three thousand watercolours and drawings of traditional US craft objects.[33]

The WPA's craft initiatives were remarkable in that their profit-making abilities were secondary to the provision of improved public and individual morale. The emphasis on individualism and improved confidence espoused by this government philanthropy had been reflected earlier in the writings of Andrew Carnegie and the charitable activities of William Earl Dodge.[34]

Philanthropy and Craft

Webb's family were philanthropic leaders, with her grandfather William Earl Dodge encouraging similar aims to Carnegie.[35] She herself was fully attuned to the "obligation" of distributing her surplus fortune, once informing Rose Slivka, editor of *Craft Horizons*, "it's the privilege of money to help those who don't have it. And believe me … it's a privilege."[36] While Webb followed Carnegie's philosophy, her gender would probably have limited her access to the determination of the spending of the wealth of her husband and father, but any such problem was solved by the surprise intervention of her "Aunt May," heiress to a large copper fortune. Aunt May was most almost certainly Alice Dodge Osborn's cousin May Cossitt Dodge, another one of William Earl Dodge senior's granddaughters:

Aunt May took Van for a drive one day, telling him she was making me her residual legatee … As far as I was concerned I was appreciative, of course, but the thought of money one way or another has never meant much to me except it gave me the freedom to say, "Yes" to people who asked for help. As a result of Aunt May I was able to help financially in the backing of the development of the American Crafts Council, supporting Crafts Horizons, American House, the Museum of Contemporary Crafts and the School for American Craftsmen. I did not feel that I was skimping on my children's lives in way as both Van and I had plenty of money for that part of the future. I also felt justified as my Aunt would have been the first to appreciate such a use of her money. I say this because of her great taste, and the money she herself spent on objects of art in all media.[37]

Webb's inheritance gave her the economic capital to work with her already large cultural and symbolic capital. The focus of her philanthropic activity was her own individual choice, but the ideals of her father, her friends (such as Eleanor Roosevelt), and the spirit of her own times, made the crafts seem a natural option.

Webb was able to institutionalize the crafts in the United States and then to attempt the same on a global level due to her ability to constitute symbolic capital for the World Crafts Council, coupled with the economic capital that supported large-scale craft projects. Although born into a privileged position and raised by parents who themselves were agents in the cultural field, her notions of proper standards of good taste were informed by a number of external factors including education, social contacts, and the objects considered appropriate for consumption and appreciation. At the age of seventeen Aileen Osborn spent a year at a girls' school in Paris, where she was

exposed to "opera, La Comedie Francaise, the museums and exhibitions."[38] During her time in France she made frequent visits to England, where her Aunt May maintained an estate. Webb wrote of her first trips hunting with Lady de la Warr in Buckinghamshire, as well as viewing the coronation of King Edward VII in the company of the Highnesses of Sax Coberg, to whom Aunt May had lent her Warwick house. Like the Dodge and Osborn families, Muriel Brassey, the Countess De La Warr, was heavily involved in philanthropic activity. She and her daughter Idina Sackville were founding members of the East Grinstead Suffrage Union, and she used her wealth to support the fight for women's suffrage.[39] As a result of these encounters with members of the British and European nobility, by 1908, her debutante year in New York City, Aileen Osborn was centrally located in the social activities of the US elite, forming contacts that would enable her to independently establish the American Craft Council.

In September 1912 Aileen Osborn married Vanderbilt Webb, the great-grandson of "Commodore" Vanderbilt, the railroad and shipping baron and son of Dr William Seward Webb, who was responsible for supervising Vermont's railroads and for building the much-admired model farm in Shelburne, Vermont, that occupied some 3,800 acres.[40] Following his junior year at Yale, Vanderbilt Webb attended Harvard Law School and then began to work for the Rockefeller family. The couple's courtship included time at the Breakers, the grand Vanderbilt mansion at Newport, Rhode Island, which was a mecca for the social elite of the United States prior to the First World War. After their marriage, Vanderbilt and Aileen Webb maintained a home on Park Avenue in New York City and a country cottage in Aileen's hometown of Garrison, New York. They inherited the farm in Shelburne, Vermont. Their lifestyle was extremely privileged, involving many servants, with Webb later associating this with her organizational abilities: "All this sounds unbelievable to those who struggle along now with no help, but it was a liberal education in managing people."[41]

Aileen Webb's sister-in-law, Electra Havemeyer Webb was also interested in the crafts. Rather than supporting contemporary craftspeople, Electra Webb was an avid collector of Americana, specifically folk art and early utilitarian crafts. She was the daughter of Henry Osborne Havemeyer, the president of the American Sugar Refining Company. From "the sugar king," she received an inheritance in 1907 large enough for her to pursue her collecting full-time.[42] Furthermore, upon the 1947 retirement of her husband, James Watson Webb, she was able to create her dream of a museum to house her US folk art and craft collection. The museum today is comprised of thirty-seven historic buildings on forty-five acres of land. The Shelburne Museum

backs onto Shelburne Farm, so it was inevitable Aileen Osborn Webb and Electra Havemeyer Webb were in close contact, making Aileen's unusual commitment to contemporary artistic craft all the more compelling.[43]

Designer-Craftsmen U.S.A.

While Aileen Osborn Webb was aware of the power bestowed upon her through her privileged position, she regarded the success of the American Craft Council (and subsequently the World Crafts Council) as her true vocation. Dealing with her responsibilities to both councils as a job, she showed up for work every day at the New York headquarters, helping with all aspects of the organizations. Webb's conviction that the crafts were as important as art, and could achieve proper status through an increase in standards of production and an improvement in public taste, held considerable sway. This was particularly evident in the large-scale travelling exhibition *Designer-Craftsmen U.S.A.*, organized in 1953 by the American Craftsmen's Educational Council.

Considered the first national survey of contemporary crafts in the United States, *Designer-Craftsmen U.S.A.* was intended to impress the US public with the highest quality of crafts available in the United States.[44] Comprised of objects designed and executed in ceramics, textiles, wood, metals, leather, and glass, the exhibition embodied the principles of art, sophistication, high standards, and good taste envisioned by Webb when she began the American Craft Council. To this end, the exhibition was carefully planned and elegantly designed; it travelled major museums and galleries across the United States, starting at the Brooklyn Museum, New York.[45] *Designer-Craftsmen U.S.A.* presented craft as fine art, utilizing the approval of Webb's powerful gaze to catapult the crafts into the national light of fine art spaces. US crafts were once again being used for nationalistic purposes.

Dorothy Giles's essay in the catalogue of *Designer-Craftsmen U.S.A.* emphasized the ability of craft to unite Americans of all backgrounds, while arguing that the noble history of US pioneers continued in the 1950s through their revolutionary approach to traditional crafts. Echoing Webb's vision of global harmony through craftsmanship, Giles wrote "it would seem as if the crafts were determined to break down racial and national barriers in order to unite men in the recognition of their common humility."[46] Words like "daring," "youthfulness," and "vigor," play throughout Giles's piece, culminating in her claim that "the American is a new man, who acts upon new principles; he must therefore entertain new ideas and form new ideas."

Giles used the focus on the new to make a strong distinction between US craft of the 1950s, with its changed sense of form and reduced emphasis on ornamentation, and the "old-fashioned" perspective of the arts and crafts movement: "The precious little communities dedicated to the Arts and Crafts which sprang up here and in England following Ruskin's and Morris's rediscovery of the importance of craftsmanship as a way of life and as a corrective of some of the baleful effects of the machine age, have gradually died of their own neuroticism."[47]

Craft's shifting sensibilities – away from restricted, binding function to endless conceptual possibilities – was witnessed through the work of US textile artist Lenore Tawney. Directly after the Second World War Tawney studied sculpture with Alexander Archipenko, drawing with Lasilo Moholy-Nagy, and weaving with Marli Ehrman at the Institute of Design in Chicago. She spent the early 1950s travelling to France and Northern Africa to study techniques, before spending 1954 studying tapestry at the Penland School of Crafts.[48] Always concerned with mastering the many technical skills involved in weaving, from open-wrap weaving to jacquard looms, Tawney's early work explored woven forms while pushing the medium through experiments in scale, surface treatments (she began integrating natural materials like pressed flowers and egg shells into her pieces in the early 1960s), and spacing. Her work was among the first to be credited with freeing weaving from the loom by creating free-standing fibre sculpture that echoed artistic innovations in other fine art media. The American Craft Council supported Tawney throughout her career, and in turn she was very involved with the Council in promoting tolerance and understanding of the exciting new possibilities for traditional craft media and forms. In 1956 Tawney was an exhibitor at the inaugural exhibition *Craftsmanship in a Changing World* at the Museum of Contemporary Craft in New York, and in 1957 Tawney had her first one-person show at America House. She was a member of the American Craft Council's Textile Design Panel for the First National Conference of Craftsmen in Asilomar, California, and in 1964 she attended the First World Congress of Craftsmen in New York. In 1975 Tawney was made a Fellow of the American Craft Council, and in 1987 she was awarded the Council's Gold Medal for lifetime achievement.[49]

By 1974, supported by the conceptual and physical adventurousness of the North American craft community, Tawney began her breakthrough weavings that integrated text. Although she had worked previously with collage and assemblage, her departure into intertextual relations entered the new space of spiritual and social significance through craft. "The Waters Above the Firmament" was well received. A linen weaving, featuring in its centre verti-

Lenore Tawney, detail, *Waters above the Firmament*, 1974. Linen, collage, and acrylic, 156 × 145 inches. Photo courtesy of the American Craft Council Archives and of Lenore Tawney.

cal cords, the bottom half made from strips of text, it was described by a reviewer as "strips of writing – sacred texts, illegible of course, and transformed into secular textures ... concerned with the notification of a change, a division from ... liquid into solid [reinforced] by all the devices in her elaborate panoply: the woven cloth, the slashed fabric, the colored design, the cut-up text, the poem pulverized into its parts, the parts reformed (in both senses) into their integrity."[50] Tawney's daring was credited with entering the crafts into the realm formerly occupied exclusively by "fine" artists, and her work was well known to Canadian textile innovators like Charlotte Lindgren: "I was aware of Lenore Tawney from the beginning, she was most impressive."[51]

Floyd S. Chalmers and Canadian Craft in the United States

Poised to take on the museum world by 1954, and as we have seen shortly to open its "own" Museum, the American Craft Council had not escaped the notice of Canadians. Indeed the organization had made important gestures towards the north: crafts by Canadian artists had been featured in small exhibitions at America House beginning in the 1940s, and in an effort to make its audience pan-North American the very first issue of *Craft Horizons* had included a long article on "Handicraft Activities in Canada," written by Deane H. Russell, Secretary of the Interdepartmental Committee on Canadian Handcrafts, Ottawa.[52] In the article Russell provided an overview of the history of crafts in Canada, careful to mention the role of First Nations craftspeople and French settlers. Russell highlighted the Canadian Handicrafts Guild and stressed the importance of Canada's "mosaic of peoples," comparing Canada to the United States with its emphasis on free expression for the new settlers. As part of Canada's postwar recovery, Russell argued for an emphasis on good craft and design, which he felt could "play a major part in a national reconstruction program designed to afford an emotional stability which is so universally desired and necessary."[53]

However, other forces were equally responsible for a growing Canadian attentiveness to the US craft scene. Indeed, at the very time Webb was working towards establishing her national infrastructures, Floyd S. Chalmers was investigating the expansion of sales of Canadian crafts to the United States and was not happy with what he found.[54] After a visit in 1939 to New York City, where he met with Douglas S. Cole, the Canadian Government Trade Commissioner, and the heads of the retailing giant the Gimbel-Saks organization, Chalmers reported the increased need for exporting Canadian crafts for retail sale in the United States. This opening was created from the loss of millions of dollars of products imported from markets now considered off limits, notably Germany, Austria, Czechoslovakia, and Italy. Chalmers invited Mr Cole, Jacques Blum, president of Messrs Gimbel Brothers, and Joseph Kelly, chief buyer for Gimbel's, to come to Toronto in August 1939 to meet with representatives from the Canadian Handicrafts Guild, the T. Eaton Co., Simpsons, and the Canadian Chamber of Commerce. During the two days of meetings, the group came to the conclusion that there were two major obstacles preventing Canadian craft from entering the international market: a lack of consistent high quality and good design, and the absence of an organizing body to coordinate orders and supplies. The group acknowledged that the Canadian Handicrafts Guild, founded in 1906, had struggled to do this work but was handicapped by a lack of funds.[55] Within a few months

America House opened and quickly thereafter enjoyed unprecedented growth as the US craftspeople it represented filled the voids left by the withdrawal of European crafts in other retail outlets; "America House was able to get high-quality merchandise from Americans, unlike lots of other stores."[56]

Chalmers was frustrated by the results of the Toronto meetings and suggested that Canada should consider bringing in Europeans and Americans to train Canadians in high-quality handicraft work. Across Canada artists, designers, and architects continued to search for a distinctive national style; crafts, with their use of local raw materials, were often used as the focus point. In 1949 the Vancouver-based "Art-in-Living" group under the supervision of Fred Ames and B.C. Binning, instructors at the University of British Columbia, held an exhibition *Design for Living* at the Vancouver Art Gallery with the goals of popularizing crafts, improving standards, widening markets, and employing local materials. The group hoped that craft hobbyists would be inspired to professionalize their production into commercial designs. While that did not happen, the exhibition did succeed in introducing more than fourteen thousand viewers to the idea of improved standards of taste and production in handcrafts.[57] In her book *Domestic Goods*, Joy Parr outlines other reactions to the problem of increasing standards in Canadian crafts. J. Murray Gibbon, the president of the Canadian Handicrafts Guild during the war, believed that a closer tie between the fine arts and crafts in Canada would contribute to better product development, while O.D. Vaughan, senior member of the T. Eaton Company, hoped to use the Scandinavian and French design examples that he imported for sale to improve the standard of taste among Canadians.[58]

Design in Industry

Parr highlights the 1945 Royal Ontario Museum exhibition *Design in Industry* in discussing how craft and design were central to the plan to rebuild Canada's industry following the war. As part of an effort to generate national pride, *Design in Industry* celebrated the raw materials and finished craft products available in Canada, as well as furnishings and appliances from international sources, mainly the United States. The message behind the show – and in Buchanan's subsequent writings on the topic – was that Canadian secondary manufacturing should focus on the crafts, with their small-scale production and high-quality goods. The wealth of raw materials in Canada was highlighted in the publicity for the show: "It has become the national cliché to refer, especially at election time, to 'our vast natural resources,' but the

DESIGN in INDUSTRY

THE CANADIAN PICTURE By Donald W. Buchanan

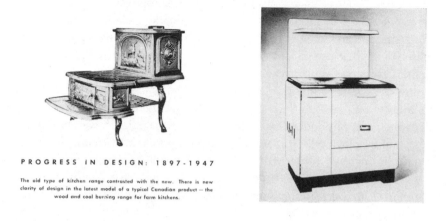

PROGRESS IN DESIGN: 1897-1947

The old type of kitchen range contrasted with the new. There is new
clarity of design in the latest model of a typical Canadian product — the
wood and coal burning range for farm kitchens.

I N Canada we have a history of good craftsmanship in Direct commissions for the designing of original models

Donald Buchanan "Design in Industry," *Journal, Royal Architectural Institute of Canada* 26/7 (July 1947): 234. Photo courtesy of the Toronto Reference Library.

greatness of a country does not depend upon the extent of its resources but upon its capacity to make effective use of them."[59] The Canadian Handicrafts Guild and Toronto's Primary Textiles Institute sponsored the two keynote speakers, both from the United States. Richard S. Cox, dean of the Philadelphia Textile Institute, lectured on "Technique in Textile Design" and René d'Harnoncourt of New York's Museum of Modern Art delivered a paper on "The Hand in Industry." By involving high-profile US design "experts," the Canadian organizers hoped to bring attention to the importance of the show. Conversely, d'Harnoncourt's position as the director of the Museum of Modern Art's new Department of Manual Industry, established in 1945, meant that he was encouraged to promote design and crafts throughout North America.[60]

The exhibition proved to be popular, with almost twenty-five thousand people attending during its brief three-week run, but the curators were upset by what Parr calls "the blurred boundaries between retail and museum display." The lack of proper labelling and the quick assembly of the exhibition was perceived to be typical of craft displays. Looking at the correspondence

and reports surrounding the exhibition (no official catalogue was published), what becomes obvious is the resentment the curators and museum staff felt toward the Canadian Handicraft Guild volunteers who helped in the organization and display of the show. The final report on the exhibition makes it clear that the mostly female volunteers were considered to be hindrances: "There is also a certain publicity value in having volunteer workers ... but as a rule volunteer workers are apt to be more of a liability than an asset."[61] Their lack of experience in setting up formal displays and in jurying objects was noted in the report as contributing to the negative reaction to *Design in Industry*.

Most upset of all, it appears, was Donald Buchanan, the chairman of the National Industrial Design Committee.[62] According to Parr, "Buchanan was appalled by what comparison with European and US work in the show revealed about the 'adolescent stage' at which Canadian production remained, 'heavy handed and lacking in both lightness and grace.'"[63] The choice of exhibiting "minor crafts" rather than design and craft objects utilizing new Canadian technologies seemed backward to Buchanan. To him it was design that needed to take precedence over the crafts, which already enjoyed a limited amount of success, "In Canada we have a history of good craftsmanship in certain types of woodworking, of originality in some kinds of handcraft weaving ... yet we possess few achievements of importance in the design of manufactured goods."[64] The privileged son of a Lethbridge, Alberta, senator and newspaperman, Buchanan had been educated at Oxford and the Ruskin School of Art. Returning to Canada in 1935, he founded the National Film Society and during the Second World War he was hired by the National Film Board of Canada to obtain enemy footage for use in Canadian propaganda films.[65] Following the war, Buchanan was made the Supervisor of Special Projects at the National Film Board, a position that was primarily concerned with industrial design. The National Gallery of Canada requested that this work come under its jurisdiction, and in 1947 Buchanan was made the head of the Industrial Design Department of the National Gallery of Canada, where he established a Library of Industrial Design.[66] He was also the editor of *Canadian Art* from 1944 to 1959, a position he used to espouse his nationalist values in art, including his belief following the 1945 *Design in Industry* exhibition that the "encouragement of very minor arts"[67] played no role in the future of Canadian industry.

Buchanan attempted to overcome the disgust he felt toward the poor products displayed at the Royal Ontario Museum in 1945 by organizing the 1948 exhibition *Canadian Designs for Everyday Living* at the National Gallery of Canada.[68] Buchanan sought to establish a serious attitude toward design

and craft in Canada. In the foreword to the exhibition catalogue he makes clear his vision for "proper" Canadian products, stressing the importance of avoiding meaningless ornament while focusing on pleasure in use. For both economic and aesthetic reasons, his main concern was that the objects demonstrate strict standards. Unlike *Design in Industry*, Buchanan's *Canadian Designs for Everyday Living* was said to prove that "Canadian products of original and distinctive merit in design are now available."[69] The exhibition did not promote individual craftspeople, focusing instead on production pieces, such as anonymous milk jugs from the Medicine Hat Potteries in Alberta and wooden salad bowls and dishes from Quebec's Habitat Woodworks. Buchanan's exhibition was touted as a success; however it was almost a decade until the National Gallery of Canada hosted another exhibition of Canadian craft and design.

Although Buchanan's exhibition made Canadian production pieces its focus, he was aware of the important role played by the Canadian Handicrafts Guild in promoting crafts in postwar Canada, as later evidenced by his reliance on Guild officials for guidance in the selection of crafts for his 1957 National Gallery of Canada show *Canadian Fine Crafts*. While Canada had several government programs designed to use craftwork to generate income during the depression, including a million-dollar investment in the 1937 Dominion Youth Training Plan of the Department of Labour, which trained farm boys and girls in handicraft work, none of these contained adequate marketing strategies.[70] The Canadian Handicrafts Guild provided the most organized marketing scheme for crafts in Canada during the great depression and the Second World War. The Guild was not solely responsible for designing craft programs for returning veterans. In Canada, the Canadian Legion Educational Services in Ottawa in cooperation with the Canadian YMCA War Services, Toronto, published a "Make Your Own" series of pamphlets outlining handicrafts for service personnel. McGill University in Montreal also offered booklets on craft techniques written for returning veterans.[71] With Guild shops set up in Montreal, Toronto, and Winnipeg, markets were made available for Canadian crafts.

The Canadian Guild of Crafts and "Noblesse Oblige" Philosophy

In Canada, "noblesse oblige" philanthropy retained links to the British nobility and arts and crafts ideals, whereas in the United States cultural philanthropy stemmed from a more republican emphasis on the power and wealth of the individual to make a difference in society.[72] Ellen Easton McLeod iden-

tifies Peck and Phillips with the Arts and Crafts movement in Canada in the late 1890s. Both British and US Arts and Crafts pioneers, philosophies, and styles had influenced Canada. The 1876 Philadelphia Centennial exhibition and the 1893 Chicago World's Fair afforded women the opportunity to view objects first-hand, and speaking tours on the decorative arts included a number of notables from the United Kingdom, Oscar Wilde (1882), Walter Crane (1891–92), Charles Ashbee (1896), and May Morris (1909).[73] In the United States, Candace Wheeler established the New York Society for Decorative Art in 1877, Rookwood pottery opened in 1880, Adelaide Alsop Robineau started the New York Society of Keramic Art in 1892, and Jane Addams and Ellen Gates Starr opened Hull House in 1889.[74] In Canada, Lady Ishbel Aberdeen, the wife of Canada's governor general played an imperious and symbolic role in many Arts and Crafts based organizations.

Canadian women were familiar with these US figures. Many Canadian women had visited or read the official guide to the 1893 World's Columbian Exposition in Chicago, where Wheeler designed rooms highlighting the work of the Rookwood Pottery. Canadian women had access to the British journal *The Studio* and the US journal *The Craftsman*. McLeod argues, "Many Canadians were cognizant of the ... crafts movement in the United States," citing Jean Grant's column "Studio and Gallery" in *Saturday Night* featuring Candace Wheeler's Associated Artists and the exhibitions of US women's enterprises at the 1900 Paris Exposition. As well, after Mildred Robertson and her mother accompanied the exhibition of the Montreal branch of the Canadian Handicrafts Guild to the 1904 World Exposition in St Louis they gave substantial reports to the Guild on US activities, which were also disseminated through Canada's art institutions. Alice Egan Hagen, a china painter and professor at Halifax's Victoria School of Art and Design, spent 1896 studying with Adelaide Robineau in New York. The painter George Reid, who taught at the Ontario College of Art, and his wife Mary Heister Reid spent the 1890s attending summer artists' colonies in the Catskill Mountains of New York established by Candace Wheeler. There they designed and decorated Arts and Crafts-style homes.[75]

The US profit-based approach to crafts conflicted with that of the Canadian Guild of Handicrafts, which, in addition to the social aspect of its work, was continuing to stress the preservation of traditional craft styles. The Guild goal to "awaken pride in the old skills" was founded directly on the arts and crafts movement: "The Canadian Guild of Handicrafts drew inspiration from the craft revival in Great Britain started by William Morris and his associates."[76] Many of the instructors who were responsible for training Canadians in the crafts were either followers of Ruskin and Morris or had

been educated in the United Kingdom at schools promoting their views. These included George Reid, the principal of the Ontario School of Art in Toronto from 1909 to 1929, "Bobs" (Zema Coghill) Haworth, Head of Ceramics at the Central Technical School, Toronto, and Alexander Musgrave, Principal of the Winnipeg School of Art.[77] Canadians were generally influenced in the early twentieth century by their connections to the imperialism of Britain, which contributed to several of the differences that were obvious in terms of the ethics of craft production in the 1950s. By that point, however, the symbolic capital of Webb and her American Craft Council in terms of the advancement of craft was obvious, and Canadians began to look much more closely at the example of the United States.

In *Mythologizing Canada*, Northrop Frye compares the growth of the railways to explain the cultural and political differences between Canada and the United States. Canada, he claims grew in one dimension, founded on small communities separated from each other by large spaces. Unity, therefore, was conceptual and was only maintained by political will. On the other hand, the United States grew in accordance to the philosophy of the "Western Frontier," a solid wall that moved steadily across the nation.[78] Frye's analogy is helpful in identifying Canada's confusion between the traditional links with, on the one hand, Britain and its cautious colonialism within Canada and, on the other, the infectious energy of US individualism embodied in the pioneering spirit. The influence of the US craft scene began to gain serious ground in Canada in 1955, the year Webb brought the exhibition *American Designer-Craftsmen* to Toronto's Royal Ontario Museum.

1955: *Designer Craftsmen* and *Canadian Fine Crafts*

A decade after Donald Buchanan's outrage over the poor quality of Canadian crafts displayed in the *Design in Industry* exhibition, Gerard Brett, director of the Royal Ontario Museum reported on the possibility of holding a Canadian Modern Design exhibition. In his notes, Brett came to the conclusion that the standards of Canadian design and craft remained disappointing: "It is my opinion that genuinely Canadian design – as opposed to the much more common Canadian-made copies of U.S. designs – is not now at a stage where this museum could hold a large special exhibition devoted entirely to it without great loss of face: Nor, I feel, is it likely to reach that stage for some years. Canadian progress in handicrafts is also very patchy."[79] In a 1954 letter to Robert Fennell, chairman of the museum board, Brett expressed the museum's interest in *Designer-Craftsmen U.S.A.* Stating that a similar show of

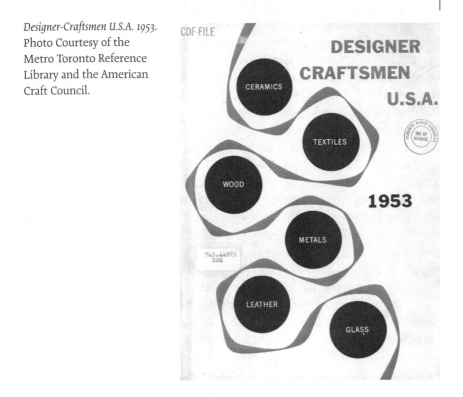

Canadian objects "seems to be a long way off," Brett proposed using the US exhibition to promote the possibility of a future show of Canadian craft with the same high standards.[80]

Designer-Craftsmen U.S.A., based on the 1953 American Craft Council exhibition of the same name, opened in Toronto in May 1955. Mrs Vanderbilt Webb's attendance at the opening was the subject of much discussion in the society columns of Toronto's newspapers. Webb was the featured guest at luncheons hosted by the Toronto Ladies' Club and the Royal Ontario Museum, as well as at a dinner held at the exclusive Granite Club, where Toronto's cultural and social elites took advantage of the opportunity to meet the guest of honour.[81] Executives of the T.Eaton Co. and the British American Oil Company were involved in the exhibition, attending the opening as well as participating in a number of special events. Mr W.B. Tucker, manager of the Contract Sales Department of the T.Eaton Co. Ltd, presented a special lecture "Furnishings and You," while Mr Thor Hansen, art director of the British American Oil Company gave an illustrated talk on "Designer-Craftsmen."[82] The strong presence of marketing representatives provided a contrast to the

craftspeople offering weekly demonstrations of craft techniques, ranging from Latvian weaving to leather tooling. Handcrafted goods continued to be big business in many of Canada's department stores, and the investment in *Designer-Craftsmen U.S.A.* would be worthwhile if it inspired a consistently high standard of craft production in Canada.

Reporters covering the exhibition were split in their reactions to the show. Pearl McCarthy of the *Globe and Mail* wrote two reviews, casting a critical eye on the invasion of US craft sensibilities. In her 26 March 1955 article, McCarthy attacked the imperialism of the American Craft Councils' desire to properly educate viewers and revealed her pro-British sentiments, "We firmly align ourselves with the British attitude of making the arts available to observers and then letting those observers make up their own minds, rather than by trying to force acceptance of anything by a campaign labelled 'education.'"[83] In her second piece, McCarthy warned of the artistic nature of the crafts contained in the exhibition, claiming that the artisans featured in the show were not practical like modern British or Scandinavian craftspeople. While she admired the work of ceramist Peter Voulkos, whose formalist ceramics were beginning to enter the realm of modernist abstraction, she admonished the other exhibitors to "take some care to make the mouths of decanters big enough that they do not have to be filled with an eye dropper, and the mouths of the silver jugs small enough that handles and human hands can take the strain."[84]

Margaret Cragg, a reporter for the women's section of the *Globe and Mail*, displayed her reverence for the cultural, economic, and symbolic capital of Mrs Vanderbilt Webb in her article on the exhibition, where she spoke with glowing praise about Webb's knowledge of home furnishings. Although Cragg makes clear that the prices of the objects in the exhibition are beyond most housewives, the improvement in taste offered by the objects is priceless, "Mrs. Webb thinks, too, that anyone can profit by studying beautifully designed objects and an exhibition like this makes one look at line and colour and texture with a new intentness. Perhaps we can't afford to pay for the time and talent the great craftsmen have put into their products but we may look at the things we can afford with a more discerning eye ... Even one or two beautiful objects in the house ... not only give a lot of pleasure but bring out standard of taste to a higher level."[85] Arguing the importance of "keeping up with the Joneses" by owning uniquely handcrafted objects, both Cragg and Webb used the *Designer-Craftsmen U.S.A.* exhibition to promote the purchase of crafts by consumers, particularly women. Hugh Thomson of the *Toronto Daily Star* also expressed admiration for Webb, describing her as "the guiding genius behind the whole enterprise" of contemporary craft.[86]

Despite McCarthy's skepticism about the exhibition, Canadian craftspeople, curators, and administrators were impressed by the professional display and high quality of the craft objects on display. After the disappointment of the *Design in Industry* exhibition, Donald Buchanan was once again ready to try institutionalizing Canadian craft into the cultural field.

Buchanan undertook the organization of the first national juried crafts show, *Canadian Fine Crafts*, in 1957. In order to ensure that the exhibition complied with his strict standards Buchanan implemented a rigorous jurying process that included the approval of an "expert" from the United States. The first step Buchanan took in obtaining possible entries for the exhibition was to write asking specific craftspeople to submit to the jury. He decided upon the craftspeople to be invited by gathering recommendations from craft leaders in the Canadian Handicrafts Guild, various Canadian universities and art schools, and local arts councils. Ceramics were selected from the second national Canadian Guild of Potters exhibition, which was held in 1957, while James Houston, the northern "expert" who had been hired by the Canadian Handicrafts Guild in the 1940s to research and promote the enormously popular Inuit crafts, chose the First Nations and Inuit crafts. The Canadian Handicrafts Guild prepared its list of craftspeople from those who won prizes at the Guild's fiftieth Anniversary exhibition in 1956. After Buchanan had accepted entries from the suggested craftspeople he turned over the final selection to the jury, which consisted of himself, Julien Hébert (the industrial designer, professor of sculpture at École des Beaux Arts, and vice-president of the Canadian Arts Council), and John Van Koert (an industrial designer from New York who had served as a juror for the 1953 *Designer-Craftsmen U.S.A.* exhibition).[87] The jury made its final selection of objects based on "both good design and good technique, but with emphasis on quality of design," echoing Buchanan's view on the importance of improved standards of design in the crafts, which foreshadowed the Canadian Craftsmen's Association's agenda.[88]

There was an ulterior motive behind Buchanan's drive to form a national exhibition of crafts. Determined not to be embarrassed Buchanan ensured that the "winners" from *Canadian Fine Crafts* went on to exhibit in the Fine Craft section in the Canadian Pavilion at the 1958 Universal and International Exhibition in Brussels. The Advisory Committee on Fine Crafts for the Brussels Exhibition agreed with Buchanan's approach to the selection of objects. The Committee was comprised of leading players in Canada's craft scene, including Ruth M. Hone, author of *Ceramics for the Potter*, and ceramics instructor at the Ontario College of Art, Galt Durnford, an architect and president of the Canadian Handicrafts Guild, Montreal, James A. Houston, director of the Arts and Crafts Branch, Arctic Division, Department of Northern Affairs, and Louis

Archambault, sculptor and ceramist and instructor at L'École des Beaux Arts and École du Meuble, Montreal. The Committee was also in agreement that it was necessary to have a representative from the United States on the jury and the members were unanimous in their selection of John Van Koert, who provided an important link to the *Designer-Craftsmen U.S.A.* exhibition.[89]

Canadian Fine Crafts was an elegant exhibition, with careful labelling, proper lighting and a formal catalogue. The participating craftspeople expressed pride in the new status afforded them by the exhibition. Toronto ceramist Evelyn Charles wrote to Buchanan, "I think that you have set it up in a most appropriate manner – quite distinguished we thought. I was quite pleased to see my two dishes there – quite an event in my life." British Columbia's Bill Reid told Buchanan that he considered it "an honour to have been asked to participate."[90] Bill Reid served as the perfect bridge between the world of European-Canadian and Native craft professionals. The son of a Haida mother and Scottish-American father, Reid remained unaware that he was "anything other than an average Caucasian-North American" until he was a teenager.[91] After discovering that he was half Native, Reid began researching his maternal ancestors through annual trips to visit his boat-builder grandfather Charles Gladstone in Skidegate, Queen Charlotte Islands. Gladstone was the nephew and a former apprentice of the famous nineteenth-century Haida silversmith and carver Charles Edenshaw. Through this connection Reid was introduced to Haida designs and animalistic forms. Reid's work relied on these traditional motifs, but he quickly distinguished himself by developing modern interpretations of both image and form that pushed the boundaries of the traditional. As a result, "Bill Reid revived an artistic tradition that had survived only in museum collections ... he reinterpreted them for a sophisticated audience of connoisseurs around the world."[92] For Donald Buchanan, who foregrounded quality of production and professionalism in his search for Canada's finest craftspeople, Bill Reid would have represented an exciting combination of technical skill, aesthetic excellence, and artistic daring.

Reid contributed to the commercial popularity of the work of Haida craftspeople, however, through his involvement in museum exhibitions and catalogues he was able to maintain his interest in the political empowerment available to craftspeople through their interpretations of ceremonial and spiritual images. As well, he was outspoken in his encouragement of high technical and aesthetic standards: "Once we discard our ethnocentric hierarchical ideas about the way the world works, we will find that one basic quality unites all the works of mankind that speak to us in human, recognizable voices across the barriers of time, culture and space: the simple quality of being well made."[93] Reid worked in a variety of media, including bronze,

Bill Reid, figure, 1972.
Silver, argillite, stand,
3.6 × 4.3 × 2.4 cm,
whale 5.8 × 3.9 × 5.3 cm.
Photo courtesy of
the Canadian Museum
of Civilization.

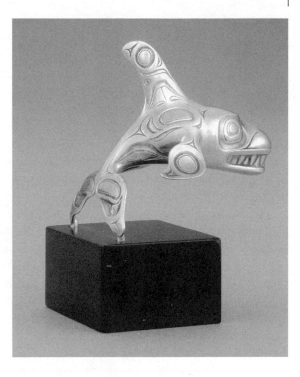

wood, prints, and fabric, but he was most renowned for his gold and silver jewellery. In these pieces he expertly played with the scale of images, success-fully manipulating enormous subjects onto diminutive surfaces. While his sil-ver whale on an argillite base stands only centimetres high, it contains massive force and vitality. Based on an earlier 1970 gold box with a whale lid, the silver whale was featured in Tom Hill's exhibition *Canadian Indian Art 74.* While it was produced after his participation in Donald Buchanan's exhibi-tion, it shows Reid's continuing development of images used on his boxes such as the one selected for *Canadian Fine Crafts.* This piece features a whale that is fused to the base by its tail. The attachment of tail to base creates a dynamic, fluid movement, one that suggests that the whale has been caught in the middle of a leap. Everything about the piece, with the exception of its sharp barred teeth, is smooth and rounded; eyes set in deep relief and the flared oval for the whale's nose are mirrored in the circles that repeat across the upper surface of the object, reflecting patterns unique to North West Coast Native design traditions. Reid expertly foreshortened the whale's body and his adaptation of the fins and tail to provide a larger surface for the deco-rative relief in no way compromises its reality. This example of Reid's work is

reflective of the larger body of his jewellery production, which embraces Haida animalistic images and traditional forms like boxes, while simultaneously expanding the formal qualities and designs. Buchanan must have perceived that the excellence of Reid's craftsmanship would silence the critics who accused craft of belonging to the realm of the amateur and dismissed Native craft as inferior souvenir objects.

Buchanan used his essay in the catalogue to continue the theme of the crafts as legitimate fine art production, arguing that crafts must be subjected to the same standards of aesthetic judgment as the other fine arts. "The time has come to take an adult view of the crafts in Canada … Purely technical perfection, smoothness and facility of execution are necessary, but they cannot stand alone. Freedom of expression, skill in choice and handling of materials and a harmonious relationship of form and colour must be present in equal measure."[94]

These sentiments paralleled the thoughts of Dorothy Giles, who in her catalogue essay for *Designer-Craftsmen U.S.A.* had advocated originality in design and uniqueness of form in addition to technical skill. Many of the craftspeople and the jurors involved in *Canadian Fine Craft* were aware of the American Craft Council and its exhibition *Designer-Craftsmen U.S.A.*: the National Gallery and the Brussels's Fine Craft exhibitions provided perfect opportunities to push for quality Canadian crafts on the international stage. Despite his acknowledgment of improvements in the design capabilities of Canadian craftspeople, Buchanan finished his catalogue essay with the admission that not all the pieces in the show were perfect, but he was optimistic that "what the leaders have achieved, the others have the competence to attain."[95] Pearl McCarthy reviewed the exhibition for the *Globe and Mail*; while critical of the lack of truly original designs in the exhibition, she praised the fast developments in many of the crafts, making the prophetic statement that the show left Canada "with a chance of coming forth with much inventive genius in a decade, with somewhere to go."[96]

Just as Webb lent symbolic capital to the *Designer-Craftsmen U.S.A.* exhibition showing at the Royal Ontario Museum, John Van Koert was perceived as possessing superior taste and knowledge in craft standards. No Canadian craftspeople objected to being juried by a representative from the United States, and all members of the Advisory Committee on Fine Crafts complied with Buchanan, Hébert, and Van Koerts's assertion that design and innovation in form were now taking precedence over traditional skills and techniques. By 1964 when the Canadian delegation to the First World Congress of Craftsmen was overwhelmed by the modernist emphasis on the conceptual and innovative in craft production, the American Craft Council had assumed that such a definition had international applications.

With over six hundred representatives from the United States present at the First World Congress of Craftsmen, the dominance of US concerns over the status of craft as a valid art form was not surprising. The "global craft community" referred to frequently during the conference was a misnomer, as non-Western representatives had to possess the economic capital to afford to travel to the United States, the cultural capital to have met Margaret Patch in her travels, and the symbolic capital to represent the craft interests of their country. While exclusiveness of membership was debated during panels, with the final decision that a body of only artist-craftspeople would defeat the purpose of international communication and development, the emphasis of the conference on the need for art content in the work of craftsmen was in opposition to the traditional craft production found in non-Western countries.[97] The lack of argument over the fine craft focus of the conference coupled with the US-based summaries of the conference proceedings indicated that although Webb was successful in bringing together "both the village artisan and the urbanized designer-craftsman," the voices of the village artisans were difficult to hear.

The border crossings experienced through the *Designer-Craftsmen U.S.A.* and *Canadian Fine Crafts* exhibitions introduced many Canadian craftspeople, administrators, and educators to the important new ideas emerging from the American Craft Council. At the end of the 1964 meeting of the First World Congress of Craftsmen at Columbia University in New York, most of the Canadian delegates were eager to participate in an international celebration of crafts spearheaded by a woman they believed possessed the skill to push the crafts up the hierarchy of the fine arts. A profound shift in Canadian craft ideology had been signaled by the emphasis on professionalism that emerged during the formation of the Canadian Craftsmen's Association and its subsequent adoption by the Canadian Guild of Crafts. Whereas the financial and cultural support of a single individual allowed US craft to unite a seemingly national professional craft group supportive of late Modernism's artistic agenda, Canada's professional elite found itself in the position of justifying and defending its vision of craft's new standards to secure funding and support. Tensions between the elite and the marginalized reached new levels and the waters of professional craft were muddied by the confusion over classifications. Despite Bill Reid distinguishing himself as a professional Native craftsperson able to reinterpret Native imagery during Donald Buchanan's 1957 *Canadian Fine Craft*, craft exhibitions during Expo 67 were preoccupied with consolidating the standards of a particular vision of professional craft and neglected to engage with emerging Native professionals. Thus the vision of craft about to be introduced to the world remained exclusive, a condition of the process of consolidating power.

On the surface, however, the growing number of Canadian craftspeople in support of the development of a modern discourse for the crafts, one with links to the approaches and aesthetics popular in the world of fine arts, appeared to be massing into a "collective consciousness" of producers. The Canadian Craftsmen's Association had tapped into this awareness in 1965 and was rewarded by federal government support, which allowed it to institutionalize this attitude during Canada's centennial year. Consequently, the Canadian Government supported craft experts who firmly aligned themselves with a particular craft ideal that was instigated by the American Craft Council. The challenge of 1967 would be to translate these principles into objects and exhibitions that were distinctly Canadian.

3

1967: A Centennial Year of Crafts in Canada and a Leadership Role for Native Crafts

EXPO 67 PROVIDED A PRESTIGIOUS INTERNATIONAL STAGE UPON WHICH TO introduce the professional Canadian craft artist. The financial support and promotion of this event, perceived as a symbol of Canada's maturation into full nationhood, paralleled the growth in professional structures for craft. The initial stage of professional consolidation experienced during the foundation of the Canadian Craftsmen's Association led to its establishment as Canada's self-regulating craft organization. Deemed a symbol of professional maturity for its organizational skills, the Canadian Craftsmen's Association found itself officially endorsed by Aileen Osborn Webb at its Kingston Conference where the North American craft community celebrated its shared professional language and knowledge. Although the Association provided professional leadership, the international recognition of Canadian craft was largely dependent on the bureaucratization that organized and supported emerging professional craft expertise. Key players in Canada's craft scene took charge of the exhibitions and conferences funded for the centennial year, with US craft "experts" often relied upon to guide and judge Canadian crafts. This chapter will discuss how a relatively small group of administrators and craftspeople, heavily influenced by ideologies of "professionalism," were able to present their tastes and standards in Canadian crafts to the world. Several events of 1967 will provide the boundaries for the chapter, all demonstrating the hope that an identifiable national culture would emerge through Canadian craft. These events include the *Canadian Fine Crafts* exhibition in the Canadian Pavilion at Expo 67, the Kingston Conference held by the Canadian Craftsmen's Association, the Canadian Guild of Crafts exhibition *Crafts Canada*, 21 June to 24 August 1967, and the National Gallery of Canada's *Canadian Fine Crafts*.

Important to this discussion will be the position occupied by aboriginal craftspeople, who elected to exhibit their work in a separate venue at Expo 67. They had seldom been included in national craft exhibitions, although historical and anonymous examples of traditional crafts were often utilized to represent all Native craft production, and this exclusionary practice continued in 1967. An examination of the emergence of Native craft organizations, administrators, and professional artists will be undertaken in order to further explore the framework in which the professionalization of Euro-Canadian craftspeople developed during the period. Despite the disparities in the treatment of Euro-Canadian and Native professional craftspeople, both groups emerged from 1967 with an increased market for their objects, a sign of professional strength and growth. In contrast to Gerard Brett's 1955 view that crafts of good quality were scarce, the world proved that it was hungry for Canadian craft products, placing Canada at the forefront of professional craft.

From Souvenir to Art: Expo 67 and Professional Canadian Craft

The Montreal World's Fair, known as Expo 67, was an international exhibition held to celebrate Canada's one-hundredth anniversary of Confederation in 1867. Crafts had been part of such fairs since the mid-nineteenth century, and like its predecessors, beginning with Britain's Great Exhibition of 1851, Expo 67 showcased the work of international craftspeople. Critics, curators, and craftspeople recognized the opportunities for funding and international exposure available for crafts during Canada's centennial year. The new professionalized status of Canadian craft and the ability of craftspeople to provide objects equal to those of the so-called fine arts were promoted in articles published in both popular and specialized craft and art journals. It was believed that these crafts could properly represent a mature, visually progressive Canada. Dorothy Todd Hénaut's article "1967 – The Moment of Truth for Canadian Crafts" offered praise for the excellence of crafts, the "unknown arts of Canada," which had in her opinion evolved "in the last five to ten years, but particularly in the last two or three" from "hobby puttering" to fine works of art.[1] Hénaut questioned why distinctions between the commercial artist, the Sunday painter, and the serious artist were established in the fine arts and not in the world of crafts and urged craftspeople to take advantage of centennial exhibitions to distinguish their professional work from that of the hobbyist. She criticized the "inadequate Canadian education in the crafts" and encouraged craftspeople to continue expanding their boundaries and awareness of international craft achievements by travelling

and studying abroad. Hénaut's article was published in the journal *Arts/Canada* and reached a wide audience. Through this exposure, craftspeople hoped that the professional crafts would come to be accepted as equal partners within the Canadian fine arts community.

Other journals for the fine arts also encouraged coverage of the crafts. *Canadian Art* began a short-lived special section named after the Expo 67 and National Gallery exhibitions *Canadian Fine Crafts*, the purpose of which was to "encourage true excellence, and ... improved standards."[2] Art critics, including Yves Robillard of *La Presse,* began covering the 1967 craft exhibitions as fine art events, and international magazines like *Time* published reviews of national craft shows. Government-funded exhibitions including *Perspective 67*, July to September 1967, and the visual arts displays in the Canada Pavilion at Expo 67 began including the crafts as one category of the diverse fine arts. Anita Aarons, the Allied Arts critic for *Architecture Canada* wrote columns focusing on the international crafts of Expo 67 in order to encourage Canadians to learn from that example. Craftspeople and supporters were excited by this new exposure. "Across Canada, the star for crafts is in the ascendant," wrote Moncrieff Williamson, curator of the Expo 67 craft exhibition.[3] What all of the reviews, articles, and craft advocates agreed upon, however, was the importance of maintaining the push for high standards and a professional image that had been the focus of Canada's new craft organizations.

During a May 1966 panel discussion titled "Canadian Souvenirs and Giftware – How Can We Improve Design and Quality?" Merton Chambers criticized the poor taste of Canadiana souvenirs being created and sold for the mass-market. The seminar was part of the increased interest in ensuring Canadian crafts of sufficient quality were ready for marketing in Canada's centennial year. The discussion, held at the Design Centre in Toronto, quickly broke down into debates concerning the issues of education and taste that had dominated the formation of the Canadian Craftsmen's Association. Worried about the production and importation of bad designs, Chambers and Anita Aarons called for the improvement of public taste. Canadian consumers, the panel argued, were adversely affected by the influx of public and broadcast programs from the United States, which militated against the formation of an independent, national craft identity. Aarons further blamed the inability of Canadian designers to create identifiable and elegant craft souvenirs on the confusion created by having to seek financial support from either the Canada Council or private US investors. Formal education, Chambers and Aarons argued, was the only solution. Harold Patton, retail sales manager for Simpson-Sears, disagreed with the Canadian Craftsmen's Association members, warning that the loss of the apprenticeship system and

the authority granted by a degree would result in a small group of crafts-people locked into an "ivory tower," unaware of the importance of industrial orientation and the need for a solid grounding in basic market realities.[4]

Moncrieff Williamson's *Canadian Fine Crafts*

In an effort to boost the image of Canadian craft from souvenir to art, a single individual, Moncrieff Williamson, juried the Expo 67 craft exhibition *Canadian Fine Crafts*. Williamson was a major figure in the Canadian cultural field, having been a curator at the Art Gallery of Victoria and director of the Glenbow in Calgary, before taking up the position in 1964 of director of the new Confederation Centre Art Gallery in Charlottetown, Prince Edward Island. He had attended the founding meeting of the Canadian Craftsmen's Association in Winnipeg, where he was introduced to Jean-Claude Delorme, secretary-general of Expo 67. In a March 1966 letter to George Shaw, acting chairman of the Canadian Craftsmen's Association, Delorme named Moncrieff Williamson the Crafts Selection Commissioner General to the Canadian Government Pavilion, charging him with sole responsibility for creating the fine craft exhibition. This appointment gave Williamson tremendous authority and increased symbolic capital in the field of craft. He was involved in several of the centennial exhibitions, acting as a curator for the Quebec branch of the Canadian Guild of Crafts exhibition *Canada Crafts* and was the official who opened the National Gallery of Canada's *Canadian Fine Craft* exhibition.

Born in Scotland in 1915 to an aristocratic family, Williamson's cultural capital had been well established prior to the centennial year. He received his education from the Edinburgh College of Art and during the Second World War undertook secret Foreign Office assignments in Europe. His travels and war experiences made him popular in elite circles, where his economic, cultural, and symbolic capitals combined to make him of great interest. He was part of the postwar London art world, where he met and married "a rich Pennsylvanian beauty," and together they returned to the United States.[5] After the marriage ended, Williamson moved to Canada where he began his work in Canadian art institutions.[6] He was credited by Mavor Moore as being an art gallery revolutionary after his presentation, "The New Museums and Art Galleries: 1967 and After," at the 1965 Canadian Conference of the Arts in Ste-Adèle, Quebec. Another of Williamson's interests was the craft of the Maritime region, which he wished to see professionalized, commenting in 1972 that he was "delighted to see the great improvement of serious, as opposed to gimmicky crafts, even at the hobby level."[7] Williamson became

involved with Norah McCullough, Sheila Stiven, and other members of the
newly formed Canadian Craftsmen's Association, whose aims of fine craft he
supported. It was Williamson's wish to set up a gallery for Canadian crafts at
the Confederation Centre, and he undertook to collect work for *Canadian Fine
Crafts* to be used as the foundation of this new gallery. By August 1967, he had
succeeded in purchasing $10,000 of crafts from the Canadian Pavilion at Expo
for the Confederation Art Gallery.[8]

Canadian Fine Crafts was conceived as an independent show, held in a
shared gallery space in the Canadian Government Pavilion, along with exhi-
bitions of paintings, graphics, sculpture, photography, and architecture.
While some critics expressed surprise at the inclusion of crafts in the art
gallery setting at Expo 67, the exhibition was praised for containing crafts of
"sufficiently high quality to rank as art."[9] *Canadian Fine Crafts* was not the only
1967 exhibition to feature crafts alongside other fine arts. The Art Gallery of
Ontario's *Perspective '67*, which ran from July to September 1967, exhibited the
fine crafts, painting, sculpture, and graphic arts of Canadians between the
ages of eighteen and thirty-five. Hénaut credited the inclusion of fine crafts
with fine art as indicating "the rapid evolution in attitude towards crafts."[10]
Williamson was also the juror for the fine crafts at the exhibition *Perspective
'67*, held at the Art Gallery of Ontario from 7 July to 7 August 1967 and spon-
sored by the Centennial Commission, which provided $32,000 in awards,
with $8000 split between the four classes of work.[11] Williamson's choices for
inclusion in the exhibition, as well as the winners of the top prizes were a
direct reflection of his selections for Expo 67's *Canadian Fine Crafts* and reiter-
ated Williamson's attitude toward contemporary Canadian crafts.

An illustrated catalogue featuring a long essay by Williamson was pub-
lished for the Expo 67 *Canadian Fine Crafts* exhibition. Williamson highlighted
the debates that faced Canadian craft. Pleasing the advocates for traditional
as well as conceptual craft, he critiqued the dangers of the variability of taste
found in mass production. Although many craftspeople still embraced the
"time-proven concept of form dictated by function," he argued that the ease
of industrial production necessitated the development of an audience appre-
ciative of the conceptual in craft: "If to a great extent function and form are
more associated in our minds with industrial design, function and form still
dominate the philosophy of craftsmanship. If the purpose is to please and
serve no useful purpose beyond the enjoyment of contemplation, then
works within this category are equally valid and we must find in them excel-
lence in workmanship and originality of imagination."[12]

Paralleling the arguments made in Williamson's catalogue essay, the exhi-
bition comprised works of both traditional and fine crafts. The bright, open

spaces of the art gallery, divided by white walls and glass displays, allowed the pieces to be exhibited following the conventions of fine art displays. Williamson often selected playful objects for the exhibition, in particular the textile works. The cover of *Canadian Fine Crafts* featured Heather Maxey's "Florigorm," a colourful combination of cloth tapestry, collage and appliqué with stitchery. Maxey's piece echoes the biomorphic modernism of the time, featuring organic radiating shapes in a geometric pattern that surround what appears to be a colourful and densely patterned tree of life. Bright greens and reds share the tapestry's surface with the impressive needlework that betrays Maxey's training in stitchery and ecclesiastical embroidery in England. Despite Maxey being featured on the cover of Williamson's exhibition catalogue, her name was not as well known as particular textile artists from Ontario and Quebec, leading one to speculate whether or not Maxey's residing in Vancouver rather than central Canada played a role, and if the national craft exhibitions of 1967 were anomalies in providing nationwide craft representation.

Canadian Fine Crafts provided a diverse array of textile works, and an exciting combination of approaches to metal and stained glass. Strikingly, however, almost all ceramic objects were of stoneware. Williamson addressed this in his essay: "In ceramics, perhaps the common denominator is the marked use of stoneware from coast to coast and the warm earthen colours associated with such products."[13] Williamson praised particular craftspeople for their ability to shift away from function, including Nova Scotia's Charlotte Lindgren, whose weavings were installed as sculpture, and Alberta's Ed Drahanchuck, whose pottery forms, although frequently functional, operated as free-standing sculpture.

During the 1960s and 1970s Ed Drahanchuk was celebrated as one of Canada's leading ceramists.[14] His functional wares were complimented by his production of large-scale ceramic sculptures and wall murals, which won him the prestigious Allied Arts Medal from the Royal Architectural Institute of Canada in 1974. Born in Calgary, Alberta, Drahanchuk graduated from the Alberta College of Art and Design in 1963, specializing in ceramics. He set up an independent studio practice in Alberta and quickly began winning major awards, including "Best Stoneware, Best Design," at *Canadian Ceramics* 1965. Drahanchuk's fame as a Canadian potter brought considerable pride to the Ukranian community.[15] Drahanchuk's ceramic work mainly utilized stoneware, and his functional vessels embraced the rough, organic aesthetic of the period. His 1973 stoneware engobe slip vase is a perfect example of this work. While Drahanchuk employed a variety of surface treatments, this vase features a thick, ropelike slip that was applied after being flattened and

Heather Maxey, "Florigorm," cloth tapestry, 1967. Collage with appliqué and stitchery, 42 × 36 inches, at the entrance to "Canadian Fine Crafts," Expo 67, Canadian Pavilion. Photo courtesy of the National Archives of Canada.

Ed Drahanchuk, engobe slip vase, stoneware, 1973. Photo courtesy of the National Archives of Canada.

modelled separately. The cylindrical vase proudly wears the marks of the maker, with obvious horizontal bands from the throwing peeking out from under the surface decoration. Wide shoulders with sgraffito markings at the shoulder line lead to a tapered, short neck and a wide, rough lip. Drahanchuk's vase, while unmistakably a functional piece, referenced his more sculptural work, which appealed to Williamson, through its bold, painterly surface and unapologetic adherence to the materiality of stoneware.

Williamson was philosophical about the ability to isolate a Canadian "style" in craft, concluding that "the universality of international style of many objects merely stresses the Canadian craftsmen's awareness of what is best in international crafts design."[16] What was the difference, wondered Williamson, between Canadian identity and "just plain North American?" He acknowledged Canada's acceptance of the universality of US forms and styles, noting that the close analogy between craft development in Canada and the United States made "such a question ... almost unanswerable."[17] Whether

true or false, Williamson's opinions seemed grounded in reality: both US and Canadian craft councils demonstrated tremendous interest toward the *Canadian Fine Crafts* exhibition. Contemporary crafts were not included in the United States pavilion at Expo 67, and Aileen Osborn Webb relied upon Norah McCullough, Canada's representative to the World Crafts Council, to inform her of the role fine crafts of Canada were to play in the Canadian pavilion, requesting information on Moncrieff Williamson, as well as a list of the craftspeople showing at Expo.[18]

The craftspeople selected by Williamson typified a particular cross-section of practitioners. While the exhibition presented both traditional and contemporary approaches to craft, the biographical background of the artists and consultants indicates that it was a group of like-minded professionals who contributed to the show, something Williamson recognized in his essay. Merton Chambers, George Shaw, Sheila Stiven, and Norah McCullough were acknowledged for their "professional advice," while Canadian Craftsmen's Association members Anita Aarons, Merton Chambers, and Jack Sures were exhibitors. More than 75 percent of the 120 exhibitors had received professional training, with many of the craftspeople complementing their Canadian education with art school or apprenticeship in the United States and Europe.[19] Williamson was careful to make his essay inclusive, acknowledging the influence of France on the advanced contemporary standards of Quebec's craft training as well as the "mosaic of imported European styles" so important throughout Canada. In an effort to avoid creating opposition between the urban and rural participants, he noted the role of rural craftspeople as equal to the professionals operating in the urban centres. The exhibition provided fair geographic representation for artists across Canada although there was a remarkably low number of craftspeople from the Maritimes. Williamson's later views that the Maritimes were slowly emerging from a history of hobby craft production may have influenced his selection. Neither Williamson nor the exhibition acknowledged the counterculture craft being produced in Canada's west, where self-reflexive craft production was opening the paradigms of Williamson's classification of craft as it was being developed. Artists like Evelyn Roth, who installed a crocheted videotape canopy over the Vancouver Art Gallery, and Glenn Lewis, who exhibited porcelain penises, were introducing a new set of conceptual standards for craft.[20]

Craft objects and occasionally craftspeople demonstrating their skills were popular in certain pavilions at Expo 67, where the theme of "Man and His World" required the universality of craft to provide cultural links. The emphasis on technology and the machine during Expo 67 contrasted with much of

the craft production that was exhibited and sold. Williamson's catalogue essay romanticized the craftsperson's independence from the machine, falsely referring to William Morris and the Arts and Crafts movement as "alien" to the machine, stating that resistance to machines was an essential component in craft production: "His resistance is inherent through the very individuality of crafts production."[21] In contrast to the anti-machine ethics of Morris, Williamson alluded to Quebec's industrial design interests. Quebec craftspeople were well represented in the Quebec pavilion, where their large-scale architectural crafts embodied the professional image that Anita Aarons had been advocating. Traditional Quebec crafts were sold at the Artisanat du Québec outlet located in Expo's "Le Village" area, where Quebec-based craft, food, and entertainment were featured. The professionalism of Quebec's craftspeople was apparent as well in the *Canadian Fine Crafts* show that showcased Maurice Savoie's large ceramic mural and a tapestry by Mariette Rousseau-Vermette, who has been credited with inspiring Canadian fibre artists to work on a grand scale while simultaneously experimenting with form, material, and colour. Her "tapestry-paintings" have brought her great recognition due to their prestigious placements, including her monumental curtain for the Eisenhower Theater in Washington's Kennedy Center in 1971. Weighing one thousand pounds and standing thirty-four feet in height and forty-four feet in length, the curtain was Canada's gift to the Kennedy Center, which was established as a memorial to the late president. Rousseau-Vermette designed the stage curtain in two halves, one black and one red, featuring interlocking squares in the centre to "symbolize the unity of all nations in friendship and progress."[22] The international recognition gained by Rousseau-Vermette through this commission, in addition to her contributions in the teaching and production of art-tapestry, led to national recognition for her contribution the crafts in Canada. In 1974 she was granted the Diplôme d'honneur from the Canadian Council for the Arts; in 1976 she received the Order of Canada; and she has been the frequent recipient of art awards in Quebec, including the esteemed Prix du Québec. The Conseil des Métiers d'art du Québec has been a long-standing supporter of Rousseau-Vermette's bold, professional work, and in turn she has supported the Conseil, participating on many levels, including giving demonstrations of her tapestry and weaving. She continues to create monumental pieces for stages, including a work for Toronto's symphony hall, composed of two thousand "woolen acoustical absorption tubes ... that dropped in various configurations to adjust the reverberation time of the hall for Baroque or romantic music."[23] By producing tapestries that appeal to architects, Rousseau-Vermette follows the ideals set out by Anita Aarons: a professional approach, the ability to work in

teams, and the creation of objects that are both practical and aesthetically important. In his essay "Rationalism and Architecture," the architect Arthur Erickson praised Rousseau-Vermette for her collaborative abilities while working with him on the Toronto symphony hall, "Acoustics, lighting, structural and mechanical engineers all worked with Mariette and myself to achieve this gigantic instrument of sound modulation."[24]

Crafts for Architecture

The architectural use of crafts had been increasing during the centennial year – due to the 1965 commitment of the federal government to spend 1 percent of public building fees on art – and influenced by a campaign by *Canadian Architecture's* Allied Arts editor, Anita Aarons. In addition to Savoie and Vermette, Merton Chambers was producing large ceramic murals and planters, Jordi Bonet had been granted a $50,000 commission to create a fifty-two-by-sixteen-foot mural for Olympia Square, Toronto, and Grace S. Varr had received $14,500 for a woven tapestry. The review of these large-scale craft pieces in *SW Magazine* concluded that the "price difference between the hackneyed souvenir and gift products" and these urban-based pieces signified an "exciting breakthrough for Canada's artist-designers."[25] The issues of class and ethnicity in the "coming of age" of Canadian crafts were secondary to the excitement generated by the ability of professional craftspeople to be considered key elements in architectural and fine arts projects.

Aarons's March 1967 exhibition *Crafts for Architecture* paid tribute to the potential relationships between architects and craftspeople. Sponsored by the University of Toronto's School of Architecture, the Ontario Crafts Foundation, and *Architecture Canada*, *Crafts for Architecture* was a showcase for Aaron's ideology of professionalism. The concepts of professionalism and potential relationships between craft and architecture were demonstrated by a collection of hangings, tapestries, stained glass, batiks, metal, and experimental ceramics designed for use by architects and Merton Chambers's "psychological walls," which encouraged interactive viewing for visitors. In her review of the exhibition, Aarons claimed that the craft objects she had selected and the craftspeople who were highlighted met the challenge of adapting craft materials for contemporary architecture by "shak[ing] off sentimental ties of 'lost traditions' and [becoming] true innovators of contemporary imagery with new materials."[26] Aarons's exhibition was successful, attracting over four hundred visitors a day, with 250 architects and craftspeople meeting for the opening. Students from the Ontario College of Art were brought

in for the exhibition, which encouraged a conceptual approach to craft or "architectural clothing" – as Aarons called the pieces.[27]

While Aarons's exhibition was relatively small in comparison to the national craft shows held during centennial year, her strong opinions on the need for craftspeople to create work that was suitable for architectural use garnered attention. She advocated the use of suitable materials, a contemporary aesthetic, and a professional, businesslike approach to commissions and deadlines through her regular column in *Architecture Canada* and her role in organizing, along with Merton Chambers and Sheila Stiven, the first national craft conference, which was held in Kingston, Ontario, in August 1967. Anita Aarons took advantage of the international audience to embarrass Canadian craft administrators over the lack of proper education for craftspeople in Canada. In a panel session called "Twentieth Century Education for a Twentieth Century Environment," she called for a complete revision of craft education in Canada in an effort to guarantee originality and an environment conducive to professional, not amateur, work, claiming that "the current state of instruction in the arts produces only copyists and is to be deplored."[28]

The Kingston Conference

The Canadian Craftsmen's Association undertook to unite Canadians with international craftspeople and speakers in Kingston, Ontario, from 6 to 11 August 1967. The conference, perhaps referencing the 1941 Kingston Conference that established the Federation of Canadian Artists, was known as "The Kingston Conference" and was timed to correspond with Expo 67. Following the event, visitors were bused to Montreal to view the World's Fair. Canadian Craftsmen's Association publications indicate that the conference was undertaken in an effort to solidify the professional identity and image of the Association. The conference invitation made clear the goal of the event and the association, "The Canadian Craftsmen's Association/Association des artisans du Canada will become, in its first national conference, a symbol of the ultimate level of maturity – organized professionalism. A perceptive few are taking steps alongside international craftsmen to oblige recognition of their professional products."[29]

The keynote speaker for this carefully organized, internationally focused conference was an old friend, Aileen Osborn Webb. Her presence in Kingston was celebrated in the promotional literature for the gathering and in the press reports which ensued. "The presence of the international craft leader Mrs. Vanderbilt Webb," wrote the Canadian Craftsmen's Association, "is sure

Canadian Craftsmen's Association's Kingston Conference 1967, Outdoor demonstration of quick firing of pottery. Photo courtesy of the National Archives of Canada.

to create considerable interest in the conference."[30] Speaking from a position of authority she had already garnered in Canada from her earlier interventions, she encouraged the further development of art content in the crafts. Webb claimed that professional craftspeople were no different from artists: "the best work of the best craftsman is very definitely the work of highly developed artists."[31]

The Association received funding from a wide range of sources, including the Canada Council, the Ontario Council for the Arts, and the Saskatchewan Arts Board, to bring in a roster of international craftspeople and speakers.[32] A total of 128 delegates from across Canada as well as the United States and England attended. In an effort to make the conference truly national, Canadians living outside of Ontario were encouraged to attend by partial reimbursements of travel expenses provided by the Canada Council. It was an effective strategy, with more than 50 percent of delegates arriving from outside Ontario. International visitors were met and escorted to Kingston by members of the Association professionelle des artisans du Québec.

The strong presence of craftspeople from the United States in the media sessions of the conference, and also Webb's symbolic presence, indicated to the conferees the importance of US ideologies in the craft world. Canadian delegates and organizers were receptive toward the increasingly self-reflexive approach of the US craft demonstrators who advocated self-expression in addition to technical virtuosity. This perspective was also embraced by the news coverage provided by the World News Agency, which sent brief daily bulletins to newspapers in participating countries. The image of professionalism attained by such international coverage and the attendance of craftspeople from the United States, England, Sweden, and France reinforced the Canadian Craftsmen's Association's position as the official organization for Canadian craftspeople. Its role as the purveyor of craft standards and good taste in craft, which had begun with its involvement in craft selection for Expo 67, increased in the view of the federal and provincial government representatives who were associated with the Kingston conference. Attending the conference was Norah McCullough, who had resigned from her position as the chair of the Canadian Craftsmen's Association in order to organize the largest of all the centennial craft exhibitions, the National Gallery of Canada's *Canadian Fine Crafts*.

Norah McCullough's *Canadian Fine Crafts*

Norah McCullough was the National Gallery's Western Liaison officer, and in 1965 she began curating a national craft exhibition intended to coincide with Canada's centennial year, although it opened in December 1966. McCullough admired Donald Buchanan's approach to the crafts demonstrated through such National Gallery of Canada exhibitions as *Canadian Designs for Everyday Living* (1948) and *Canadian Fine Crafts* (1957). McCullough praised Buchanan's understanding of the "desirability of good design in the things used in everyday life: from pots and pans to furniture, fabrics, lighting fixtures and so on."[33] Buchanan had provided the mandate for the exhibition of crafts in the National Gallery of Canada and McCullough's *Canadian Fine Crafts*, which, like the Expo 67 exhibition, employed Buchanan's title, intended to further the role of crafts within a fine art institution.

The professional approach taken by McCullough to *Canadian Fine Crafts* marked an important first for craft exhibitions. As it had failed to do for previous shows, the National Gallery of Canada provided McCullough with the funding and time to create a national showcase for Canadian craft. Buchanan had been critical of the lack of care taken with the craft exhibitions of the

Canadian Fine Crafts, Installation View, National Gallery of Canada, December 1966.
Photo courtesy of the National Gallery of Canada.

1940s and 1950s, which he believed reflected a lack of concern with the important place craftspeople occupied in Canadian culture. McCullough was sure to provide the detail and care expected in a fine art exhibition, and she received praise from members of the Canadian Craftsmen's Association for these efforts. Merton Chambers and Anita Aarons thanked McCullough on behalf of "our professional group," expressing the hope that *Canadian Fine Craft* would serve to elevate the status of Canadian craft by ensuring that it embraced the "proper" audience, those with the cultural and economic capital to become the patrons for Canadian craft: "By directing it to higher ups and others we also hope to eliminate the attitudes that crafts are minor, abundant and not worthy of sufficient planning ahead of time. Your efforts here and frustrations are well appreciated."[34] These same members were critical of Moncrieff Williamson's less rigorous approach to the Expo 67 *Canadian Fine Crafts* exhibition, which was running late and "engendering some nasty comments from many sources."

After its initial opening at the National Gallery of Canada in December 1966, *Canadian Fine Crafts* was designed to travel the country, transported in specially commissioned display stands doubling as travel cases designed by John MacGillivray.[35] Norah McCullough wanted to ensure that the exhibit would travel in order to give the craftspeople from across Canada, as well as

people living outside Ontario, the opportunity to see their pieces in the exhibition. In her role as western liaison for the National Gallery of Canada McCullough was aware of the importance of integrating rural audiences and artists, who were producing outside Canada's major cities, into the Canadian cultural scene. Her interest in bridging the gap between, on the one hand, Central Canada and, on the other, the Maritimes, the Prairies, and the west began with her work for the Saskatchewan Arts Board, during which time she organized the art pottery at Fort Qu'Appelle, Saskatchewan. Her work with the World Crafts Council convinced her of the ability of crafts to unite diverse populations, an ideology she brought to bear upon the Canadian Craftsmen's Association.

In preparation for the exhibition *Canadian Fine Crafts*, McCullough continued her hands-on approach to Canadian crafts, travelling across Canada to visit a diverse range of craftspeople; her voyage was described by *Time* magazine as "scour[ing] the country by plane, train and Volkswagen ... logg[ing] 4000 miles [and] turning up 1000 items."[36] Although McCullough was careful to stress the need for wide inclusion in the craft field and used the exhibition to introduce emerging craft artists, the majority of craftspeople she visited were professional, studio-based artists. Their work, with its strong aesthetic qualities and links to use, embodied the founding philosophy of the Canadian Craftsmen's Association, which under its original name, the Canadian Council for the Environmental Arts, had promoted crafts related to all the various human environments. McCullough hoped that these craft objects, covering a broad range of approaches and environments from domestic use and decoration to architectural installation work and body decoration, would inspire viewers to begin pursuing an interest in craft: "In other words, this should not be simply a cold display of beautiful objects but one that is essentially didactic."[37] Critics credited the exhibition with achieving its educational goals while proving that crafts formed an integral part of the fine arts. The *Ottawa Citizen* review gushed that "the showing should teach and challenge the thousands of individuals who have been pursuing one of the many crafts represented," while *Time* magazine argued that "fine crafts have something artistic to say."[38] The diversity of craft objects on display was praised for providing the viewer with differing approaches to the idea of craft: "The 360 exhibits include sculpture-like pottery, enamelled platters more suited for walls than for tables, rugs too fine to walk on, ashtrays in which only a boor would be so brash as to stub out a cigarette. Scarcely less striking because they are also useful, there are switched-on stoneware spice jars and tea bowls, applewood eggcups, an ornate silk bookmark — even a pair of Eskimo snow goggles carved from bone, and a graceful Indian lacrosse stick."[39]

Canadian Fine Crafts/Artisanat canadien 1966/67 exhibition catalogue featuring Joan Bobbs, Bottle. Reduced Stoneware, height, 8 inches. Photo courtesy of the National Gallery of Canada.

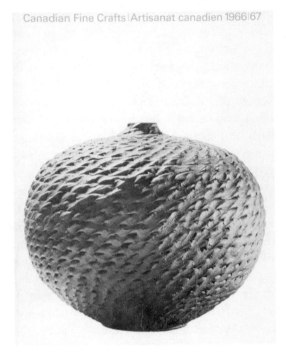

Canadian Fine Crafts|Artisanat canadien 1966|67

While Williamson and McCullough's exhibitions had some artists in common, the selections made for McCullough's show appear to be less playful than Williamson's. The surface ornamentation on most objects was subtle, rarely featuring patterning, and tended towards an emphasis on raw materials. Existing patterning draws from the treatment of the materials themselves. The majority of textiles were weavings, displaying all varieties of weave – checks, thick, soft, nubbly, bumpy surfaces, wall hangings composed of arithmetical repeating patterns, or macramé-like play with yarns that were bunched into narrow bands or feathered into a soft blur to contrast with the geometrically rigid woven support structures. Among the non-woven textiles linens, tie-dying and batiks were featured. Both *Canadian Fine Crafts* exhibitions were overwhelmed with stoneware ceramics. The cover of McCullough's catalogue featured Joan Bobb's stoneware bottle, a simple, smallish rounded form, with a thickly impasto surface. Raised diagonal marks that reiterate the woven structures of the textiles move upward. The surface of the clay body itself is rough with raised granules evident in the clay, which does not appear to be heavily glazed. Some of the metal objects in the exhibition also featured a similar surface treatment to Bobb's stoneware bottle.

De Passille-Sylvestre's enamelled metal liqueur glasses had a dimpled metal surface, and many of the other pieces were hammered.

An artist shared by both Williamson and McCullough was Charlotte Lindgren. Unlike the majority of textile pieces in the exhibitions, all of Lindgren's work was titled, with "Winter Tree" in Williamson's and "Flapper" and "Katchina" in McCullough's. Another noticeable difference between Lindgren's work and that of her peers were the materials used. Amidst the wool, linen, and cotton, Lindgren's monkey hair, lead wire, and plastic stand out. Lindgren's work demonstrated a sophisticated approach to traditional craft materials and techniques that reflected the goals and aims of the modernist-based professional community. Her work mirrored her belief that "every artist transcends his materials and the visual elements of colour, form, texture, line and space to express perceptions of spirit."[40] That she worked in textiles was secondary to her ability to manipulate the material into a technically perfect and conceptually literate object. It was no surprise that Lindgren approached her work in this manner. Born in Toronto, Lindgren moved with her architect husband to Winnipeg, Manitoba, in 1956 where she began teaching weaving at the University of Manitoba after only taking one course in weaving herself. Lindgren worked under Lillian Allan, a textiles instructor who had just returned from studying at the Cranbrook Academy of Art. Lindgren credits this experience with inspiring her to pursue weaving, a material approach that allowed her to express both process and concept.[41] In 1964 Lindgren won a scholarship to study at the Haystack School of Craft in Deer Isle Maine, with Jack Lenor Larsen, head of the textiles studios. Larsen was a major name in the US textiles community. Co-director of the Fabric Design Department at the Philadelphia College of Art from 1952 to 1962 and co-curator of the Museum of Modern Art's 1968–69 *Wall Hangings* exhibition, Larsen was also the director of his own fabric company, Larsen the Company, founded in 1952. The "Larsen look" featured entirely hand-woven fabrics done in natural yarns with various geometric patterns.[42] The push toward the conceptual Lindgren had already taken with her early weaving was cemented through her experience at Haystack. Larsen gave his students specific weaving problems to solve, for example, a project to weave narrow African patterned bands on the loom, and he was impressed with Lindgren's approach to these assignments. Larsen told Lindgren that she had an original mind, loaned her an eight-harness loom, and encouraged her to go to her new home of Halifax to "weave beautiful things and bring them to him in New York."[43] "He flung the glove down," states Lindgren, who took Larsen up on his challenge and began to produce sculptural weavings.[44] According to Lindgren Larsen was not fond of her large-scale sculptural work, preferring

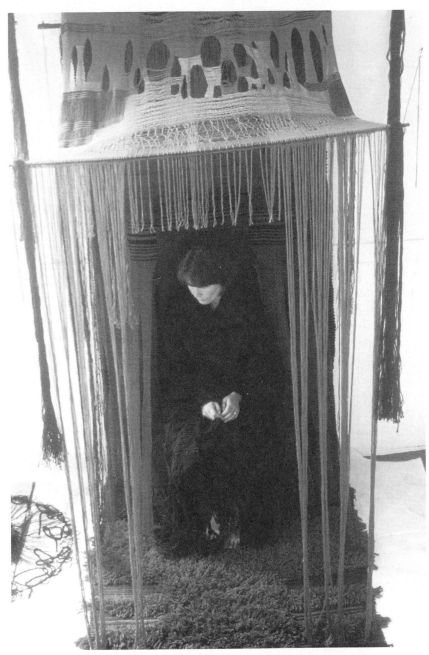

Charlotte Lindgren, "Aedicule," 1967. Mohair, wool, synthetic, silk, 96 × 60 × 96 inches. Photo courtesy of Charlotte Lindgren.

instead her earlier smaller scale weavings. Lindgren, however, was inspired to push woven structures in new directions.

"Aedicule," completed in 1967 for the International Biennial of Tapestry in Lausanne, Switzerland, is a three-dimensional self-contained "sanctuary." Starting with the rug the viewer's eye works up to the chair, splitting into three cloths that lead the tapestry up into the canopy. These domestic and architectural elements are all expressed in a single piece, completed entirely on one loom and not pieced or sewn together.[45] When "Aedicule" was displayed in Lausanne in 1967 it was the only three-dimensional piece. Heavily guarded, people could not touch "Aedicule" in Lausanne, which Lindgren saw as unfortunate as the sanctuary was not a completed space until people sat in it. Much of Lindgren's work invites interplay with the viewer, and while McCullough's *Canadian Fine Craft* featured two of Lindgren's pieces, it followed a very traditional format for the display of craft objects.

After McCullough's initial selection of one thousand items had been completed, the National Gallery brought in a craft expert to help McCullough jury the final selection. Unlike Williamson who had been given complete authority over both the selection and curating, McCullough was required to work with a male judge, selected by the National Gallery, who possessed the proper symbolic capital. Daniel Rhodes, ceramist and professor of ceramics at Alfred University, agreed to serve as the juror for the exhibition.[46] The Gallery and the press promoted his involvement, believing that it would ensure a professional approach to the crafts. Rhodes was well-known in North American for his books on ceramics that espoused the view that artistic individuality and technical skill could be achieved simultaneously.[47]

Written material on the exhibition always acknowledged McCullough's key role in the show, in particular texts by Hénaut, who called McCullough a champion for the crafts in Canada. Nevertheless, Rhodes soon stole the spotlight as a leading authority on Canadian crafts. Jean Sutherland Boggs, the director of the National Gallery of Canada, thanked Rhodes in her foreword to the *Canadian Fine Crafts* catalogue for his "wise guidance." McCullough herself wrote to Rhodes thanking him for his "sound guidance in selecting the crafts," while stating her gratitude for "clarifying my own judgment,"[48] but masked her resentment over the credit Rhodes had been granted for performing as a single juror. These feelings surfaced in an October 1966 memo to Jean-Paul Morrisset, in which she clarified that "As for the jurying please note that our notices state that Rhodes assisted in the jurying for I actually was his co-juror. In fact, he left almost all the weaving to me."[49] The perceived need for Rhodes's symbolic capital in determining the objects for exhibition was echoed in the National Gallery of Canada's invitation to

Moncrieff Williamson to open McCullough's exhibition in December 1966. While Williamson had an entire exhibition and catalogue in which to espouse his views on Canadian craft, Norah McCullough was rendered mute despite the central role she had taken in organizing the largest exhibition of Canadian crafts Canada had ever witnessed. Daniel Rhodes provided the assessment of the exhibition in his catalogue essay for the National Gallery of Canada's *Canadian Fine Craft*, while McCullough remained silent. The woman who had been involved in the Canadian craft scene for over a decade, organizing Canada's first truly professional craft organization and serving as Canada's delegate to the World Crafts Council, was given no formal space in which to record her views on Canadian craft. While Aileen Osborn Webb possessed the economic capital to influence the American Craft Council's approach to crafts, Norah McCullough found that she did not possess adequate symbolic capital to influence the final decisions for her own exhibition, nor the cultural capital to be given the opportunity to write the catalogue entry for the show she had fought to create.

Rhodes's selection as the essayist for the *Canadian Fine Crafts* catalogue suggests his role was that of an expert from the United States gazing upon the weaker Canadian craft scene. Just as Paul Smith of the Museum of Contemporary Crafts in New York had been asked to curate an exhibition of Canadian crafts at the Royal Ontario Museum in the 1950s and Paul Soldner and Wendell Castle had been invited from the United States to the Kingston conference to lead Canadian craftspeople in media sessions, Daniel Rhodes was expected to indicate which direction Canadian craftspeople should take to ensure that their craft production was able to match that of the United States. Instead, Rhodes provided a thoughtful essay on the state of craft in North America as a whole, an approach that delighted Canadian craftspeople who saw themselves as finally achieving parity with their US peers. *Time* magazine reported Rhodes opinion that "'Five years ago, the state of the art in Canada was relatively crude,' says Rhodes, who was appalled at the proliferation of clumsily whittled maple leaves and leatherette wallets labelled SOUVENIR OF CANADA. 'But the difference between then and now is astounding.'"[50]

In his essay Rhodes acknowledged the importance of craftspeople from various ethnic groups who continued traditions of design that were influencing contemporary craftspeople. He argued that more traditional examples of Indigenous craft had been selected over contemporary items due to the sureness of design found in the older work, "The Indians and Eskimos are generally on sure ground with respect to workmanship and function, but they are experiencing a diminishing conviction and clarity in their relationship to traditional design."[51] While Rhodes did not judge this as a necessarily negative

shift, he believed that the lack of continuation between contemporary pieces and traditional crafts resulted in work that did not possess a synthesis of method, material, function, and meaning. Rhodes extended this critique of weak work that had difficulty transitioning from traditional craft to fine art to Euro-North American craftspeople. The Canadian examples he felt were the most successful were more modest and functional than the "unique, one-of-a-kind expressions, not much different in intent than the work of painters and sculptors." Like Anita Aarons and other members of the Canadian Craftsmen's Association he gave credit to the expanding and improving educational opportunities for craftspeople for the increase in sophisticated crafts. However, he seemed unaware of the discrepancies that existed between the educational institutions for craftspeople in the United States and Canada. Rhodes concluded his essay with a generalized statement about crafts in North America; he hoped they would enter into a period where "technical sophistication can be made to sustain esthetic and social ends with more effectiveness."

Although Rhodes was a craftsperson and academic from the United States, there is no record of objection to his role in jurying the National Gallery of Canada craft exhibition. McCullough promoted Rhodes's involvement to Bernard Chaudron, the president of the Association professionelle des artisans du Québec, claiming that Rhodes's experience and understanding of good design would benefit Canadian craft, which needed the *Canadian Fine Craft* exhibition to raise the quality and diversity of production throughout Canada. Her letter to Chaudron was in response to his concern that the National Gallery of Canada was unwilling to purchase the work in the exhibition. Chaudron argued that by not purchasing the pieces in the show, the National Gallery was asking craftspeople to lose potential income on items that would be out of commission for several months.[52] This reflected the professional and businesslike approach embraced by many Quebec craftspeople who expected to earn a living from their production.

Many professional craftspeople are not exhibiting in major galleries, where curators are unsympathetic to the commercial requirements of objects they consider to fall under the mantle of fine art, isolated from business in the white cube of the gallery. These separations were evident earlier in the Royal Ontario Museum's 1945 *Design in Industry* exhibition, where curators complained of the inclusion of prices in the labels of the exhibition. Moncrieff Williamson's Expo 67 craft exhibition did not include pricing as Williamson purchased the works for Charlottetown's Confederation Centre. Chaudron's letter led McCullough to follow Williamson's lead in securing a purchaser for the *Canadian Fine Craft* exhibition as a whole. By the summer of

1966 the Cultural Affairs Division of the Department of External Affairs had agreed to purchase 160 items from ninety-three artists for $6885.90.

Following a travelling exhibition across Canada, these craft pieces were to be exhibited in Annecy, France, at the opening of Journées Canadiennes in September 1967 and later would be displayed in Canadian embassies around the world.[53] This agreement with the Department of External Affairs disproved Moncrieff Williamson's earlier declaration that his Expo 67 *Canadian Fine Craft* exhibition would be more international in scope than McCullough's efforts.[54] Just as she had been watching Williamson's Expo 67 show, Webb was keenly interested in the outcome of McCullough's exhibition. McCullough kept her informed of the development of *Canadian Fine Craft*, agreeing to meet with Webb, World Crafts Council chairman James Plaut and World Crafts Council secretary Margaret Patch in New York in September 1967 to provide a synopsis of the events of 1967 and the development of Canadian craft.[55] Despite record-setting attendance numbers, drawing purely positive reviews, and catching the attention of US craft administrators, *Canadian Fine Craft* was the last exhibition of Canadian craft sponsored by the National Gallery of Canada. McCullough retired from the Gallery in 1968 having been promised that a continuing series of "Norah McCullough" lectures devoted to craft topics would be held in her honour. Following a shift in administration in the late 1970s the lecture series was cancelled and has not been reinstated.

The reviews of *Canadian Fine Crafts* at the National Gallery of Canada consistently noted the sudden growth in the popularity of crafts in Canada and the increasing market for craft. The expectation that there would be a steady upsurge in leisure time available for craft activity and the focus on youth culture and the "back to the land" possibilities of self-sufficient craft production may have contributed to the increasing attention craft received during centennial year. Experts, who continued to classify crafts as a leisure-time, rather than professional, activity, shared the opinion that technological innovations guaranteed more leisure time in the future, proclaiming "the two day work week, an annual wage of $13,000 a year for the average family ... all just around the corner, in the year 2000."[56] Suddenly craft was "hip" for youth, a political tool for aboriginal people, and an international source of creative recognition for Canada. The Canadian Guild of Crafts was aware of the importance of participating in the craft fever of 1967, and the Quebec branch undertook its most ambitious exhibition ever, *Canada Crafts 1967*.

Canada Crafts 1967

Staged at the Canadian Guild of Crafts' Galerie des Artisans, from 21 June to 24 August 1967, *Canada Crafts 1967* was designed to highlight the progressive nature of the Canadian Guild of Crafts. The exhibition grew out of the biennial national competitions traditionally held by the Guild. The 1967 show promised to "establish stringent standards of excellence" by offering generous cash prizes and a rigorous jurying process.[57] Some of the long-time Guild members complained that the presence of the jury prevented them from entering the show, while organizers argued that the increase in standards convinced professional craftspeople to participate in an exhibition they had previously considered to be dedicated to the hobbyist. In the end the Guild received 750 entries from across Canada. Of these, more than two hundred were selected for display, and twenty-seven prizes of "substantial value" were awarded, to a total of $6,000. Although *Canada Crafts 1967* operated to push the Guild into the arena of professional crafts in Canada, the aging organization had been unwilling to support the efforts of the Quebec branch, which overextended itself financially for the exhibition. The selection of the Canadian Craftsmen's Association as the official Expo 67 craft organization led some to believe that the Canadian Craftsmen's Association had usurped the Guild for federal assistance for craft projects, and as a result the validity of the Guild as a national organization was questioned. The question "Should the Guild continue as a national organization?" was debated at the December 1967 National Committee Meeting, where members agreed that the various branches were no longer willing to contribute to national projects.[58] This marked a turning point within the Guild's national strategy, which allowed the Ontario provincial branch to begin its ascendancy into national prominence.[59]

Williamson continued to increase his capital within the craft field by occupying the role of juror for *Canada Crafts 1967,* while Jacques de Tonnancour of the École des Beaux Arts provided a Quebec fine arts perspective on the jurying process. The Guild rounded out its jury with Paul Smith, the curator of the Museum for Contemporary Crafts in New York City.[60] The Museum was a project of the American Craft Council, and Webb credited Smith with being a leader in identifying trends in contemporary crafts. Smith had previously refused an invitation from the Royal Ontario Museum to curate an exhibition on Canadian craft in 1955, but by centennial year he agreed to participate in such a show. The Guild had selected three jurors who represented major elements within North American crafts. Along with Williamson, who had become the "expert" for professional crafts, de Tonnancour provided ideas about craft that reflected Quebec's interest in industrial production and con-

tinental European influences, while Smith brought to bear upon craft his modernist ideologies, which had been cultivated through his involvement in the New York art scene.

The symbolic capital of US craftspeople and administrators played a key role during Canada's centennial craft events, from Daniel Rhodes and Paul Smith to Aileen Osborn Webb's presence at the Kingston Conference. These were not the only Americans who were involved in Canadian craft exhibitions during the year. J.T. Tripetti, the director of the New Hampshire League of the Arts and Crafts, juried the Canadian Guild of Crafts Ontario branch exhibition for the Canadian National Exhibition. The larger craft shows had depleted the entries available for the annual show, and Tripetti was scathing in his comments on the items that had been received: "Most important, though, are the ingredients I found absent – vitality, inquisitiveness, adventure."[61] These were the same traits that Aarons had argued were lacking in Canadian crafts due to poor educational opportunities. Despite the successes of crafts in the exhibitions of centennial year and the favorable comments on the progress made in professionalizing Canadian crafts, the majority of Canadian craftspeople and administrators agreed that it was essential for Canada to improve the education of its fine craftspeople. As a result, and aided by increased spending generated by the centennial year, the years following Expo 67 were to provide Canadians with new schools, departments and programs dedicated to craft.

A Separate Space: Native Craft in Canada

Though Native people in Canada had been involved in professional craft production for more than one hundred years, their involvement in the centennial year craft exhibitions was severely restricted and shaped by their position as colonized subjects of the nation. The few Native and Inuit items on display were generally treated as anonymous ethnological references, consistent with the Canadian Handicrafts Guild's traditional system of exhibition. McCullough's *Canadian Fine Crafts* did not exhibit contemporary examples but instead relied upon a colonial approach to aboriginal craft. With the exception of beaded moccasins by Mrs John Morris of Trout Lake, Ontario, the nineteen Native and Inuit crafts were anonymous, historical/traditional examples that contrasted greatly with the carefully labelled, individual fine crafts from Euro-Canadian craftspeople. While no mention was made of the resulting distinction between the ethnographic "curiosities" of the Indigenous crafts and the studio crafts of the other exhibitors, this very silence was

indicative of the discourses surrounding Native production. That McCullough had overlooked this binarism, considering the care she had taken in representing a cultural cross-section of Canadian crafts, confirms the entrenchment of attitudes that regarded Indigenous crafts as somehow separate from the concerns of professional and contemporary craft.[62] Moncrieff Williamson's *Canadian Fine Crafts* avoided the dilemma of proper selection and representation of Indigenous crafts by including only three examples in the exhibition. The contemporary designs of Bill Reid's gold box and Elda Smith's Iroquois pottery contrasted with the presence of an anonymous Inuit basket from the Great Whale River.[63]

In essence, while the concerns of Euro-Canadian craftspeople were being pushed into the professional sphere through a number of national exhibitions, Native craft appeared to remain within the narrower, more traditional realm that had been created by the Canadian Handicrafts Guild. This ran counter to reality: aboriginal craftspeople were experiencing their own move toward professionalization. The main focus of the members of the Canadian Craftsmen's Association and the American Craft Council was to shift attitudes about craft away from romanticized, nostalgic stereotypes to one of professionally educated craft artists producing objects for a distinguished public who possessed good taste. Aboriginal craftspeople were also interested in effecting these changes, but, in addition to the struggles faced by Euro-Canadian craftspeople, they were required to address the construction of "Indianness" that surrounded their craft objects and the Western imperialist concern with authenticity.[64] Non-Native craftspeople were encouraged to explore new combinations of craft material in collaboration with fine arts schools and institutions, but objects produced by Native craftspeople were supposed to be symbolically identifiable as "Indian" by the mainstream, while utilizing local raw materials and traditional forms.

The Canadian handicrafts Guild and the Preservation of Native Craft

Indigenous craft production has been critically analyzed by art historians during the 1990s, revealing that the production and consumption of Native crafts both inscribed stereotypical images of authentic "Indianness" and allowed First Nations artists to make interventions into the hegemony of European power. Gerald McMaster has identified the impact of the Canadian Handicrafts Guild on Native craftspeople during the Reservation period (1870s to 1950s), when historical relationships with the resources of the land and sea were replaced by a European-style economic base that resulted in

new associations with traders and the government. In an effort to assimilate Indigenous peoples, the 1884 Indian Act forbade cultural expression and traditional education.[65] As a result, the "civilization" of Natives led to the production of craft objects deemed acceptable by the Department of Indian Affairs, which supervised the Indian exhibits at industrial and agricultural exhibitions. McMaster defines the roles played by ethnologists and Western connoisseurs in further reshaping traditional craft objects through their personal taste for "artistically" formed works. This is in contrast to the Canadian Handicrafts Guild, which had been concerned with preserving all of Canada's craft traditions, including those of the Indigenous population: "The [Guild] … hopes to prevent the rapidly declining Indian arts from disappearing altogether – a loss the importance of which is as yet scarcely realized … [traditional crafts] showed a great superiority in both design and colour over the work done nearer to civilisation, where natural taste has been influenced by the demand for cheap imitations."[66]

In 1912, the Guild sent Amelia M. Paget to Saskatchewan to "revive and conserve" Indian crafts and by the 1930s was worried enough about the loss of Native craft skills that it successfully sought to convince the Department of Indian Affairs to establish a system of collecting and marketing Indian art and craft. The Guild's educational and technical committee, formed in 1932 to study why Indian crafts were diminishing, came to the conclusion that it was a result of the influence of imported Japanese imitations of Native crafts. This quickly led to the formation of an "Indian Committee," headed by Alice Lighthall, and in 1936 the Department of Indian Affairs appeared to echo some of the Guild's concerns when it created the Welfare and Training Division, where arts and crafts were encouraged for reasons of economic self-sufficiency. Careful restrictions were placed upon the objects produced, with a list of acceptable items and set prices defined. These items were marketed through large department stores. McMaster points out that the Guild's activities regarding Native craft work counteracted the Indian act, which prevented the participation of Indigenous peoples in exhibitions; in doing so, the women of the Canadian Handicrafts Guild were important in expanding the role played by Native crafts. The Guild had become politically involved in 1933, helping to defeat a revision of the Indian Act designed to prevent Natives from wearing their traditional dress.[67] Unfortunately the war interrupted the Guild's efforts, and by the early 1950s it had shifted its focus toward Inuit crafts as interest in these arts grew.[68]

In 1949, the Guild sent James Houston to Port Harrison as its Arctic representative. Houston had studied at the Art Gallery of Toronto with Arthur Lismer in the 1930s and collected a stone carving on a painting trip to the

Arctic in 1948. Upon his return Houston showed the piece to the Canadian Handicrafts Guild, and the organization gave him $1,000 to return to the Arctic and purchase more. The thousand carvings he brought back sold out within three days. After the enormous success of the Guild's first Inuit carvings exhibition and sale, the Canadian Government and the Hudson's Bay Company lent their support by providing a grant for Houston to purchase Inuit carvings for the Canadian Handicrafts Guild.[69]

Houston introduced Inuit artists to modernist aesthetics and techniques while encouraging them to depict traditional scenes. He did not want the items produced for the Guild to look like "contemporary" art, instead he sought work that adapted modernist conventions to historical depictions of significant Inuit activities. This combination proved to be highly successful. Newspaper reports celebrated him as developing Inuit crafts, praising his good taste and collection standards. Houston's intervention prescribed the choice for Euro-North American consumers who awaited the annual shipment of carvings to the Guild. The *Globe and Mail* described Houston's collecting procedure in a 1966 article: "He had his own method of safeguarding the quality of the pieces he acquired. 'Well you see,' he laughed, 'there was this big crack in the sea ice. Whenever I ran into a piece of poor quality I'd drop it into that crack – at night.'"[70] Houston was perceived as the authority on Inuit craft, having been the first civil administrator of West Baffin Island from 1953 to 1962 and later writing two children's books on Inuit legends, as well as books for adults using the Inuit context.

For the women of the Canadian Handicrafts Guild, their concern with Native crafts seemed to be the legitimate continuation of the philanthropic attitude toward the crafts. In *Trading Identities: The Souvenir in Native North American Art from the Northeast 1700–1900*, Ruth Phillips demonstrates that the seemingly naturalized relationship between women as "noble" consumers of Indigenous craft and teachers of Christian charity was in fact a result of the "civilizing mission" of imperialism. While the souvenir crafts of Native artists have until recently been disregarded within art history as kitsch, Phillips shows that these objects embodied cultural resistance through the maintenance of traditional artistic concepts while allowing Indigenous people to modernize their economies and lifestyles.[71] Phillips analyzes the significance of the patronage of "ordinary people" as well as the upper classes on aboriginal craft, which was desired by people of all classes. She notes the exploitive role of colonialism, which succeeded in keeping the prices of Native craft low while collectors and ethnologists created a market for expensive "authentic" craft. Like the Canadian Handicraft Guild "Indian Committee" members, many of the collectors of aboriginal craft felt that

they were possibly preventing the disappearance of the Native peoples themselves by purchasing their handcrafts.

"Authentic" Native Craft

Indigenous craft had been collected from the first contact with non-Native peoples. The collecting imperative was founded on the principle of uniqueness; Native crafts were necessarily objects of exoticism to foreigners, expected to symbolically represent particular historical narratives and legends. Non-Natives quickly appropriated these culturally significant objects. As early as 1714 Ursuline nuns in New France both copied and adapted the crafts of aboriginal women to suit the growing market, producing curios for their patrons in France.[72] For example, in the Woodlands region, as tourist numbers increased in the nineteenth century, so did the popularity of Native crafts, which were accepted as proper parlour decorations and home beautifiers. The sale of crafts allowed Native producers to earn income.[73] Phillips argues that in the Woodlands area it was women who turned to the production of art commodities when they were left alone to support themselves and their families, while McMaster believes that the shift to women as craft producers resulted from increasing opportunities for Native men in the factories found in the Great Lakes region. While the development of a tourist trade for Native crafts varied from region to region, by the 1930s, when the Canadian Handicrafts Guild initiated its "Indian Committee," it was mainly women who were operating as both the patrons and producers of Native crafts.

The value of Native crafts was their ability to mark difference between the consumer culture and "Indian" heritage, contributing to the classification of Indigenous art as nostalgic and symbolically specific. Although this categorization was an effective marketing tool, it restricted the expansion of aboriginal craftspeople, forcing them to continue producing craft objects expected by their Euro-North American audiences. By the 1950s specific forms and materials were naturalized as Native craft, even as many of the raw materials from reserve lands were being exhausted. Ruth Phillips identifies the nineteenth-century Woodlands craft items that were popular, including moccasins, beadwork, quillwork, and carving, and that served as the templates for twentieth-century production. In its efforts to preserve traditional crafts, the Canadian Handicraft Guild encouraged the learning of these craft techniques.[74]

By the 1960s the appropriation of Native symbolism and images was common to the Canadian experience. From children's magazines to children's camps in the Woodlands area, Canadian stories and popular culture items

were filled with Native motifs.[75] Although this colonial practice was widely accepted as part of the building of Canadian national identity, the appropriation of Native arts by non-Canadians, namely the Japanese producers of imported souvenirs, was perceived as negative. Although the Canadian Handicrafts Guild had participated in the appropriation of Native art and craft, the growth in Japanese reproductions became a concern for the Guild. Aboriginal craft leaders were involved in fighting the double racism of appropriation that they faced as the popularity of Native symbols and images grew worldwide. In the 1950s Florence Hill of the Six Nations Reserve in Ontario organized the Ohsweken Art Group, which later developed into the Six Nations Arts Council. The purpose of the group was to promote Native arts and crafts and improve standards of craftsmanship and public taste through exhibitions.[76] Other groups and individuals, ranging from professional artist craftspeople to retailers, organized to demonstrate the professionalism, good taste, education, and proper marketing of their craftwork.

Ojibwacraft

Aboriginal craftspeople had historically travelled to retail their craftwork, a practice that continued into the twentieth century. Gladys Taylor, a quill-worker from Curve Lake, Ontario, who was a popular exhibitor at shows sponsored by the Canadian Handicrafts Guild and the Ontario Crafts Foundation, reported that, after 1966, it was no longer necessary for any of the Curve Lake members to travel to sell their wares as an important new store had been established to retail their work from a central location.[77] This store, Ojibwacraft, opened in 1966, as a project of Ojibway Chief Dalton Jacobs and Councilor Clifford Whetung, was designed to underwrite the six hundred Ojibway people who lived in Curve Lake. A $50,000 building with a large workshop, retail area, and storeroom was constructed.[78] Owned by Whetung and his wife, the $50,000 annual gross of the Ojibwacraft label resulted in $16,000 in wages for the band members. Chief Jacobs praised the Whetungs for their professional organization, claiming that "Where poverty was once considered a plague, particularly during the winter months, and welfare payments were the norm, both have virtually become a thing of the past. Since the Indians are now working together for the betterment of the reserve as a whole and themselves individually, there has been a general uplift in morale."[79] Ashley Taylor created traditional birch bark and porcupine quill boxes decorated with Canada's maple leaf in quillwork, while carved totem poles featured a mix of West Coast, Plains, and Great Lakes imagery.

Examples of craft objects produced by Whetung Ojibwa Crafts, centre. On the right is an example of the Smith's pottery under the title Mohawk Pottery. Photo courtesy of the National Archives of Canada.

When questioned about the authenticity of the craft products sold by Ojibwacraft, which included such novelty items as feathered headdresses and carved totem poles as well as moccasins and baskets, Whetung defended the cross-cultural nature of the items, arguing they were what the public demanded: "White people associate totem poles with Indians and seem to expect us to make them, so our people have obliged."[80] The Ontario Government was involved in the opening of the new building, inviting Arthur Laing, Minister of Northern Affairs and Natural Resources, to be the guest speaker at the powwow and the Hon. Lt Col John Keiller MacKay, chairman of the Ontario Council for the Arts, to cut the leather "ribbon" to open the crafthouse. Whetung took the opportunity of the opening to make a statement about the political potential of Curve Lake crafts, telling reporters that "However well they adjust to the paleface's laws, the Curve Lake Indians have found a way to make the White Man pay off."[81]

Whetung and other Native administrators were careful to ensure that their Native crafts were properly labelled and identifiable to consumers. In addition to appropriating the images of aboriginal culture, Japanese and other non-Native manufacturers had been designating their mass-produced objects as "handcrafted," "authentic," and "original."[82] As the Canadian Copyright Act was not established until 1988, Native craftspeople had to compete with these misleading reproductions by establishing their own labelling systems. Valda Blundell terms the appropriated mass-produced souvenirs and more expensive hand crafted items "fakelore."[83] Additionally, non-Native artists had been encouraged to appropriate Indigenous images as part of

their own craftwork. *National Asset/Native Design*, published in 1956 by the Pulp and Paper Industry Commission of Canada, featured Art Price's illustrations of traditional images in the hope that it would "help to widen the adaptation of native arts … to wherever craftsmanship can add distinction and value to the products of Canada."[84] Art Price was a Native artist craftsperson and founding member of the Canadian Craftsmen's Association. Clearly, tourists and craft collectors required the proper cultural capital to distinguish Native-made crafts from imitations.

The elevation of public taste required indoctrinating consumers into the sign systems of Native craft labels. *Chatelaine*'s consumer column instructed readers on how to distinguish between authentic and fake Indigenous crafts. Following the nineteenth-century tradition of charitable consumption, *Chatelaine* warned that "Native artists, who depend on the income received from sales, live so far from the retail markets that other Canadians must protect them from exploitation." Although readers were informed that the authentication of genuine crafts was the responsibility of the Department of Indian Affairs and Northern Development, collectors were encouraged to protect themselves by becoming familiar with Native arts by visiting museums: "Authentication of genuine arts and crafts is the responsibility of the Department of Indian Affairs and Northern Development, Ottawa."[85] The use of the colonial term, "authentication," indicated that only the Department of Indian Affairs knew what constituted "real Indian" craft. The contemporary work of artists with partial Native backgrounds would not have been classified as "Indian," fitting the stereotype of the imaginary "Indian" and the historical persona expected by the mainstream market. The attitude that Native crafts were stagnant, arts relegated to the dusty cases of the ethnology museum, continued the ethnographic response to Indigenous art as confined to the past. The classification of Native crafts within narrow boundaries responded to the modernist myth of the naive primitive that had been cultivated since the early-twentieth-century appropriation of Native arts by art groups, including the Surrealists.[86] By the 1960s, aboriginal craftspeople were ready to expand their production beyond the limited cultural field to which they had been relegated in the hierarchical craft structure.

The federal Department of Forestry commissioned a three-month study on Canadian Indian Crafts in June 1966 in the hope of establishing a program to develop markets for Native crafts. The study identified the major groups of consumers of aboriginal craft as Canadian and US tourists, the Indigenous population, collectors, and European tourists. It estimated the annual sales of crafts at one to two million dollars and concluded that European marketing system for crafts was foreign to the value system of Native craftspeople. Just

as was the case in the Euro-North American craft industry, the study demon-
strated that "the larger the craft industry became in an area, the more men
became interested." The study identified Whetung's Ojibwa Crafts of Curve
Lake as the most sophisticated craft operation owned and managed by
Natives. The principal conclusion of the study was that the Native population
as a whole wished to expand and improve its crafts, and that Native crafts-
people were aware that the quality and standards of their products suffered
from the need to meet the demands of a non-Native market.[87] Earlier, in
October 1965, Canadian Arctic Producers was established, operating inde-
pendently of government control but subsidized by the federal government
departments formerly responsible for Arctic crafts, including the Depart-
ment of Northern Affairs. Canadian Arctic Producers established a distinctive
logo featuring a stylized igloo that they attached to each of their products.[88]
Another group noted for its importance in the study was the Smith's pottery
established at Ohsweken on the Six Nations Reserve. The Smiths, who em-
ployed eight potters all using their trademark, were unusual in that they were
successful in translating traditional designs into contemporary ceramic forms.

The Smith's Pottery

Elda Smith's children encouraged her to pursue her interest in ceramics in
1962, after years of sewing buckskin jackets and jockey silks for Ontario race-
tracks. Smith had Tess Kiddick, a professional potter and member of the
Canadian Guild of Potters, come to Ohsweken to teach eleven women to pro-
duce ceramics. Elda Smith and her husband Oliver turned their pottery into a
professional studio, building a workshop and studio in the back of the house
and a showroom in the front. Their pieces, which included a range of sou-
venir ceramics including teepee ashtrays and cups, were sold mainly through
the Canadian Handicrafts Guild Shop in Toronto. Smith began experimenting
with designs she had studied on ancient pieces of Iroquois pottery. The sur-
faces of her contemporary ceramic forms were ornamented with animal
figures representing the clan symbols of the Iroquois, as well as textured dec-
orations made by broken twigs, cord, and berries.[89] Although the Smith's
Pottery (known as Mohawk Pottery) used local clay deposits and traditional
images, the elders complained that Elda Smith's work "didn't look like real
Indian pottery."[90] There were many family members that worked with Elda
Smith producing the distinctive Smith pottery. The surface decoration of the
tea service produced by Elda Smith's sister-in-law Sylvia Smith is typical of the
work of Mohawk Pottery, but the form is unusual. Most of the pieces follow

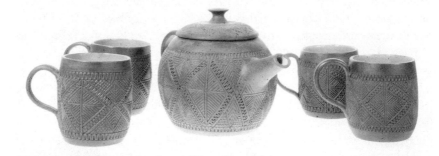

Sylvia Smith, tea service. Clay, teapot 12.4 × 15.6 × 25.1 cm. Photo courtesy of the Canadian Museum of Civilization.

traditional Iroquoian pottery shapes as well as decorative motifs; however, Sylvia Smith's teapot and matching mugs successfully translate the patterns onto her contemporary teapot. The heavy, brown stoneware teapot has been glazed bright turquoise on the inside, creating a dramatic interplay between the exterior and interior surfaces. The outside remains brown in order to emphasize the traditional designs that have been incised on the teapot, its lid, and the four accompanying mugs. Intricate patterns of rectangular bands divided into repeating triangles that are further subdivided into diamond shapes have been etched into the surface of the objects with startling precision. Many different weights of incised lines are found on the wide range of pieces made by various potters. Sylvia Smith's tea service is exceptional for the minuteness of the crosshatched details within these geometric designs. Like all of the work produced at Mohawk Pottery, the bottom of the tea service is marked with a logo depicting an arrowhead and feather with the initials "SN," probably referring to "Six Nations," the affiliation of the pottery.

A former chief warned Smith that her pieces employing motifs from old Iroquois wampum belts could not be sold because of their significance and could only be given away. Smith refused to abandon her experimental forms, working to capture the smoky look of traditional Iroquois ware. Their experimental works often found markets beyond the Guild shop; Smith used such pieces to promote her pottery by presenting them to Secretary of State Judy La Marsh. In turn, La Marsh had Smith give a pot decorated with symbols of the League of the Iroquois to Queen Elizabeth during her centennial year visit to Canada, an important event in terms of the government recognition of non-traditional Native craft.[91] Smith was the sister of Jay Silverheels who

played Tonto on the television show *The Lone Ranger*. This fact was highlighted as frequently as her ceramic abilities among the press and government officials who covered her ceramic work. While descriptions of Elda Smith portrayed her as the stereotypical Hollywood "Indian," her determination and commercial success with experimental Native ceramics demonstrated that she was operating outside of the traditional discourses surrounding acceptable and authentic Native craft.

Craft "organizers" such as the Smiths and Whetungs were part of a larger movement within Native culture of the late 1960s. While political protests and occupations were increasing in number, aboriginal artists began to question the production of tourist crafts.[92] A critique of souvenir crafts and of the expectation that these were the only products of aboriginal craftspeople was building, described by Phillips as a "necessary step in the repositioning of contemporary [Native] art as modernist and postmodernist fine art."[93] The questioning of categorization was complicated, for on one hand it strengthened the ability of Native artists to break through the hierarchical restrictions placed on their production, while on the other hand Native crafts risked shifting from ethnographic and tourist curiosities to fine art objects operating outside the sphere of craft. Formal debates over modernism's effects on craft production have only been undertaken recently. However, during this period the American Craft Council and the Canadian Craftsmen's Association struggled to equalize craft and fine art while preventing craft objects from simply collapsing into fine art.

Developing Modern Native Craft

The United States led the way in recognizing the formal artistic qualities of Native arts and crafts. Throughout the 1930s, Native craftspeople in the United States found encouragement through Roosevelt's Works Progress Administration economic development programs. As early as 1932 a formal art program was established at the Santa Fe Indian School, known as "The Studio School." The Works Progress Administration employed graduates from the Studio School to paint murals. In the United States the Indian Arts and Crafts Board was established in 1935 as part of President F.D. Roosevelt's New Deal programs. The new organization was responsible for the "preservation and expansion of saleable arts and crafts and the implementation of supplemental income to American Indians."[94] Like the Canadian Government initiatives, the Indian Arts and Crafts Board was most concerned with effective marketing. Under the direction of René d'Harnoncourt, (manager from

1936 to 1941), products were developed that suited both the collectors market and the buyers of useful craft. These areas were emphasized in order to avoid the loss of craftsmanship and tradition that d'Harnoncourt saw as part of the souvenir market. Born in Vienna, Austria, to an aristocratic family, d'Harnoncourt enjoyed friendships with many members of the USA's government elite. He was perceived as possessing the cultural capital required to institute the tough new standards that the federal government had developed to qualify Native American crafts to receive the official government stamp of approval.[95] During this period the American Craft Council did not have a committee or program devoted to Native crafts, unlike the Canadian Handicrafts Guild; however, Aileen Osborn Webb was familiar with René d'Harnoncourt.

In 1941 the Museum of Modern Art staged the exhibition *Indian Art of the U.S.*, which arranged pottery, beadwork, and silver beside easel paintings and other "fine art" forms.[96] The Rockefeller Foundation funded the Institute of American Indian Arts, which was founded in 1962, promoting individual artistic expression, part of what Janet Berlo and Ruth Phillips describe as the "ethos of self-determination."[97] Although the American Craft Council did not have programs specifically for Native American craftspeople, it included and promoted Indigenous crafts not as anonymous objects like those in the Canadian Handicrafts Guild exhibitions but as works by individual craftspeople. [98]

Negotiating a Separate Identity:
The Indians of Canada Pavilion at Expo 67

With the attention of the world focusing on Canada and Expo 67, the Canadian Government entered into a period of generous spending on cultural initiatives. In an effort to make a political statement about the conditions surrounding Canada's First Nations, Native craftspeople were participants in the successful negotiations for a separate "Indians of Canada" Pavilion at Expo 67. Tom Hill, a Seneca Indian from the Six Nations Reserve in Ontario who later curated the exhibition *Canadian Indian Art '74*, described the influence of Alex Janvier on the political nature of the Expo 67 pavilion. Janvier, a Chipewyan painter from Edmonton, Alberta, accepted a position at the Department of Indian Affairs in the mid-1960s. Motivated by his political awareness, Janvier undertook to develop a cultural policy for Native artists and saw Expo 67 as providing the opportunity to do so: "He encouraged the government to hire other Indian artists for the exterior murals on the Indian Pavilion at Expo 67. Besides painting a mural, Janvier spearheaded the drive

The Indians of Canada Pavilion at Expo 67. Photo courtesy of the National Archives of Canada.

to 'tell it like it is' after government critics argued with the ideas in the pavilion and tried to tone down its 'controversial content.'"[99]

The pavilion was designed to represent a giant teepee, with totem poles carved by the Hunt Brothers of British Columbia at the entrance.[100] While miniature totem poles were popular souvenirs, these giant carvings surprised many guests, with newspaper reports describing them as purposely dwarfing non-Natives. As visitors entered the pavilion they were met with a strong and accusatory message: "You have stolen our native land, our culture, our soul ... and yet our traditions deserved to be appreciated, and those derived from an age-old harmony with nature even merited being adopted by you."[101] The reception area exhibited traditional craft objects representing six distinct regions, leading visitors to a ramp where they entered a series of displays entitled "The Awakening of the People," again featuring traditional craft objects.

People viewing interior displays, The Indians of Canada Pavilion at Expo 67. Photo courtesy of the National Archives of Canada.

In an effort to present these objects as "art rather than ethnographic exam-ples," all of the crafts were carefully displayed in individual cases.[102] Photo-graphs of contemporary Native peoples were highlighted in the "Contem-porary Native Achievements" bay, one of five areas surrounding the central teepee structure. These images were designed to contrast with the tradition-al and expected roles of stereotypical "Indianness." Idealistic images of crafts-people creating traditional objects formed a binary to photographs of Native lawyers, doctors, and businesspeople. The crafts that were contained within the pavilion in the reception area and "The Awakening of the People" display were utilized to highlight the theme of Native oppression, contrasting with the anonymous producers of non-Native souvenir crafts available for tourists outside Expo 67. The "Indians of Canada" pavilion represented the first revi-sionist approach to a display of Native culture at an international exhibition

and provided an important starting point for Native artists and craftspeople to renegotiate the expectations placed upon their craft objects. It provided essential opposition to the stereotypical images that had surrounded pre-Expo reviews of the involvement of Indigenous craftspeople at Expo 67.

A September 1966 *Montreal Star* article on Eliayah Publat and Koomakoolo Saggiak, Inuit carvers and graphic artists from Cape Dorset who were brought to Montreal to create a three thousand square foot mural in the Canadian Pavilion's Tundra Restaurant, exposed the dominant culture's view of these craftspeople as pre-modern and uncosmopolitan: "Obviously devoted to his little family, as Eskimos are noted to be ... Both men are avid hunters and fishermen and still seem to consider this their real work, while carving and drawing is simply play."[103] Gladys Taylor was featured in a January 1967 trip to London, England, where she gave a demonstration of her quillwork and sang an Indian hymn on the BBC to promote Expo 67. Very few Native and Inuit crafts were displayed at Expo 67 in the Canadian Pavilion as part of the craft exhibition *Canadian Fine Crafts*, where despite the gains made by the "Indians of Canada" pavilion the sole Inuit craft, an example of basketry, was listed as an anonymous, ethnographic curiosity, included in the conception of a national craft but alienated from the common goals of modern tastes, education, standards, and marketing.

Bill Reid and Elda Smith were exceptions, featured in Euro-North American craft exhibitions as contemporary peers. Although the centennial exhibitions hosted by Canada were careful to mention the importance of aboriginal craft, it remained stereotyped as a traditional, ethnographic part of history, rather than a living, changing artform. The struggles of Native craftspeople to overcome the expectations of North American audiences were motivated by the emergence of artistic and political leaders who were introducing debates over empowerment. With Elda Smith's fight to train and work as a professional ceramist, the Ojibwa Crafts of Curve Lake's independent craft marketing, and the political nature of the "Indians of Canada" pavilion at Expo 67, aboriginal craftspeople were making statements on both the local and international levels.

For the first time Canadian craft ideals had been translated onto the international stage, albeit through the illusion of a nationally cohesive professional identity. Exhibitions stressed shared national language structures for professional craft – increasingly complex techniques and the ability to critically analyze and situate one's own work. As Moncrieff Williamson stated in his catalogue essay for *Canadian Fine Crafts*, it was hard to separate out Canada's professional crafts from those of the international community, evidence of the sophistication of production. While the aesthetics of craft may

have been perceived as pan-North American, Canadian craftspeople had begun to separate themselves from their US peers in one fundamental way: their reliance on the government bureaucratization of craft. The attempt to create a monopolistic view of Canadian craft in 1967 led to the realization that this was impossible due to the fragmented nature of craft and to the regional and multicultural diversity of Canada. Collective consciousness for craft was not a shared phenomenon. First Nations makers were skeptical of being classified as craftspeople, instead embracing the ability of craft to operate as a political vehicle. Quebec's long history of professionalism in craft and its institutionalization of specialized craft knowledge were never adequately recognized by Canada's craft elite, while in turn the strong financial and cultural support of craft by Quebec's provincial government was often resented by Anglophone Canadians. Despite these differences, a major problem in the professional infrastructures for craft – inadequate educational opportunities – was nationally recognized, and, as a result of the attention paid to craft during 1967, efforts to rectify this situation were about to be undertaken.

4

Professional Education, Professional Aesthetics

EDUCATION WAS A VITAL COMPONENT IN THE DEVELOPMENT OF PROFESSIONAL Canadian craft. Following Expo 67 the stage was set to begin the large-scale process of institutionalizing specialized knowledge for craft. Significantly, Anglophone Canada often turned to US instructors and examples for educational leadership rather than investigating the strong educational process for craft that had been previously established in Quebec.[1] The growth in college and university programs for craft created a fundamental shift in craft ideology, firmly aligning it with late modernist art discourses. As many craft programs developed immediately following the nationalist euphoria of Expo 67 there was a reluctance to acknowledge the importation of "outsider" professionals, particularly from the United States, to populate Canada's new system of craft education.

Barry Lord, a critic and editor who organized the *Painting in Canada* exhibition for the Canadian Government Pavilion at Expo 67, issued a declaration of independence in his 1968 *Art in America* article, "Canada: After Expo, What?" Assessing the impact of Expo on the Canadian cultural scene, Lord postulated that Canada had established new conditions for the arts: "Centuries of reverence for things European and decades of willing subservience to the U.S. influence may be said to have definitively ended in 1967."[2] While Canadian culture had indeed established itself on the international scene, Lord's assertion was not completely correct for the craft community.

Fundamentally, Canadian craft could not achieve a national craft identity that would counter the influences of the United States and Europe. Regions were divided in their approaches to the role of professionalism with its

attendant fine craft focus. While craftspeople still lacked the opportunity to obtain a professional craft education (BFAS or MFAS in craft media) at Canadian art schools and universities, the provinces varied greatly in the educational standards for craft that were provided. First Nations craftspeople found themselves romanticized and marginalized within the broader context of national Canadian craft. Quebec's craft organizations with their uniquely strong professional history were at odds with the rest of Canada.

Although the desire for a cohesive Canadian craft identity was unable to be achieved nationally, it was successfully achieved professionally. Across the country a particular segment of the craft community found itself linked through its adherence to a professional ideology that seemingly cut across regional and ethnic divides to appeal to shared language, knowledge, and aesthetics. The new educational programs validated this approach. Ironically, this Canadian vision was an echo of the professional standards generated in the United States, but Canada's professionals acknowledged that it was essential to remain separate from the United States, while using the guidelines that the United States had established. These guidelines relied heavily on abstract expressionism. While Barry Lord saw Clement Greenberg's ideology of formalist abstraction as a national threat, aspects of Greenbergian modernism remained crucial in defining professional craft. Paul Smith, curator of the Museum of Contemporary Crafts in New York, and Rose Slivka, editor of *Craft Horizons*, expected that their audience would both use and understand abstract expressionism's late modernist ideology. Essentially this boiled down to well-resolved experiments in craft media that ensured technical virtuosity, conceptual and artistic originality, uncluttered surfaces free from overornamentation, and a clear statement of the craftsperson's concept or idea.[3]

The dissemination of these professional ideals was achieved in large part through the education of craftspeople. A prerequisite for the existence of a professional group is the establishment of a "collective consciousness" and a specialized body of knowledge that results in the granting of awards. A monopoly built through exclusions is fundamental in maintaining a professional elite that can generate ideology, and education is the central factor in this process. Following the expansion of professionalization, the federal government of Canada became increasingly interested in professional craft activity, and soon the Department of Industry, Trade and Commerce was actively attempting to define and classify professional craft. Professional voices in the Native craft community became stronger as well during this period, most notably First Nations leader Arthur Soloman, who struggled to have his ideals override the continued classification of Native craft as a historical or traditional entity.

The craft exhibitions and conferences undertaken for Canada's centennial celebrations attempted to provide the international craft community with a cohesive Canadian craft identity. The focus on professionalism and increasing standards initiated by the Canadian Craftsmen's Association and followed by the Canadian Guild of Crafts left many amateur craftspeople feeling excluded from the national organizations. Conversely, professional craftspeople, such as the Nova Scotia goldsmith Orland Larson, avoided these groups, fearing that they continued to be dominated by "dilettante" interests; "I am a serious craftsman and teacher. What concerns me is the amount of diddling that goes on and how the diddlers influence crucial decisions that affect all crafts-men."[4] Despite the divisiveness of the professional/amateur binary that was established, the two national organizations insisted on further defining and classifying what they meant by Canadian craft.

Classifying Craft

The need to create distinctions and guidelines for framing craft on the national scene was predicated upon a desire to establish governmental and public support for the field. In terms of international reception, it was be-lieved that a strong, united, and recognizable professional Canadian craft definition would ensure a leading role in world exhibitions and conferences, as well as the ability to remain separate from US craft. The institutions and individuals responsible for cultivating Canadian craft relied upon the Western epistemological discourses available for the classification of craft. Michel Foucault's theoretical writings are important for any analysis of the develop-ments that occurred in 1960s Canadian craft. Through his interdisciplinary approach, Foucault calls into question the rationality that grounds the estab-lishment of a regime of acceptability,[5] allowing us to situate the institutions that defined professional Canadian craft not as truths or givens but as a col-lectivity of individuals and concepts that have historical and cultural con-texts. The struggle during this period to structure and define appropriate craft objects was secondary to the development of discourses constituting the subject of craft. To focus on craft requires that the concern with the isola-tion and separation of characteristics within craft be considered as part of a larger concentration on craft as a developing field within an already institu-tionalized structure.

The arguments within the Canadian Craftsmen's Association and the Canadian Guild of Craft regarding membership shared a common concern with the politics of language. In his lecture "The Discourse on Language"

Foucault described the powerful presence of discourse in his hypothesis, stating that in every society the production of discourse is "at once controlled, selected, organized and redistributed according to a certain number of procedures, whose role is to avert its powers and dangers, to cope with chance events, to evade its ponderous, awesome materiality."[6] This concept of language as powerful is fundamental to the establishment of a professional craft identity in Canada, for language not only determined what was knowledge, but what or who was excluded from membership. According to Foucault individuals are determined by the structures of meaning rather than creating meaning. This holds many implications when examining the relationships between North American craft organizations, art institutions, and craft educators in the years following Expo 67.

Abstract Expressionism

By the mid-1960s, the American Craft Council's Museum of Contemporary Crafts, which opened in New York City in 1956, had long sponsored exhibitions of craft that defied easy categorization. The museum's mandate showed a clear focus on artistic excellence, originality, and creative vigor.[7] Early exhibitions of Peter Voulkos's sculptural ceramics indicated that the museum intended US craft to be aligned with the artistic currents found in painting, sculpture, and art criticism. While Aileen Osborn Webb, whose money established the museum, did not always agree with the craft pieces selected by the curators for exhibition, she did not interfere with their choices, trusting them to continue expanding the artistic content of US craft: "Though a determined woman, Mrs. Webb never uses her will or position to countermand the artistic decisions of those working under her. 'A john has no reason for being made into pottery,' she said, recalling the way she expressed her frank displeasure at a funk artwork under consideration for one show at the Museum of Contemporary crafts. But she never raised a finger to prevent its inclusion, said Paul Smith, the Director."[8]

In 1963 Paul J. Smith, who had worked developing educational programs for the Council since 1957, was named director of the Museum of Contemporary Crafts.[9] Smith brought to the museum exhibitions that emphasized youthfulness and a unified nationwide community with strong links to the conceptual. He developed an ambitious and experimental exhibition program that was designed to "broaden connections, report on a history that didn't exist ... and stimulate possibilities for the field of craft."[10] Although his shows were not always understood by the broader craft community, they

reflected the environment of the 1960s with its conceptual and artistic freedoms and focus on the creative process.

Two of Smith's 1969 exhibitions, *Young Americans 1969* and *Objects: U.S.A.*, featured the work of craftspeople emerging from the strong craft programs in many US universities. The press praised their innovative objects and contemporary sensibilities. Descriptions emphasizing self-expression, humanistic dimensions, individuality, and experimentation filled the reviews. Rose Slivka, editor of the American Craft Council's magazine *Craft Horizons*, summarized the self-reflexive focus of the professional American craftsperson as springing from a "lack of active, indigenous folk traditions to draw upon. He is largely the product of universities and workshops, and his approach is intellectual and grounded in theories of color and form."[11] Rose Slivka "was brought up in the emerging elite art world [of New York City] and hung out with Jackson Pollock and other Abstract Expressionist painters. Her husband was a painter and she knew this world before ... developing a sensitivity to the values of craft processes and meanings."[12] Slivka's position at *Craft Horizons* allowed her to pursue her goal of having craft accepted as art.

In its review of *Young Americans 1969*, *Newsweek* identified two main sources of innovation in US craft: educational institutions and abstract expressionism; "Places like Rochester, Penland (North Carolina), Cranbrook in Bloomfield Hills, Michigan, Berkeley, the University of Wisconsin, Haystack, Alfred University, have become the spawning ground for craftsmen whose drive toward self-expression has eroded the idea that the craft object must always be functional. In fact, abstract expressionism has most heavily influenced their philosophy. Ceramist-sculptor Peter Voulkos, a genius of the first rank and a pioneer in freeform ceramics, is the acknowledged leader of the crafts breakthrough in art."[13] The exhibition *Objects: U.S.A.* continued the theme of craft as art, a concept that was popularized by the media. *Woman's Day*, a magazine that featured traditional crafts for the home, praised *Objects: U.S.A.* while explaining its title to its readership: "Anyone who thinks of craft as confined to ceramic ashtrays is in for a delightful surprise. The creations of many of the new breed of craftsmen are not necessarily functional, but intended for the owners to contemplate and enjoy as works of art – which is why the generic term used for the exhibition is 'objects.'"[14]

The relationship between academic craftspeople and abstract expressionism appeared to be natural, but was fraught with irony given Clement Greenberg's disdain for craft. Greenberg was a critical champion of abstract expressionism. Grounded in Emmanuel Kant's formulation of intuitive experience and aesthetic judgment, Greenberg's writings were essential in establishing the modernist institutions of art.[15] His 1939 article "Avant Garde and

Kitsch" became the manifesto for the abstract expressionist movement, encouraging the invention of an entirely new artistic truth that rejected the subject matter of common experience. Craft objects, with their traditional roots, were rejected from this new aesthetic. In *How New York Stole the Idea of Modern Art*, Serge Guilbaut describes abstract expressionism as an elitist movement that appealed to "people with upwardly mobile cultural aspirations."[16]

Clement Greenberg's position as the "author" of abstract expressionism granted him the power to determine accepted art and artists. He achieved this through his writing, which immobilized craft within the powerful modernist art world through simple neglect. The language employed by Greenberg performed a taxonomic, ordering function, arranging art into a hierarchy determined by the judgment of the art critic, with traditional craft placed on the lowest level. With the benefit of historical hindsight it is apparent that Greenberg's cultivated neglect of craft, culminating in his 1992 assertion that "Craft is not Art,"[17] imposed certain limitations on the language that acceptably could be used to describe craft. A determination to rid craft of its links to tradition that guaranteed a non-place in the art world led to new languages structured for gaining acceptance, such as *Objects: U.S.A.* It was US craftspeople, curators, and educators who led the way in establishing a new vocabulary for crafts and craftspeople. Peter Voulkos was termed a "ceramist-sculptor," textiles became "wall art," and craftspeople became artist-crafts-people, although until 1974, when feminist ideologies began affecting language structures, artist-craftsmen remained in use. Canada followed this lead, with the Canadian Guild of Crafts dropping the outdated term "handi-crafts" in 1966.

After attending the 1971 First National Conference of the Canadian Artists' Representation in Winnipeg, Barry Lord was forced to rethink his 1968 argument that Canada had emerged from the shadows of British and US influence. Lord analyzed the continuing influence of the United States on Canadian arts in his article "Living inside the American Empire of Taste," where he identified Greenberg and abstract expressionism as the culprits:

The advance of this Greenberg ideology of formalist abstraction into Canada marked a new phase in the Americanization of Canadian art. For Greenberg, art develops as a series of solutions to formal artistic problems and has little if any relevance to social reality ... By the mid-1960s they had become as universal as a commodity on the international art market as the American dollar was on the exchange. And Greenberg himself made sure of their impact on Canada. The New York tastemaker not only visited [Jack] Bush; he also toured the prairies, and spent a highly influential summer session at the University of Saskatchewan's off-season painting workshop at Emma Lake.[18]

During the Winnipeg meeting it was determined that Canada needed to increase Canadian representation in the arts. Motions were passed to allow only Canadian writers to submit to the national arts magazine *artscanada*, and to increase to an 85 percent quota of Canadian professors at Canadian universities, "referring specifically to the problem of American and British staff takeovers of our art colleges and the art departments of our colleges and universities."[19]

Craft Education in Canada

The introduction of fine arts ideals into Canadian craft programs can be partially attributed to the large number of US teachers who came to Canada during the late 1960s and early 1970s. To be sure European and British instructors were also responsible for the shifts in craft ideologies during this period, as were Canadian craftspeople who brought a cosmopolitan knowledge of craft techniques and forms to their students. However, Canada's close proximity to the United States meant that a substantial number of US instructors came to Canada, while a large number of Canadian students went to the United States for their advanced craft education. An investigation of six key institutions reveals that across Canada there were differing reactions to the impact of US ideals on Canadian craft education but that the overall significance was strong.

The Nova Scotia College of Art and Design directly imported abstract expressionism through a program of visiting artists. Unable in 1967 to find a Canadian resident to direct the college, the board hired Garry Neill Kennedy, a Canadian citizen who had been living in the United States, working as the head of the art department at Northland College in Ashland, Wisconsin. Kennedy gave a boost to Canadian craft and design education when he restored the term "design" to the college in 1968–69. During Kennedy's tenure, 1967 to 1990, the faculty of the Nova Scotia College of Art and Design increased from seventeen to twenty-six. These new hires included instructors in craft media, among them the ceramist Walter Ostrom, who had completed his MFA at Ohio University. Ostrom was hired in 1969 to teach ceramics and oriental art history at the college. His interest in Asian ceramics remains strong, and in 1996–97 he was a visiting professor at the Jingdezhen Ceramics Institute in Jianghi, People's Republic of China. Acknowledged as a leader in the field of contemporary maiolica, through his teaching Walter Ostrom has inspired many of Canada's top ceramists to produce colourful, historically based earthenware ceramics. During his studies at Alfred University Ostrom

himself was inspired by his teacher Andrea Gill, who introduced him to maiolica. His own studio work reflects his dedication to this style. Often playful, his objects have covered a range of forms, styles, and sizes. Curator Ingrid Jenkner notes that Ostrom was exceptional in his dedication to earthenware: "In 1975, during the heyday of stoneware, Walter Ostrom discovered the Lantz clay native to Nova Scotia. He transformed himself into an earthenware activist."[20] A recent exhibition, *120 Dessert Plates*, perfectly demonstrates Ostrom's love of ceramic history, gardening, and maiolica. Installed in an intimate gallery space, 120 dessert plates were mounted in a grid on three walls, offering the viewer an immediate sense of a large-scale installation work that conflicted with the small-scale, individual nature of the objects on display. Each of the twenty-centimetre hand-formed earthenware plates were based on a six-petal flower, resulting in scalloped, rounded edges surrounding a circular middle. They were arranged sets of four plates, some in squares, some at right angles, with all groupings encapsulating a particular moment in the history of ceramics. These included the terracotta and blacks from Greek urns, delicate celadon greens referencing Chinese glazes, eighteenth-century porcelain stamps, and minimalist off-white plates featuring bright splashes of colour dotted on each of the petals. As well as the tremendous variety of glazes employed on the plates, Ostrom incorporated a number of different surface treatments, ranging from relief moulding to painting. *120 Dessert Plates* demonstrates Ostrom's open-minded approach to the broad history of ceramics, a trait that would have appealed to Kennedy during his revitalization of the Nova Scotia College of Art and Design. Through the exhibition Ostrom references the influence of US art that have influenced the college: "Installed in a grid formation on the wall, the plates playfully demonstrate the principle of variety within uniformity, which is typical both of plant genetics and the conceptual art styles that have evolved at the Art College since the early 1970s."[21]

In addition to the influx of instructors from the United States, Kennedy's program of visiting artists brought in the largely male "all stars" of minimalism, conceptual art, and abstract expressionism, from Sol Lewitt to Joseph Bueys.[22] The US connections Kennedy brought to bear on the college affected the approach of students to craft. The Maritime tradition of utilitarian craft was quickly adapted to reflect conceptual, self-reflexive concerns, a shift that proved to be of concern to the faculty at the college involved in teaching craft. In a 1972 meeting between representatives from the federal Ministry of Industry, Trade and Commerce and the Nova Scotia College of Art and Design, it was concluded, "members of the College's faculty have tried to get the students to use materials and designs which are indigenous to Nova

Walter Ostrom, *120 Dessert Plates*, 2002. Photo courtesy of the Mount Saint Vincent University Art Gallery and Darrell Freeman.

Scotia. They felt that students from Nova Scotia suffered from an inferiority complex about their background with the result that it took some time for them to recognize local capabilities."[23] This inferiority complex was experienced to varying degrees across Canada, where a wave of US ideologies and instructors were taking charge of craft programs at the invitation of institutional boards that believed Canadians were not capable of filling leadership roles in the crafts.

The Fine Arts Department of the University of Saskatchewan in Regina in 1964 hired Ricardo Gomez, an artist from San Francisco, California, to teach sculpture. His interest in sculptural clay led Gomez to invite leading California Funk ceramists to Regina and, more importantly in terms of the Regina Clay movement, inspired interdisciplinary exchanges between the sculpture and ceramic studios at the university.[24] In 1965 Gomez was involved in the hiring of the Canadian Jack Sures, a director of the Canadian Craftsmen's Association. Sures was charged with establishing the ceramics section of the Department, where he brought forth the vision of professionalism central to the Association. Although Jack Sures continues to receive accolades for his ceramic production, he was formally trained as a two-dimensional artist, receiving his masters degree in painting and printmaking from Michigan State in 1959. Sures worked as a self-taught studio potter in Winnipeg before moving to the University of Saskatchewan Regina Campus. There he met Norah McCullough, who, through her position as the Western liaison officer for the National Gallery of Canada, was able to spend half of her year living in Regina. McCullough and Sures occupied the same "artistic

milieu" that made up a strong social group.[25] It was through this group that Sures met George Shaw, executive director of the Saskatchewan Arts Board and chair of the Canadian Craftsmen's Association, and later became involved himself with the Association, serving as chair in 1969. By 1969 Sures was the chair of the university's Fine Arts Department, and he decided to take leave of ceramics in order to teach courses in printmaking. He hired the California Funk ceramist David Gilhooley to replace himself in the Ceramics department. Despite this hiatus, Sures never abandoned his ceramic production. He was constantly involved in a wide range of ceramics, from studio pottery to architectural commissions. For example, in 1959 he completed a ceramic relief in the foyer of the John A. Russell Building on the University of Manitoba campus, and in 1966–67 he participated in Norah McCullough's *Canadian Fine Crafts* exhibition, where he exhibited functional wares like a planter and a teapot. Sures was able to combine his love of ceramics and drawing through the surface treatments of many of his pieces. Abstracted as well as whimsical figurative images have decorated his functional wares. Sures employs a broad palette of glazes and clays, but the majority of his pieces remain within the early tones of browns, greens, and reds. Like his forms, Sures's glazes are varied. Some pieces remain unglazed while others enjoy thick glazes. Many of the pieces have heavily worked surfaces featuring clay pinched and pulled into shape and heavy relief with bits projecting off an inch or more.

In light of the needs of architects and the expectations of the public, the scale of Sures work can be impressive. In 1989 his wall mural for the Tour Group Arrivals Lobby of the Canadian Museum of Civilization was unveiled. This sixty-foot-long mural titled "Air, Earth, Water, Fire" curves along a tunnel wall, leading the eye over eight thousand cylindrical ceramic tiles in terra cotta brown and black that have been seemingly been placed randomly against a black background. Upon closer inspection one can discern that the tiles are organized into patterns reminiscent of waves. Like much of Sures's ceramic artistry, "Air, Earth, Water, Fire" has a broader message: "This mural is about the formation of matter into the constituent elements of air, earth, water and fire; it is about forces in nature, electricity, magnetism, wind and water; it is about the evolution of life; it is about chaos and order and most importantly, to me, it is an exciting visual experience that one partakes of from a moving vehicle, that will truly stimulate the viewer to the experiences they will encounter on the inside of the building."[26]

Joe Fafard, a Canadian who received his MFA from the University of Pennsylvania, was hired in the sculpture department, where he experimented with clay. Sures notes that Gilhooly heavily influenced Fafard.[27] Apart from

Jack Sures, *Air, Earth, Water, Fire*, 1989. Terracotta, 430 x 6,000 cm. Photo courtesy of the Canadian Museum of Civilization.

the Canadians Sures and Fafard, the strongest influence in Regina came from California ceramics.[28] Curator Joan McNeil describes this period in California ceramics as liberating clay, "when Voulkos, [Robert] Arneson and others rejected pottery tradition and embraced abstract expressionism, surrealism and pop art. Their clay sculpture was reckless, eccentric, nastily humourous and autobiographical. They created a clean slate by stripping clay of historical meaning and encouraged slip-casting, monumental slab-building and clay collage. If any movement in ceramics disrupted tradition, this was it."[29] Jim Melchert gave a lecture on California ceramics at the university in the late 1960s, and Ron Nagle of San Francisco visited Regina to give workshops to the students at Emma Lake. Emma Lake was a series of summer workshops sponsored by the University of Saskatchewan, and featured US artists and curators who espoused the virtues of conceptual art. The language of art shared by Clement Greenberg, Frank Stella, Barnet Newman, Donald Judd, William Wylie, and Ron Naigle helped to classify what was and was not valuable in Canadian art and crafts. Many Canadian students in the department

Peter Voulkos, standing –
from left, Bud McKee,
Ron Nagle, James Melchert,
Berkeley, California, c. 1962.
Photo courtesy of Ricardo
Gomez.

adopted the emphasis on individual, non-traditional uses of craft material
and forms. Vic Cicansky was a student of Jack Sures in Regina, later studying
with Robert Arneson at the Haystack Mountain School of Crafts in Maine and
completing a postgraduate degree at the University of California at Davis.
Marilyn Levine, another student of Jack Sures, went on to study with Peter
Voulkos in California.

In September 1967, the Ontario Craft Foundation opened the Sheridan
College of Crafts and Design in an effort to improve the standards of crafts in
Ontario. Bill Davis, the Minister of Education, supported the initiative and
provided funds for the Foundation to hire staff and set up facilities. Bunty
Hogg (formerly Bunty Muff) worked for the Youth and Recreation branch of
the Province of Ontario and was responsible for provincial crafts. Active in
the Canadian Guild of Crafts and soon to replace Norah McCullough as the
Canadian representative to the World Crafts Council, Hogg was responsible
in large part for planning the school and suggested that the Foundation look
outside Canada for faculty who possessed Masters degrees: "It was assumed

Donald Lloyd McKinley, bowl, n.d. Walnut, laminate, 24.8 x 72.5 x 26.5 cm. Photo courtesy of the Canadian Museum of Civilization.

that a Canadian applicant who had stayed in Canada wouldn't have as much training as the faculty should have, that advertising in Canada alone would limit applicants to those who had been denied the kind of design school they indeed now wanted to create. So Canadian applicants would have to have travelled somewhere else for education."[30] The American Donald McKinley had received a Masters degree in Industrial Design from Syracuse University in 1964 and was teaching Three Dimensional Design as an assistant professor at Alfred University when he was approached by Bunty Hogg to apply for a position as instructor in the Furniture studio of the new Sheridan College of Crafts and Design.

Donald Lloyd McKinley specialized in taking everyday utilitarian wood-based forms and manipulating them into objects that challenged the audience's conceptualization of function. An early interdisciplinarian, McKinley was influenced by the teachings of the Bauhaus school and advocated for the integration of art, craft, and architecture. He felt that this could be achieved through a "sound sense of form and colour," which would ultimately benefit larger society.[31] As a former Fulbright Scholar (McKinley studied at Ateneum in Helsinki), he retained a lifelong love of learning and teaching. McKinley's woodwork reflected this; for example, his simple wooden card boxes, designed after 1981, were constructed following the exacting principles and proportions of the "golden mean." As a result of his work as an educator,

McKinley completed very few commissions. Many professional studio crafts-people working outside the academic setting have been critical of the distance between the realities of the marketplace and the production of faculty craftspeople. This was certainly true for McKinley; however, his position at Sheridan granted him the opportunity to experiment, resulting in a relatively small but unique body of production. He played with the multiple personalities of wood through steam bending, or employing staves of wood to create bold striping, or splitting wood into sections to reveal the positive-negative colouration. His furniture was not limited exclusively to one material. He experimented with various plastic, metals, and fibres, integrating some of them into wooden forms. His segmented serpentine bowl, almost a metre in length, matches wood with laminate. The black laminate interior successfully plays off the articulated, glossy walnut veneer face. The angles of this undulating, playful bowl are suspiciously impractical for food usage, forcing one to reinterpret its role as an object for display and contemplation. It is a dynamic, energetic work, with an upturned, scooped-end wall that breaks free of the traditional containment expected of a bowl.

Hogg met McKinley in his capacity as trustee for the Northeast Region of the American Craft Council. McKinley was interested in Canada before he became aware of the position available at Sheridan: "We'd been here for crafts shows and had been listening to your excellent CBC radio program ... [we] felt pretty sympathetic to the Canadian life, especially politically," he told the *Toronto Star* in a 1974 interview.[32] McKinley worked with Hogg and the board of the Ontario Craft Foundation, recommending craftspeople for faculty positions.[33] Robert Held, a graduate of the MFA program at the University of California, headed the ceramics department and Haakon Baaken, a graduate of the MA program at the School for American Craftsmen in Rochester, was responsible for the jewelry department. Winn Burke, who joined the ceramics faculty in 1972, commented on the large US influence that dominated Sheridan from the start: "Canada as a whole doesn't look outside themselves very far. They look to the U.S.A., but reject a lot because of a longstanding mistrust of things American."[34]

The presence of instructors trained in the conceptual artistic climate of the United States had a major impact on the students and craft objects coming out of Sheridan. The ideology of self-reflexivity, with its emphasis on the non-utilitarian, non-traditional, individual craft object soon dominated the college. This approach was encouraged by the Canadian craft community, who welcomed an influx of objects and ideas that were youthful, "cutting edge," and of interest to the wider artistic community. The staff and students of Sheridan intrigued provincial and national papers, and many articles were

published commenting on the lifestyle of craft students. The *Toronto Star* commented "beards abound as do long hair and far-out clothes," while the *Globe and Mail* described the students as possessing "a kind of happy, hippie feeling."[35] All reports on Sheridan noted how the individualism, industry, and self-motivation of the students marked them as professional craftspeople. As director of Sheridan, Donald McKinley told reporters that the students were attending the school as a lifestyle choice: "They're here because they're not interested in working in places like IBM. So some of them might look like hippies ... but they're too committed for that."[36]

The correlation drawn between craftspeople and hippies was popularized in the media. It was more than a surface comparison, as many students were seeking to utilize craft as the springboard to an alternative lifestyle, one often located in rural communities. This "back to the land" movement was part of a reaction to the consumer-oriented lifestyle of the previous generation. As C.R. Robertson described in his "Task Force Report on Government Information" to Pierre Elliott Trudeau in 1969, "these people all seem to want one thing, not money or security, but self-respect and community respect and the privilege to lead their own existence."[37] In *Society's Shadow: Studies in the Sociology of Counter Cultures* Kenneth Westhues argues that "because the hippies could not go to Washington or Ottawa, the proponents of the new order could go only to the country, where untold thousands live today."[38]

In the decades prior to that of the "hippie" generation, the Kootenay Region of British Columbia had provided a refuge for many groups, including communities of Doukhobors (a group of Russian-speaking religious dissenters who came to Canada in 1899) and Quakers. A small Quaker community existed in the West Kootenays.

In the United States during the Quaker's Philadelphia Yearly Meeting in 1967, the Friends voted to oppose the Vietnam War effort and to engage in an "underground railroad" sending resisters and medical supplies across the border to Canada.[39] The "back-to-the-landers" thus consisted of not only of urban refugees but also political refugees: the US border was easily accessible, only a few kilometres away from Nelson, British Columbia. Though no statistics are available for the number of draft dodgers in the Kootenays, official government records suggest that by January 1974 between five thousand and six thousand Americans were living in exile in Canada, with unofficial reports estimating the number to be as high as forty thousand.[40] Although there is no documented evidence of a connection between Doukhobor or Quaker communities and the draft dodgers, their convergence in the Kootenays is of interest. Westhues provides a clue as to the popularity of the Kootenays to alternative groups: "For many centuries, the United States and Canada were a

safe refuge for countercultural movements that arose in Old World Europe in opposition to established orders and then came to the New World in the hope of finding in the vast expanse of North America a place in which to give concreteness to alternative mentalities ... Mennonites, Doukhobors, Shakers ... the hippies sought this refuge in the same shrinking wilderness."[41]

The craft activity of these groups and the creative oasis provided by the Kootenays had long been popular. Ina Campbell Uhthoff came to Kootenay Lake, BC, as a war bride in 1913, one year after her graduation from the Glasgow School of Art, and taught art classes. In 1926 Uhthoff moved to Victoria, where, together with Emily Carr, she organized master classes by the US painter Mark Tobey in 1929 and 1930, and worked as the art critic for the *Daily Colonist*.[42] Norah McCullough, Western liaison officer for the National Gallery of Canada, visited the Quaker Colony near Nelson in 1965, reporting back to the Gallery that the Quakers "came in 1958 to escape McCarthyism in the United States" and produced crafts to partially support their lifestyle.[43]

In 1958, the Kootenay School of Art opened, sponsored by Notre Dame College. By 1965 the school had an enrollment of fifty-four students and two full-time and one part-time instructor. One of the instructors, Santo Mignosa, was born in Sicily and had received his Master's degree at the State Institute of Fine Arts in Florence, Italy. He came to Canada in 1957, teaching at the Banff School of Arts and the University of British Columbia before moving to Nelson.[44] Mignosa's approach to fine art ceramics differed slightly from those of instructors from the United States. While Mignosa was a proponent of fine art ceramics, he was interested in maintaining links between modern design and utilitarian wares. The National Design Council of the Department of Industry for a Canadian Design 1967 award selected one of Mignosa's soup bowl designs for mass production by slip-casting process.[45] Mignosa's connections to Italy were strong, and he encouraged his students to participate in the Annual Exhibitions of Ceramic Arts in Faenza, Italy. The Kootenay School of Arts did well in these competitions, winning a silver medal for best overall school in 1966. After being named as one of the top art schools in the world by a jury of seven Europeans, the enrolment at the school doubled, attracting students from the United States.[46]

As early as 1964 the Kootenay School of Arts brought in exhibitions of US craft. The exhibition *American Ceramics* opened in November 1964 following its showing at the Edmonton Art Gallery. John MacGillivray, the director of the Edmonton Art Gallery, wrote in his introduction to the exhibition, "These pots from people working in the United States show imagination and originality and a searching for new expressions in pottery as fine art."[47] The

ceramic work and writing of US ceramist Daniel Rhodes, who had acted as the juror for Norah McCullough's *Canadian Fine Craft* exhibition at the National Gallery of Canada in 1967, was featured in the catalogue. An excerpt from Rhodes's 1959 book *Stoneware and Porcelain* was reprinted, capturing the US focus on individuality through craft: "Pottery making is a kind of adventure in which, if one is successful, one finds, in the end, oneself. It offers the chance of making a synthesis of one's physical self, the coordination of hand and eye, the 'handwriting' of ones' skills, within a philosophy, a point of view, a statement of values. When the craft of pottery becomes an art, it can never be codified, hedged with rules or principles, or fully explained, any more than any other art. Our pots, if they are to live at all, must be really good. They must be individual, expressive and beautiful."[48]

Santo Mignosa left the Kootenay School of Art in 1967 to study in Firenze, Italy, on a Canada Council Senior Fellowship, leaving permanently in 1969 to complete his MFA at Alfred University, New York State. The Canadian potter Walter Dexter, whose emphasis on stoneware and functional pottery influenced students to create organic shapes with experimental glazes, replaced Mignosa. Chris Freyta, a student of both Mignosa and Dexter, feels that the US emphasis on individuality was tempered by influences coming from Alberta. Professional potter Ed Drahanchuk, well-known for his focus on natural Alberta clays, earthy colours, flecks in the glaze, and bottleneck forms, created an aesthetic in Canadian craft that went beyond ceramics into the earthy look of weaving, macramé, and wood.[49] Drahanchuk's brother, Walter Drohan, introduced these sensibilities into the ceramics program at the Alberta College of Art. The priority given to ceramics reflects its status as one of the plastic arts, able to negotiate between the fine art of sculpture and the craft of clay. Ceramics were generally the first of the craft media to be introduced into Fine Arts departments. Elaine Alfoldy, a student at the Vancouver School of Art from 1964 to 1968, remembers pursuing her interest in textiles independently, as the school had no instructor for the fibre arts, focusing instead on ceramics and graphic art. The Kootenay School of Art began offering instruction in textiles as late as 1971.[50]

Craft education in Quebec took a different direction from the rest of Canada. Whereas other provinces were concerned about introducing students to approaches popular in the United States and Britain, Quebec sought inspiration from within its own cultural background, occasionally looking outside to France. Jean-Marie Gauvreau, the director of the École du Meuble, influenced this approach. After receiving a degree in cabinetry at L'École Technique in Montreal, Gauvreau studied interior decoration at L'École Boulle in Paris from 1926 to 1929. Gauvreau became director of L'École du

Meuble in 1935, at the point when it had gained its independence from L'École des Beaux Arts. In this new school he was able to argue for the importance of avant-garde interiors in the French Art Deco style, having published a book on the subject, *Nos intérieurs de Demain* in 1929. In her book, *École du Meuble 1930–1950*, Gloria Lesser stresses that Gauvreau was a "staunch Quebec traditionalist," dedicated to the use of native Quebec craft material and local craftsmanship, eager to halt the importation of US and European crafts, particularly furniture. When École du Meuble instructor Louis Parent went to the Pennsylvania Museum School of Industrial Arts to study drawing in 1935 and to the New York State College of Ceramics at Alfred University in 1939 to study ceramics, Gauvreau "considered Parent disrespectful to the conservative continental European ceramic traditions."[51]

Gauvreau's dedication to craft based on the native materials and traditions of Quebec was enormously important in ensuring that student production remained truly Québécois. By selecting professors who were from Quebec and France and knowledgeable of traditional crafts, Gauvreau was able to keep craft education in Quebec largely independent from the US influences that were permeating other Canadian institutions. In 1966 college-level craft education was taken over by Quebec's CEGEP system.[52] Quebec's system of craft education guaranteed a nationalist ideology of pride in native materials and craftsmanship, combined with an emphasis on craft as a professional endeavor.

Yvan Gauthier, until recently the executive director of the Conseil des métiers d'art du Québec, argues that Quebec's later identification with US craft, following the integration of craft programs into the CEGEP system in 1966, was not one of artistic emulation, but rather admiration for their system of professional university-level craft education and the strong focus on the business of craft. The Centrale d'artisanat du Québec, an agency created in 1950 by Gauvreau under the auspices of the Quebec Government to coordinate the work of craftspeople throughout the province, communicated directly with Lois Moran of the American Craft Council in an effort to obtain information on the support and funding of crafts in the United States. In 1971 Moran, then the director of Research and Education at the American Craft Council, wrote Cyril Simard, director of the agency, outlining the history and development of crafts in the United States, the involvement of the United States Government in supporting craft training, and the role of education in training professional craftspeople.[53] The Quebec Government generously supported the professional associations and exhibitions, providing students with a network that could ensure success as professional craftspeople.[54]

Craft and the Counterculture

The craft education Canadian students were receiving in art institutions did not meet with consistent praise. While curators, exhibitions, and the media were generally positive about the accent on the conceptual and the break from the traditional, some professional craftspeople in Canada felt that the fine arts attitude to craft left students without the technical or business skills required for survival as a craftsperson in Canada. The potter Ed Drahanchuk complained to Rosalind Orr, Gail Hancox, and Meredith Filshie of the Ministry of Industry, Trade and Commerce that "the present university courses often lead to the development of a fine arts attitude," and, when the Madawaska Weavers in New Brunswick were asked whether they would employ graduate students from schools such as Sheridan College or the Nova Scotia College of Art and Design, "the women criticized the education system in that graduating students did not understand principles of design and lacked the ability to design for mass market sales."[55]

The popular image of craftspeople as "hippies" engaging in alternative lifestyles outside the social contexts of class and economics was in direct contrast to the realities faced by those living independently from their craft. The national and emerging provincial organizations and schools for craft recognized the importance of providing professional craftspeople with outlets for their products as well as the skills to properly market their work. The late 1960s and early 1970s witnessed the establishment of artist-run cooperatives and craft fairs. The success of these ventures was a result of the desperate need for outlets that retailed handcrafted objects as well as their ability to market a celebration of craft as an alternative lifestyle. During a period of political and social upheavals, manifested in the drive for Quebec sovereignty, the sexual revolution, and anger toward the colonial repression of minority cultures, Canada was preoccupied with analyzing its break from the comforts of tradition. Just as Adelaide Marriott and Alice Lighthall had produced glowing histories of the Canadian Handicrafts Guild in an effort to defend it from the charges of traditionalism it faced prior to 1967, articles emphasizing the positive aspects of a nostalgic "lost" Canada emerged during this time of social questioning. *Chatelaine* magazine regularly featured pieces by Canadian craftspeople as well as craft projects for its readers, claiming, in 1973, "Crafts have been with us as a splendid record of the taste and skills of each generation for 300 years. And today we're more interested in getting in touch with our roots than ever before."[56]

Mass production, marketing, and the alienation of the worker were criticized as a reflection of the disenchantment of the modern world. Craft objects

Salon des Métiers d'art du Québec, 1971. Photo courtesy of the National Archives of Canada.

were able to serve as "possessions of self hood [sic]," acting as nostalgic symbols; "People are buying wall hangings, as they are other handcrafted work, to warm and humanize their surroundings. It's going back to nature, part of the revolution. Buying a wall hanging could be looked at as a way to enjoy taking part in the social revolution," claimed Paul Bennett, executive director of the Canadian Guild of Crafts Ontario branch.[57] Craftsmanship, with its links to tradition, continues to operate as a nostalgic symbol as is witnessed through the direct exchange between creator and purchaser at studios and craft fairs. The craftsperson is seen as an extension of his or her objects, representing an idealized image of a person safe from some fundamental dangers of our society.[58] The twentieth-century consumer then uses this idealized image to counter the homogenizing effects of mass production and consumption. "Craft objects reinforce personal identity ... consumers intuitively read the uniqueness of the handmade object as a tangible analog to their own singularity: the marks of hand fabrication symbolize the uniqueness of an individual life."[59] The Canadian Guild of Crafts continued to operate its outlets in Toronto, Montreal, and Winnipeg, while the

Canadian Craftsmen's Association initiated Christmas and summer craft fairs in Ottawa.[60] The Conseil des métiers d'art du Québec began its annual Salons in Montreal, limited to only professional craftspeople, as early as 1955.[61]

The Association also attempted an apprentice program sponsored by the Federal Opportunities for Youth initiative. During the summer of 1971 students from recognized art colleges and institutions received one hundred dollars to apprentice with craftspeople across Canada. Several of those who benefited from these "free" assistants were instructors, including Jack Sures of the University of Saskatchewan, Monique Mercier from the Université du Québec à Montréal, Robin Hopper of the Georgian College of Applied Arts and Technology, and Orland Larson from the Nova Scotia College of Art and Design. Some members of the Association felt it was unfair that craftspeople affiliated with art colleges and universities received summer assistance from apprentices. Sheila Stiven, the Canadian Craftsmen's Association executive secretary who oversaw the program, was sent several letters from angry craftspeople such as John de Vos, a professional potter from Vinemount, Ontario, who complained that "teachers need apprentices like they need a hole in the head. One small group, that I belong to, makes it possible for the public to get used to using handmade things by putting them in the stores. The courses that are open for students are really a poor education for someone who wants to be a producing potter. We are not adequately represented by anybody and we are constantly ignored."[62]

Craft Dimensions Canada

The definition of professional craftsperson shifted, depending upon the intended audience. Consumers purchasing utilitarian craft objects from outlets categorized craft differently from those viewing crafts in staged exhibitions sponsored by art institutions. Whereas art critics may have acknowledged the presence of crafts in a fine-art setting, or the work of students in craft media at a recognized university or art college, craftspeople like John de Vos remained unrecognized by the social institutions surrounding professional craft. As Janet Wolff summarizes, "judgments and evaluations of works and schools of art, determining their subsequent place in literary and art history, are not simply individual and 'purely aesthetic' decisions, but socially enabled and socially constructed events."[63] The Ontario branch of the Canadian Guild of Crafts heralded the 1969 exhibition *Craft Dimensions Canada* as the most important and comprehensive national exhibition of craft ever

held in Canada. It played a key role in determining the discourses surrounding professional Canadian craft and, not surprisingly, was heavily tinged with US craft influences.

Craft Dimensions Canada was organized by the Ontario branch of the Canadian Guild of Crafts as part of its modernization campaign. Three days after the exhibition opened, Guild president B.S. Ellis wrote to Peter Swann, director of the Royal Ontario Museum, thanking him for the opportunity to increase the value of the Guild: "Over the recent years we, at the Guild, have sensed a definite unrest amongst the craftsmen – a sense of frustration that their work, their labour, has been denied adequate public recognition. Now *Craft Dimensions Canada*, through the Royal Ontario Museum, has provided the physical setting and the magnificent display which will act as a vehicle for tremendous public exposure. The standard of objects submitted and chosen are of such excellence that they will undoubtedly merit public acclaim."[64] The exhibition was hosted by the Royal Ontario Museum and received additional funding from the Canada Council.[65] It ran from 23 September to 23 November 1969 and was divided into two sections, contemporary crafts in the lower level exhibition hall and historical crafts on the upper floor. Harold Burnham, the former president of the Guild, curated the exhibition of traditional crafts in *Craft Dimensions Canada.* In his review of the show for *Canadian Antiques Collector*, he was careful to distinguish between "older, usually utilitarian products for everyday use" and the art-craft work of the new pieces produced since 1967.[66] All objects in the exhibition were for sale, continuing the consumer orientation of craft exhibitions that had troubled curators at the Royal Ontario Museum in 1948 and at the National Gallery of Canada in 1967. Guild volunteers were provided with a "craft kit" for selling objects.[67]

Craft Dimensions Canada stressed proper display techniques for the craft objects, mounting them on pedestals, on the walls and behind glass, following the formal reading of objects so important to modernist gallery spaces.[68] The lack of tactility was part of a cultivated plan to shift both the perception and aesthetic of the craft objects in the show and ran parallel to the increased self-reflexivity of the objects with their breaks from tradition. This display emphasized the observer paradigm, where the observer and object formed two autonomous realities.[69] The historical craft objects were displayed in a more conventional but similar manner, forcing the viewer to rely on a single sense for artistic authority. While Peter Swann had convinced the Royal Ontario Museum to mount an exhibition of Canadian crafts, despite its emphasis on sales, there remained resistance to the introduction of aesthetic synesthesia, which threatened to erode the hierarchy of economic, cultural, and symbolic value that had been cultivated to divide art spaces along class,

race, and gender lines. First Nations, traditional Québécois, and ethnic crafts were categorized as historical and relegated to the upper display halls, while modern conceptual production occupied the lower halls as Canadian craft. Organizers had considered creating an exhibition that contrasted modern crafts against a background of native and ethnic material but decided against the idea because "this has to be an unconscious source of inspiration."[70] The cultural construction of the exhibition demonstrated Michel Foucault's hypothesis that all forms of rationality have a historical specificity, a regime of acceptability.[71]

Initially, Marjory Wilton, head of the Guild's exhibition committee, had turned to Paul Smith of the Museum of Contemporary Crafts in New York for advice on mounting the contemporary craft portion of the exhibition. Wilton and the exhibition committee had met Smith in 1968, when he accompanied an exhibition of contemporary crafts from America House in New York to Toronto.[72] After having lunch with Smith, Wilton wrote to Mrs Hugh R. Downie, Royal Ontario Museum Programme Secretary, that she believed having "his ideas from the very beginning would result in a very significant exhibition."[73] The Guild and the Royal Ontario Museum began courting Smith in the hope that he would agree to curate the exhibition. Smith was polite in his refusal, stating that while he endorsed the idea of the exhibition and would be happy to offer advice, he strongly believed that the show should be organized by a Canadian not an American.[74] In order to ensure that *Craft Dimensions Canada* showcased modern fine craft sensibilities that identified the Guild as a forward thinking organization, Wilton and her committee were convinced of the importance of seeking US guidance in the exhibition.[75]

Rather than hiring Smith to act as the sole curator of the show, the Guild's exhibition committee sent out calls for craftwork that would then be juried by a panel of three experts. Canadians from across the country responded to this call, sending in a total of nine hundred entries, from which 189 were selected.[76] The choice of the jury seemed simple to the committee, who believed that "Canadian handicraft hasn't developed to the point where we have anyone qualified to judge our own."[77] Instead, the Guild selected three jurors from leading professors and craftspeople, all male and all from the United States.

Described by the Royal Ontario Museum news releases as an "international jury," the three jurors were Robert Turner, professor of ceramics, Syracuse University, Glen Kaufman, professor of textiles, University of Georgia, and Ronald Pearson, metal smith and co-owner and founder of Rochester's Shop One craft outlet. The Guild, the Royal Ontario Museum, and the Canadian

press praised the jurors for their symbolic and cultural capital, manifested in their ability to bring high standards to Canadian craft. "The judges for the exhibition are renowned authorities," wrote *Canadian Interiors*, while the Royal Ontario Museum press releases emphasized the jurors as the finest, "internationally known craftsmen."[78] What becomes evident from the jurors' statements is that they brought to the exhibition the conceptual art emphasis that US instructors had been importing into Canadian educational institutions. This relationship was reciprocal, as students instructed in these approaches did well in the jurying process, and the jury praised the advances made in Canadian craft. As Pierre Bourdieu states, "taste classifies, and it classifies the classifier."[79]

Glen Kaufman lauded the textile work "employing non-woven structure" and criticized Canadian textile artists who failed to see "the whole work as a unified statement." In jurying the ceramics, Robert Turner questioned the intention of the pieces he found to be of good quality, but subdued: "the group as a whole is good if not notably provocative in range of colour and shape: perhaps inevitably a group appears quiet today which does not include the vibrant color, hard-edge painting, or pop art approach of current art fields." Ronald Pearson's assessment of the other craft fields was positive, as he had found that "Canadian expression parallels work done in other countries yet I do not find it imitative." The distribution of the twenty-three awards of one hundred dollars heavily favoured Ontario, which received 57 percent of the prizes.[80] Craftspeople from only six provinces won all the awards, and many of the winners had direct ties to universities and art colleges. Donald McKinley, the director of the Sheridan College of Art and Design, and his wife, ceramist Ruth Gowdy McKinley, won top prizes for his table and lamp of polyvinyl chloride, tubing, and sheet plastic and for her stoneware ceramics. Robert Turner chose Ruth Gowdy McKinley for a special juror's award for ceramics. Sheridan students and faculty received nine of the twenty-three awards, providing the new school with a reputation for providing exceptionally high standards in Canadian craft.

Pearson delighted the organizers by viewing the exhibition as being of sufficient quality as to merit a venue in the United States.[81] The idea indicated a substantial shift in the perception of Canadian craft, although his proposal was never followed through. The American Craft Council's journal *Craft Horizons* featured *Craft Dimensions Canada* in its September 1969 issue, giving a brief history of crafts in Canada, describing the influence of US immigrants and imports, and expressing admiration for "a stirring exhibition [that] ... shows the vitality and scope of Canadian crafts."[82] This praise from US "authorities" contrasted greatly to the comments made in 1955 by Gerard

Brett, director of the Royal Ontario Museum, regarding the possibility of mounting a Canadian Modern Design exhibition. Brett had concluded that the standards of Canadian craft and design were disappointing, and, as such, a show of Canadian objects "seems to be a long way off."[83] Fifteen years later, *Craft Dimensions Canada* was taken to prove that Canadian craft had evolved into a professional artistic field. Canadians responded favourably to the exhibition as well, with 128 craftspeople participating, more than twenty-five thousand visitors in six weeks, and more than two thirds of the craft pieces sold during the show.[84]

On the surface, most Canadians seemed to appreciate the involvement of Americans in judging their craft production. Some regarded their praise for the high quality of professional craft in Canada as an indication that Canadian craft had been established as a dynamic, artistic, and professional movement. English-language papers made very few negative comments about the jury, with the exception of Bernadette Andrew's comment in the *Toronto Telegram* that "a lot of people would disagree" with the Guild's opinion that there were no Canadians qualified to judge.[85] It was Quebec's press that recognized the hegemonic overtones of importing Americans to act as the sole judges of professional Canadian craft. The Montreal newspaper *La Presse* described the importation of US jurors as a colonial situation, suggesting that the American favouring of art craft may have resulted in the low number of Québécois craftspeople who received awards from the jury.[86] Quebec craftspeople were poorly represented in *Craft Dimensions Canada*, with many of them making a political statement by not submitting to the exhibition. Rather than contributing to a national craft show, many Quebec craftspeople exhibited within the province, later rallying in 1971 to participate in the first international Francophone craft exhibition, *Unity in Diversity* (*Exposition internationale d'artisanat: mille arts une solidarité.*).

Organized by the Paris-based Agence Culturelle, twenty-two countries with strong Francophone populations were represented in *Unity in Diversity*, which ran in Canada in Ottawa, Toronto, Montreal, Winnipeg, and Moncton.[87] Objects for the exhibition were selected for their "authenticity," allowing Quebec craftspeople to submit work that incorporated traditional materials and forms, "beside scenes of French Canadian life we find Eskimo sculptures; Black Africa is represented not only by tom-toms from Dahomey or gold filigree from Senegal, but also swagger sticks from Rwanda or Tuareg camel saddles."[88] Both the Canadian Guild of Crafts Ontario branch and the Canadian Craftsmen's Association were eager to help this new Francophone organization in the hope that it would lead to a more favourable association between their national groups and Quebec craftspeople.

The North American Alliance

The increase in the number of institutions training craftspeople, the outlets available for retailing craft, and the popular interest in consuming craft made the classification of craft more difficult than it had been previously, when national organizations could argue that they were preserving dying traditions. While books like *A Heritage of Canadian Handicrafts*, compiled by the Federated Women's Institutes of Canada in 1967, still relied upon the easy definition of regional craft traditions to create clear distinctions, where Canadian craft began and US influences ended became more difficult to identify.[89] In 1969 Aileen Osborn Webb proposed the establishment of a North American Alliance in the World Crafts Council. In addition to facilitating the administration of the World Crafts Council, Webb felt that such an Alliance would strengthen the bond between Canadian and US craftspeople. Webb organized a meeting between the Canadian and US committees of the World Crafts Council at her family home in Shelburne, Vermont, in August 1969.[90] Beyond the practical necessity of administrating North America as a single unit, Webb expressed her hope that the union would create a "strong and enduring Canada-United States alliance"; frustration was expressed toward the governmental barriers that prevented full participation between the countries, including problems of customs and tax for craftspeople transporting work across the border, the need for binational exhibitions, and the necessity of a guide for North American craftspeople.[91] With the formation of a North American Alliance in the World Crafts Council, Canadian craftspeople and administrators were forced to reconsider their relationship to the dominant American Craft Council; an organization now identified as an equal partner with Canada's craft organizations under the new Alliance. E.N. Roulston, the Nova Scotia representative who attended the meeting, concluded that although Canadians had become more nationalistic following the centennial celebrations, "we still have strong traces of our old habit, of 'Let George do it,' particularly when it came to financing the costs of the Alliance." In the Nova Scotia craft journal *Handcrafts*, Roulston urged Nova Scotia craftspeople to accept the responsibilities that resulted from living in an independent nation.[92]

Mary Eileen Muff, the Canadian representative on the World Crafts Council, was fond of Webb and sought her advice on a number of administrative issues. In particular, Webb intervened on Muff's behalf to secure permission from the federal government to sponsor a gift from Canada to the people of Ireland during the 1970 World Crafts Council conference in Dublin. Webb and Muff had agreed that a totem pole would be a good symbolic gift from

Robert Davidson, spoon, 1974.
Silver, 18.6 x 5.1 cm.
Photo courtesy of the Canadian
Museum of Civilization.

Canada to Ireland. Webb used her position to write to Prime Minister Pierre Elliott Trudeau in order to secure funding for the gift; "As President of the World Crafts Council, I am being so bold as to write and request that the government of Canada send Mr. And Mrs. Robert Davidson to our biennial conference in Dublin, Ireland. The purpose of Mr. Davidson's presence would be to carve a totem pole, demonstrating the skills of the Canadian Indians in wood carving."[93] Reaction to Davidson's totem pole from the international craft community reflected the still entrenched colonial constructions of "Indianness."

Robert Davidson is a professional Native artist who had graduated from the Vancouver School of Art in 1970. He is a master of many different media, ranging from silverwork, wood, and paper to his more recent forays into fashion design. Davidson's father, Claude Davidson, was a well-known carver, and both Davidson and Bill Reid are descendents of Haida artist Charles Edenshaw. Beyond the production of craft and art that follows Native traditional imagery and form, Davidson is committed to reclaiming Northwest

Coast songs and stories through his creation of button blankets and drum-
ming with the Rainbow Creek Dancers.[94] Following his contribution to the
success of the Canadian delegation to the World Crafts Council conference in
Dublin, Davidson's career has flourished, and he has received many awards
and accolades, including the Order of Canada in 1997, honorary doctorates
from Simon Fraser University and the University of Victoria, and the National
Aboriginal Achievement Award. In 1997 the Royal Canadian Mint issued a
twenty-two-karat gold coin featuring Davidson's image "Raven Bringing Light
to the World."

Davidson's craftwork successfully manipulates traditional Northwest Coast
imagery onto a variety of objects. His lines are bold and innovative but remain
dedicated to the creation of recognizable motifs. Rather than simply translat-
ing his two-dimensional work onto three-dimensional forms, Davidson's
work reflects his skill and comfort in working with functional items. A silver
spoon produced in 1974 for Tom Hill's exhibition *Canadian Indian Art 74* takes
the image of the dogfish and brings it alive utilizing the bowl and handle
shapes contained within the spoon. The bowl's width has been exaggerated
to accommodate the dogfish's face with its serrated teeth. The slightly short-
ened and widened handle is decorated with a variety of asymmetrical images.
All of the potentially sharp edges on the spoon have been softened into
curves that suit Davidson's interpretation of the dogfish. While Davidson's
talents as a craftsperson were appreciated by many of those attending the
World Crafts Council conference, they were sometimes overlooked by the
interest in his Native status.

After Webb's intervention, Robertson and his wife were sent to Dublin as
part of the Canadian delegation to the 1971 World Crafts Council conference.
While there, as part of ongoing live demonstrations, Robertson carved a
totem pole that at the close of the conference was presented to Ireland as a
gift from Canada. Somewhat later, Mary Eileen Hogg (née Muff), received a
letter of thanks from the Irish World Crafts Council representative, along
with a newspaper clipping about the totem pole, which had been put next to
the Canadian black bear pit in the Zoological Gardens. Hogg reported to her
fellow Canadian representatives that she had the writeup "and any of you
who would like to read it are welcome to read it but the last paragraph starts
off in such a way that I have not even been able to send a copy to the carver
of the totem pole: The Red Indians of North America are far from savage and
most of them stay on their reservations."[95]

Hogg's embarrassment about the newspaper report reflected new attempts
by the national craft organizations to assist aboriginal craftspeople in estab-
lishing themselves as professional artists. While this was a departure from the

traditional philanthropic "civilizing mission" of the Canadian Handicrafts Guild, problems remained in reconciling the emergence of autonomous, professional Native craftspeople with expected Native "souvenir" crafts. Disdain for mass-produced, poorly made imitations of Indigenous craft was frequently conflated with the images of "Indianness" found in souvenirs of "ersatz Indians and lumpy Eskimo imitations."[96] The Canadian Guild of Crafts Ontario branch had begun to rethink its approach to First Nations and Inuit crafts. In 1971 Joan Chalmers, the chair of the Exhibition Committee, wrote to James Noel White, the vice-president for the European section of the World Crafts Council, asking for his advice on the display of Canadian craft in the forthcoming 1974 World Craft Council exhibition. Among her many questions on the proper display of craft, Chalmers indicated that aboriginal craft was not considered a normal part of the Guild's juried shows, asking, "should Indian and Eskimo work be submitted?"[97] The Guild wanted to take a more inclusive approach, noting "the situation has changed considerably," with Indigenous craft reaching "a point of world recognition and a degree of financial independence."[98]

Professional Native Craft Organizations

Native craftspeople organized several important institutional changes that allowed them to gain entrance into the field of professional craft. Arthur Soloman, a Native political leader from Ontario, had been involved in the national craft scene since he attended the 1964 First World Congress of Craftsmen in New York, and had expressed frustration over the administration of Canadian craft which he felt was inadequate in comparison to the US model:

We seem to always be on such a high level of thinking that we never get down to where the people are, it seems to be a sterile and artificial level, it has left me out right from the start till now, this is not my feeling with Mrs. Webb and Mrs. Patch ... Our Canadian delegation at New York left me cold except for two people, it was the same in Winnipeg when we founded the Canadian Craftsmen's Association ... Most of our Canadian World Crafts Council and Canadian Craftsmen's Association members seem to be only cold, capable, supremely self-confident and lacking in real humility and unselfishness.[99]

Soloman's opinions may have been only his, or they may have reflected a general consensus among the Native craftspeople of Canada who did not

play a role in the administration nor the exhibitions of the Canadian groups. The production of contemporary craftspeople continued to be overshadowed by popular exhibitions of traditional Native crafts that showed no modern pieces: "Aboriginal Art in Paris," which showed at the Musée de l'Homme, later travelling to the National Gallery of Canada as "Masterpieces of Indian and Eskimo Art," and the US exhibition "Native American Arts" were examples of such exclusionary events.[100]

Art Soloman addressed the colonial attitude toward Native craft in his 1969 presentation to the Department of Northern Affairs. He deconstructed the myth of the disappearance of aboriginal craft that had been popularized by the Canadian Handicrafts Guild and James Houston, its Arctic representative, arguing instead that the problem was one of organizing the supply of craftwork to match the demand. Insisting on diminished governmental involvement with Native crafts, Soloman urged the Parliamentary committee to reconsider its own definition of Indian craft. "We must not think of Indian crafts as being only beaded moccasins and mukluks, snowshoes and such things; we must think in terms of the Indian's ability to make an absolutely unlimited variety of beautiful and useful things to suit the needs of everyday shoppers, as well as those of the most sophisticated and demanding buyer."[101] Soloman took his argument into the Native communities, holding a meeting of forty First Nations representatives at Sioux Lookout, Ontario, in October 1969. The meeting resulted in the unanimous passing of a motion that Art Soloman "should devise and implement a craft development programme ... also requestion [sic] the Union of Ontario Indians to give me help in that regard." A second motion, forming the short-lived Indian Crafts Council, with Art Soloman as the director, allowed him to "speak on behalf of the craftsmen before governments."[102] Soloman's organization was directed toward "Indian" crafts, which he felt remained underdeveloped in comparison to Inuit crafts. By 1969 there were forty cooperatives for Inuit craftspeople. The main organization, Canadian Arctic Producers, estimated sales for 1969 at $800,000, with 90 percent of the profits returning to the craftspeople themselves.[103] Soloman worked to ensure the same level of success for Native craftspeople in Southern Canada: Indian Crafts of Ontario, which replaced the Indian Crafts Council, was incorporated on 13 February 1970, receiving a startup grant of $200,000 from the Province of Ontario.

The stated aims of the non-profit organization were to "reach Indian communities especially in the North, bringing back authentic Indian arts and crafts for wholesale distribution," to provide "Indian teachers to communities fully qualified to teach both traditional arts and crafts and also the more contemporary expressions of Indian culture," and to develop a distinctive

"Indian craft tag" with a symbol of the Thunderbird.[104] Art Soloman was responsible for overseeing the selection of the craft, ensuring that it maintained high standards of quality. Unfortunately, Indian Crafts of Ontario soon ran into both financial and aesthetic trouble, with prohibitive prices for the pieces being demanded and confusion regarding what qualified as "proper" Indian craft.[105]

Following the Indian Crafts of Ontario initiative, the Ontario provincial government sponsored a new program with a focus on education rather than the distribution of First Nations crafts. Referencing back to earlier attempts by the Canadian Handicrafts Guild to foster self-respect through crafts, the Manitou Arts Foundation was a cultural renewal project that received $300,000 to provide local and summer school programs to Native artists in an effort to "reaffirm a proud sense of Indian-ness and self-esteem, without which no race can survive."[106] Although Arthur Soloman's hope for an independent marketing board for contemporary Native craft had not succeeded, the support of the provincial and federal governments for the work forced the national craft organizations to rethink their official positions regarding aboriginal craftspeople. In his 1972 report on Canadian craft for the Department of Industry, Trade and Commerce, John Gibson noted the importance of crafts as "opportunities for Indians and Eskimos to exercise their own autonomy." He summarized that "Indian craft is therefore more general and more of a souvenir production than Eskimo craft ... Indian products tend to be inexpensive and of a simple design" and recommended that the Department of Indian Affairs and Northern Development continue offering opportunities for formal training as well as research and development in Native craft, stressing that "recognition and appropriateness must be dominant factors."[107] This opinion was reflected in the minutes of the Canadian Craftsmen's Association meeting of 11 December 1971, where Gerry Tillipaugh "expressed concern about the lack of Indian/Eskimo representation."[108]

Growing Demand for One National Craft Organization

With two national craft organizations competing for funding from the same sources as many of the new Native craft organizations, the federal government began taking a closer look at the phenomenon of craft. The Canadian Guild of Crafts enjoyed the positive feedback from its exhibition *Crafts Dimensions Canada* that had been opened by Secretary of State Gerard Pelletier. Pelletier revealed the federal government's interest in the crafts during his opening address, in which he advised craftspeople to continue producing for

the emotional and cultural well-being of Canada, warning that "the uniformity of urban life is producing alienated and apathetic people."[109] The presence of Pelletier at the opening of *Craft Dimensions Canada* was perceived as a boost for the Canadian Guild of Crafts, which had become increasingly worried about its lack of political connections in comparison with the Canadian Craftsmen's Association. Despite having to work together on the Canadian committee of the World Crafts Council, there remained resentment and mistrust between the two groups. While they had attempted to work together on producing a national craft magazine, *Craftsman/L'Artisan*, with the Canadian Guild of Crafts lending the name and financial support and the Canadian Craftsmen's Association providing the articles and editing, the Guild withdrew its support following the first issue.[110] The Guild feared that as an organization it no longer maintained a truly national representation and that the Ottawa connections of Sheila Stiven, the executive secretary of the Association, made the federal government all too aware of the Association. Following the Secretary of State's 1969 grant of $10,000 to the Canadian Craftsmen's Association, the Guild issued a report, "Becoming Better Known in Ottawa." The Guild concluded "we had been too much wrapped up in our two operation in Montreal and Toronto, and had paid too little attention to Ottawa and the rest of Canada ... we must broaden our concept of the national organization and how it should operate."[111]

Meanwhile, the Canadian Craftsmen's Association had been cooperating with the Education Division, Cultural Information Section, to formulate a national survey on Canadian crafts. The results of the "Canadian Crafts Survey and Membership Plebiscite" were released in November 1972, making it clear that Canadians wanted one national craft organization. On 8 November 1972, the executive of the Canadian Craftsmen's Association and Gordon Barnes of the Canadian Guild of Crafts met with federal government representatives from the Secretary of State, Statistics Canada, and the Department of Indian Affairs and Northern Development. Following the meeting an official release was issued by the Guild and the Association, stating, "The National General Committee of the Canadian Guild of Crafts and the Council of the Canadian Craftsmen's Association, take the results of the Plebiscite, part of the 1972 Crafts Survey, as a mandate from their respective membership and the Canadian craft community to proceed with the establishment of a single Canadian craft organization."[112]

Despite this declaration, the federal government continued to be dissatisfied with the dual nature of national craft representation in Canada and undertook its own investigations into the state of Canadian craft.

Craft fell under the jurisdiction of the Department of Industry, Trade and Commerce, which prepared two major reports during 1972. In February 1972

John W. Gibson released "A 'Desk' Commentary: The Role of Federal Government Departments with Respect to Canadian Handicrafts." The purpose of Gibson's report was to provide background information on Canadian crafts to assist in decisions regarding future research and development. Gibson wanted to preface his report with a definition of handicraft but immediately reported that no general definition existed. The discourses surrounding craft and its institutional roles defied classification, forcing Gibson to provide two separate descriptions of what constituted handicrafts. The first he took from the Report of the Royal Commission of National Development in the Arts, Letters, and Sciences, published in Ottawa in 1951, which defined handicraft as "An individual product of usefulness and beauty, created by hand on a small scale, preferably by the same person from start to finish, employing primarily the raw materials of his own country and, where possible, his own locality." The second definition, like many of Canadian craft ideas of the time, was borrowed from a US source, the October 1966 publication *Encouraging Americans in Crafts: What Role in Economic Development?*, produced by the Economic Development Administration, United States Department of Commerce: "Arts and Crafts, handcrafts and handicrafts are terms generally used synonymously to refer to articles produced predominantly by hand rather than by line techniques so that there is a maximum of control of the design and the process by the hand worker so that the finished product exhibits a special quality or individuality as a result of the method of production. A true craft object reflects the time, the place, the man, and the methods by which it was made."[113]

Gibson acknowledged that the US definition was more relevant and was more appropriate for the type of craft he was addressing in his paper. The differences between these definitions are important, for the choice of the second reinforced the assimilation of the US emphasis on individuality, the importance of self-expression, and the need for uniqueness in design. It is interesting that a more recent definition for craft had not been produced in Canada and that Gibson's report employed the term "handicraft," a word both the Canadian Guild of Crafts and Canadian Craftsmen's Association had agreed was outdated. Several federal departments were identified as craft supporters, ranging from Agriculture, Health and Welfare to the Secretary of State. The Canadian Craftsmen's Association was named as the key national craft organization, receiving annual grants from the Secretary of State. Sheila Stiven, the executive secretary of the Association, was listed as a craft consultant to the federal government. Gibson concluded his report with the suggestion that the corporate structures of the Guild and the Association be examined, with the aim of establishing a corporate body "with the ultimate objective of improving the quantity and quality of Canadian handicrafts."[114]

One month after Gibson's assessment, an anonymous report, directed toward furthering the industrial development of craft, was drafted. Unlike Gibson who was careful to identify the current trend toward individuality and self-expression in Canadian craft, the Materials Branch of the Department of Industry, Trade and Commerce report was not interested in the artistic temperaments of Canadian craftspeople. The lack of a relationship between the crafts and industry was blamed upon craftspeople: "Artisans by temperament and training, most are not adequately prepared nor do they have the inclination to look after business details." Craft organizations were also targeted: "The sector as a whole is fragmented with several national organizations and many regional and local associations infrequently having common objects."[115] While the study acknowledged that there was a minor role for art craft, it argued that more emphasis needed to be placed on industrial craft, which would reach a broader population, the ideal being "a system where one artisan designs and produces a type which is then farmed out for manufacturing by a firm using mass production methods."[116] The Department undertook a full investigation of the possibility of adapting crafts to industry.

During the summer of 1972 Meredith Filshie, Gail Hancox, and Rosalind Orr of the Materials Branch travelled Canada, speaking with craftspeople and administrators from every province. Submitted in 1972, the resulting "Report on the Canadian Handicraft Situation" exceeded one hundred pages and contained the most comprehensive federal research on Canadian craft ever undertaken. The findings of the study reflected the differing concerns of craftspeople from across Canada, concluding that craftspeople in British Columbia, Alberta, Quebec, and Ontario had attained more sophisticated levels of design in craft, while the Atlantic provinces were in need of more opportunities for skill development. Several common themes emerged, namely changes to the tax laws affecting craftspeople, the need for small, low-interest loans, travelling exhibitions of craft that would reach craftspeople living in rural areas, and an increase in educational opportunities.[117]

The desire for changes to tax laws and customs and excise duties was something that had been consistently stressed by Aileen Osborn Webb, who argued that it limited the exchange of exhibitions between Canada and the United States.[118] Unlike "Fine Art" and sculpture, which could enter the United States duty free for either display purposes or sale, the work of Canadian craftspeople was subject to duties based on the basic materials used and could reach as high as 55 percent for luxury materials used in jewelry. Craftspeople earning more than $3,000 a year were subject to a 12 percent sales tax on the finished object, while the fine artist was taxed only on the cost of materials.[119]

In addition to the hierarchy dictated by such a system of categorization, the classification of craft as small manufacturing rather than art had an economic impact on craftspeople. The intellectual climate of an earlier period was reflected in the language system that distinguished craft as non-art. With the discourses surrounding craft shifting in the university and college systems toward art craft, the code of knowledge reflected in the Canadian taxation, custom, and excise laws was being challenged by professional craftspeople who questioned the arbitrary nature of their designation as non-artists. Filshie, Hancox, and Orr concluded that "artist-craftsmen" were their target group and that, although the Department wished to increase the industrial crafts of Canada, the cultural climate dictated that artist-craftspeople were the source of well-designed items. Their report called for the National Gallery of Canada to play a more important role in elevating the status of Canadian craft, recommending that the Gallery "display quality Canadian crafts in a permanent exhibition and that the National Gallery should consider circulating such an exhibition both in Canada and abroad."[120]

A careful distinction was made between professional and hobby craftspeople in the "Report on the Canadian Handicraft Situation": "Hobbyists would not be considered in any departmental program since their production does not contribute substantially to the Canadian economy. Remaining, therefore, are artist-craftsmen and industrial craftsmen. The group that this Department would identify with most closely would be the cottage industries and craft-based industries or the industrial crafts."[121] An extensive analysis of the Canadian Craftsmen's Association and the Canadian Guild of Crafts was also proffered, coming to the damning conclusion that "professional craftsmen indicated that they avoided commitment to craft associations because these groups did not meet their needs."

A major factor in identifying a professional craftsperson was education. Academic training in craft, and the resultant diploma or degree, was a social indicator of knowledge. The granting of university degrees demonstrated that craft was increasingly accepted as a legitimate field for artistic training. Universities and colleges were the ideal forum for the creation of professional experts through increased technical training, exposure to artistic ideals, and the formation of a like-minded and similarly educated community. This knowledge base led to increased power for these professional experts, who were called upon to act as jurors, to generate craft discourse through their objects and writings, and to act as consultants to the federal and provincial governments. Indeed, Filshie, Hancox, and Orr relied on these craft experts for help with their report, which resulted in the major recommendation made to the Department, that the craft industry "be encouraged to form one national organization, with national representation."[122] Obviously increased

educational opportunities were not helping to resolve the split between the two national craft organizations. To the Canadian Craftsmen's Association and the Canadian Guild of Crafts this was a strong message: it was time to set aside their differences and focus on unification. Not only could they not risk losing professional craftspeople from their ranks, it was also a timely warning; Canada had been selected to host the 1974 World Crafts Council conference and exhibition in Toronto, and, as it had been for Expo 67, the cultivation of a united craft image was deemed imperative. The growing emphasis on professional craft was able to overcome many of the regional differences that made up Canada's national craft identity. While based on US guidelines, Canadian professionals were aware of the importance of maintaining a uniquely Canadian craft identity. The pressure of organizing the World Crafts Council's largest conference and exhibition in collaboration with the United States was to prove the hardest test yet for Canada's professional craft community.

5

The Dis/Unity of Craft:
In Praise of Hands, Toronto, 1974

THE 1974 WORLD CRAFTS COUNCIL CONFERENCE AND EXHIBITION *In Praise of Hands* was the ultimate show of North American professionalism, one that continued to project late modernist art ideologies onto international craft. Canada had successfully developed a strong professional craft sector, demonstrated through its ability to organize and promote an event of this size in Canada. Whereas Expo 67 served to introduce Canadian professional craft to the world, *In Praise of Hands* brought international crafts to Canada following the guidelines established by Canadian and US authorities. While the veneration of Aileen Osborn Webb reached its apex in Toronto in 1974, Joan Chalmers emerged as Canada's elite craft expert, a woman who possessed cultural, symbolic, and economic capital similar to Webb's but who combined this with her pragmatic support of professional business practices in the craft world. Federal, provincial, and municipal governments, in tandem with private enterprise, accorded Canadian craftspeople and organizers unprecedented financial and social rewards that recognized the professional community as an economic and cultural force within Canada's art world. Simultaneous with these increased rewards was the struggle with the United States, which ruled over the Canadian-based event. Resentment from Canadian professionals was marked, and for the first time concerns were vocalized over the importance of disentangling the World Crafts Council from the domination of the American Crafts Council. Instead, the 1974 gathering cemented the American Crafts Council's professional standards, often the same ones shared by Canada's professionals, as the international ones.

By no means was this a smooth process. The complexity of the international craft community challenged Canada's own definitions of professional craft and craftspeople while bringing to the surface tensions over identity within the national craft structure. The specialized and elitist nature of Anglophone Canada's professional craft community was revealed as Francophone professionals refused to participate in World Crafts Council's events and Tom Hill galvanized Native professionals into supporting their own separate exhibition, a celebration of the privilege of professional self-regulation. The Canadian Craftsmen's Association's position as the pre-eminent professional craft organization in Canada was disputed during the organization and planning of *In Praise of Hands*. Joan Chalmers lent the Canadian Guild of Crafts, Ontario branch, a new professional status that forced the Association to consider merging with the Guild to form the Canadian Crafts Council. In the end, they created a situation in which Canadian craft remained a divided rather than genuinely national pursuit, a fragmentation that paralleled the underlying problematics of Webb's search for a global craft community. The event that led to the crisis and regrouping of professional craft in Canada had started two years earlier with a triumphant announcement of US recognition of Canadian professional capabilities.

"They thumped the desks yesterday in the legislature, with justification. The Ontario Science Centre has been selected as the site of the first World Crafts Council exhibition," reported the 25 April 1972 *Toronto Star*.[1] Mary Eileen Hogg, crafts advisor for the Province of Ontario and Canadian representative to the World Crafts Council, had succeeded in convincing Aileen Osborn Webb of the suitability of Toronto to host the tenth anniversary conference and exhibition of the World Crafts Council. The promise of generous provincial funding for the project and Hogg's friendship with Webb had in fact led to the selection of Toronto as host city the year before, when Hogg convinced R.E. Secord, director of the Youth and Recreation Branch, Ontario Department of Education, to write to Webb inviting the World Crafts Council to hold its 1974 conference in Toronto. Securing a suitable venue for an exhibition had been the final challenge in guaranteeing both the conference and exhibit for Toronto. Through the connections of Joan Chalmers, vice-president of the Canadian Guild of Crafts, Ontario branch, who knew Raymond Moriyama, the architect of the Ontario Science Centre, the Centre came to the rescue.[2]

The biennial conference of the World Crafts Council was held at York University in Toronto from 9 to 15 June 1974, uniting 1,500 craftspeople from more than seventy countries, although the Soviet Union, the People's Republic of China, and other communist nations were notably absent. The accom-

panying exhibition, the first international craft exhibition organized by the
Council, ran from 11 June to 2 September 1974 and was seen by more than
half a million people. As Chalmers declared, "1974 must be a total craft year,"
a command turned into reality through the efforts of the Canadian Commit-
tee of the World Crafts Council.[3] The Canadian Committee consisted of Mary
Eileen Hogg; Joan Chalmers, North American representative on the World
Crafts Council Exhibition Executive Committee; Glen Wilton, chairman of
the World Crafts Council Planning Committee; Gordon A. Barnes, chairman
of the Canadian Committee; and Alan Campaigne, chairman, Selection
Committee for Canadian Entries.[4] Members of the Co-ordinating Committee
who worked with the main organizers included members of the Ontario
branch of the Canadian Guild of Crafts: Paul Bennett, Ruth Markowitz, Beth
Slaney, and Leland Thomas.

Celebrating the two main events, the National Film Board of Canada pro-
duced a film, also called *In Praise of Hands*, and the tobacco company Benson
and Hedges helped to fund a book of the same name. The federal govern-
ment supported craft initiatives: the Ministry of Industry, Trade and Com-
merce sponsored the first Design Canada Craft Awards, and the Department
of Indian Affairs allowed Tom Hill to take a paid leave of absence to organize
the Royal Ontario Museum show *Canadian Indian Art '74*, which ran from
10 June to 31 August, timed to coincide with *In Praise of Hands*. Other art spaces
followed the Royal Ontario Museum's lead, and more than twenty-five gal-
leries across Canada held craft exhibitions in conjunction with *In Praise of
Hands*. Publications geared toward the crafts were funded, most notably
Chatelaine craft editor Una Abrahamson's coffee-table book, *Crafts Canada: The
Useful Arts*, aimed at both professional artist craftspeople and recreational
hobbyists. The City of Toronto was enthusiastic about hosting the World
Crafts Council event, with Toronto mayor David Crombie proclaiming 9–15
June "Craft Week, Toronto." The department stores Birks, Eaton, and
Simpson featured Canadian craft entries in their window displays, while their
advertisements urged consumers to "get crafty" by purchasing kits they were
selling to promote Craft Week. Television programs on craft ran during *In
Praise of Hands*, highlighting Canadians engaging in ethnically specific craft
activities.[5] Thomas Cook World Travel Service offered conference delegates
special craft tours to Northern Canada, Western Canada, Historic Ontario,
and Historic Quebec, as well as the Eastern United States. Most important to
the future of the Canadian craft field was the 15 June inaugural meeting of
the newly formed Canadian Crafts Council, held during the conference.

Canada's Role in Facilitating *In Praise of Hands*

Immediately following the announcement of the Ontario Science Centre as the exhibition venue for *In Praise of Hands*, the *Globe and Mail* reported "Vanderbilt Webb of New York ... has set up an executive committee for the exhibition."[6] In fact, Webb and the staff of the World Crafts Council headquarters in New York had already been working closely with Hogg, Chalmers, and members of the Canadian Committee, preparing initial guidelines for the conference. Accompanied by Hogg, James Plaut, the executive secretary of the World Crafts Council, flew to Ottawa in August 1971, to seek federal support for the 1974 conference and exhibition. Plaut's presence in Ottawa may have had a positive effect, with Webb writing enthusiastically to Hogg about his visit: "we have established a pleasant sense of comradeship between the two countries which bodes well for the future."[7]

Plaut embodied the cultural capital cultivated by Webb and sought by those members of the Canadian craft field who perceived themselves as professionals. A Harvard graduate, Plaut was entrenched in the world of fine art: appointed director of the Institute of Contemporary Art in Boston in 1939, he had been the director of the Art Looting Investigations Units in Washington, London, France, Italy, Germany, and Austria immediately following the Second World War. He had made the radical transition to a supporter of crafts during his involvement in organizing the Industrial Design Division of the Museum of Modern Art in 1948. Through his friendship with Aileen Osborn Webb, Plaut was fully aware of the modernization of craft sought by the American Crafts Council. Webb had personally selected Plaut to act as the executive secretary of the World Crafts Council in 1967, believing him capable of extending his fine arts sensibilities to the international craft world.[8]

Following the Ottawa visit, the North American Assembly of the World Crafts Council met in Toronto during November 1971, to discuss ideas for the conference. Plaut's comments during this meeting betrayed the secondary role Canada was about to play as host of the New York directed conference and exhibition. When the Canadian Committee expressed concern about the process of selection for the exhibition, "Mr. Plaut explained that the Host Country [Canada] and the World Crafts Council always take full responsibility for the ideology and planning for a conference, and they would welcome any help from Canada."[9] Canada was to be the facilitator, rather than the executor, of the two events. There was a slight edge in Hogg's succinct explanation of the relationship between Canada and the United States in her 1974 World Crafts Council Progress Report: "We work under direction from New York."[10]

The omnipresence of the United States in the UNESCO-supported World Crafts Council greatly influenced the ideologies and approaches toward the attainment of a global craft community that would be emphasized in Toronto.

Webb's internationalist intentions continued to dictate the direction of the world body, causing resentment among certain Canadian craft administrators. Sheila Stiven, former secretary of the Canadian Craftsmen's Association, objected to the dominance of the American Craft Council in the decision-making processes of a supposedly neutral organization, pointing out to Webb during a 1974 meeting that the close relationship between the American Craft Council and the World Crafts Council caused confusion as to where US interests stopped and world interests began. In a very blunt fashion, she urged the World Crafts Council to "extricate itself from the clutches of the American Craft Council."[11]

Stiven's concerns failed to modify the situation. It was a handful of select, friendly players – in particular Webb, Plaut, Chalmers, Hogg, and Paul Bennett, executive director of the Canadian Guild of Crafts, Ontario branch – who intended to unite the world through craft, while offering Canada national cohesion along the way. They possessed enough Western political and cultural connections, as well as access to economic capital, to influence the perception of professional craft. The Western classification of craft promoted through *In Praise of Hands* was bound up with issues of consumption, class distinctions, and exoticized images of the "other," creating binaries in the promotion of professional Western crafts.

Maintaining the Dream: A Global Craft Community

Aileen Osborn Webb's vision of the World Crafts Council uniting all craftspeople regardless of race, class, gender, or geography did not waver in the decade following its articulation in 1964 at the First World Congress of Craftsmen in New York. The US respect for individuality in craft would elevate the crafts of the world from traditional, joyless labour lacking aesthetic direction to art craft, marketable throughout the capitalist market economies of the world. As she argued, "We've removed crafts from the level of the church fair in this country – now we must do it for the world."[12] Webb's message was timely, as craftspeople and the general public were concerned with the effects modernization would have on craft objects and society in general. Like the ethnologists and philanthropists who had been involved in preserving Native American craft production in the late nineteenth and early twentieth centuries, Webb was dedicated to conserving particular forms of

craft activity that would adhere to US art categorizations. Her work uniting US craftspeople through the American Craft Council was praised for its ability to generate a cohesive community of craftspeople, something she believed could be pursued on the world stage.

The idea of a community based on craft had been eagerly embraced by the delegates represented at the 1964 conference in their attempts to establish national craft communities. It seemed logical to the World Crafts Council that these national communities could easily be blended to form a strong international or global community. Globalization continued to emerge as a concept, although theorists like Canada's Marshal McLuhan were cautious in their definitions of a "global village," a concept popularized by the media as an ideal universal goal. Only recently has this formulation been deconstructed by sociologists who argue a global society is impossible due to the constraints placed upon the possible fields of exchanges and to the colonization and domination of particular economic, political, and cultural systems.[13] It now seems clear that Webb's vision of a global community was part of the "Americanization" of the world in the Cold War climate of the 1960s, when US values and economic and political systems would "elevate" all countries. The World Crafts Council can be read as one of the participants in this US-controlled global community. Although affiliated with UNESCO, the Council had its headquarters in New York, its administration composed mainly of Americans. Canada's role as the host of the 1974 exhibition and conference might be perceived as a convenience for the US organizers, but for the Canadians involved it was considered to be more than a US puppet operation. *In Praise of Hands* was seen as the chance to emerge as a strong national unit on the international stage, a chance to replay the aspirations of Expo 67.

The Process of Canadian Amalgation

The 1971 announcement of Toronto as the host city for the World Crafts Council gathering hastened the process of unification between Canada's two national craft organizations. So too did the two major reports issued in 1972 by the Ministry of Industry, Trade and Commerce, both of which concluded that the formation of one national craft organization was imperative. The Canadian Craftsmen's Association and the Canadian Guild of Craft, concerned over a possible impact on their funding from the Department of the Secretary of State, began working together on amalgamation. The first joint meeting of the Association and Guild's boards and executives took place in Toronto in January 1973. This was followed by a meeting in Ottawa in March,

sponsored by the Secretary of State, which resulted in the announcement of the formation of a single national craft organization for Canada, the Canadian Crafts Council. Embracing all crafts, this group was to be chartered on 23 March 1974, just in time to hold its founding sessions during the World Crafts Council Conference. It was to displace the Canadian Guild of Crafts and the Canadian Craftsmen's Association, putting an end to the decade-long existence of two competing national organizations.[14]

The pressure to come together and to operate "effectively" had not been and would not be subtle. In the wake of the March 1973 meeting, Secretary of State J. Hugh Faulkner wrote a warning letter to Ann Suzuki, chair of the Canadian Craftsmen's Association, in which he identified the key concerns of the federal government: "I think it is most important that a truly national structure evolve from this action capable of representing craftsmen throughout Canada and which will take into account the country's bilingual and multi-cultural character and also reflect provincial and regional aspirations. I believe that the degree of confidence which the government might place in the organization which emerges from your deliberations will depend in large part on the extent of its success in achieving these goals."[15]

Faulkner identified the issues of bilingualism, regionalization, and multiculturalism that had plagued both the Association and Guild in their previous attempts to unite Canadian craftspeople into a national community. Most of those involved hoped the new Canadian Crafts Council would be able to overcome language, ethnic, and regional differences, but from the beginning it was clear that resolution, if possible at all, was not going to come easily. A January 1973 letter from Rei Nakushima of the Visual Arts Centre in Montreal to Ann Suzuki and Sheila Stiven of the Canadian Craftsmen's Association indicated that tensions between Francophone Quebec craftspeople and English-speaking craftspeople from the everywhere in Canada remained high:

The approach to crafts is entirely different here. Here they are interested in raising the general level of the crafts which are done on a production level. The tradition of crafts in the home is long and provides the background which brings out this value ... it is a type of industry to them. In contrast, the Canadian Craftsmen's Association has always emphasized the "one-of-a-kind," "unique" item and their activity is based on this premise. The Artist is praised, the craftsman is ignored. They feel that after ten years of hitting their heads against a wall, they no longer had the patience to listen to anymore unrelated discussions to their own circumstances. Quebecers have had a long suppressed situation. The Latin temperament and the Anglo-Saxon Puritan traditions are miles apart.[16]

Nakushima urged the Association directors to come and listen to the executive of the Conseil des métiers d'art du Québec before the March amalgamation meetings, but her advice was ignored. No meeting took place, and instead the Conseil des métiers d'art du Québec held its own congress in May 1973, adopting an independent five-year plan that stressed the nationalistic ideals of its craft production, arguing that crafts were the "vehicle of Quebec cultural identity."[17]

While the Canadian Committee of the World Crafts Council set about requesting a grant of $111,500 from the Government of Canada to support the Toronto conference and exhibition, arguing that such an event would enhance the Canadian mosaic through the active participation of diverse craft organizations, Guy Vidal of the Conseil des métiers d'art du Québec wrote the Secretary of State in anger over the exclusionary practices of the exhibition committee. Ironically, the Canadian Committee, justifying its requests on the Committee on Bilingualism and Biculturalism's finding that craft production was one of the ways in which the many cultural groups were able to retain their identity in Canada, provided English-only correspondence about the World Crafts Council exhibition.[18] This enraged the Conseil des métiers d'art du Québec: the English-only correspondence was cited as indicative of a lack of respect for the craftspeople of Quebec. The Conseil accused the organizing committee of not understanding that there were two cultures in Canada with different philosophies and major cultural differences (typically, there was no mention of First Nations as another distinct Canadian culture). As a result, the Conseil des métiers d'art du Québec declined participation in the World Craft Council exhibition, stating that it would not submit Quebec craft objects as part of the Canadian entries. Instead, it offered to organize and present an exhibition on Quebec craftspeople to run during *In Praise of Hands*, juried by the Conseil des métiers d'art du Québec itself.[19] The Canadian Committee did not accept this offer. Quebec's official craft organization supported the new Canadian Crafts Council on paper only, making its displeasure clear through its refusal to participate in the June 1974 founding meetings.

Sheila Stiven of the Canadian Craftsmen's Association had read Mary Eileen Hogg's initial brief to the Secretary of State requesting financial support for the World Crafts Council conference and responded strongly to the Ontario focus of the draft. She reminded Hogg of the importance of having a truly national involvement in the project: "indicate active involvement with groups in the West, the Maritimes, and especially Quebec ... I believe you are jeopardizing your chances by such TORONTOISM!"[20] Despite these warnings, the Canadian Committee did not focus on the split between Quebec's profes-

sional craft organization and the rest of Canada; rather it emphasized the multicultural nature of the new organization and exhibition. The hypocrisy of the situation was not overlooked by Quebec craftspeople, who felt increasingly excluded from the vision of a national community, as they continued to receive World Crafts Council rhetoric mailed to them in English. Memos from the organizing committee were filled with global sentiments, particularly with regard to the type of objects to be included in the exhibition. The stated goals of the exhibition were to "promote greater public understanding of the role and condition of the creative craftsman in contemporary society" and "to set, by example, standards of excellence in the crafts."[21] Evidently, the examples were not to be those of Quebec.

Joan Chalmers

While Quebec craftspeople refused to participate in the new national craft organization and the World Crafts Council exhibition, Ontario craftspeople took the opportunity to solidify their position at the apex of professional Canadian craft. The Canadian Guild of Crafts Ontario Branch had enjoyed renewed status following the success of its 1969 exhibition *Craft Dimensions Canada*, selected by an exclusively American jury, and had undertaken a series of high-profile shows. Joan Chalmers, the daughter of the wealthy publishing philanthropists and craft supporters Floyd and Jean Chalmers, had much to do with these successes. A graduate of the Ontario College of Art in architecture and design, Chalmers had been a writer for *Canadian Homes and Gardens* and the art director of *Mayfair Magazine, Canadian Bride Magazine, Canadian Homes and Gardens*, and *Chatelaine*.[22] Chalmers became a director of the Ontario branch of the Guild in 1967 and soon took up the organization of large-scale exhibitions, serving as exhibition chair from 1970 to 1972. One of her first priorities upon becoming involved with the Guild was to increase the level of professionalism of both the Guild and its members. The perception of craftspeople as an unprofessional group Chalmers attributed to their improper shipping of materials, sloppy labelling, uneven pricing, disregard for deadlines, and frequently poor object designs, and she set about to change this image. She insisted on proper packing both by and for craftspeople, instituted firm deadlines, juried rigorously for good designs, had professional letterhead designed for the Guild, and focused on the Guild's presentation of its members' work through improvements in lighting, the flow of traffic in shops and exhibitions, and proper signage.[23] Chalmers was elected as the first woman president of the Canadian Guild of Crafts, Ontario Branch, in the

spring of 1974. As the North American representative on the World Crafts Council Exhibition Executive Committee, Chalmers played an important role in deciding various aspects of the *In Praise of Hands* exhibition.

Like Webb, Chalmers was born into a public-spirited family who possessed the economic capital to enhance her cultural and symbolic capital. Chalmers's presence on the board of the Ontario branch of the Guild was significant, for she provided recognizable cultural capital within the field of craft. Webb's parents had no prior involvement in the crafts, but Chalmers's mother, Jean Chalmers, served as the vice-president of the Canadian Handicrafts Guild in the 1940s and her father, Floyd S. Chalmers, visited New York in 1939 to investigate the possibility of opening up markets for Canadian crafts in the United States. Joan Chalmers's first summer job at age fourteen was working at Toronto's Canadian Handicrafts Guild shop run by Adelaide Marriott.[24] Floyd S. Chalmers was one of Canada's leading cultural philanthropists. He joined the *Financial Post* in 1919, becoming the chief editor in 1925. By 1942 he had become the vice-president of the Maclean-Hunter publishing empire and was made president in 1952, then chairman from 1964 to 1969. During his career Chalmers amassed a substantial personal fortune, which he shared generously through his support of various Canadian cultural initiatives. He established the Floyd S. Chalmers Foundation in 1963, remaining president until 1979. The Foundation funded a wide range of activities, from theatre and music to the visual arts. In 1973 the Chalmers Awards were instituted, and Joan Chalmers encouraged the Foundation to support Canadian craft through annual monetary awards.[25]

Newspaper accounts of both Webb and Chalmers conveyed images of confident, culturally important women. A 1974 *Toronto Star* article described Chalmers as "tall, attractive Joan Chalmers, newly elected as the first woman president of the Canadian Guild of Crafts (Ontario), and a key figure in bringing the first World Crafts Council exhibition to Toronto," while a 1972 *New York Times* description of Webb stated, "the five-foot, ten-inch tall regal-looking Webb ... is organizing the first World Crafts Exhibition, scheduled to take place in Toronto in 1974."[26] In Chalmers, Canada had finally found a figurehead for the crafts who was of similar stature to Webb. Chalmers was enthusiastic about her role in promoting the crafts in Canada, becoming well recognized as she drove around Toronto in a Jeep Wagoneer bearing the license plates "wcc074."

Webb and Chalmers worked to elevate both the standards of craft and the taste of the public. Utilizing their cultural pedigrees and position within the cultural nobility of North America, they sought to improve the material conditions of the world through craft. Their taste was "good taste," accepted by

the cultural field as a given rather than a social and cultural construct; the determining factors of class, race, and economic capital were deemed secondary to this innate good taste allegedly possessed by both women. While Webb and Chalmers were cognizant of the differences that existed between their elite status and the masses, as evidenced through their philanthropic deeds, they used their position to legitimate "proper" crafts. These objects tended to be reflections of the cultural constructs that formed the ideology of the prevailing artistic taste of the times, rather than objects reflecting the popular aesthetic.[27] Following the philosophy of William Morris, Webb advised Canadians during the 1955 exhibition *Designer-Craftsmen U.S.A.* to have one or two beautiful handcrafted objects in the house to provide pleasure while raising the standard of taste to a higher level. Chalmers argued that the best education was exposure to beautiful crafts: "If you go to any craft fair, especially the church basement ones, you just know how awful it's going to be ... What's worst of all are the crocheted fancy dress ladies that become socks to go over the extra roll of toilet paper ... if people don't have a developed taste it's their problem. All you can do is try to educate people by exposure to beautiful crafts."[28]

In her role as exhibition chair of the Ontario Branch of the Canadian Guild of Crafts, Chalmers attempted to elevate the standards of Canadian craft through large-scale exhibitions emphasizing art-craft. One of the most important of these, *Entr'Acte,* ran from 13 November to 15 January 1974 and challenged craftspeople to create pieces based on the idea of the theatre.[29] The exhibition received $15,000 in private sponsorship from the cigarette manufacturer Benson and Hedges Canada, which hoped to benefit from the popularity of contemporary craft. Benson and Hedges's President Charles Lombard was featured in many newspaper articles across Canada, shown viewing various craft pieces. Described alternately as "examining," "gazing," or "admiring" craft, Lombard represented the entry of professional Canadian craftspeople into the corporate scene and their acceptance as fine artists, symbolized by a widening spectatorship. This process mirrored that in the United States, where private sponsorship of craft exhibitions had long involved corporations such as Ford and Johnson and Johnson.

The Guild took advantage of the exhibition to honour Adelaide Marriott, a member and employee for more than forty years. Calling Marriott the "mother of our crafts: nurse to our growing pains and a patient but firm upholder of the verities of honest professionalism," the Guild paid tribute to her with the purchase in her name of Harold O'Connor's sculptural piece "Left Out," shown in *Entr'Acte*, while York University in Toronto gave her an honorary doctorate.[30] It was Floyd S. Chalmers, chancellor of York University

1968 to 1974, who conferred the Doctor of Laws degree on Adelaide Mariott.[31] If Joan Chalmers operated as a symbol for the newly revitalized Guild, promising private philanthropy and showy exhibitions similar to the US model, Marriott was recognized as the figurehead for the long history of the Guild, providing a link between the new Guild ideals of professional art craft and the necessary corps of volunteers and amateurs who had been increasingly dismissed as dilettantes. Even *Chatelaine* had criticized dilettantes in the 1970 article "Who Runs Culture in Canada?" classifying "handmaidens ... daughters of rich families, wives of rising young executives" and matrons "with the bun of hair, smoothing her skirt with plump, ringed hands" as the true cultural establishment of Canada, deciding "to an astonishing degree what our Canada needs."[32] The Canadian Craftsmen's Association also involved female volunteers, but in contrast to the Canadian Guild of Crafts' attitude, these women were never dismissed as "dilettantes." This could be due to the professional nature of the female administrators of the Association, career women such as Norah McCullough, the western liaison officer for the National Gallery of Canada, and Ann Suzuki, a full-time craftsperson. Nonetheless, the women of both organizations, all open admirers of Webb, played tremendously important roles in determining the type of craft promoted in Canada.

Promoting *In Praise of Hands*

In contrast to its intense involvement in the craft exhibitions surrounding Expo 67, the Canadian Craftsmen's Association played a minor role during the organization of *In Praise of Hands*. This shift might be explained by Mary Eileen Hogg's replacement of Norah McCullough as the Canadian representative to the World Crafts Council. In 1972 the government department where Hogg worked, the Youth and Recreation Branch of the Ontario Ministry of Community and Social Services, was announced as officially assisting the Canadian Committee of the World Crafts Council in organizing the 1974 events. This was followed by the decision of the Youth and Recreation Branch to enlist the services of the Canadian Guild of Craft, Ontario branch, and the Ontario Craft Foundation in the official arrangements. Glen Wilton, a member of both the Guild and Foundation, was appointed chairman of the Conference, and the Canadian Guild of Crafts was made responsible for selecting Canada's entries for *In Praise of Hands*. Hogg's decisions regarding the organization of the conference and exhibition effectively excluded the Canadian Craftsmen's Association.[33] McCullough's retirement from the

National Gallery and the loss of Sheila Stiven as editor of the Canadian Craftsmen's Association publication *Craftsman/L'Artisan* to the Nova Scotia provincial department concerned with craft, were also contributing factors.

Jack Sures and George Shaw, former chairs of the Canadian Craftsmen's Association, perceived the Canadian Guild of Crafts as fuelling opposition between the groups by arguing that they were in competition with each other. In separate letters to Herman Voaden, the president of the Canadian Guild of Crafts from 1968 to 1970, Sures and Shaw outlined their vision of the Guild leading Canadian craftspeople in marketing and exhibitions, while the Association took responsibility for overseeing policy initiatives related to craft. Shaw wrote to Voaden that the Association was created to "provide an alternative to the Guild," stating that he was saddened when Voaden "interpreted the existence of the Guild and Association as conflicting, which it is not." The letters of Sures and Shaw provide clues regarding the lack of involvement of the Association in the high-profile exhibitions surrounding the World Crafts Council conference in 1974, a task that the executive of the Canadian Craftsmen's Association may have perceived as belonging to the Guild.[34]

Exhibitions such as *Craft Dimensions Canada* and *Entr'Acte* demonstrated that the administrators and craftspeople involved with the Guild now supported individualistic, self-expressive craft objects, often products of professional craftspeople with formal artistic training. In other words, they too had adopted the Canadian Craftsmen's Association's goals. Not everyone was happy with this "conversion." The 1973 exhibition *Entr'Acte* was held at the O'Keefe Centre, an elegant, large cultural venue in downtown Toronto: across the street the St Lawrence Centre for the Performing Arts featured an exhibition titled *Salon des Refusés*, comprising the work of artist-craftspeople rejected from the official Guild event. Playing off the famous Salon des Refusés mounted by the late nineteenth-century impressionist artists rejected from France's official Salon, this group of artist craftspeople released a manifesto outlining complaints against the professional Canadian craft establishment: "We of the *Salon des Refusés* are a diverse group. We: question exclusivity … question the right of institutions to form the aesthetic opinion of the time."[35] Those exhibiting were mostly professionals whose work had been deemed inadequate by the Canadian Guild of Crafts (Ontario) jury, but their Salon was considered by many to be a very respectable adjunct to *Entr'Acte*. Both exhibitions were favourably reviewed, with Kay Kritzwitzer of the *Globe and Mail* acknowledging that both were of high quality. The questioning of standards and exclusivity by the craftspeople rejected from the Guild's formal exhibition paralleled, although certainly did not echo, the concerns of the Conseil

Harold Town, *In Praise of Hands* poster, 1974. *Art Magazine* 5/18 (Summer 1974): cover.

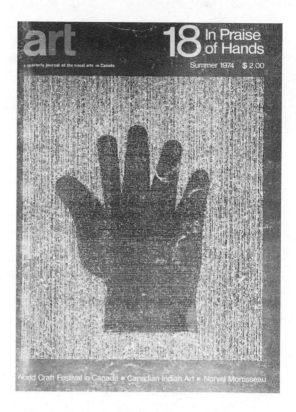

des métiers d'art du Québec. Having been selected by Hogg and Webb as the main organization to be involved in the *In Praise of Hands* exhibition, the Canadian Guild of Crafts remained focused on promoting nationwide its message of raising standards for professional crafts, evidently largely untroubled by the concerns of the Salon and the Conseil des métiers d'art du Québec. It is important to note, however, that Alan Campaigne, the author of the "Manifesto of the Salon des Réfuses," became a member of the Canadian Committee for *In Praise of Hands*, perhaps an attempt at reconciliation with one of the disgruntled groups.

Another powerful figure behind the message was Paul Bennett, executive director of the Ontario branch of the Canadian Guild of Crafts. Bennett was an arts administrator who was vocal in emphasizing the need for professionalism and equality for crafts within fine arts structures. Before joining the Guild, Bennett had been the director of the Robert McLaughlin Gallery in Oshawa, Ontario, and an advisor to the Community Programs Branch of the Sports and Recreation Bureau for the Province of Ontario, where he became familiar with the political and social structures determining the cultural poli-

cies of Ontario.³⁶ This was important information for the Guild which worried over securing governmental and private support. The combination of Joan Chalmers's presence and Paul Bennett's practical expertise led to unprecedented financial support for the Guild, and its largest undertaking ever, organizing *In Praise of Hands* for the World Crafts Council.

More than $600,000 was raised for the exhibition and conference. Federal sources of funding totaled $225,000. The Secretary of State, Art and Culture Branch, spent $22,000 to bring craftspeople in as demonstrators; the Multicultural branch donated $18,000 to sponsor "ethnic nights" at the Ontario Science Centre; the Canada Council gave $10,000 for a four-colour, sixteen-page supplement on crafts to be distributed in cultural magazines; the Department of Industry, Trade and Commerce contributed $14,000 toward administration costs; and the Department of External Affairs granted $15,000 to bring ten international master craftspeople to Toronto. The Government of Ontario contributed over $300,000 for administration and exhibition costs, as well as maintaining the salary for Mary Eileen Hogg, who worked exclusively on the exhibition. The municipal government of Toronto sponsored a barbeque at Black Creek Pioneer village for almost 1,500 delegates to the conference, and the provinces of British Columbia, Alberta, and New Brunswick paid a total of $20,000 to send craftspeople to Toronto. In addition to the generous provincial and federal funds, Benson and Hedges President Charles Lombard pledged $50,000 to be shared between the establishment of a Benson and Hedges house to accommodate craftspeople involved in demonstrations at the exhibition and funding for the official poster and book for *In Praise of Hands*.³⁷ Jean Chalmers donated $25,000 to purchase all the Canadian entries in the exhibition for a future permanent craft exhibition, and an anonymous private donor gave $5,000 to have craft students at Ontario colleges brought in for the conference and exhibition.³⁸

Promoting Professionalism

As the contributions toward the exhibition continued to grow, the Guild sent Paul Bennett across Western Canada to promote *In Praise of Hands*. The February 1974 tour to major cities in British Columbia, Alberta, Saskatchewan, Manitoba, and Northern Ontario turned into a media event, popularizing Bennett's view on the importance of professional crafts in Canada, which he claimed had finally come of age. In addition to interviews with major newspapers and radio stations in the cities he visited, Bennett and his observations on Canadian craft were foregrounded in *Craft Ontario*, the publication of the

Ontario Craft Foundation.[39] "I take the attitude that any program we develop should be aimed at the very highest level of craftsmen," stated Bennett, who referred to the graduates of Canadian craft programs as the top level of young professionals. "Thus we emphasize the professional craftsmen." For the first time since the term "professional" had been introduced into Canadian craft discourse, a definition was proffered, Bennett defining it as "One who has artistic ability, a sense of design, a definite period of artistic training, an intent or determination. The attitude to life itself is so important. You must believe that what you are doing is worthwhile, so important that you have to do it despite your low income when you are young and just beginning." When asked by the interviewer what he felt about the "discord aroused by people making a contemptuous distinction between the amateur and the profession-al," Bennett simply replied that "such conduct is unprofessional."[40] Obvious from Bennett's interviews was his insistence that craft is art and that professional craftspeople must conduct themselves accordingly. As Anita Aarons, Merton Chambers, and the supporters of the Canadian Craftsmen's Association had argued in the mid-1960s, amateur and hobbyist craftspeople were no longer included in the formal definition of craft being promoted by Canadian craft organizations. In her 1970 oral history interview with the Smithsonian Institution, Aileen Osborn Webb acknowledged the divisive nature of defining craft professionals: "Now a person who doesn't need to make any money can be a professional, to my mind, as long as he really is highly skilled and the quality is there. There has always been a great deal of quarreling about what is a professional. A lot of people like to say that it's just a person who earns his living at it. I don't agree with that. I think a professional is a person who is outstanding in his work and makes a contribution."[41]

This indeed was a "contemptuous" distinction, for the membership of the Guild and the Association included large numbers of part-time or amateur craftspeople who were now told they did not possess the proper qualifications to be regarded as professional craftspeople. A system of classification had been practiced in Quebec since the formation of the Conseil des métiers d'art du Québec, which insisted on a rigorous peer jury system for members. Unlike the situation in Quebec, however, even professional craftspeople who earned their full-time income from their art now faced possible exclusion if they were not properly educated, or if they relied upon traditional designs. Aarons, Chambers, and Bennett's definition of professional craft paralleled the views of the American Craft Council, made public by *Craft Horizons* editor Rose Slivka and Museum of Contemporary Craft curator Paul Smith. In a 1969 *Newsweek* interview, Slivka and Smith confirmed "the best craftsmen are, in both their approach and achievement, artists by any definition."[42]

In the notes from a 1972 "think tank" session of the North American Assembly held in Toronto, Bennett and Plaut were in complete agreement that the World Crafts Council conference and exhibition had to target professional craftspeople. "Any amateur can get a glimmer of what is happening here," stated Bennett, with Plaut agreeing that they should design "the most challenging program imaginable for professional craftsmen. If an amateur or non-practicing craftsman doesn't like it so much the better."[43] Bennett's aggressive promotion of Canadian crafts as professional extended into the United States through his interviews with US newspapers. The *Detroit Free Press* quoted Bennett as saying, "It's time Canadians began to think of their craftsmen as professionals ... When most Canadians hear the word 'crafts' they think of a little old lady who crochets doilies for antimacassars."[44] Una Abrahamson, author of *Crafts Canada*, a glossy book released in time for *In Praise of Hands*, repeated Bennett's views on professionalism in interviews promoting the book: "too often crafts have been lumped with hobbies and cottage industry. I am talking about the creations of professional craftsmen who combine skill and imagination to produce exquisite work."[45]

Members of the Women's Committee of the Canadian Guild of Crafts were aware of their categorization, often expressed in very dismissive terms, as amateurs or dilettantes. Despite this, they continued to play an active role in the conference and exhibition, serving as information staff, hostesses, guides, and salespeople. More than 170 female volunteers assisted in 1974. Although their names were not mentioned in publications and their voices within and regarding the exhibition were rarely heard, they believed that even though "scant attention was paid to our views at the Committee level, yet there is no doubt that the exhibition bore the stamp of our personality."[46] While this program of professionalization was perceived as a positive step toward insinuating the crafts into the realm of fine art, many groups who had benefited from craft activity, specifically women and ethnic minorities, were left out of a formulation based on privilege and access to proper education.

Tradition vs Innovation: Jurying the Global Craft Community

Radio, television, and newspaper reports about Bennett show a fascination with the international scope of the *In Praise of Hands* exhibition. In addition to promoting the professional nature of Canadian craft, Bennett stressed the theme of the global community. Articles with titles such as "A global Holding of Hands" and "Crafts around the World" waxed poetic about the "common thread of empathy and understanding and artistry running through the

whole craft world."[47] Bennett promised that the lifestyles of craftspeople would be highlighted, providing new understandings between people who occupied very different worlds. The discrepancies between Western and non-Western craftspeople were acknowledged in some of the articles, but the larger theme of global harmony prevailed: "The disparity of the lifestyles of the master craftsmen appearing ... will enable the conferees to gain new comprehension of such extremes as the conditions prevailing in the most remote crafts-producing villages and the most sophisticated centres of technologically-oriented production."[48]

Bennett took the opportunity of his tour to locate Canadian craftspeople of various ethnic identities to come to Toronto as demonstrators, promising honorariums as well as airfare and accommodation to those selected. A problematic division of Canadian craftspeople emerged. Those possessing visible ethnic traits were recruited as demonstrators, while the "professionals" consisted mainly of Anglophone Canadians. Some demonstrators, though living in Canada, were brought in as "Danes" and "Tibetans," thus conflating "ethnicity" and "global." Bennett told reporters that "visiting craftsmen will be able to see an Atlantic Dory, an Indian dugout canoe, an Eskimo kayak, and a Prairie sod shack, all made by native or ethnic craftsmen. An entire family is being transported from Quebec – the mother a weaver, the father and brothers furniture builders – to work at their crafts in their own living room and workshop which will be moved lock, stock and barrel to the exhibition location."[49] Yet these same craftspeople were not represented in the exhibition itself. Their work, denied standing as official Canadian craft, merely lent "colour" to the event.

The process of selection for the official Canadian entries to *In Praise of Hands* further underscored and exacerbated issues of exclusivity. The selection process was intended to be two-phased. First, member countries would collect and jury their own crafts, and then these items would be sent on to a New York-based international jury with members from the United States, Switzerland, and Japan, which would make the final choices. The call for Canadian entries had the initial deadline of 1 December 1972, and a three-dollar entry fee was charged. All pieces were to have been produced after 1970 and were to be for sale. The response to the call was enthusiastic: 297 craftspeople submitted a total of 584 entries. These were adjudicated at the Ontario Science Centre during January 1973 by a jury consisting of the textile artist Joyce Chown, architect Arthur Erikson, ceramist Luke Lindoe, painter Christopher Pratt, and jeweller Guy Vidal.[50]

The jurors, all recognized artists who adhered to the principles expounded by Bennett, brought to the judging their particular conceptualization of

craft and were disappointed by the first set of entries, which they felt fell below proper standards. Joan Chalmers shared their disappointment, reporting to the National General Committee of the Canadian Guild of Crafts how "it quickly became obvious that the standard of entries ranged from the ludicrous to the superb. Bad design and colour naturally over-ruled what might have been fine craftsmanship." As Chalmers's mother, Jean, had agreed to purchase the works representing Canada for a future public collection, Joan Chalmers had a personal interest in ensuring the highest standards, as defined by the taste of the purchaser. Following the jury selection, the exhibition committee agreed that "the works submitted were not truly significant of the craft quality available in Canada today" and decided to solicit specific craftspeople to submit work. Chalmers indicated the pressure felt by the Canadian Committee to impress its US counterparts, stating that the main objective of the jury "was to send only the very best crafts representative of Canadian craftsmen to New York."[51]

The Committee understood the potential for controversy if craftspeople were made aware of the decision. The only public report came in April 1974, long after the jury had completed its second set of deliberations, when the *Globe and Mail* reported that the preliminary selection had been a disappointment, forcing the committee to send out calls to "Canadian professionals" in order to send "what it felt was a representative selection of Canadian crafts to New York for further viewing."[52] The fact that the committee had the power to decide what and who qualified as "representative" Canadian craft indicates the cultural/political power at play in the categorization of craft and the hegemony that allowed a small group to override the intentions of the whole. The desire to create a homogenous, national group of "true" Canadian craft objects was predicated upon a set of accepted categorizations based on class, race, and gender lines. Professional craftspeople were largely educated Anglophones who did not fall into the category of female "hobbyists."

Led by Webb and the American Craft Council, the pursuit of art craft was being replicated in Canada. As Pierre Bourdieu emphasizes, different social groups have access to different classificatory systems, based on different cultural capitals, circulating in different cultural economies.[53] The aesthetics of high culture have always defined themselves against the popular, and, in the case of the selection of Canadian objects *for In Praise of Hands*, this remained true, with art craft and traditional craft positioned as binaries. The exhibitors selected to represent Canada were professional craftspeople known to the small organizational group, most with the proper educational background and all with artistic intentions for their final pieces. Following the resubmission of pieces by selected craftspeople, the jury in New York met again in

Paul Smith and Erika Billiter jurying for *In Praise of Hands*, 1973. Photo courtesy of the National Archives of Canada.

April 1973, and sixty pieces were sent to New York. There, fourteen pieces by twelve Canadian craftspeople were chosen for the exhibition.[54] It is significant that nine of the twelve Canadians were from Ontario and that, of those nine, four were associated with the Sheridan College of Art and Design in Mississauga, Ontario.

The international jury consisted of Erica Billeter, curator of Zurich's Museum Bellevive; Paul Smith, director of the Museum of Contemporary Crafts, New York; and Sori Yanagi, the head of the Yanagi Industrial Design Institute, Tokyo. Billeter had curated international exhibitions of textiles and ceramics for a variety of museums in Switzerland, as well as writing extensively on the subject for the accompanying catalogues. The jury met for four days and selected 387 pieces from 2,400 slides submitted from more than seventy countries.[55] Superficially, the members of the jury appeared to have no trouble making the final selection, agreeing in their official selection statement that "whereas esthetic judgment was exercised, the committee did not consider that it was serving as a 'jury' to *judge* objects as 'good' or 'bad' but rather to *select* those objects that would come together to form a great exhibition within the agreed upon humanistic spirit of the theme."[56] However,

Yanagi was vocal in his displeasure over the nontraditional focus of the exhibition. A *Financial Post* interview with Yanagi identified the split in the World Crafts Council between traditional and conceptual crafts, with Yanagi complaining that "The exhibits from the United States were mostly what we call craft objects, created more for self-expression than for providing utility, and seem to communicate the psychological confusion and uncertainty of Americans today."[57] The tensions within the Canadian craft hierarchy were mirrored in the international community, as seen in Yanagi's comments.

Although Yanagi was in favour of uniting the world through *In Praise of Hands*, it was understandable that he adopted the more conservative approach to crafts. He was the son of Soyetsu Yanagi, director of the National Folk Museum in Tokyo and a friend and admirer of Bernard Leach.[58] In his famous 1940 *A Potter's Book*, Leach had espoused to craftspeople around the world the philosophy of truth to materials and natural forms. Although Leach's dedication to tradition differed from the views of the American Crafts Council, his desire to unify the East and West through craft was not dissimilar to Webb's ideals. British craft historian Tanya Harrod compared Webb to Leach, stating that "Her internationalist ideas were a cruder variant of Leach's proselytising for a unity of eastern and western aesthetics, in which connections and friendship between craftsmen of all races would create harmony between nations."[59] Leach's dislike for the sculptural approach to ceramics advocated by the art critic Herbert Read and the potter William Staite Murray, a professor at the Royal College of Art in London, was well known.

The same ideological split was evident in North America. The proponents of self-referential, original pieces by artist-craftspeople (the members of the governing body of the 1974 conference being prominent such proponents) were in conflict with adherents of traditional craft techniques. As early as the 1968 World Crafts Council conference in Lima, Peru, Canadian craftspeople were questioning the predominance of conceptual craft. Art Soloman of Garson, Ontario, reported "There was no place in the conference for an ordinary, everyday, practicing craftsman. I wholeheartedly endorse the objectives of the World Crafts Council ... but I seriously wonder whether there is any place in it for craftsmen?"[60] The dichotomy between *In Praise of Hands* and the activities surrounding the exhibition, such as the sale of craft kits, maintained the divide between "ethnic" demonstrators and professional artist craftspeople. One of many examples of this tension was demonstrated in the June 1974 edition of *Craft Horizons*, which featured special sections on the World Crafts Council and the crafts in Canada.[61] Rose Slivka's editorial, "The Object as Poet," was a lyrical ode to the supremacy of art craft, presented with the understanding that Canada and the United States were agreed on

the view of "the modern craftsman [as] an object-poet, transcending the material and functional limits of the object." Slivka was an admirer of sculptural ceramics. As the biographer of Peter Voulkos and active supporter of art craft, Slivka acknowledged the similarities between the United States and Canada's "plurality and sheer individualism," noting that this differentiated North America from European and Latin American dependence on the patronage of the church and the ruling classes. This independence, she concluded incorrectly, was embodied in the training of craftspeople through North American universities and professional schools, where "the secret is in the unique imprint of individual personality not in virtuoso techniques."[62]

Slivka's assessment of North American craft was clearly shared by the Canadian Committee of the World Crafts Council, as well as the Canadian Guild of Crafts. At the end of her article she thanked Mary Ellen Hogg and Paul Bennett for the special trip they made from Toronto to New York to consult with the American Craft Council on the material and ideas presented in the special issue. Jean Libman Block, a well-published US writer, contributed an alphabetized list of "The Crafts in Canada," focusing on the question, "What is the Canadian style?"[63] She paid tribute to the conceptual art influences of the United States, highlighting craftspeople who were involved in this approach. "R" was for Regina, Saskatchewan, "home to an extraordinary group of ceramists, a number of them trained on the west coast of the United States," while "V" was for the videotape creations of Vancouver's Evelyn Roth, "who finger-crochets a slip-cover for her car, sculptural sweaters that encase up to four human beings in a cozy huddle and her major work, an eight-hundred square foot canopy for the Vancouver Art Gallery."[64] The pieces illustrated throughout the special section reflected the professional craftspeople embraced by the Canadian craft organizations, including Marilyn Levine, Anita Aarons, and Ruth Gowdy McKinley.

Marilyn Levine's dramatic *trompe l'oeil* ceramic sculptures lent the prairie native widespread fame within the North American arts community. She was working with relatively functional ceramics during her time training and teaching at the University of Saskatchewan, Regina, where she was exposed to the California ceramists and ideas that flowed through the department. As a result, Levine left to study in California with Peter Voulkos, completing her master's degree in sculpture at the University of California in Berkeley. In the early 1970s she began her realistic clay sculpture that startled viewers through material illusions, leading viewers to regard clay as leather. "John's Mountie Boots" (1973) show a worn pair of boots, tops bent over with age and use. The surface perfectly mimics cracked, scuffed leather, with lighter patches on the toes and folds and curves outlining the wearer's foot. The

Marilyn Levine, *John's Mountie Boots*, 1973. Ceramic and mixed media, 16.2 x 33.6 x 33.23 cm. Photo courtesy of the MacKenzie Art Gallery, University of Regina Collection.

piece is composed of painted clay with real leather laces. Levine builds her sculptures from reinforced clay slabs, which she then sculpts into leather-like objects that taunt the viewer by denying tactility while throwing the visual sense into a perceptual spin. Each of her pieces is named after the imagined wearer, leaving one to wonder who "John" was.

In contrast to Levine, Ruth Gowdy McKinley's work remained dedicated to the functional in ceramics, and at various points in her career she was curious about entering into the realm of production ware. McKinley instructed ceramics at Sheridan College, and she was renowned for her expert forms and glazes. It is easy to imagine her wood-fired stoneware teapots, wine decanters, creamers, and planters all reflecting the back-to-the-land lifestyles of their users. From her popular forms to her insistence on wood-firing in her studio on the Sheridan College campus, McKinley captured one of the most popular ceramic aesthetics of the late 1960s and early 1970s. Her professional approach to the production of these objects set her apart from the many hobby potters who sought similar forms and surfaces in clay. The brown stoneware teapot with bamboo handle demonstrates McKinley's skill in throwing this form. She was able to manipulate the body of the pot into a low, wide circle, with a fat spout leading up into a delicately pointed mouth. The teapot lid sits snuggly on top without interrupting the flow of either the body or the handle. Using the popular material of bamboo for the handle,

Ruth Gowdy McKinley, teapot, n.d. Stoneware with bamboo handle, 12 × 20.8 × 18.2 cm. Photo courtesy of the Canadian Museum of Civilization.

McKinley further manipulates the traditional form by moving its attachment to the middle of the teapot body, resulting in an off-centre, slightly squared look. The contrast between Levine's sculptural ceramics and McKinley's lovingly utilitarian pieces demonstrated the advancements that had been made in Canadian clay. Diverse styles and aesthetics combined with enormous technical skill and daring led to increasing attention from an international audience.

Six historical quotes regarding the antipathy between Americans and Canadians were taken from Raymond Reid's 1973 book *The Canadian Style* and scattered throughout the special edition of *Craft Horizons* in separate small text panels. Reid's book sought to demonstrate the unique character of Canada by examining statements Canadians had made about themselves. One of his goals was to overcome the perception that Americans and Canadians were essentially the same, "after a few minutes discussion with Americans, a Canadian soon begins to realize that he is talking from a different set of premises, a different national experience, a different background."[65] An 1895 quote from Lady Aberdeen, the wife of the former governor general of Canada and supporter of the Women's Art Association that

later became the Canadian Handicrafts Guild, was featured: " ... for myself, my antipathy to the essential spirit of the American people, their customs, their everything, grows every time I come into contact with them, and my thankfulness that there is still such an essential difference between them and the Canadians." The quotes operated, however, as playful reminders of the tensions that historically existed between Canadians and Americans, and the segment was a celebration of the shared approach to professional crafts in North America.

Nestled in the letters page of the magazine was a reminder of the existence of the growing debate in North America over the increasing use of art-craft to represent all contemporary craft. David Smith of Maine, a production potter, had written in disgust over *Craft Horizons'* earlier feature article on the sculptural funk ceramics of California's Robert Arneson. Smith argued that the recognition of Arneson "is a blow to the identity of the craft potter – a slap in the face and an insult that cannot go unrationalized any longer."[66] Although the national craft organizations and the World Crafts Council had decided that North America was to be represented through art craft at the 1974 conference and exhibition, this was not a view shared by all practicing craftspeople.

Rose Slivka used one of several new Margaret Atwood poems featured in the issue to open her editorial. Many of the poems alluded to the struggle between machines and human creativity, a theme which continued to be popular in discussions of the importance of craft. Following Slivka's poetic tribute to North America's pioneering craft spirit was Atwood's poem, "For G. Making a Garden," set among photographs of the Canadian landscape and craft objects.

This anti-machine spirit enabled organizers to bridge the obvious gap between Western and non-Western craft objects represented in the exhibition. Crafts appeared to be the ideal medium for the revolutionary spirit of the 1960s; supporting the back-to-the-land movement, and the creation of a global community through the commonality of the hand. Theoretically this was so, but beneath each of these individual movements there remained tensions separating the centre from periphery, for it was the centre that continued to decide how and what crafts were participants in the cultural shifts of the times.

In determining the type of crafts to be submitted to the New York jury from each national group, the organizing committee expected that "special emphasis will be placed upon those crafts for which each country is justly known. Many countries will select objects of popular or folk art, while others will select the work of contemporary designer-craftsmen and some countries

will appropriately select both kinds."[67] The juries at both the national and international levels approached the crafts with certain preconceived expectations. As the Canadian example shows, it was each national committee's taste and perception that were sent forward.

The question must be asked: was self-identification suppressed in the attempt to create an image of national craft? The main emphasis of the seventy separate national juries appears to have been on harmony. By examining the objects and demonstrators involved in the final exhibition, it appears that the creation of a harmonious image for the global craft community was of primary importance. Issues relating to the role of craft within non-Western societies, such as the impact of income generated from crafts on gender relations, the patriarchal basis of global capitalism, and the gender systems operating in specific indigenous groups, were not considered by the Canadian and US organizers. Instead, they were concerned with creating an exhibition that replicated the ideology of harmony through craft.[68] The final international jury, composed exclusively of members from industrialized nations, could only approach their final selection with the gazes they possessed.

Dichotomy and Division: Exhibiting the Global Craft Community at *In Praise of Hands*

Taizo Miake, the Ontario Science Centre's director of Programs and Exhibitions, was excited by the opportunity to design an international craft exhibition. Like many of the World Crafts Council organizers, he believed that the early technology embodied in craft was relevant to a science centre. His hope was to create a non-traditional exhibition, opening up objects to physical interaction with viewers; however, many of the traditional ritual objects in the exhibition continued to be presented in an anthropological or ethnological manner as exotic curiosities. This was in contrast to the art craft pieces, particularly the textiles, which were hung directly along the viewer's path. Miake's design featured an ornate two-storey wooden structure in the Great Hall, intended to keep viewers moving past exhibits that were accessible to their touch. *The New York Times* described this arrangement as "a giant double decker structure. In that outsized jungle gym, gossamer laces, multi-coloured tie-dyes, bold patchworks and exotic prints function as canopies or hang from the rafters."[69] The lower level was referred to as the "action deck" providing space for the demonstration booths. Although visitors and participants alike enjoyed the interactive nature of the exhibition, the high attendance put certain objects at risk, in particular the textiles.[70]

In Praise of Hands, exhibition view, 1974. Photo courtesy of the Ontario Science Centre and Gordon Barnes.

More than 600,000 visitors were able to touch many of the wall hangings, which were hung to correspond with participation rather than contemplation. As Kay Kritzwiser of the *Globe and Mail* remarked, "If I have any criticism of the installation, it's that full justice hasn't been done to the wall hangings. You get bisected views, and I shudder to think what that feather carpet by Spain's Esperanza Rodriguez will look like if many more dumb women ruffle it."[71] By August, work was being damaged through constant interaction, and organizers were forced to remedy the circumstances that had raised insurance concerns. The *New York Times* analyzed the situation as an ideological gap between the World Craft Council's "look" policy and the Ontario Science Centre's "touch" policy. After debate between the two organizations, the World Craft Council had the display assessed by an insurance company, and twenty-three fibre pieces were removed from the exhibition. These pieces were temporarily exhibited at the Science Centre warehouse, situated one mile from the Centre, causing controversy, particularly among visitors who

had come to see the missing textile pieces.[72] With the exception of certain "art" pieces and ritual objects, visitors to In Praise of Hands were able to enjoy physical contact with the objects in addition to interacting with the crafts-people, affording intimacy and nostalgia while opening up their experience to multiple senses: "And down there in a corner of the exhibition centre, suddenly we were in a crofter's kitchen, where hands were busy, patiently, monotonously combing the fleece, carding wool, spinning it on wheels directed by a rhythmic foot ... where the clacking of tongues and bits of songs and story-telling fall so sweetly on the ear in a day when the ear hears not a thing but that cursed television blither. This kind of personal emphasis in a vast and beautiful exhibition dedicated to the hands of the world."[73]

This process of exhibition and consumption was similar to that of craft fairs, a phenomenon that was growing in popularity across North America and Europe.[74] These interactions were in opposition to traditional gallery spaces that utilize the observer paradigm, where observer and object are two autonomous realities.[75] Modernist tradition dictates that visual art must rely on a single sense for artistic authority and is resistant to an aesthetic synes-thesia, for it erodes the hierarchy of economic, cultural, and symbolic value, which has been cultivated to divide art spaces along class, race, and gender lines. The British craft theorist Pamela Johnson has argued that the value of crafts lies in helping to restore conceptual responses to the realm of the sens-es, that the contemporary interest in craft is not one of nostalgia but rather one of fulfillment, recapturing the ability to engage with the world through materials and narrative.[76] In Praise of Hands marked an important moment in the precursor to the postmodern reconsideration of gallery display tech-niques, providing new possibilities for the display of craft and the disruption of the accepted hierarchy of the visual.

While the organizers of In Praise of Hands believed the exhibition capable of offsetting the reality of the marginalization of many World Craft Council members, the international craft community was subject to the binarism of centre and periphery made evident through both the craft objects and the demonstrators. This difference can be clearly discerned in the classifications of craft used in the exhibition and book In Praise of Hands. Five categories were utilized: Apparel and Adornment; The Home: Utility and Embellishment; Play; Ritual and Celebration; and the Maker's Statement (Clay, Glass, Metal, Fibre). The majority of conceptual pieces, all the work of craftspeople from industrialized nations, were placed in the Maker's Statement category. These pieces were signed and formally attributed to individual makers. Very few of the Western pieces in other categories were anonymous, operating in contrast to a significant percentage of non-Western traditional items. For

example, in the "Apparel and Adornment" chapter, almost 50 percent of non-Western objects were anonymous. This ratio was reversed in the "Maker's Statement" chapter, where 95 percent of the objects were attributed to specific Western craftspeople.[77]

The split between traditional and non-traditional crafts was encapsulated in the essays contained in the book *In Praise of Hands*. Ironically, the book began with an extract from Soetsu Yanagi's "The Kizaemon Tea-Bowl," adapted by Bernard Leach, which espoused the beauty of simple, functional crafts: "Its healthiness is implicit in its function."[78] This sentiment accorded well with the essay "Use and Contemplation" by the Mexican poet Octavio Paz. Paz was not a casual choice for the exhibition essayist, he was well known for his controversial relationship with the Mexican Government over the 1968 Mexican massacre of students prior to the Olympic games. A Nobel Prize winner, Paz had many international connections; he had served as the Mexican cultural attaché to Paris from 1945 to 1951 and served as the Mexican ambassador in India from 1962 to 1968. His US connections were strengthened during his tenure as the Charles Eliot Norton Professor at Harvard University from 1971 to 1972.[79] Arguing that usefulness made handcrafted objects captivating, Paz identified major issues affecting a global craft community that paralleled the problematics raised by the exhibition. In a critique of the display techniques associated with craft objects, he urged viewers to remember the historical contexts and specific functions that were intimately related to the senses beyond sight: "Not an object to contemplate: an object to use." Although it could "acquit itself honorably" in the museum setting, craft did not share the destiny of art, which was "the air-conditioned eternity of the museum." Contradicting the World Craft Council ideals of government support for craft and the global village, Paz positioned craft as a local rather than international phenomenon, adding that "bureaucracies are the natural enemy of the craftsman, and each time that they attempt to 'guide' him, they corrupt his sensibility, mutilate his imagination and debase his handiwork."[80] In underscoring the impossibility of global unity due to the persistence of local communities, Paz was rebelling against popular sociological theories of the time. In contrast, James Plaut's essay "A World Family" maintained the theme of the united world.

Utilizing the essentialist symbol of the hand featured in Harold Town's poster for the exhibition, Plaut wrote, "Whatever their differences of origin, race, tradition, geography, or social order, the world's craftsmen have one thing – one great gift – in common. They work, create and achieve *with their hands* ... the dominant, overwhelming impact of this assemblage of the world's crafts is that it underscores the *universality* of craftsmanship." For his

part, Plaut seemed blissfully unaware of craft's inability to overcome political barriers. Ignoring Paz's view of government as damaging craft development, Plaut applauded the measures being taken by "many third world governments, made newly aware of their country's richness and tradition in the crafts."[81]

The eleven-day conference was marked by a series of panels on topics relating to the crafts. The panel topics ranged from "Education through International Communication" and "Design for Production" to "The Preservation of the Cultural Values of a Society through Craftsmanship."[82] The theme of government was central to the conference as well as the exhibition. North American organizers decided to hold a special international seminar called "Government Participation in Crafts." Although the Canadian Committee worried that such a panel might generate a negative response toward government involvement, the federal and Ontario governments sponsored the visit of several international speakers. Viscount Eccles, chairman of the British Library and former paymaster general, chaired the session, which was considered a success.[83] The capitalist overtones of the government session fed into a discussion of marketing, one of the key issues at the conference. The World Crafts Council had prepared a study, "Marketing Crafts from the Third World," done by a US research firm, and this formed the nucleus of many of the seminar discussions. The popularity of non-Western craft products led the World Crafts Council to worry about the possible exploitation of craftspeople by wholesalers and importers. The Council believed that government supervision of the crafts could provide proper assistance in marketing crafts.[84] Plaut credited the purchase of these imported goods by North American and European consumers with drawing the world's attention to the crafts of the "third world," which he believed were fragile and in need of preservation. This sentiment echoed that of the early Canadian Handicrafts Guild with its dedication to the preservation of Canada's Indigenous crafts, a largely female concern that has been linked to the "civilizing mission" of imperialism. Indeed, the imperialistic overtones of In Praise of Hands are undeniable, from the ethnological approach to the non-Western crafts on display to the importation of "exotic" demonstrators who were on display outside the Science Centre and in the "Great Hall" below the gallery space.

The Toronto Star reported on the Benson and Hedges's "Craftsmen's Stopover" house on Prince Arthur Avenue in Toronto. Paradoxically, the Tibetan and Danish couples featured in the article were Canadian citizens who had been brought to In Praise of Hands to demonstrate not as Canadians but as Tibetans and Danes. They were demonstrators at the exhibition, but their traditional crafts of weaving and lace-making were not part of the official

Mennonite women demonstrating quilting at *In Praise of Hands*, 1974. Photo courtesy of the Ontario Science Centre and Gordon Barnes.

Canadian entries.[85] According to Tanya Harrod, British representatives at *In Praise of Hands* were disturbed by the strong presence of marginalized ethnic demonstrators. Harrod quotes Marigold Coleman's review of the show in the journal *Crafts*, where Coleman expressed worry about the ethics of the conference, describing a Mexican (most likely Jose Sanchez) in traditional dress demonstrating his craft: "He raised too many questions in my mind about the reasons for his work, the validity of its context, the alternatives open to him and the buying power of his remuneration after others had taken their cut."[86]

 Richard Baumin and Patricia Sawih believe that the role of folk life participants in festivals and exhibitions constitutes a political field independent of the larger political arenas. In their article "The Politics of Participation in Folk life Festivals" they provide the perspective of the participant rather than the organizer, claiming that the adaptation and reframing of the activities the folk demonstrators are expected to perform is a complex and problematic process. The power and authority rests in the hands of the festival producers, who dictate the space and format available to the demonstrators: in an effort to promulgate the organizers' ideologies, "participants can all too easily be taken as relatively passive and objectified communicative instruments in the

service of a larger message."[87] For craftspeople demonstrating at *In Praise of Hands*, these constraints were in operation. Although the global nature of craft and the universal quality of the hand were intended to unite all crafts-people, demonstrators performed in a decontextualized setting, under the watchful eye of Western organizers and officials.

The demonstrations of craftspeople as well as their objects continued a long tradition of the display of the "other" in Western exhibitions. While *In Praise of Hands* was juried and displayed as an art exhibition, the presence of continuous demonstrators, the sale of the pieces in the show and the partici-pation of visitors turned it into a celebratory event with obvious ties to the tradition of the exposition. Curtis M. Hinsley describes expositions as imperi-alist in their conception and construction, beginning with the 1851 Great International Exposition at London's Crystal Palace. Hinsley argues that all subsequent fairs contained two aspects: the display of industrial achievement and the exhibition of primitive "others" collected from the colonies. The first US exposition, the 1853 New York "Crystal Palace" fair, under the direction of Phineas T. Barnum, featured the "Wild Man of Borneo," Fijian man-eaters, and three hundred Natives from fifty tribes under the direction of "George Anderson, the Famous Texas Scout."[88] People, Hinsley demonstrates, were raw material. The Paris Exposition of 1889 introduced the popular display of ethnographic villages, where visitors were educated in human culture by viewing imported "others" undertaking ritual tasks in their "natural" setting. Chicago's 1893 World Exposition was supervised by the Smithsonian Institu-tion and intended to replace Barnum's earlier side show display of exotic peoples with "an illustrated encyclopedia of humanity," in an effort "to edu-cate and formulate the Modern." The anthropologist Franz Boas, who influ-enced Canadian ethnographer Marius Barbeau, was chief assistant for the Chicago exposition and brought in a group of Kwakiutl Indians from British Columbia, along with an entire village from Skidegate, Queen Charlotte Islands, which was reassembled on the fair grounds. Hinsley notes that despite the presence of a Native village at the fair, the Kwakiutl people had to sleep on the floor of the stock pavilion. The display of ethnic groups at these fairs was utilized as a marketing tool. By constructing the identity of "others" in relation to the centered viewing subject, these fairs indicated that the way to overcome these differences was through the equality of trade and exchange. The process of commodification, Hinsley argues, was the great "equalizer," comforting Western audiences with the knowledge that "the world, no matter, how bizarre, is reducible to cash terms."[89]

Although *In Praise of Hands* intended to overcome inequalities between international craftspeople, many of Hinsley's arguments apply to the exhibi-

tion. All objects were for sale in the exhibition, and the conference seminars on government and marketing worked toward a greater freedom of exchange of craft as commodity. The flow of goods, however, remained from the periphery to the centre, replicating the colonial structures at the base of earlier expositions. In general, non-Western craftspeople sponsored to demonstrate at *In Praise of Hands* could retail their work but did not possess the capital to purchase pieces, particularly those done by the artist craftspeople of North American and Europe. Attendance lists indicate that there was a limited number of attendees from non-Western countries.[90] The universal symbol of the hand and the emergence of discourse surrounding "handcraftsmanship," "handcrafted," and "handcraftsmen" allowed Western consumers to believe they were contributing to a better lifestyle for "third world" craftspeople. At the same time, the marketing of non-Western crafts relied on easy categorizations of these products as exotic, non-industrialized craft done in remote villages by indigenous peoples. This stereotyping remains intact today.

Carol Hendrickson's analysis of mail-order catalogue images of Guatemalan craft demonstrates that Mayan products remain classified as "primitive" in the Western world. The terminology surrounding these objects refer to the distance of their exotic geographic origins. Hendrickson summarizes that the transnational presentation of craft leads to the intimacy and familiarity purchasers feel toward these objects and makers. These catalogues with their generic use of "primitive," referring to no single national, cultural, or social group, lead Western consumers to believe that their patronage of these craftspeople will allow them to make positive changes in the world.[91] Like the early Canadian Handicrafts Guild's mission of Christian charity through the crafts, the philanthropic purchases of contemporary consumers reflects a desire to preserve traditional crafts described as facing extinction. The World Crafts Council stressed the concept of preservation through Western intervention. In his catalogue essay, Plaut wrote of the "curious paradox" of nonindustrial crafts: "left alone, the indigenous crafts would have ceased to exist."[92] The changes forced on these crafts as imperialist intervention forced them to adapt to industrialized markets and the expectations of Western consumers remained unacknowledged by the World Crafts Council; however, reviewers of the exhibition noted the obvious difference between Western and non-Western participation, frequently describing it as a breakdown between conceptual and traditional craft.

Kay Kritzwiser, reviewer for the *Globe and Mail*, quoted Plaut on the paradox of the survival of indigenous craft, going on to critique the strong presence of art craft, which she felt fell below the standards set by the more

traditional pieces. Kritzwiser revealed how the contrast between traditional and non-traditional objects in the exhibition had forced her to philosophize on the relationship between art and craft. She concluded the two were not compatible. Her admiration for the "wool, dyed and woven into garments, into useful accessories and truly gorgeous hangings" contrasted with her contempt for the US ceramist Patti Warashina Bauer's "Car Kiln," a "silly clay car." Conceding that Warashina's piece made of "hand built clay with low fire clay glaze, underglazes and china paint, wood and leather base" was a marvel of technology, Kritzwiser felt the "Car Kiln" was symptomatic of the descent of the crafts of developed countries into "Tom Wolfe's The Kandy Kolored Tangerine Flake Streamline Baby Syndrome." For Kritzwiser, craft was an object to live with, not "a showcase of ego," which she believed described the ceramic objects, in particular Australian ceramist Joan Ground's stoneware wrapped parcel, which promised on the ceramic label that it contained a traditional tea set inside the conceptual exterior.[93] In contrast Sol Littman of the *Toronto Star* took the opportunity to criticize what he saw as the conservative nature of Canada's official entries to *In Praise of Hands*. Littman was excited by the items in *Ceramics '74*, the Canadian Guild of Potters annual exhibition, composed mainly of sculptural ceramics: Joe Fafard's portrait figures, Victor Cicansky's "Champagne Fountain" showing a farmer leaving an outhouse, David Gilhooly's frog woman perched on a cookie jar, Gathie Falk's "funky" dinner set; "Throughout the United States and Canada, the barriers separating 'art' and 'craft' have been tumbling down. Potters, weavers and leather workers are no longer content to make cookie jars, stoles and sandals. Instead they talk of 'sculpture in thread,' 'ceramic sculpture,' 'leather art' ... these works say more about where we are today than the mannered pieces selected by the judges [of *In Praise of Hands*]."[94]

New York Times reviewer Rita Reif shared Kritzwiser's enthusiasms, stating in her article that the traditional items "pulse with the greatest power." Reif was more neutral toward the non-traditional ceramics, which she described as continuing to "reflect trends in the world of painting and sculpture, especially pop art," citing Grounds's stoneware parcel as her example. The traditional ceramics, Reif argued, including a platter by Shoji Hamada, "possess in their simplicity and obvious functionalism something far more memorable."[95] British reviews of the exhibition took the opposite approach, insisting that the dominance of traditional crafts "had the effect of drowning out everyone else and unbalancing the exhibition."[96] Reviews of *In Praise of Hands*, ranging from Rose Slivka and Marigold Coleman's endorsements of art in craft to Kay Kritzweiser's disdain for the art of craft, were among the first to delve into the art/craft binarism that continues to divide the craft world.

While the theme of art versus craft had certainly been alluded to in earlier writing, foreshadowed by the debate over the definition of professional, the World Crafts Council events of 1974 highlighted the differences between functional and non-functional craft, as well as the split between non-Western and Western objects, resulting in an unresolved ideological divide.

Canadian Indian Art 74

In an effort to redress previous exclusions, the Indian and Eskimo Committee of the Guild grappled with how it should present Native art during *In Praise of Hands*. As early as 1968, the women of the Committee had been concerned about the future role of the Guild in assisting Native craftspeople. Committee chair Diana McDougall stated her concerns in a letter to the Guild president Herman Voaden: "I feel that it is our responsibility to show the nation and visitors to the nation that we strongly maintain our interest in Native crafts. There are craftsmen amongst the Indians who are thinking and working along contemporary lines and I feel that a small exhibition by invitation of some of the better artists ... would contribute greatly to the work of the National Guild. It is true that the federal and provincial governments are increasingly concerned about our Native crafts but I feel that as a National Guild of Canadian Crafts we cannot ignore the Indians and Eskimos as Canadian craftsmen."[97] Elizabeth McCutcheon, who was to become Committee chair in 1970, was put in charge of the Guild exhibition *Canadian Indian Arts/Crafts '70* to be held at Place Bonaventure in Montreal. An announcement for entries was issued in English and French with space for translation into Indian languages. The Committee had approached the National Indian Brotherhood, a group of Native cultural leaders, for help in advertising the exhibition. The Committee sponsored a visit to Montreal by Kwakiutl Chief James Sewid, the vice-president of the British Columbia Brotherhood, to promote his autobiography *Guests Never Leave Hungry*. Alice Lighthall, the founder of the Indian and Eskimo Committee, worked with McCutcheon on the exhibition and was active in encouraging the increased participation of Native craftspeople and leaders. *Canadian Indian Arts/Crafts* operated as an exhibition, competition, and sale; it ran from 10 to 22 November 1970. Jury members Tom Hill, Art Price, and Jean Noel Poliquin selected 235 of the 295 submissions the Committee received. Tom Hill, now the director of the Woodlands Cultural Centre, is a Seneca Indian from the Six Nations Reserve in Ontario who at that time was working at the Department of Indian Affairs. Price was a Native artist who had actively promoted the importance of traditional First

Nations' designs in contemporary work. Poliquin was a full-time Francophone artist. Chief George Manuel, president of the National Indian Brotherhood gave the opening address for the exhibition, commending the Guild for its continuing efforts in supporting Native craftspeople.[98] *Canadian Indian Arts/Crafts '70* was a tremendous success, and, in an effort to continue the advances being made toward artistic independence by Indigenous craftspeople the earlier philanthropic "subjects" of the Guild, the committee made a radical decision.[99]

In January 1972, committee chair Elizabeth McCutcheon, with the support of Tom Hill, requested that the Guild undertake a show dedicated to contemporary and traditional Native arts and crafts, this to run concurrently with the World Crafts Council conference and exhibition. When Hill had discovered that the World Crafts Council exhibition was coming to Toronto, he asked the Guild to consider undertaking a separate Native art exhibition. According to Hill, his suggestion did not sit well with some members of the Guild's Committee: "There was some resistance – the World Crafts Council was going to incorporate Native craft in its exhibition so why have it separate?" Hill had argued that it was necessary "to get people to look at Indian art and craft differently ... the Guild was dictating what sells and doesn't sell, but they couldn't dictate our ideas."[100] Alice Lighthall and Elizabeth McCutcheon were supportive of the idea of artistic freedom for Native craftspeople and approached Webb, who agreed with the need for a separate Native art and craft exhibition. In her argument to the Guild for such an exhibition, McCutcheon claimed that, "Indian Affairs, since Mr. Tom Hill started working for them, has been doing increasingly more ... I would like to see an exhibition of Indian work that is both modern and traditional."[101] Her proposal was approved, and in the summer of 1972 the Royal Ontario Museum agreed to host the show. Hill was the natural choice as curator of the exhibition.

Tom Hill was known for his book *Indian Art in Canada*, one of the first to present contemporary Native craft as legitimate art. The Department of Indian Affairs agreed to release Hill from his regular duties in order to act as the coordinator of the exhibition. Along with Dr E.S. Rogers of the Royal Ontario Museum, Hill set out across Canada collecting contemporary pieces for the exhibition, to contrast with historical pieces from the Royal Ontario Museum's collection.[102] The Department of Northern Affairs, the Guild, and the Royal Ontario Museum contributed $90,000 toward the exhibition, with the Central Marketing Division of Indian Affairs agreeing to purchase the contemporary objects in the exhibition for future shows in Canada and abroad. Most important to Hill was the designation of the final jury for the

objects he was amassing. It was agreed that Hill would select the jury, com-
posed of "Indian people with artistic backgrounds."[103] The exhibition, named
Canadian Indian Art 74, would provide Native craftspeople with the opportu-
nity to make a statement to the international craft community about their
contemporary production.[104] As well as sponsoring the exhibition, the Depart-
ment of Indian Affairs arranged an Inuit art seminar to correspond with the
Canadian Indian Art 74 and *In Praise of Hands* exhibitions.

Tom Hill and the Development of a New Perspective on Native Craft

Through *Canadian Indian Art 74* Tom Hill offered Canadians a new perspective
on Native art and craft. In his interviews and catalogue essay, Hill deconstruct-
ed traditional approaches to Native craft as souvenir or anthropological
curiosity. "This display proposes to give the more wondrous arts and crafts an
identity that will distinguish it from a vast quantity of souvenirs being pro-
duced," Hill told the *Indian News*.[105] In an interview for *Art Magazine,* Hill theo-
rized three key reasons for the decline of Indigenous art and craft during the
late nineteenth and early twentieth centuries: the adaptation of Native art
forms to the predominant taste of the Western world for commercial success;
the attitude of Victorian Canadians toward Native art as anthropological rem-
nant and the popularity of "curios" in Victorian parlours; and the Canadian
Government's official policy of assimilation, specifically Section 114 of the
Criminal Code of Canada in force until 1951 and forbidding "pagan rites."[106]
The exhibition attempted to shift the boundaries defining Native craft and
art, and reviews indicated that Hill's educational mission was succeeding.

Hill stressed that traditionally Native arts and crafts were not classified
according to Western categorizations. Native languages are more verb than
noun oriented, therefore the idea of craft is predicated on the notion of
doing something rather than the finished object: "the creative process is
more important than the end result."[107] The *Globe and Mail* described the
"hazy boundary" between craft and art occupied by the contemporary craft
objects utilizing traditional forms to make modern, individual statements.
John Blueboy's twig decoys made of woven tamarack reeds were praised for
their stylized and graceful form, and the abstracted Salish tapestries of Ely
and Monica Phillips were credited with translating a traditional geese in for-
mation pattern into a bold geometric design.[108] Blueboy, affiliated with the
Eastern Woods Cree, created his geese from delicately woven tamarack twigs,
which he shaped by wrapping them with a fine, thin thread that tapered into
a tightly tied little knot for the tail. The form is elegant. A generous oval for

John Blueboy, Twig decoy, 1974. Tamarack twigs, 35 x 21 x 45 cm. Photo courtesy of the Canadian Museum of Civilization.

the body squeezes into a long, thin neck leading up to a negative space suggesting the face of the goose, finished with a pointed, thin, beak. Three delicate twigs support the decoy. The geese, which were made in a variety of sizes ranging from ten to almost forty centimetres in height, remain one of the most easily recognizable Native craft images of the period.

Monica and Ely Phillips's stylized wool blankets titled "Flying Geese," captured the attention of critics and audiences alike. By successfully adapting the traditional Coast Salish craft of woven handspun wool blankets into large, abstracted wallhangings, the Phillips forcefully demonstrated how contemporary First Nations craftspeople were operating outside the confines of restrictive souvenir craft production. Over three metres in height, the two blankets exhibited at *Canadian Indian Art 74* played off each other through the Phillips's use of contrasting colours. One blanket featured a blue background with white geese, while the other inverted the colour scheme. The geese are depicted as long rectangular shapes with triangles for heads lined up in a row over the surface of the blanket. This image was also used on the Phillips's "Salish Weaving" logo and label. Like the minimalist canvases popular in 1973,

when the blankets were created, bold bands of abstracted colour successfully play off of the contrasting background, resulting in wallhangings of startling intensity. Unlike their minimalist counterparts, the Phillips's work also offers the viewer a material rich in Native history. The blanket's surfaces are full of variations. The hand carded and spun wool, dyed with natural dyes, provide blues that range from dark indigos to light shades of sky while knots and bumps on the surface of the wool keep the images from becoming static.

The separation of Indigenous craft from the universalizing *In Praise of Hands* exhibition helped to highlight the professional nature of contemporary Native craftspeople. Hill's desire to give First Nations' craftspeople the opportunity to participate on a separate but equal level with other Canadian professionals was realized through the exhibition, and in his catalogue introduction he was careful to thank Elizabeth McCutcheon and the Canadian Guild of Crafts for taking the initiative in providing a new awareness of the cultural experience of Native Canadians.

The Canadian Crafts Council

Canadian Indian Art '74 provided the setting for a pivotal moment during the Conference: the retirement of Aileen Osborn Webb from the presidency of the World Crafts Council. At age eighty-two, Webb was ready to step aside as the leader of the organization she had founded and helped to fund for a decade. The *New York Times* described Webb as "the talk of the conference," with Joan Chalmers proclaiming that "she's not the initiator, she's the glue of this movement."[109] Praise for Webb filled the conference reports. Webb's successor as president, Viscount Eccles, told the 1,500 attendees, "What a patron saint you have had. Without her where should we be today? Not here in Toronto, at best poking around a craft shop in our own country."[110] The official book, *In Praise of Hands*, was dedicated to Webb and Margaret Patch, who had helped Webb to initiate the World Crafts Council, and described them as "two American women of courage, generosity, and vision, pioneers in befriending and supporting craftsmen everywhere."[111] Conference notes, reviews, and discussions offered no critiques of Webb's universalizing view of the crafts nor her position as a dominant imperial force on the international craft scene. Instead, Canadian organizers expressed sincere sadness over her departure as World Crafts Council president.

A decade after Webb's First World Crafts Congress had forced Canadian craftspeople and administrators to assess the challenges they faced as a national group, Webb's retirement marked the birth of the Canadian Crafts

Council, an idealistic project designed to continue the dream for the unification of professional craftspeople across provincial borders. Mary Eileen Hogg's speech at the conference opening was a tribute to Webb and her role in guiding Canadian crafts onto the professional scene: "We appreciate your generous offering of guidance and encouragement and your enthusiastic response to artistic accomplishments ... Mrs Webb, thank you from all of us. We respect you and we love you."[112] The Canadian committee of the World Crafts Council presented Webb with a pot by Bailey Leslie, one of the Canadians whose work was selected for the exhibition. In the ceremony at the Royal Ontario Museum, Webb was celebrated again by the Canadian Committee, who arranged to have Webb participate in a ceremonial dance by the Jimmy Skye Dancers of the Six Nations Reserve. Engaging in this ritual of Native exhibition, with its allusions to the long history of Indigenous encounters with dominant white culture, was an ironically symbolic exit for Webb, who had seemingly managed to unite the crafts of the world. Her exit was timely as the ideological separations between traditional and conceptual craft as well as tensions between Western and non-Western craftspeople were threatening to erode her project of a globally harmonious craft world.

Hogg's tribute to Webb promised that Canadians would continue to work toward "strengthening that internationally common bond" celebrated at *In Praise of Hands*.[113] The excitement surrounding the success of the conference and exhibition overshadowed the founding meeting of the newly formed Canadian Crafts Council on 15 June 1974. Celebrated as a truly Canadian organization and endorsed by the federal government and by both of the former groups, the Canadian Crafts Council was nonetheless plagued by issues that had surfaced during the previous decades. The Conseil des métiers d'art du Québec agreed in principle with the amalgamation but felt that it still was not receiving fair representation at the national level. Native craftspeople had been offered an olive branch by the Canadian Guild of Crafts in the form of *Canadian Indian Art '74*, but they were not participants in the new organization. Members struggled to balance the desire for inclusive membership with the maintenance of professional standards. As well, the dependence on government sources of funding, acclaimed by Webb as "taking the lead ... in the development of craftsmen sponsored by government help," threatened to lead to complaisance and a lack of private philanthropy and commercial support.[114]

The struggle to define professionalism and set new standards for Canadian craft in the years preceding *In Praise of Hands* would be followed by decades of unprecedented national and international success for Canadian craftspeople. The formation of the Canadian Crafts Council was an important step in focus-

ing professional experts into one organization that could effectively lobby the federal government. Experts were called upon to operate within the new group, but ideas around innovation, self-regulation, and even the definition of craft plagued the new group. The location of the Council in Ottawa made sense in terms of government lobbying; however, the power of this new group was increasingly tested by the rise of provincial craft councils, with their attendant regional experts. It seemed that the internal problems faced by the Canadian Crafts Council at its inception as a national body foreshadowed some of the future difficulties that it would confront.

6

The Professional Ascendancy of the Crafts

TO THE INTERNATIONAL PARTICIPANTS AT THE 1974 WORLD CRAFTS COUNCIL conference in Toronto, it may well have appeared that the crafts in Canada had reached a stage of full professionalism. The tenth anniversary conference of the World Crafts Council and its exhibition *In Praise of Hands* had enjoyed great success, and the Canadians who had helped the events to achieve such prominence were poised to set up a new national organization designed to further enhance the perceived quality of craft production. As previous chapters have demonstrated, any such reading of the situation would have been false. Even a glance beneath the surface of the Toronto events, including the founding session of the Canadian Crafts Council, would have revealed serious fissures, indicative of the complex nature of the Canadian context. In the haste to reactivate a national craft strategy, brought about by the selection of a Canadian venue for the World Crafts Council conference and by pressure from the Canadian Government agencies, a great deal had been left outstanding. There had been no resolution of how to address the concerns of the representatives of Quebec craftspeople, and relations with the burgeoning field of contemporary First Nations craft continued to be clumsy. Moreover, there was much to suggest that the influence of Ontario craft organizers had reached a level of great imbalance: in any sphere of Canadian activity, the perceived dominance of that province is scrutinized and viewed with dismay. The push to strengthen provincial craft councils in the face of the continuing threat of Canadian centrism was inevitable.

Faced with many challenges, the Council benefited from the widespread popularity of the crafts in the 1970s. The fashion for crafts led to increasing

government support for craft projects and opportunities for craftspeople to argue that their professional standards necessitated shifts in the classification of craft within the fine arts hierarchy. In the 1980s, economic realities began to negatively impact the market for craft, while simultaneously the field experienced watershed moments in the public recognition of craft by major institutions. As a result, the 1990s featured market-savvy craftspeople producing carefully designed craft objects. During this decade, and continuing today, craftspeople and administrators were provided with unprecedented opportunities to vocalize their concerns over the status of craft through an increase in curators receptive to craft, a wide range of exhibitions, the establishment of craft history courses, conferences, and academic publications.

What were the indicators that Canadian crafts had reached a level of mature professionalism post-1974? Foremost was the widespread acceptance of professional frameworks, including specialized craft language and knowledge structures that were respected and widely recognized. Practitioners, patrons, and bureaucrats accepted terms like sculptural wall works, fine crafts, and interdisciplinarity. The dissemination of this ideology continued through educational programs designed to train technically skilled and conceptually articulate craftspeople. As a result of the implementation of these professional infrastructures rewards grew for the craft community. Self-regulating organizations, including the Canadian Crafts Council, oversaw the institution of high-profile awards like the Saidye Bronfman Award and lobbied for the presence of craft experts and the inclusion of craft objects in realms previously reserved for "art," such as Canada's national museums and galleries and the Canada Council. This led to increasing financial rewards as the market that had been established for craft grew at a remarkable rate, enabling many professional craftspeople to live successfully as independent, self-employed makers.

Defining Craft

Peter Weinrich, the executive director of the Canadian Crafts Council from its inception in 1974, argued that the shifting status of craft was directly related to the lack of a formal definition of craft. The Council saw itself as a policy-making body for Canadian craftspeople and was therefore dependent upon providing the federal government with an easily identified official definition of craft. The struggle for government funding led to the Council's emphasis on high-quality professional production rather than popular interpretations of craft. As Peter Weinrich summarized "All sorts of people – municipalities,

provinces, federal governments, foundations and so on – are into crafts ... There is such tremendous demand for 'individual' things that damn near anything can be sold by sticking a handmade tag on it or wearing a beard and beads and flogging it at a festival ... it is effectively impossible to avoid government, and government needs to label people and set its policy."[1] Previously, members of both the Canadian Guild of Crafts and the Canadian Craftsmen's Association had attempted to define craft. The February 1965 founding meeting of the Canadian Craftsmen's Association in Winnipeg, Manitoba, had resulted in a flurry of contradictory definitions of craft and craftspeople. A decade later, Weinrich struggled to clearly articulate what was the craft and who were the craftspeople represented by the Canadian Crafts Council. By October 1974, Weinrich had created a background paper, "Working Definition of Crafts." In it he divided craftspeople into four categories: 1) producers of non-functional, decorative, or folk arts; 2) producers of utilitarian objects; 3) producers of pre- or post-mass production artifacts (to provide the models and tools for craftspeople); and 4) service and repair men [sic] (watchmakers, electricians, etc.).[2] Although these categories were reminiscent of those described by Merton Chambers in 1965, Chambers had focused on professional craftspeople, breaking that group into three sub-headings: artist-craftsperson, designer-craftsperson, and designer in the craft field.[3] Like Chambers and Anita Aarons, who had stressed the importance of professional standards for craft in her "Allied Arts" column in the journal *Architecture Canada*, Weinrich emphasized the need for craftspeople to improve their design skills. Weinrich's paper explored many possible meanings for the word *craft*, but he accepted that while "we are trying, in effect, to create a definable category somewhere between 'fine arts' and mass production ... it is very difficult to find a generally satisfactory definition."[4] This echoed the previous frustrations expressed by both the Guild and the Association in their attempts to balance inclusivity with quality.

Weinrich concluded his definition of crafts by stating that craft objects were marked by their aesthetic diversity, an argument that was readily accepted by the federal government. The Council emphasized the multiplicity of craft during its first large-scale travelling exhibition and lecture tour, *Artisan 78*, which featured the work of seventy-eight of Canada's top craftspeople. Orland Larson, president of the Canadian Crafts Council, whose own work as a goldsmith embodied both professional standards of craftsmanship and an exploration of new directions for traditional craft materials, travelled across Canada, lecturing on the high quality of contemporary craft. The National Gallery of Canada sponsored Larson's lecture tour as the final one of the Norah McCullough Lectures on Craft that had been created to honour

her retirement from the Gallery in 1968. Larson was outspoken in his media interviews, demanding public funding support for craft and questioning why the Canada Council still refused to "put us in our rightful place alongside the other artists in this country"[5] by denying a separate jury and award system for craft. The intent of Larson's tour was to introduce Canadians to the superb quality of craftsmanship promoted by the Council in order to create support for a national organization. Securing such support proved difficult as autonomous provincial craft councils were being established across the country. Larson acknowledged the tension created between federal and provincial organizations: "In the world of crafts nationalism and regionalism are at work simultaneously."[6]

Tension: The Canadian Crafts Council and its Provincial Counterparts

Between 1965 and 1980, ten provincial craft councils were incorporated.[7] Growing out of established groups, these organizations were officially mandated by provincial governments and most began receiving public funding. Representatives from each provincial council maintained a seat on the board of the Canadian Crafts Council, and they viewed themselves as parallel to, rather than integrated into, the Canadian Crafts Council. These councils developed new publications, conferences, stores, educational services, and exhibits, resulting in the establishment of quality juried exhibitions and important craft collections across Canada. As a result of the smaller regional displays mounted in the 1970s and 1980s, Canada's major galleries that had previously hosted large craft exhibitions, including the National Gallery of Canada, the Art Gallery of Ontario, and the Vancouver Art Gallery, devolved responsibility for exhibiting craft. This is reflective of the ebbing and flowing ghettoization of craft within institutions, Alan Elder argues, where museums and galleries turn to the perennially popular crafts when they are in need of more accessible and egalitarian media to increase their audience.[8]

The relationship between the provincial craft councils and the Canadian Crafts Council became increasingly problematic during the 1990s. Expectations that a national body could negotiate within and forcefully represent the bilingual, multicultural mosaic of the Canadian craft community had not been fulfilled. Unlike the American Craft Council, which was left a financial trust from Aileen Osborn Webb, or the British Crafts Council, which receives stable annual funding, federal funding to the Canadian Crafts Council was never guaranteed and fell under the responsibility of various governmental departments. Despite Peter Weinrich's early attempts to define craft, the

Council was shifted between the Department of the Secretary of State and the Department of Industry and Commerce. In the early 1990s, the Council was moved under the Department of Canadian Heritage, a damaging change that resulted in the crafts being regarded as outside the definition of "Cultural Industries" as defined in the North American Free Trade Agreement (NAFTA). Rather than being considered an economically viable part of the cultural field, Canadian crafts fell under the rubric of artisanal history.[9] During its twenty-four-year history the Council coordinated international exhibitions for the Department of External Affairs, created the national touring show *Artisan 78* and the *National Invitational Crafts Exhibition* at the 1988 Winter Olympics in Calgary, organized the annual Saidye Bronfman Awards, and served as the official liaison with the World Crafts Council. Despite this, the increasingly active provincial craft councils began questioning the role played by the Canadian Crafts Council in uniting the provinces. Shortly after moving under the Department of Cultural Heritage, the federal Government of Canada withdrew its funding from the Canadian Crafts Council, citing federal cutbacks to arts organizations as the rationale.[10]

Following the withdrawal of funding, the national Canadian arts representation group (CARFAC), which wanted to develop a sector for the crafts within its organization, approached the newly reorganized Canadian Crafts Federation. In February 1999, President Robert Jekyll and former President Jan Waldorf attended a CARFAC tribunal meeting in Toronto, where they represented the concerns of craftspeople regarding incorporation into CARFAC. The craft community had reacted negatively to the proposal, fearing that CARFAC would "raise the traditional flags between art and craft again, with the visual arts steamrolling craft."[11] Jekyll and Waldorf cited poor communications between the sectors over the years and the lack of knowledge CARFAC possessed on craft as major concerns. According to Jekyll, at the end of the tribunal CARFAC representatives stated that all they wanted to do was represent the visual arts community as a whole; therefore only craftspeople who defined themselves as visual artists would be included. *What happens to all the craftspeople that do not consider themselves to be artists?* was the question that remained unanswered at the end of the meeting.[12]

Provincial groups, including the Conseil des métiers d'art du Québec, the Alberta Crafts Council, and some of the Maritime craft councils, which had previously questioned the ability of the Council to unite crafts, threatened to terminate their memberships within the organization.[13] Jan Waldorf, the president of the Canadian Crafts Council during its difficulties in 1995, worked hard to keep the group alive despite the complete loss of funding. From 1995 to 1998 Waldorf volunteered to run the Council from her Oakville

home on a $6,000 budget with no staff, convinced that the complete loss of the Council would be impossible to repair and that, despite provincial objections, the organization was invaluable in facilitating national unity and lobbying the federal government. Waldorf cited difficult hurdles like the costs of publishing in English and French, the bureaucracy that prevented easy export of crafts into the United States, and the lack of Native participation in the Council as factors contributing to the loss of support. Native producers, uncomfortable labelling themselves as craftspeople rather than artists, were reluctant to join the Council, as they were supported under a variety of separate federal funding programs that did not make the distinction between craft and art. Although the American Craft Council during this time was struggling with developing economic strategies to cope with financial difficulties, the generous tax benefits to private individuals and corporations who assisted in its funding were not applicable to the Canadian Crafts Council.[14]

By 1998 Waldorf had succeeded in convincing provincial representatives to meet and discuss the future possibilities for the Canadian Crafts Council, which found itself in a holding pattern without the financial support to develop or make changes. A meeting was held in May 1998 in Montreal, with seven provinces represented.[15] Delegates agreed that it was important to maintain federal representation in the form of a national craft organization, but the Council's name was changed to the Canadian Crafts Federation, signaling a heightened role for provincial craft organizations. Of the provinces represented, only Ontario had formulated a proposal for dealing with the federal organization. Ontario Crafts Council President Robert Jekyll recommended that Ontario could be responsible for coordinating the provinces, and for developing a website for the Canadian Crafts Federation. This strategy met with resistance. "Vexed discussions occurred around Ontario's proposal," Jekyll states, "the subtext of the resistance being that 'it will just become another project of Central Canada.'"[16] Jekyll was not wrong in his description of this opposition. For the executive directors of the Crafts Association of British Columbia and the Conseil des métiers d'art du Québec, the overpowering presence of Central English Canada in the national organization remained a strong theme. Additionally, Yvan Gauthier, until recently the executive director of the Conseil des métiers d'art du Québec, objected to the tradition of "partly elected, partly private club" that dominated the Canadian Crafts Council. Although the new Canadian Crafts Federation representatives must be elected, Gauthier believes that the Federation will have to work hard to overcome the differences between Quebec and the other provinces because Quebec has developed an independent, aggressive marketing strategy for the crafts, one that is unafraid of money and professionalism.

The Federation, he argues, risks continuing the romanticization of craft in Canada, forcing professionals to operate alongside amateurs.[17] The generous provincial funding that is given to the Conseil des métiers d'art du Québec supports Gauthier's strong views on professionalism, entirely consistent with the history of his organization. By aggressively marketing craft through the federal government's international trade programs and launching a strong internet campaign, the Federation is successfully overcoming accusations of amateurism.

The Canadian Crafts Federation website (www.canadiancraftsfederation.ca) is beautifully designed, featuring the work of recent Bronfman Award winners and a wide variety of relevant information for Canadian craftspeople. The presence of a specially designed button offering immediate translation from English to French overcomes decades of linguistic tensions between former national craft organizations and their Francophone members. Five areas are featured on the site: Inspiration, Advocacy, Education, Connection, and Information. Inspiration begins with a constant flow of beautiful images of Canadian craft and guides the visitor through a series of brief essays on the state of contemporary craft in Canada.[18] The Education area provides information on "professional development coupled with straight forward step by step tutorials," as well as an excellent craft bibliography and a glossary of craft terms. Connection gives a full range of links to all the provincial craft council websites, professional guilds, and associations, as well as to the World Crafts Council, the American Craft Council, and the Crafts Councils of Great Britain, Australia, and France. The section that is most indicative of the transformation of Canadian crafts from historic cultural curiosities into professional artistic goods is that of Advocacy. It is obvious from this page that Quebec's strategy of aggressive craft marketing has infiltrated the new national organization, resulting in exciting directions for Canadian craft. The "Study of the Crafts Sector in Canada" prepared in May 2001 for Industry Canada and the Department of Foreign Affairs and International Trade, "Canadian Crafts: Study of the French Market" a study prepared in October 2001 for CAP EXPORT France Arts and Cultural Industries Promotion Division of the Department of Foreign Affairs and International Trade, and "Career Self-Management in the Cultural Sector: What Next" by Dana Boyle, Business Development Officer at the Consumer Products and Cultural Industries Branch of the Canadian Consulate emphasize the role of craft as cultural industry. This page serves to "put a face on an invisible industry," one which "contributes at least $14 million" annually to the North American economy.[19] While the Federation's website is an impressive new space for Canadian craft, it must be noted that there are no links to First Nations organizations, or to non-European craft councils.

There is a growing interest in the role of the internet in contemporary craft as craft techniques begin to incorporate computer technology, and craftspeople and administrators employ websites to retail their work internationally.[20] The sense that the craft world remains divided both nationally and internationally despite the advantages of new global technologies is predicated upon two binaries that figure prominently in the world of contemporary crafts. First, adherents of traditional and production craft techniques often oppose the one-off objects of artist-craftspeople. Second, the concept of a united and global craft community is unable to overcome the ideological gap between Western arguments over the art/craft split and traditional non-Western craft production. The excitement over the possibilities of new markets and audiences generated by cyberspace sounds international in scale, but as the internet is increasingly critiqued along social, cultural, political, and economic lines, it becomes clear that virtual-reality technologies are mediated spaces, operating largely within boundaries prescribed by Western culture. The expense of ensuring that websites are bilingual and the selection of craftspeople that are represented on the Canadian Crafts Federation's website remains restrictive. While over 400 million people are connected to the internet, the majority of these users are from advanced industrial societies and middle-class Western households.[21] This raises fundamental questions over the purported democracy of the virtual world and the ability of the internet to create a unified culture of craft, whether in a single geopolitical entity or globally. Despite these critiques, the internet provides an interdisciplinary tool that links craftspeople in terms of geography and media.

The Role of Native Craftspeople within Craft Organizations

With the exception of Quebec, provincial organizations maintained ideas about equal access for all craftspeople rather than pushing for the development of exclusively professional groups. Some provincial councils took up issues surrounding inclusiveness and regional identity that had not been resolved by the Canadian Crafts Council. Increasing government interest in supporting First Nations craft production led the councils to investigate ways to include contemporary Native craftspeople. Most initiatives failed. As part of the larger policy changes towards Canada's First Nations, Tom Hill's exhibition *Canadian Indian Art 74* had demonstrated the originality and professionalism of contemporary aboriginal craftspeople, dispelling previous romantic notions of the "Imaginary Indian" producing traditional or souvenir craft. The Canadian Guild of Craft's (Ontario Branch) support of the exhibition

showed the willingness of craft organizations to rethink their approach to First Nations craft and craftspeople; unfortunately the momentum generated by *Canadian Indian Art 74* was not utilized by the Canadian Crafts Council.

The federal government was anxious to assist Native craftspeople. At the First National Indian Cultural Conference in March 1970, Russell C. Honey, the Parliamentary Secretary to Jean Chrétien, then the Minister of Indian Affairs and Northern Development, outlined his ideal vision of federal programs and organizations collaborating with First Nations craftspeople: "I see a young Indian who wishes to use his respect for his heritage seeking skills and training in craftwork, in jewelry making, in fine art. I see such a young man being helped in his pursuit of training by our education programs. Then I see such a young man meeting with people like yourselves, searching for the traditional designs of his people. Then I see him converting the skills he has gained and his insights into his people's cultural heritage into products – into works of art, and I would like to think the Department could help him in designing and marketing such works so that he is amply rewarded."[22]

What neither Honey nor the Canadian Crafts Council could envision was how to involve First Nations craftspeople on the board of the Council itself. By 1974 the Council had still not dealt with the issue of Native representation. Following the success of *Canadian Indian Art 74*, Tom Hill became involved in a "Gold Label" project for the Department of Indian Affairs. Like Peter Weinrich's attempts to define craft for the federal government and the public, Hill's project intended to label the various craft objects being produced by First Nations craftspeople. Objects would be classified as fine crafts, fine arts, and production arts, with the highest quality objects receiving a gold label representing official endorsement.[23] During his work on the project Hill became interested in the issue of Native representation in the Canadian Crafts Council. As Weinrich explained to Hill, the board of the Canadian Crafts Council was comprised of five to twenty directors, representing each of the provinces and territories, with up to eight directors elected by the membership at large. During the Council's founding meeting at the World Crafts Council conference in Toronto, members agreed that due to the important role of First Nations craftspeople in Canadian culture it was imperative to have Native representation on the board. Unfortunately, the structure of the board prevented easy access for First Nations representatives, relying as it did on provincial and territorial votes. Any Native voice would be obscured by the elected member's obligation to represent his or her province or territory.[24] As a result, First Nations' voices remained unheard in Canada's national craft organization.

It is however, dangerous to assume that First Nations craftspeople necessarily felt that their absence from the board of the Canadian Crafts Council

was problematic. As Tom Hill, today the director of the Woodlands Cultural Centre in Brantford, Ontario, explains, the politics surrounding the issue of labelling Native craft affected the language structures employed by aboriginal craftspeople to explain their production.[25] Historically categorized as ethnographic curiosities or souvenirs by craft organizations and exhibitions, contemporary Native craft was increasingly recognized as valuable art-craft by the 1970s. Consequently, First Nations craftspeople were hesitant to label themselves as craftspeople. Stephen Inglis, director general of Research and Collections at the Canadian Museum of Civilization, points out that many Native craftspeople do not aspire to make craft, they aspire to make either art or specific ritual objects, utilizing craft materials to express ethnicity, community, or spirituality.[26] Recently, Aboriginal craft and art objects have been displayed alongside historical painting and sculptures at the Art Gallery of Ontario, and the National Gallery of Canada. The on-going exhibition *Art of this Land,* curated by Native artist Greg Hill was opened in 2003. It places both ancient and modern (up to the 1970s) crafts, sculptures and paintings throughout the Canadian galleries and has been credited as an important step in transforming the way First Nations artistic production is viewed. Tom Hill explains that traditionally Aboriginal craftspeople and artists made no distinction between art and craft, therefore occupying the separate space of a craft council would appear artificial. Despite the major policy changes following *Canadian Indian Art 74,* vestiges of the noblesse oblige approach to collecting First Nations craft remained intact in North America during the 1970s. This was particularly evident in the United States, where Aileen Osborn Webb's American Craft Council retained a board composed of US nobility who promoted the collecting of craft, including Native work. The media profiled Barbara Rockefeller, chairman of the board of the American Craft Council in 1977, as a genteel woman who along with her influential friends (including Joan Mondale, wife of the then vice-president of the United States) supported traditional Native craft. Reporters followed Rockefeller and Mondale around various craft exhibitions and fairs, describing their interaction with Native craft: "Mrs. Rockefeller was carrying a basket that she had just bought from ... a sweet grass basket maker."[27]

Global Disparities

The World Crafts Council had strugged with funding following its success at *In Praise of Hands,* but these financial difficulties were overcome with assistance from Webb. Paul Smith and Joan Chalmers both recall Webb's sale of important family paintings, including a piece by Paul Gauguin, to raise

money for the World Crafts Council.[28] The Council never enjoyed another conference or exhibition on the scale of *In Praise of Hands*, and, while it remains active today, it enjoys a considerably less public profile. It is evident that Webb's dedication to her vision of a global craft community was essential to the Council, but the goal of the Council proved to be unattainable. Paul Smith, a juror for the 1974 exhibition *In Praise of Hands*, notes that it was impossible to reconcile the economic and cultural differences between non-Western craftspeople who were earning fifty dollars annually producing utilitarian objects and Western craftspeople who could retail conceptual craft objects for five thousand dollars.[29] The success of *In Praise of Hands* represented the boom in craft that had been enjoyed throughout the late 1960s and the decade of the 1970s. The development of a craft aesthetic, with its focus on heavily textured surfaces and an adherence to natural material and colours, was often linked with lifestyle. It was assumed that to make or purchase craft one embraced the desire for a simpler world. The notion of global unity through craft continued this romantic vision. While craft and lifestyle were certainly united for many craftspeople and consumers, this period also witnessed the emergence of the professional craftsperson. Conscientious to avoid accusations of amateurism, the push for standards by this group of craftspeople and organizers resulted in tremendous advances for craft during the 1960s and 1970s. The implementation of new university programs, national and international exhibitions, galleries, outlets, and publications was inspired by and contributed to the ascension of professional craft. Many assumed that the seemingly endless market for crafts of all types would remain unabated; however, Webb's death in 1979 marked the beginning of a transitional period for North American crafts.

Crisis and Watershed: The 1980s

1982 was a pivotal year for Canadian craft. Confidence in the strong economy that had driven the apparently endless growth of craft during the 1960s and 1970s was shaken. The economic recession of 1982 brought to an end the glory days of craft, when Peter Weinrich's 1976 assertion that "anything can be sold" appeared to be true. Suddenly the market for craft had disappeared, resulting in the loss of many retail outlets, large-scale government funding for craft, and certain craftspeople themselves, who turned to work outside the craft field for economic security. The state of the crafts by the end of 1982 so concerned the Canadian Crafts Council that it called a "Meeting on the Future of Crafts," reporting "Within the last two or three years some thought

the crafts had 'peaked,' others thought the change was more closely connect-
ed to the wide world – perhaps economic (recession etc.), perhaps a fading of
the values and images of the 60s with which crafts seems to have been so
closely, perhaps too closely, identified ... there was certainly a feeling that
crafts had reached a watershed or plateau of some sort ... are we stagnating?
Declining? Breaking up and reforming? Perhaps we are becoming more real-
istic and professional?"[30] Certainly the changes about to take place in the
public profile of Canadian craft, as well as the craft objects themselves, sup-
ported the argument that the 1980s produced a high level of professionalism.

It was also in 1982 that the Canadian Museum of Civilization (then called
the Museum of Man) hired Dr Stephen Inglis while at the same moment the
museum was approached to accept the Massey Foundation Collection of
crafts. Stephen Inglis had just returned to Canada from India, where he had
been working with artisans, and while he felt he knew virtually nothing
about Canadian craft, he soon inherited the responsibility of overseeing the
almost one thousand pieces in the Massey Foundation Collection, and thus
began his research. The Massey Collection emphasized functional craft and
provided the Museum of Civilization with objects dealing with issues of iden-
tity and utility. The museum already had in its collection many examples
of Canadian craft; however, these pieces were classified as ethnographical,
historical, archaeological, or folkloric examples, following the traditional
approach to craft in gallery or museum spaces. Inglis was involved in craft
in terms of folklore, having returned from an Asian context, but, with the
acceptance of the Massey Foundation Collection, Inglis and the Canadian
Museum of Civilization began rethinking the disciplinary categories occu-
pied by craft. In 1984 Inglis curated the exhibition *Works of Craft: The Massey
Foundation Collection*, which opened at the Museum of Man before travelling
nationally. Soon linkages were being made between craft and the twentieth-
century studio movement.[31]

Inspired by the Massey Foundation Collection, this reconsideration of the
space occupied by craft represented a beachhead for the institutional recogni-
tion of contemporary professional Canadian craft. The exhibition of contem-
porary craft within large Canadian museums and galleries had floundered
during the 1970s. The National Gallery of Canada had abandoned contem-
porary craft despite the enormous success of Norah McCullough's 1966–67
exhibition *Canadian Fine Crafts*, and larger Canadian institutions were deac-
cessioning craft exhibitions to smaller provincial and regional organizations
like the Crafts Association of British Columbia and Toronto's Harbourfront
Centre. Links with the Canadian Crafts Council were forged as a result of the
Canadian Museum of Civilization's developing interest in contemporary craft.

The new relationship between the Council and the museum was signifi-
cant. The Council had been evolving a proposal for a National Museum of
Crafts and Design, garnering support from a variety of sources, including
James Plaut, executive director of the World Crafts Council, who wrote
"Canada should have a national museum devoted to the decorative and
applied arts, crafts and design."[32] It was the Council's intention to provide a
national gallery exhibiting one-of-a-kind objects, workshop production,
industrial design, graphic design, and architectural design. The Council wor-
ried about the geographic location of its proposed National Museum of
Crafts and Design. After decades of allegations of "Torontoism" or Canada
centrism, the Council formulated an innovative solution to the tensions
between national and regional craft relations. Its museum would have
branches in every province and territory, with the branch in Ottawa serving
as the flagship and coordinator.[33] In addition to permanent and travelling
exhibitions, craftspeople would be in residence demonstrating their skills, an
idea that was taken from the success of the demonstrations at *In Praise of
Hands*. Although Canadian craftspeople and organizers had long been admir-
ers of the American Craft Council's Museum of Contemporary Craft in New
York (today the American Craft Museum), the Council stressed that "What
we are not thinking of is a gallery like the American Craft Council one in New
York City with a mere parade of exhibits, however inspired they may be."[34]
Instead, Canada's national craft and design museum would be a permanent
collection for future generations to use as a resource base, much like the
British example of the Victoria and Albert Museum. The Council was opti-
mistic that Prime Minister Pierre Trudeau's announcement of $185 million in
funding to the Museum of Man and the National Gallery of Canada would
mean that government support for a National Museum of Crafts and Design
would be available. The funding never materialized. The increase in support
to the Canadian Museum of Civilization led to the announcement of a new
building that would house the crafts already existing in the museum's collec-
tion, as well as the recently bequeathed Massey Foundation Collection. This
new space for the collection and exhibition of crafts, along with the growing
craft expertise of Stephen Inglis, resulted in the establishment of the Canadian
Museum of Civilization as the national institution representing Canadian
craft. The Council's drive for a craft and design museum lost its momentum.
The National Gallery of Canada remained closed to contemporary craft, a
point of contention that remains today as craftspeople question why their
production is preserved outside the officially sanctioned space of the "fine
arts." In 1988 the Canadian Crafts Museum was opened in Vancouver as
Canada's first national institution devoted exclusively to the crafts. The man-

date of the museum was to preserve fine craft while demonstrating its social relevance. Sadly, despite a name change to the Canadian Craft and Design Museum in 2002, the under-funded museum was forced to close that same year. Today the situation remains the same; "it's unthinkable that a country like Canada still doesn't have a national craft museum," states Marianne Heggtveit, Visual Arts Officer at the Canada Council for the Arts.[35]

During the early 1980s the Canadian Crafts Council and the Canadian Museum of Civilization began collaborating on a project that was offering fine craft a prominent position within Canadian visual and material culture. In 1977 the Samuel and Saidye Bronfman Family Foundation had established the Saidye Bronfman Award for Excellence in Fine Crafts. Created to honour the eightieth birthday of Saidye Bronfman, the award was to be given annually to Canada's top craft practitioner. Today valued at $25,000, it is one of Canada's most important cultural awards. The Canadian Crafts Council was selected to administer the award on behalf of the Bronfman Family Foundation. Initially the award was to run for a decade, but it continues today. The Saidye Bronfman Award for Excellence in Fine Crafts has been a major contributor to the development of a high-profile, professional image for Canadian craft. Following the decision to make the Canadian Museum of Civilization the institutional base for Canadian craft, the Canadian Crafts Council and the museum began collaborating on the Bronfman Awards. The Council would retain responsibility for overseeing the award, and the museum would house the objects purchased from the winners of the award by the Bronfman Family Foundation. The new Canadian Museum of Civilization building provided the proper storage and, hopefully, the proper display of these valuable collections. It was decided that the museum would host an exhibition of Bronfman Award winners as one of the premier exhibitions in its new building.

Masters of the Crafts: Recipients of the Saidye Bronfman Award for Excellence in the Crafts, 1977–1986, curated by Inglis, was a celebration of both the professional abilities of Canadian craftspeople and the newly declared institutional home for the display and collecting of these crafts. Analogies were drawn between the dramatic new museum building, designed by architect Douglas Cardinal, and the new era for craft in Canada, "The sweeping curves of its new building offer the Canadian Museum of Civilization a dynamic exhibition space and an opportunity to help shape a new era ... The old categories by which museums separate and classify artifacts according to status labels like civilized versus primitive, fine versus folk, or art versus craft are being replaced by an approach that seeks to show interconnections rather than distinctions between social groups and their forms of cultural expression."[36] The crafts

highlighted in the exhibition and catalogue reflected the advances made in Canadian craft throughout the 1970s and 1980s. Two other exhibits that helped in the establishment of the museum's craft program followed: *The Turning Point, the Deichmann Pottery 1935–1953*, which was curated by Inglis and opened in 1991; and *Opus: Musical Instrument Making in Canada*, curated by Carmelle Begin, which opened in 1992. In 1996 Alan Elder, now the Canadian Museum of Civilization's curator of Canadian Crafts, Decorative Arts and Design, curated the exhibition *Transformations* for the museum. This travelling exhibition showcased twenty years of Bronfman Award winners and had as its stated purpose the "transform[ation] of the profile of crafts in Canada."[37] In addition to introducing audiences across Canada and in New York to Canada's leading craftspeople, *Transformations* provided an overview of the evolving craft aesthetic, as well as differing approaches to the role of craft in the hierarchy of the arts by the craftspeople profiled in the exhibition.

Changing Aesthetics, Changing Styles

The first winner of the Bronfman Award, ceramist Robin Hopper, was born and educated in England before immigrating to Canada in 1968 to become head of the ceramics department at the Central Technical School in Toronto.[38] By 1973 Hopper was working full-time as a studio potter in Hillsdale, Ontario, before moving to Victoria in 1977. Hopper fulfilled the Bronfman Award requirements of producing aesthetically and technically excellent work, as well as contributing to the development of crafts in Canada. His work had been selected for the Canadian Guild of Crafts' exhibitions *Craft Dimensions Canada* (1969) and *Make* (1971), and he had been involved as a director for the Canadian Guild of Crafts and a member of the executive of the Ontario Craft Foundation. Hopper's unique vessel designs combined with his artistic treatment of the exterior of the form enabled important crossings between the materiality of craft and the visual tradition of the surface. Frequently Hopper's functional and one-of-a-kind objects referenced the Canadian landscape.[39] For example, "Olympic Mists," a square-shouldered vase with an elegant narrow neck produced in 1977, featured painterly tree forms and clouds with a suggestion of mountains. Hopper's surface design and ability to paint with glaze, controlling his landscape scene while balancing it with glaze drips expertly incorporated into the image, was aesthetically unique and vastly different from the exterior treatment of clay undertaken in the 1960s and 1970s.

Whether it was due to the popularization of a lifestyle that emphasized simplicity and natural materials or the influence of modernism's anti-ornament

Robin Hopper, *Olympic Mists*, 1977. Stoneware, 43 x 25 x 10.5 cm. Photo courtesy of the Canadian Museum of Civilization.

aesthetics, the majority of previous works emphasized the use of the ceramic medium itself as decoration, often through rolling, pinching, or stamping the wet clay with texture, and glazed with earthen tones. The late 1970s witnessed the dramatic reintroduction of surface decoration on clay. Walter Ostram advocated for the use of colourful low-fire maiolica ware and the study of international ornamental traditions in ceramics to his students at the Nova Scotia College of Art and Design. This has resulted in generations of Canadian ceramists such as Katrina Chaytor, who produce both functional and sculptural ceramics that reflect historically knowledgeable and ornately decorated surfaces. Certainly Canadian ceramics had reached new levels of popularity during the 1970s and it might be argued that this led to the reintroduction of heavily ornamented surfaces. Donald Blake Webster states that

this was the case at the end of the nineteenth century for stoneware potters along the eastern seaboard of the United States: "... a substantial number of decorated pieces seemed to become common only when potters ... approached market saturation."[40]

Undoubtedly, the official recognition of Robin Hopper as Canada's outstanding craftsperson for 1977 signaled a change in the style and aesthetic of craft. The past decade had celebrated the wild and wooly – sensual surfaces heavy with texture and natural colour that emphasized new manipulations of traditional craft media. The 1980s and 1990s witnessed the development of increasingly design-oriented forms that highlighted the maker's skill and showcased a wider range of colours and controlled surfaces. These changes were assisted by improvements in the media themselves, which included better dyes, glazes, and equipment (and safety precautions), complemented by a steady increase in the publications, conferences, and educational opportunities that introduced craftspeople to these enhanced techniques. The work of Carole Sabiston, the 1987 winner of the Saidye Bronfman Award, exemplifies the aesthetic shifts in craft. Her pieces frequently produced for architectural commissions, mix embroidery, tapestry, weaving, and quilting into colourful designs officially labelled textile assemblage. While Sabiston's work in the 1970s featured heavily embroidered surfaces in natural colours, by the mid-1980s and 1990s her work had exploded into bright colours and metallics with carefully designed intricate surfaces. Each panel of "Two Bits of Sky: Day and Night" is over two metres in height, depicting dramatic images of swirling skies that incorporate a variety of fabrics and techniques.

The Art vs Craft Debate

The convergence of stylistic change and increased opportunities for the national recognition of craft resulted in a higher profile for fine craft, intensifying the longstanding debate over the position of craft within the fine-arts hierarchy. Craftspeople received training and degrees equivalent to that of other fine artists, yet biases against the perceived functionality of craft forms and tradition of techniques continued to be emphasized by critics and curators leading to lower pricing, restricted exhibition opportunities, and limited critical attention. Craftspeople, many who were raised during modernism's halcyon days, remained divided in terms of their allegiance to modernism. Some, like the metalsmith Bruce Metcalf, have been vocal in their opposition to the application of the myths of modern art onto craft. Metcalf argues that, although "modern art with its history and theory is envied for its financial

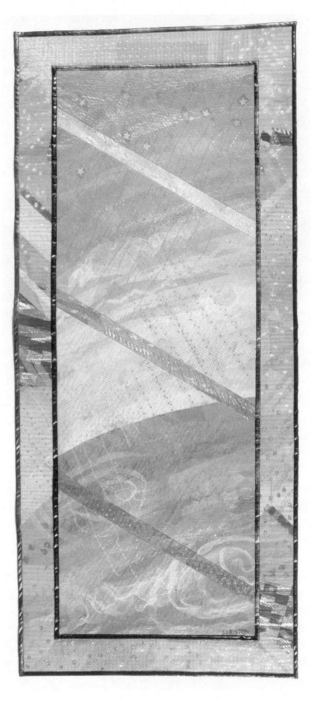

Carole Sabiston,
Two Bits of Day Sky...
Wall Hanging,
each 216 x 94 cm.
Photo courtesy
of the Canadian
Museum of
Civilization.

rewards by craftspeople," status-hungry producers who manipulate craft in order to fit it into the modernist vision of "high" art should be wary as such machinations deplete craft of its intrinsic social and material values.[41] What modernism has done to alienate the crafts is to emphasize form as the most important aspect of art, therefore leaving craft's implicit utility and materials as unimportant. Formalism was Clement Greenberg's key to saving high culture from the threat of kitsch. During the 1960s and 1970s many in the craft world adopted formalism, its language, and its focus on "the bowlness of bowls and clayness of clay."[42] However, formalism privileges the power of sight, leading to a sensory elitism with damaging potential to craft with its synaesthetic properties. For craft objects to be treated formally they would have to be removed from their utilitarian function before you could perceive them aesthetically under glass in a museum or gallery. Modernism is still the theory that many craftspeople believe is being practiced by the art world. This leads many, like Bruce Metcalf, to dismiss any art theory, stating "art has its own rules and its own language, which make implicit claims to dominance over all other codes. If you want to join the club, you have to speak, act and think like club members, and they are not particularly interested in being challenged."[43] Metcalf made this statement in 1993, and it can be argued that this is no longer the case, because, in the postmodern age, many theories lay outside modernism.

During the late 1980s and 1990s craftspeople and critics realized that, in addition to the new material overlaps generated by postmodernity, within the postmodern there were openings for discussion of craft in theory. They also recognized the importance of generating a field of craft theory, history and critical writing that could operate to introduce the concerns of craft into a broader interdisciplinary context, interdisciplinarity being defined as knowledge "which exists within groups of closely related disciplines," signifying "the synthesis of two or more disciplines establishing a new metalevel of discourse."[44] The creation of a critical history of craft and its production and consumption is necessarily an interdisciplinary project. The hierarchical nature of traditional art history, which classified craft as not art, following Greenberg's assertion, has been eroded through postmodernity's emphasis on theory. The need for theory is the fundamental base for developing craft beyond a marginalized area of art. Specifically the work of writers such as Michel Foucault have allowed theorists and historians to understand that the barriers to craft within art have specific histories that postmodernity opens up to questioning. Interdisciplinarity affords craft the prospect of slippage, the chance to explore opportunities for itself within a range of disciplines without entirely abandoning its own disciplinary rules.

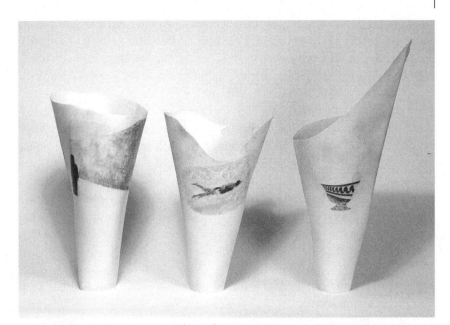

Jeannie Mah, *"Je nage; donc, je suis"* (detail), 2003. Porcelain, installation dimensions 10 x 2 x 2 feet. Photo courtesy of Jeannie Mah.

The mixing of techniques characterized by Sabiston's "textile assemblages" has led to exciting border crossings between all craft media and forms. For example, the ceramic artist Jeannie Mah utilizes traditional porcelain forms in exaggerated sizes and incorporates them into gallery installations that address the theories and politics of identity. The surfaces of her paper-thin porcelains contain photo images and text associated with the fields of photography, printmaking, and painting. Mah successfully enhances traditional ceramic materials and forms through the integration of photography, installation and critical theory.

The introduction of interdisciplinarity into craft has led to a renewed crisis of identity. In 1965 when the Canadian Council for the Environmental Arts/ Conseil Canadien pour les arts de l'espace was formed to encourage craftspeople to integrate the concerns of design, architecture, and art into their practice it was met with great resistance, ultimately leading to its renaming as an expressly craft-based organization, the Canadian Craftsmen's Association. While Arnold Rockman, Merton Chambers, and Norah McCullough supported the interdisciplinary aims of the new group, members of the Canadian Guild of Crafts feared that the concerns of craft would be overshadowed. Such fears continue today, frequently expressed through the continuation of

the art/craft debate. Some, like Paul Mathieu, see the integration of theory into craft practice and writing as offering a way to bridge the gap between craft and art. In his writing and ceramic production, Mathieu seeks to eliminate entirely the artificial boundaries encouraged by the fine arts hierarchy:

What is a potter doing meddling with theory and ideas anyway? I believe it is essential to confront the art world in the language it speaks, to address the problem on its territory ... Despite recent talk of de-hierarchization, the crossing of borders, and openness to difference and otherness, the prevalent categories and taxonomies are still effective. Well, crafts are unclassifiable. They defy categories. In fact, craft is the activity where de-hierarchization, the crossing of borders and categories, and differences between the races and sexes are explored the most thoroughly today, as well as historically. The one border the art world refuses to cross is that of craft. What exactly is it afraid of?[45]

Others, such as the British craft critic Peter Dormer, have argued that "craft and theory are oil and water."[46]

The semantics surrounding the use of the word craft have both immediate and far-reaching consequences. The formal recognition of the work of craftspeople by the Bronfman Award stresses the use of the word craft, lending the traditional term both status and financial rewards. The Canadian Crafts Council, now the Canadian Crafts Federation, continues to use the word craft to describe its membership, as do the provincial organizations. With the financial assistance of Joan Chalmers the Canada Council, long resistant to crediting craft as forming part of the fine arts, now has a separate jury and awards system specifically for craft. This hard-fought recognition is also attributable to the political restructuring of the Canada Council and its acknowledgement of the need to open up consideration to previously marginalized practices of all backgrounds. Unfortunately, during the craft boom of the 1970s the Canada Council did not invest in professional support structures for craft, such as the dissemination and documentation of Canadian craft history through writing and academic publications. In 1995, when the Canada Council introduced its craft program, it was met with universal support, and today the Council is making enormous contributions to the field of Canadian craft. Craft is classified as one of several branches of the Council's Visual Arts section.

Contemporary professional craft in Canada has developed significantly since Peter Weinrich's earlier attempt to define craft for the federal government. Today professional craft enjoys a high level of formal recognition, as well as increasing economic rewards. Worries in the early 1980s that craft had

reached a plateau have been replaced by the confidence that Canadian craft occupies an important place in national culture. A growing audience of professional craftspeople, critics, curators, and scholars has led to an increased interest in craft exhibitions, publications and conferences. In 2002 alone the Canadian Museum of Civilization appointed Alan Elder full-time curator of Canadian Craft, Decorative Arts and Design, and the Nova Scotia College of Art and Design, the Alberta College of Art and Design, and Concordia University appointed or advertised for full-time craft historian positions.

While the art versus craft debate continues, the ascendancy of professional craft allows questioning of whether such debate is still necessary. At the 2001 conference "1000 Miles Apart," Desmond Rochfort, past president of the Alberta College of Art and Design, asked whether defining craft is now beside the point. Seemingly, the idea of a difference between craft and other forms of material and visual practice is redundant; however, it remains imperative that craft practice, history, and theory is privileged within educational and market settings. In order to continue the advances made in the past forty years in the status of craft within the fine art hierarchy and the attendant financial recognition, it is important that a discourse of craft is established from which to train scholars in history, theory , and criticism so that they can influence public perception, educational and financial opportunities, and even the practice of craftspeople. In this age of interdisciplinarity, craft objects, craftspeople, and craft theory, history, and critical writing must be promoted as independent subjects of scholarship. This is a monumental task in terms of Canadian craft, where a basic history is currently being constructed from long-neglected archival sources, oral histories, and poorly treated craft collections. This task is made more challenging by the need to acknowledge the Euro-North American focus of the majority of historians and theorists, who risk marginalizing craft practitioners operating outside the dominant culture in an effort to formulate an "official" history. A useful body of research is required, one that opens up arenas of debate while conceptualizing craft's broader role in society. Changes in the production, reception, and audience structures for craft witnessed from the 1960s to today indicate that craft is ready to occupy a broader role within Canadian material and visual culture. The confidence that paralleled the establishment of a professional craft community in Canada with its attendant rewards, self-regulation, and monopolies, has translated into an exciting position for twenty-first-century craft.

Conclusion

TREMENDOUS ADVANCES FOR PROFESSIONAL CRAFT HAVE BEEN ACHIEVED in Canada over the past fifty years. Once considered to be the preserve of the amateur, or simply an ethnographic curiosity, craft has become thoroughly entrenched in the institutional culture of our country. Today we can boast of craft education at the post-secondary level, complete with growing numbers of craft historians to analyze and categorize historical developments. Despite an attempt from 1988 to 2002 by Vancouver's now-defunct Canadian Craft and Design Museum, Moncrieff Williamson's dream of a National Craft Museum remains unfulfilled, although today Canada has a national curator for craft, decorative arts, and design at the Canadian Museum of Civilization. The Canadian Crafts Federation, a phoenix that rose from the ashes of the Canadian Crafts Council, is making impressive gains in the international marketing of Canadian craft, thanks in part to the federal government's placement of craft under the umbrella of trade and development rather than heritage. Despite these developments a fundamental question remains – has a field of professional craft been determined? Or perhaps more importantly, in the twenty-first century, what is the validity of determining this field?

While some may regard this concern as an exercise in semantics, it highlights the still disparate nature of craft production, reception, and consumption in Canada. It is a relatively small but powerful community that controls the products considered to be professional; in contemporary terms, meaning objects that are conceptually erudite, technically advanced, materially experimental, and able to engage in the discourses of eclectic postmodern culture. Often the makers who participate in this value system are dedicated to the materials of craft, but are increasingly open to shifting the boundaries of the

language used to describe their work. This openness is not, however, a new phenomenon.

During the 1960s the mandate of fine craft in Canada was enlarged to include an increased emphasis on interdisciplinarity. This was made clear during the 1965 formation of the Canadian Craftsmen's Association under its original title, Canadian Council for the Environmental Arts/Conseil Canadien pour les arts de l'espace. This name, suggested by Arnold Rockman, the editor of *Canadian Art*, was seen as ushering in a new phase for craft, one that would expose it to further industrial developments while increasing its interaction with sculpture, painting, and architecture. Of course strenuous objections to the definition of professional craft put forward by the new group were mounted, but the federal government saw this as the opportunity for craft to stand as a strong representative of Canadian visual culture. During Canada's centennial year, in particular at Expo 67 , the crafts stood alongside all other forms of art, and many architectural structures integrated craft commissions. University craft programs were quick to utilize this innovative approach to craft to foster unprecedented levels of interdisciplinary experimentation, in particular at the University of Regina, where sculpture and ceramics experienced frequent overlaps.

Throughout the 1970s, and into the 1990s, people debated the term craft as it pertained to this interdisciplinary group, but it remained in common usage. Perhaps as a result of the institutional advances made by craft throughout this time, qualifying adjectives like "fine," or "studio," were frequently dropped in favour of simply using craft. Despite this, confusion over the multitude of objects encompassed by the term remained, perhaps most evident during the growth in the popularity of craft fairs, a title applied to all manner of events, to paraphrase Aileen Osborn Webb's famous quote, from "the church basement" to rigorous peer-juried markets. It seemed, at times, that the specialist knowledge of professional craftspeople was lost in common misconceptions around the term fundamental to their field.

The self-regulation of the craft community has been intimately bound up with debates over definitions. As director of the Canadian Crafts Council, Peter Weinrich found himself in the position of explaining to the federal government what it was exactly that his organization meant by the term craft.[1] In this, nothing had changed, for a decade earlier Norah McCullough was trying to reconcile this term in the development of the Canadian Craftsmen's Association. It appeared that by the 1990s the professional craft community had not fully achieved its longstanding aim of occupying an equal, yet distinct, position within the cultural hierarchy. Indeed, rather than having intermingled the specialized knowledge and language of craft with the concerns of art, the two stood in increasing dialectic opposition to each other. René

d'Harnoncourt and Harold Rosenberg's 1964 message to craftspeople that the development of craft as a professional field depended upon a self-consciousness of technique that would translate across disciplines, was perceived by the 1990s as embodying modernism's supposedly oppositional position to craft. Throughout the 1990s writers on craft promoted this antagonism, indulging in a self-pitying stance for craft that demonized the Abstract Expressionist critic Clement Greenberg for his statement, echoed later by John Bentley Mays, "Craft is not art." This debate neither furthered the cause of craft, nor did it result in increased professional standards for craft. Rather, it could be argued that it marginalized craft by rendering it an anachronistic oddity that refused to recognize that modernism was not a monolithic entity, and that the field of cultural production had entered into the postmodern period.

Within the discipline there is still some perception of the need to oppose modernist positions; however, the urgency to define craft appears to be waning, replaced instead by an increasing confidence that, although not fully accomplished, the efforts of craft experts over the past half-century are being rewarded by a greater understanding of the strengths of craft within the visual arts community. While vigilance is necessary to preserve the distinct identity of craft materials and traditions, and to explore the rich history of craft, no longer does craft have to be threatened by a misinformed idea of modernism. Rather than seeing the use of craft materials and approaches by painters and sculptors as symptomatic of a decline for craft, it is possible to celebrate the expanded interest in this rich field.[2]

One thing that is becoming progressively clear from the study of craft history is the cyclical nature of the battle cry that craft will die in the face of artistic intervention or technological change. There will always be a market for handcrafted goods and an audience for the studio craftsperson. Critics will continue to decry craft for its lack of participation within industry, a relationship that despite the best intentions has never been resolved. The Museum of Art and Design, formerly the American Craft Museum, has rationalized its recent name change through a critique of the isolationist and anti-industry position of craft, arguing that the elimination of the term craft "reflects what has been true throughout history – that 'craft' is an artform equal to all others."[3] Some craftspeople will produce objects that defy easy categorization, in particular through the new hybridity – created by Computer Aided Design (CAD) and Computer Aided Manufacture (CAM) – affecting craft. Recently craft materials have been reinvested with anti-capitalism and anti-globalization meanings. The idea of craft as a form of resistance can be seen in the Canadian group, the Revolutionary Knitting Circle, whose motto

reads "Building community, and speeding toward the revolution, through knitting."[4] The notion of anti-globalization through craft is supported by the regional nature of much craft practice. Ironically, this regionalism contributes to the success of craft within the capitalist market, as tourism promotes craftspeople and their objects as representing authentic local identities. This has led to growing debate surrounding ideas of authenticity, particularly important in terms of craft, with its long legacy of cross-cultural exchange and appropriation. As the field of academic study surrounding craft expands, issues relating to capitalism, globalism, cultural appropriation, and eclectic postmodernity will be explored.

Now that these impasses have been identified it is the responsibility of craft historians and theorists to increase the knowledge base for craft, thus expanding the resources available for craftspeople. The objective is not the formation of overarching metanarratives. Instead, we should aim for the creation of a fuller picture of craft's position within visual culture as a whole. This starts by recognizing that modernism is not the enemy, nor is it a single entity; rather, it is a movement that fully involved craft, in differing ways during various periods. Craft's response to the master narrative of art requires further exploration; in particular its creation of interdisciplinary strategies for survival, operating within the contexts of design, industry, and architecture. Perhaps most salient to future research on craft is one of the key themes of postmodernity – the existence of multiple voices. Now may be the time to acknowledge that craft does involve a wide cross-section of all societies, and, while it is vital to define professional craft in order to identify the power elite, it is also important to study those who fall outside this privileged domain.

Notes

INTRODUCTION

1 Bruce Metcalf has been the most vocal opponent of modernism, stating, "art has its own rules and its own language, which make implicit claims to dominance over all other codes. If you want to join the club, you have to speak, act, and think like club members, and they are not particularly interested in being challenged." Metcalf, "Replacing the Myth of Modernism," 40.

2 For a discussion of the new position of crafts in late modern culture, see Greenhalgh, *The Persistence of Craft*, 1–17.

3 Harrod, *The Crafts in Britain in the 20th Century*, 211.

4 Aarons, "Canadian Handicrafts and the Architect," 19.

5 See Durkheim, *The Division of Labor in Society.*

6 Foucault, *The Birth of the Clinic: An Archaeology of Medical Perception,* 29.

7 Larson, *The Rise of Professionalism.*

8 Ibid., x.

9 MacDonald, *The Sociology of the Professions,* xii; Perkin, *The Third Revolution: Professional Elites in the Modern World,* xii.

10 Perkin, *The Third Revolution,* 1.

11 Rosenberg, *The Tradition of the New,* 63.

12 Larson, *The Rise of Professionalism,* 41.

13 Ruth Phillips's work on Woodlands souvenir art/craft and her analysis of the reception of these "exotic" objects provides an entry from which to discuss the importance of Native craft production. Phillips, *Trading Identities: The Souvenir in Native North American Art from the Northeast 1700–1900,* 48, and "Nuns, Ladies, and the 'Queen of the Huron.'"

14 Perkin, *The Third Revolution,* xiv. These characteristics are taken from Perkin's summary of the support structures for postwar professionalism.

15 Krause, *Death of the Guilds: Professions, States, and the Advance of Capitalism, 1930 to the Present*, 3, 9.
16 Ibid., 3.
17 Ibid., 5.
18 Larson, *The Rise of Professionalism*, 55.
19 Krause, *Death of the Guilds*, 4. Krause argues that the principle of self-government used by craft guilds ultimately led to an elitist situation in which master crafts-people could abuse the rules of the guilds, for example, by practicing nepotism, and yet go unpunished because many guilds had their own court system for members.
20 Ibid., 6.
21 Larson, *The Rise of Professionalism*, 55.
22 Crawford, "The Object Is Not the Object: C.R. Ashbee and the Guild of Handicraft," 2.
23 Ehmer, "The Artisan Family in Nineteenth-Century Austria: *Embourgeoisement* of the Petite Bourgeoisie?" 197.
24 Larson, *The Rise of Professionalism*, 232. Larson states that the mastership of the guilds was equated with the power of self-employment.
25 Foucault, *The Birth of the Clinic*, 31.
26 Statistics Canada, Education Division, Cultural Information Section, *Canadian Crafts Survey and Membership Plebiscite*, November 1972.
27 Peter Weinrich, *Report and Recommendations to the Department of Canadian Heritage and the Canadian Crafts Council on Crafts Policy*, appendix III. Conseil des métiers d'art du Québec, *Profile and Development Strategy for Craft in Canada*, vii.
28 Ibid, 37. "In general throughout the economy, higher earnings are attributable to higher education levels ... However, this relationship does not appear to apply for these cultural occupations." Jacqueline Luffman, "Earnings of Selected Culture Workers: What the 1996 Census Can Tell Us," 1.
29 Weinrich, *Report,* Conseil des métiers d'art du Québec, 10; and Statistics Canada, "Monthly Survey of Retailers," 1.
30 Conseil des métiers d'art du Québec, *Profile and Development Strategy for Craft in Canada*, vii.
31 I am referring to works such as the following: Barros, *Ornament and Object: Canadian Jewellery and Metal Art*; Crawford, *A Fine Line: Studio Crafts in Ontario from 1930 to the Present*; DeSève, *Hommage à Jean-Marie Gauvreau*; Elder, "Reflecting and Affecting Craft: Federal Policy and Contemporary Canadian Craft"; Flood, *Canadian Craft and Museum Practice 1900–1950*; Hickey, *Making and Metaphor: A Discussion of Meaning in Contemporary Craft*; McLeod, *In Good Hands: The Women of the Canadian Handicrafts Guild*. Harrod's monumental text *The Crafts in Britain in the 20th Century* provides a comprehensive history of British crafts and touches upon the important role of Aileen Osborn Webb, the American Craft Council, and the World Crafts Council during the 1960s and 1970s.

CHAPTER ONE

1 Flood, "Craft in Canada: Overview and *Points from Canadian Craft and Museum Practice 1900–1950*," 25.
2 Campbell, "Designer-Craftsmen U.S.A. 1960," 15.
3 Boyanoski, *Loring and Wyle: Sculptors' Legacy*, 1.
4 See Reid, *A Concise History of Canadian Painting*, 2:192, and McCullough, *Arthur Lismer Watercolours*.
5 *Ontario College of Art Alumni Association Alumnus* (Spring 1983).
6 Norah McCullough, *Biographical Notes*.
7 Pearl McCarthy, "Art and Artists," *Globe and Mail*, 4 January 1938.
8 "The old native whispered to her to retreat quickly to her car and as she ran the native women commenced throwing stones at her," described H.J. Lawless in "A Girl against the Veldt." The exoticism of McCullough's encounters with the "natives" was also captured in an article in the *Regina Leader Post*, where McCullough praises her students, "The African Natives she described as intelligent and extremely appreciative of any assistance given them ... In Miss McCullough's opinion the natives are especially talented in handcrafts." "New Cultural Vistas Open to Rural Areas," *Regina Leader Post*, 10 February 1948, 7.
9 McLeod, *In Good Hands*, 24–9.
10 Ibid., 1. McLeod points out that women from prominent families had more opportunities in higher education and also more access to power and positions relative to the working classes, the Indian settlers, and the many new settlers in Canada.
11 Ibid., 264.
12 Ibid., 266. See also Floyd Chalmers, "Sales of Canadian Handicraft Products in the United States," 29 August 1939, 1–7.
13 Bourdieu, *The Field of Cultural Production*, 43.
14 McLeod, *In Good Hands*, 263–9.
15 Norah McCullough, letter to Mrs H. Reidl-Ursin, 9 February 1966.
16 The Saskatchewan Arts Board is an amazing entity, said by some to be the second arts board to have been formed in the world. Sandra Flood is currently researching its history.
17 Norah McCullough, *Looking Back to my Early Days in Regina*. During McCullough's time at the Saskatchewan Arts Board, Canada's first arts board, it established initiatives to "assist handicrafts groups." "New Arts Board for Saskatchewan," *Regina Leader Post*, 2 February 1948, 3. Sandra Flood points out that McCullough's home industries program was undoubtedly influenced by Vivian Morton, who headed Saskatchewan's handicrafts committee and who was the moving force behind the Saskatoon Arts and Crafts Society, a group that had been exhibiting and marketing crafts across the province since 1923. (Sandra Flood, email correspondence, 6 August 2002.)
18 Franz Boas, a well-known anthropologist and ethnographer who had been active in the United States during the late nineteenth century, heavily influenced Marius Barbeau. As chief assistant, Boas was instrumental in importing Native groups for display at the 1893 World's Columbian Exposition in Chicago. See Hinsley, "The

World as Marketplace: Commodification of the Exotic at the World's Columbian Exposition, Chicago, 1893," 345, 349, 362.

19 Flood, *Canadian Craft and Museum Practice 1900–1950*, 51. Flood notes that Barbeau "didn't appear to have any interest in contemporary innovative or urban-based work ... he was interested in the "exotic other," even if they were Québécois, but peasants. Class attitudes were rife in Quebec and it is quite obvious in his writing, he was in the professional class and an anthropologist." (Sandra Flood, email correspondence, 6 August 2002.)

20 Flood, *Canadian Craft and Museum Practice 1900–1950*, 78, 49.

21 "Fort Qu'Appelle was ... mostly a base for teaching,. The Saskatchewan Arts Board needed a full-time pottery teacher who would go around the province as groups became interested." (Sandra Flood, email correspondence, 6 August 2002.)

22 McCullough, *Looking Back to MyEarly Days in Regina*.

23 Ibid., 353.

24 Norah McCullough, letter to Molly and Bruno Bobak, 21 February 1957.

25 Norah McCullough, "Handicraft in Denmark Suggests a Fresh Approach to Canadian Crafts." Scandinavian crafts had been increasingly popular in Canada during the 1950s. The Royal Ontario Museum hosted a Scandinavian craft exhibition from 19 October to 21 November 1954, and the T. Eaton Company had been importing Scandinavian furniture and design examples for sale at its flagship stores. See Hodges, *Sigrun Bulow-Hube: Scandinavian Modernism in Canada*, MA thesis.

26 Walpole, "Around the Town."

27 Gwyn, "Guild at the Crossroads," 277.

28 The jury was composed of Norah McCullough, Gordon Webber, and Paul Arthur. Gordon Webber was a professor at the Montreal Museum of Fine Arts, and Paul Arthur was the Managing Editor of *Canadian Art* magazine.

29 Gwyn, "Guild at the Crossroads," 279.

30 Association professionnelle des artisans du Québec, *Brochure*, 1965.

31 "Canadian Handicrafts Guild Presentation to Seminar 65." Alan Jarvis of the Canadian Conference of the Arts wrote to Adelaide Marriott, the Canadian Handicrafts Guild representative, that discussions regarding the funding of Canadian crafts would be continued at the Winnipeg meeting convened by Norah McCullough. Alan Jarvis, letter, 4 February 1965, to Adelaide Marriott. Gail Crawford notes that *Canadian Art* developed a fine craft section because Alan Jarvis was then its editor and it was an initiative of his. Gail Crawford, letter, 8 August 2002.

32 I will refer to the American Craftsmen's Council by its contemporary title, the American Craft Council.

33 Webb, *Almost a Century*,129.

34 Aileen Osborn Webb was so sure of her vision of a World Crafts Council that she undertook to hire the internationally known lawyers the Courdet Brothers to draw up a constitution, organizing the Council as a United Nations-related organization with individual countries as members. Webb, *Almost A Century*, 129.

35 The third largest delegation was Italy with twenty-eight representatives, the fourth largest was Mexico with twenty-two, followed by India with fourteen. New Zealand, Australia, Japan, Bolivia, Liberia, Ethiopia, Ghana, and Tanganyka all had representatives at the conference. Czechoslovakia and Hungary were the only countries

from "behind the iron curtain." "First World Congress of Craftsmen," *Craft Horizons*, 8.

36 *Short Guide to World Crafts,* June 1964, American Craft Council Archives, World Crafts Council, Box 2. The Canadian participants in the First World Congress of Craftsmen were: Françoise Braise, Montreal, Secretary of the Canadian Handicrafts Guild; Harold B. Brunham, Toronto, president of the Canadian Handicrafts Guild; Merton Chambers, Toronto, Canadian Handicrafts Guild; Helen Copeland, Toronto; Olea Davis, Vancouver, Canadian Handicrafts Guild, Canadian Guild of Potters; Professor and Mrs Eric Dodd, Calgary; Aleksandra Dzervitis, Toronto; Ruthann Gardner, Thornhill, Ontario; Mrs McGregor Hone, Regina; Tess Kidick, Jordan, Ontario; Mr and Mrs Michel Lacombe, Vacheres, Quebec; Bailey Leslie, Toronto, Canadian Guild of Potters; Norah McCullough, Regina, National Gallery of Canada; Ludwig Nickel, Winnipeg; John Pocock, Toronto; Eileen Reid, Montreal; H. Baroness Riedl-Ursin, Montreal; Ellis Roulston, Halifax, Canadian Handicrafts Guild; Catherine Ross, Toronto; Mildred Ryerson, Toronto; Tutzi Haspel Seguin, Toronto; Mr and Mrs N.G. Shaw, Regina; Laurent Simard, Les métiers d'art de Québec, Montreal; Sheila R. Stiven, Toronto; J.R. Woolgar, Yellowknife, Canadian Handicrafts Guild; Jack Young, Saskatoon.

37 *Short Guide to World Crafts,* June 1964, 101.

38 Ibid., 12.

39 Lois Moran, personal interview, 9 December 1999, New York.

40 *Craft Horizons* changed its name to *American Craft* in 1979, with Lois Moran appointed editor in 1980.

41 "American Craft Council 1943–1993: A Chronology," 137.

42 Rosenberg, *The Tradition of the New,* 63.

43 Jacqueline Rice, ed. *The First World Congress of Craftsmen, June 8–19, 1964,* 146.

44 Ibid., 84.

45 Ibid., 84.

46 In 2002 the American Craft Museum changed its name to the Museum of Art and Design.

47 Anita Aarons, "An Absent Minded Attitude," 22.

48 *Canadian Handicrafts Guild Bulletin,* no. 53, March 1964.

49 Gordon Barnes, unpublished paper, "History of Canadian Crafts," 2.

50 It is important to remember that, although Harold Burnham was not perceived as embracing the ideals of conceptually innovative craft, he was a professional himself: "he was a full-time weaver, ran a weaving studio with his wife, had completed architectural commissions, and was very knowledgeable about traditional weaving in Ontario." (Sandra Flood, email correspondence, 6 August 2002.)

51 Wilson Mellen, letter to Adelaide Marriott, 25 January 1965.

52 Norah McCullough. *Newsletter to the Craftsmen of Canada from Miss Norah McCullough, Regina.* 16 September 1964.

53 The Searle Grain Company had sponsored a training program in weaving for prairie girls during the 1930s. "It was set up with Renee Beriau as consultant and she selected and trained the first four weaving teachers, who were selected from various ethnic communities therefore fluent in a language other than English.

After that initial period the program ran out of the Searle Grain Company's weaving store in Winnipeg with Dorothy Rankine as weaving consultant. Société d'enseignement postscolaire du Manitoba was already teaching weaving on the Québec Cercles des fermières system." (Sandra Flood, email correspondence, 6 August 2002.)

54 "Stress Excellence of Design," *Windsor Daily*, 8 April 1965.

55 "Report 4 March 1965. The Formation of a National Association of Craftsmen."

56 Anita Aarons, "Canadian Handcrafts and the Architect," 16.

57 Interview with Mr Archie F. Key, 23 January 1965. Archie Key was approached to join the Handicrafts Guild as executive secretary, a position that he did not accept. It was reported that Key was "extremely interested in our desire to change the name which he said had become an anathema in the west to craftsmen."

58 *Canadian Handicrafts Guild Questionnaire to Craftsmen*, 1964. Adelaide Marriott was born in Ontario in 1883 and was a graduate in piano at the Royal Conservatory of Music in Toronto. In 1930 she and her husband Francis Marriott, a chemical engineer, moved from Montreal to Toronto, where she managed the Guild retail store at the T. Eaton Company in Toronto from 1932 to 1944. From 1944 to 1955 Marriott was the assistant dean of women at the University of Toronto. In 1973 Marriott received an honorary degree from York University for her work in Canadian craft – it was the first formal recognition for work in the crafts in Canada.

59 Judith Tinkl, *Craft Directory*. Tinkl noted that Chambers was involved in many crafts guilds and organizations and was helping to organize a professional society of craftspeople.

60 Stair, "Dora Billington," 24–5.

61 Gail Crawford, personal interview with Merton Chambers, 16 June 2002. Thank you to Gail Crawford for so generously sharing the transcripts of her interview with Merton Chambers.

62 www.aber.ac.uk/ceramics/gendered/bibliographies/barber.htm.

63 Crawford, personal interview with Chambers.

64 Ibid.

65 Ibid.

66 Ibid.

67 Ibid.

68 It was ironic that the Woman's Committee believed that a man could best represent them at the conference.

69 Murray Wilson, president, Quebec branch, Canadian Handicrafts Council, letter to Mrs Louis E. Johnson, 22 October 1964. Wilson writes, "I believe it would do irreparable damage if such a council were organised whether successful or not."

70 *Report of the Meeting of the Pro-tem Committee to Establish a Council of Craftsmen in Canada, 5–7 February 1965*.

71 Harold Burnham, "Report of the Winnipeg Conference."

72 Harold Burnham, "Crafts and Craftsmen."

73 Merton Chambers, "Formation of a National Crafts Council," 26–8.

74 Merton Chambers, letter to Harold Burnham, 13 February 1965.

75 *Report of the Meeting of the Pro-Tem Committee to Establish a Council of Craftsmen, February 5–7, 1965*. This would have pleased Donald Buchanan, who before his death in 1962

had pushed for a wider view of craft and improved design standards through his work at the National Gallery of Canada.

76 *Report of the Meeting of the Pro-Tem Committee to Establish a Council of Craftsmen, February 5–7, 1965.*

77 Ibid.

78 Mary Eileen Muff, "Report from the Meeting of Canadian Craftsmen, Winnipeg, 5–7 February 1965."

79 Arnold Rockman, "Editorial," 7. I have found no evidence of resistance from craftspeople regarding Rockman's insistence on abandoning "the ideology of the handmade object," an idea that contradicted the growing interest in studio-based, one-off craft pieces.

80 Chambers, "Formation of a National Crafts Council," 26, 28.

81 *Report of the Meeting of the Pro-Tem Committee to Establish a Council of Craftsmen, February 5–7, 1965.*

82 Jean-Claude Delorme, letter to George Shaw, acting chairman, Canadian Council for the Environmental Arts, 10 March 1966.

83 Yvan Gauthier, personal interview, 21 January 2000, Montreal.

84 Oscar A. Beriau, "Craft Revival in Quebec," 25.

85 Beriau, letter to Mrs Vanderbilt Webb, 10 January 1947.

86 Beriau, letter to Mrs E.W. Brownell, Executive Secretary, Department of Planning and Development, Ontario, 30 May 1946. Beriau relates his meeting with Senator Coburn of Vermont at the Clinton County Historical Society meeting in Plattsburg, New York, where Coburn "said that a handicraft service was inaugurated in his state and the necessary appropriations voted by the legislature as a result of my sending a collection of Quebec exhibits in 1940."

87 McLeod, *In Good Hands*, 264. McLeod writes that Quebec's Agriculture Minister J.L. Perron used the 1929 Canadian Handicrafts Guild annual exhibition to announce that the Quebec Government would be assuming public authority in the field of crafts, "A *man* will be placed in charge of this department, and *he* will go about the province and note its handicrafts productions. *He* will form a plan whereby they will be increased in both quality and production."

88 Lotta Dempsey, "Is Past Ruining Present?"

89 Tanya Harrod, "Herbert Read," 14.

90 Anita Aarons, "An Absent Minded Attitude," 22.

91 Anita Aarons, "To the Professional – A Challenge!"

92 Bourdieu, *Distinction*, 32.

93 Aarons, "To the Professional."

94 Adelaide Marriott, *History: The Canadian Guild of Crafts*, Archives of Ontario. Marriott also noted the Guild's involvement in other international exhibitions, such as the 1937 international exhibition of Arts, Crafts and Sciences in Paris, where the Guild worked on the display in cooperation with Dr Marius Barbeau.

95 Alice Lighthall, *The Canadian Handicrafts Guild: A History*.

96 "Report 4 March 1965, The Formation of a National Association of Craftsmen."

97 Mrs Cheeseborough, "Canadian Handicrafts Guild – Past, Present and Future."

98 Harold B. Burnham, "Report of the Winnipeg Conference."

99 Norah McCullough, letter to Glen Lewis, University of British Columbia, 26 August

1965. McCullough writes: "We would never get our charter through the Secretary of State office because it seems there are already too many organizations with 'Canadian Council' linked in their terminology."

100 Norah McCullough, letter to Alan E. Blakeney, lawyer, 6 July 1965.

101 Hugo McPherson, "Culture Planning, Canadian Style," 42. McPherson asks "How well is Canadian art developing? Not well enough or fast enough to satisfy the Secretary of State, the Centennial Commission, or the Canada Council, all of whom hope that in 1967 Canada will impress international visitors as a vital, articulate, and forward-looking society."

102 Mrs Vanderbilt Webb, letter to Sherman Burbank, Victoria, 7 February 1966. In reply to Burbank's question regarding the paucity of formal training in crafts in Canada Webb wrote: "This is because the crafts, themselves, are not understood by twentieth century people – their value or their cultural implications and any form of mass education is bound to be slow and costly."

103 Mary E. Black, letter to Galt Durnfurd, Quebec branch, Canadian Handicrafts Guild, 3 August 1964.

104 Lotta Dempsey, "Is Past Ruining Present?"

105 Lotta Dempsey, "The Non-Collaboration of Artists and Architects."

106 Robert Fulford, "Some Hard Truths about Public Art."

107 Flood, *Canadian Craft*, 278.

108 "Report Prepared for the Province of Ontario Conference on the Arts Meeting with Community Programmes Branch," Department of Education, 20 March 1964.

109 "Province of Ontario Council for the Arts Press Release," 10 April 1965.

110 "First Craft Conference Lake Couchiching, 23–25 April 1965."

111 Ibid.

112 Lois Moran, personal interview, 9 December 1999, New York.

113 George Shaw, "A Brief to Request Relief to Artists of Federal Sales and Excise Tax."

114 Jack Sures, chair, Canadian Craftsmen's Association, letter to Herman Voaden, chair, Canadian Guild of Crafts, 7 January 1969.

CHAPTER TWO

1 Surprisingly, aside from her unpublished autobiography and various articles devoted to her in *American Craft*, Webb remains a relatively unexplored figure in the history of Western crafts.

2 Campbell, "Designer-Craftsmen U.S.A. 1960," 13–27.

3 The New Hampshire League of Arts and Crafts was established in 1931 as the first state-supported craft organization in the United States. Steele, *The League of New Hampshire Craftsmen's First Fifty Years*, 2.

4 Paul Cummings, oral history interview with Mrs Vanderbilt Webb, 7 May–9 June 1970, 43.

5 Webb, *Almost a Century*, 71.

6 Ibid., 72. America House was based in New York City. It was initially located at 7 East 54th Street from 1940 to 1943, moving then to 485 Madison Avenue in order to provide space for expanding Council activities. In 1949 America House

moved to 32 East 52nd street, where it remained until 1959, when it moved to 44 West 53rd Street. The shop closed in 1971.

7 Ibid., 73. The Works Progress Administration (WPA) was the largest of Franklin Delano Roosevelt's New Deal programs. Launched 6 May 1935, the WPA was intended to be a enormous work-relief effort employing people in five major areas of the arts: Visual Art (including handicrafts), Music, Theatre, Writing, and the Historical Records Survey. Each of these projects had a national director. Holger Cahill was the director of the Federal Art Project, which at its height employed 5,300 visual artists and related professionals. See Bustard, *A New Deal for the Arts* and www.wwcd.org/policy/US/newdeal.html

8 Webb, *Almost a Century*, 73. Webb writes "I do not think Anne was ready to advance too much material aid. The financial problems were the reason for my willingness to help Anne Morgan's program." For more information on Anne Morgan, see Lewis, *Ladies and Not so Gentle Women*. Many of Morgan's papers are at the Pierpont Morgan Library in New York. Archival records of the American Handicraft Council are available at the Smithsonian Institution's Archives of American Art, mq235547, reel 3466.

9 Webb, *Almost a Century*, 89.

10 The first editor of *Craft Horizons* was Mary Lyon, who was hired in 1947. Rose Slivka, famous for her support of sculptural ceramics, was the editor of *Craft Horizons* throughout the 1960s and 1970s. *Craft Horizons* changed its name to *American Craft* in 1979, with Lois Moran appointed editor in 1980.

11 Webb, *Almost a Century*, 110. Webb's brother, General Frederick H. Osborn was an advocate of the Army Crafts Program, which he helped to initiate in late 1941 under the Facilities Section of Special Sources. See Noelle Backer, "Arts and Crafts in the U.S. Army: The Quiet Side of Military Life," *The CraftsReport Online!*, www.craftsreport.com/december96/army.html.

12 Webb, *Almost a Century*, 114. Owen D. Young was the board chairman of the General Electric Co. and Radio Corporation. He had been involved in the 1924 Dawes Plan and had chaired the 1929 Second Reparations Conference in Paris. He was named *Time Magazine*'s Man of the Year in 1929. His second wife Louise was involved in several craft projects. Her first initiative was a firm called Powis-Brown, based in the Philippines, where she had local women embroider her designs onto lingerie and table linens that were sold in New York, Chicago, and Paris. Through his involvement in the Bankers Trust, Young established credit for his then friend Louise Brown. After Owen and Louise Young were married in 1937, she set up new craft projects in Van Hornesville, New York, first turning her home into Van Horne Kitchens, where local school girls produced more than seventy-eight varieties of canned goods and preserves. Her second project began in 1939, when she purchased the first of six old houses that were renovated into artisan studios for weaving, pottery, and painting. Due to his wife's own endeavours, Owen D. Young was probably receptive to Aileen Osborn Webb's craft-based initiatives. For more information on Young, see www.time.com/time/special/moy/1929.html and Case and Case, *Owen D. Young and American Enterprise*, 689–94.

13 "American Craft Council 1943–1993: A Chronology," 137.

14 Ibid., 138.

15 Wry, "Uniting the World's Craftsmen," 11.

16 By 1975, twenty-four members of four generations of the Dodge and Osborn families had attended Princeton. Henry Fairfield Osborn, Aileen Webb's uncle, was Princeton's first professor of comparative anatomy, later becoming the president of the American Museum of Natural History. Her father served as a trustee of Princeton, and her brothers Frederick H. Osborn, major-general responsible for the army's education program in the Second World War, and Fairfield Osborn, president of the New York Zoological Society and author of the book *Our Plundered Planet*, were Princeton graduates. Her mother funded an American History chair at Princeton, and today Dodge-Osborn Hall, part of Woodrow Wilson College, honours the history of both families (etc.princeton.edu/CampusWWW/Companion/dodgeosborn_hall.html).

17 Known as a "copper baron," Dodge also made shrewd investments in railway lines, timberlands, and lumbermills, owning extensive tracts in Canada and between 100,000 and 400,000 acres of land in each of five states.

18 He funded the first Young Men's Christian Association building, was on the board of directors of the American Bible Society, the Metropolitan Museum of Art, the New York Children's Aid Society, the American Natural History Museum, and was president of the National Temperance and Publication Society. Dodge believed in the importance of equality in American society and "devoted himself to the work of educating colored people and the Indians," giving large sums of money to the Lincoln University for Colored Students. "A Good Life-Work Ended," *New York Times*, 10 February 1883, 8.

19 Like her grandfather, Grace Hoadley Dodge worked towards providing equality for American citizens. The New York Traveler's Aid Society assisted poor immigrant women and children through education.

20 "Grace Hoadley Dodge," *New York Times*, 28 December 1914, 9:5. See also, lweb.tc.columbia.edu/exhibits/dodge/dodge12.htm.

21 His twin sons continued their father's love of the Near East. Baynard Dodge served as president of the University of Beirut in Lebanon, and Cleveland E. Dodge was the president of Princeton's Near East Foundation. See etc.princeton.edu/CampusWWW/Companion/dodgeosborn_hall.html.

22 "William Church Osborn," *New York Times*, 5 January 1951, 20:3.

23 Webb, *Almost a Century*, 3–11.

24 Ibid., 23. Between 1910 and 1929 Webb was occupied caring for her four children: Derick, William Osborn, Richard, and Barbara.

25 Slivka, "Aileen Osborn Webb, David Campbell: A Reminiscence," 136.

26 "William Church Osborn," *New York Times*, 5 January 1951, 20:3.

27 etc.princeton.edu/CampusWWW/Companion/dodgeosborn_hall.html.

28 Paul Cummings, oral history interview with Mrs Vanderbilt Webb, 7 May–9 June 1970, 3.

29 Cook, *Eleanor Roosevelt: Volume One 1884–1933*, 47.

30 Webb, *Almost a Century*, 69. Like Webb, Nancy Campbell and Ernestine Baker were upper class women from New York City who owned vacation homes in the scenic region of Putnam County, New York. Ernestine Baker's husband Edward was a well-known artist who did a number of cover illustrations for *Time Magazine*.

31 Webb, *Almost a Century*, 68.
32 Green, "Culture and Crisis: Americans and the Craft Revival," 39.
33 O'Conner, ed., *The New Deal Art Projects: An Anthology of Memoirs*, 73. Scholarship on the Index of American Design includes Allyn, *Defining American Design: a history of the Index of American Design, 1935–1942*, unpublished MA thesis; Hornung, *Treasury of American Design: A Pictorial Survey of Popular Folk Arts Based upon Watercolour Renderings*; Christensen, *The Index of American Design*; and Schrader, *The Indian Arts and Crafts Board: An Aspect of New Deal Indian Policy*, 1983.
34 Carnegie, *Gospel of Wealth and Other Timely Essays*, 2:15. Carnegie's philanthropist philosophies were outlined in his 1898 essay "The Gospel of Wealth," where he claims to echo Christ's words regarding the betterment of all man [*sic*]: "The man of wealth thus becoming the mere trustee and agent for his poorer breathen, bringing to their service his superior wisdom, experience, and the ability to administer, doing for them better than they would or could do for themselves." This vision would be accomplished through the creation of ladders by which the aspiring could rise, namely free libraries, universities, works of art, parks, and recreation, all aimed to improve the public taste. There are a whole series of "Carnegie Libraries" in towns and cities across Canada and the United States. Carnegie, who made his fortune through the Carnegie Steel Company, was the son of a poor Scottish weaver. When he sold his company to J.P. Morgan, the father of Anne Morgan, in 1900 for $400 million dollars, he dedicated the rest of his life to the dispensing of his fortune. By the time of his death in 1919 he had given away $350,695,653. Considered to be the wealthiest human being of his time, Carnegie urged other monied philanthropists to "Set an example of modest, unostentatious living, shunning display or extravagance; to provide moderately for the legitimate wants of those dependent upon him; and, after doing so, to consider all surplus revenues which come to him simply as trust funds, which he is called upon to administer."
35 When Webb's grandfather was a trustee at the Metropolitan Museum of Art it became the object of Carnegie's praise, "In the Metropolitan Museum of Art in New York we have made an excellent beginning. Here is another avenue for the proper use of surplus wealth." Carnegie, *Gospel of Wealth*, 31.
36 Slivka, "Aileen Osborn Webb, David Campbell: A Reminiscence," 134.
37 Webb, *Almost a Century*, 86. George Eggleston Dodge's obituary indicates that he died in England, where he had gone for "his health and family." As his daughter May Cossitt Dodge maintained an English estate, where Aileen Webb recalls staying with "Aunt May," I have drawn the conclusion that this is the same "Aunt May" who left her fortune to Webb. "George Eggleston Dodge," *New York Times*, 15 April 1904: 9.
38 Webb, *Almost a Century*, 22.
39 Lansbury, *Looking Backwards – And Forwards*, 76.
40 In 1886 William Seward Webb and Lila Vanderbilt Webb began Shelburne Farm. The history of this model agricultural estate is outlined in Foreman, *The Vanderbilts and the Gilded Age: Architectural Aspirations 1879–1901*. The Smithsonian Institution has offered tours of the farm as part of its annual study tours (www.Smithsonianstudytours.org).

41 "We had a nurse, a nursemaid, a chambermaid, a waitress, a cook, of course, and a kitchen maid, to say nothing of a laundress by the day, who drank and whose grandmother was about to die periodically." Webb, *Almost a Century*, 33.

42 The Havemeyers were serious collectors of impressionist paintings, bequeathing a major collection to the Metropolitan Museum of Art. Electra's mother Louisine Elder Havemeyer was lifelong friends with Mary Cassatt and played a pivotal role in encouraging American interest in impressionist painting. The family was also interested in the decorative arts, and in 1890 they commissioned Louis Comfort Tiffany to decorate their New York City mansion. See Frelinghuysen, *Splendid Legacy: The Havemeyer Collection*, and Weitzenhoffer, *The Havemeyers: Impressionism Comes to America*.

43 For more information on Electra Havemeyer Webb and the Shelburne Museum see *An American Sampler: Folk Art from the Shelburne Museum*, www.shelburnemuseum.org/htm/museum/mu_hist.htm, and for background on the Havemeyer family see Catlin, *Good Work Well Done: The Sugar Business Career of Horace Havemeyer, 1903–1956*.

44 "There had never been an exhibition of the work of American craftsmen before 1953," Paul Cummings, oral history interview with Mrs Vanderbilt Webb, 12.

45 Dorothy Giles, *Designer-Craftsmen U.S.A. Catalogue*, 2. The exhibition travelled coast to coast: The Art Institute of Chicago, The City Art Museum, St Louis, The Cleveland Museum of Art, the Currier Gallery of Art, the Denver Art Museum, the Detroit Institute of Arts, the San Francisco Museum of Art, the Virginia Museum of Fine Arts, and the Wadsworth Atheneum, Hartford.

46 Ibid., 11.

47 Ibid., 17.

48 www.jra.org/craftart/awards/1999/tawney.htm.

49 Lenore Tawney, American Craft Council Archives, individual artists' files.

50 Howard, "Tawney," 71.

51 Personal interview, Charlotte Lindgren, Halifax, Nova Scotia, 14 June 2003.

52 The Interdepartmental Committee on Canadian Handicrafts was organized by the federal government from 1941 and 1944 in an effort to administer all Canadian craft activity during the war. It fell under the jurisdiction of the Department of Agriculture with Russell as its head. For more information see the National Archives of Canada, War Files, Interdepartmental Committee on Canadian Handicraft, Activities of Deane H. Russell, RG 17 Agriculture, Vol. 3418, File 1500-40-1. Deane Russell was a craftsperson who produced knives.

53 Deane H. Russell, "Handcraft Activities in Canada," 19–21.

54 Floyd S. Chalmers was involved with the *Financial Post* from 1925 to 1942 as president and chairman, holding every major executive position at Maclean-Hunter, Ltd. As one of Canada's leading philanthropist families, Chalmers and his wife Jean and daughter Joan contributed both time and money to a wide range of artistic activities from crafts to the performing arts. A 1979 article on the Chalmers stated "Over the course of the last half century and more, this Toronto family has set a brilliant example of community service in the contribution of time, attention and personal resources to the support of the arts in our community." The Ontario Arts Council is now the organization that oversees the distribution of two awards

in The Chalmers Program: Chalmers Art Fellowship and Chalmers Professional Development Grant. Edinborough, "Chalmers and Arts: Time, Thought and Money," 73:7.

55 Report by Floyd S. Chalmers, 29 August 1939, "Sales of Canadian Handicraft Products in the United States," 1–7.

56 Oral history interview with Mrs Vanderbilt Webb, 16.

57 Paula Gustafson, "Mapping the Terrain," 14–15. See also Elder, *Designing a Modern Identity: The New Spirit of British Columbia 1945–1960.*

58 Parr, *Domestic Goods: The Material, the Moral, and the Economic in the Postwar Years,* 40–63.

59 Adamson, "Exhibit Sets New Goals for Industrial Design," 4.

60 A Museum of Modern Art news release of 1945 spoke of the Department of Manual Industry's mandate to "study the potential contribution of manual industry to the modern world and to assist in its development. Its activities will not be confined to the United States but will include all the American Republics and Canada" (Museum of Modern Art, "The Museum of Modern Art New York Appoints René d'Harnoncourt Director of New Department"). René d'Harnoncourt had also organized and directed the influential 1941 Museum of Modern Art exhibition *Indian Art of the United States,* which had its own plan to market contemporary Native fine handicraft. See Berlo, ed., *The Early Years of Native American Art History.*

61 "Report on the Design in Industry Exhibition," July 1945, 11.

62 The study of organizational structures for industrial design would form another completely different book, one that would focus on the National Design Council. At particular points the Design Council was concerned with Canadian craft, particularly in relation to exhibitions. In 1955 the National Industrial Design Council distributed brochures titled "The Story behind the Design Centre" during the *Designer-Craftsmen U.S.A.* exhibition at the Royal Ontario Museum. The brochures encouraged the public to ask a number of questions before purchasing objects, including "Is the form suited to the job it has to do?" and "Is there an absence of unnecessry and meaningless ornament?" The brochure listed Floyd S. Chalmers as the vice-chair of the Council, and Donald Buchanan as its Secretary. In 1974 the National Design Council instituted special Craft Awards designed to "stimulate good craft design," "increase public awareness of the craft industry," and "develop products for the domestic and export souvenir gift markets." The winners were exhibited at Ottawa's National Art Centre in June 1975. See "The Story behind the Design Centre" and Sonja Bata, "Foreword," *National Design Council Annual Report 1974–1975,* 29.

63 Ibid., 47.

64 Donald Buchanan, "Design in Industry: The Canadian Picture," 234.

65 Lesser, "Biography and Bibliography of the Writings of D.W. Buchanan (1908–1966)," 32.

66 National Gallery of Canada Archives, Buchanan, Donald William, DOC/CLWT.

67 Donald Buchanan, "Design in Industry – A Misnomer," 194–7. *Design in Industry* was exhibited at the National Gallery of Canada in 1946 and toured the country until February 1950.

68 According to Alan Elder the exhibition was titled *Canadian Designs for Everyday Living,* while the publication that accompanied it (which was actually the beginning

of the Canadian Design Index) was *Canadian Designs for Everyday Use* (email, 18 November 2003).

69 *Canadian Designs for Everyday Living,* 1948 Catalogue.

70 Chalmers, "Sales of Canadian Handicraft Products in the United States," 4. See also Flood, *Canadian Craft,* 221.

71 Archives of Ontario, Ontario Crafts Council, Archives of Canadian Craft, MU5769, Box 24, DQ3-D4.

72 For an excellent analysis of the links between noblesse oblige and arts and crafts ideals, see McLeod, *In Good Hands,* 11–50.

73 McLeod, *In Good Hands,* 56.

74 Ibid., 56–7.

75 Ibid., 58–116.

76 Alice Lighthall, *The Canadian Handicrafts Guild: A History,* May 1966, 3.

77 Flood, *Canadian Craft,* 236–43.

78 Frye, *Mythologizing Canada: Essays on the Canadian Literary Imagination,* 17–18.

79 Gerard Brett, "Notes on a Possible Canadian Modern Design Exhibition," 1.

80 Gerard Brett, letter, 22 December 1954.

81 "Handicraft Expert Guest at Luncheons," *Globe and Mail,* 16 May 1955.

82 "Special Events flyer," Royal Ontario Museum Archives.

83 McCarthy, "Designer-Craftsmen U.S.A. Coming with Honest Appraisal Its Motive," *Globe and Mail,* 26 March 1955.

84 McCarthy, "Designer-Craftsmen Coming with a Display of Exploratory Ideas," *Globe and Mail,* 15 May 1955.

85 Cragg, "About the House: Homemakers Will Enjoy Craft Show at Museum," *Globe and Mail,* 19 May 1955.

86 Thomson, "Stress Fine Simplicity in United States Craftsmen Show," 4.

87 The memos regarding the selection of John Van Koert as the American representative on the jury contained two different spellings of his name – Van Koert and Van Hoert. The American Craft Council referred to him as Van Koert, as does Barros in *Ornament and Object.*

88 National Gallery of Canada Archives, Exhibitions in Gallery 5.5C, *Canadian Fine Crafts* 1957, Box 1, File 2.

89 "Memo from Donald W. Buchanan," 29 June 1956, National Gallery of Canada Archives.

90 Evelyn M. Charles, letter, 26 June 1957, and William Reid, letter, 21 May 1957. The craftspeople whose work was selected to be shown in the Canadian pavilion at the Universal and International exhibition in Brussels, 1958, were Olea Davis, Vancouver; Tess Kidick, Jordon, Ontario; Bailey Leslie, Toronto; Hilda Ross, BC; Louis Archambault, Montreal; Kjeld and Erica Diechman, New Brunswick; William Reid, BC, Harold B. Burnham, Ontario; Micheline Beauchemin, Montreal; Denyse Beauchemin, Quebec; Foster and Eleanor Beveridge, Halifax; Claude Vermette, Quebec; Helga Palko, Saskatchewan; and Arthur Price, Ontario.

91 www.civilization.ca/arts/bronfman/reid1e.html

92 Barry Herem, "Remembering Bill Reid," www.civilization.ca/aborig/reid/reid08e.html.

93 www.civilization.ca/arts/bronfman/reid1e.html.

94 Donald W. Buchanan, *Canadian Fine Crafts 1957 Catalogue,* 1.

95 Ibid., 2.
96 McCarthy, "Two-Way Surprises at Fine Craft Show," *Globe and Mail*, 8 June 1957: 24.
97 McCullough, *Newsletter to the Craftsmen of Canada from Miss Norah McCullough*, 1. In the first *World Crafts Council Newsletter* published in August 1964, Aileen Webb listed the key problems of the global craft community as standards, design, marketing, and pricing, stating that "the orientation towards the art concept in craftsmanship is a result of the belief that as world technology increases there must be an outlet for the creativity of man through which the continuing culture of a nation may flow." This statement did not acknowledge the enormous gulf in technologies available to craftspeople in certain non-Western countries (Webb, *World Crafts Council Newsletter*, August 1964).

CHAPTER THREE

1 Hénaut, "1967 – The Moment of Truth for Canadian Crafts," 20–2.
2 "Canadian Fine Crafts 1967," *Canadian Art*.
3 Moncrieff Williamson, "Escalation in Canadian Crafts," *The Craftsman/L'Artisan* (June 1966).
4 Panel Discussion at Design Centre 11 May 1966, *Canadian Souvenirs and Giftware – How Can We Improve Design and Quality?* Archives of Ontario.
5 Mavor Moore, "Lives Lived: Moncrieff Williamson," *Globe and Mail*, 2 September 1996.
6 During Williamson's directorship at the Confederation Centre in Charlottetown he became known for his work on the painter Robert Harris and his painting "Fathers of Confederation."
7 "Vast Change Noted in Island Handcrafts," *Charlottetown Guardian*, 16 May 1972.
8 Norah McCullough, "Report to Craftsmen," Memo for *World Crafts Council Newsletter*, 31 August 1967.
9 "Expo a Storehouse of World's Treasure," *The Montreal Star*, 28 April 1967: 66.
10 Hénaut, "1967 – The Moment of Truth," 22.
11 The recipients of the Fine Crafts awards were Ed Drahanchuk, Calgary $1,000 (Ceramics); Charlotte Lindgren, Halifax $3,000 (Tapestry); Anne Pare, Quebec $1,000 (Tapestry); and Walter Schluep, Montreal $3,000 (Metal). Charlotte Lindgren and Anne Pare were the only women who received awards in the *Perspective '67* exhibition. Barrie Hale, "Perspective '67 Opens at AGO," *The Telegram*, 8 July 1967.
12 Williamson, *Canadian Fine Crafts*, 4.
13 Ibid., 11. One could speculate that such a marked use of stoneware was linked to the influence of Bernard Leach, Michael Cardew, Michael Casson, and the use of stoneware in the "back-to-the-land" movement of the 1960s. Many Canadian potters were able to find local sources for their clay.
14 In 1983 Ed Drahanchuk shifted his focus from ceramics to painting. Today he creates bright, colourful, large-scale multimedia images in his Quadra Island studio.
15 Articles on Drahanchuk that emphasize his Ukranian ancestry appeared in *Novy Shliakh* (21 August 1965, 25 September 1965) and *The Windsor Viter* 8/6 (December 1998).
16 Williamson, *Canadian Fine Crafts*, 5.

17 Ibid., 6.

18 Aileen Osborn Webb, letter to Norah McCullough, 20 December 1966. The United States pavilion at Expo 67 featured abstract American painting and traditional folk arts.

19 Williamson, *Canadian Fine Crafts*. The catalogue contained biographical information on the artists, including their place of birth and locations of formal training. Of the 120 exhibitors, ninety-five (79 percent) had received professional craft education. Of those with professional training, 79 percent had received their education in Canada, with 27 percent of those educated in Canada receiving their training in Quebec. A further 32 percent had attended school or apprenticed overseas (mainly Europe), while 19 percent had attended a craft school in the United States.

20 Paula Gustafson, "Mapping the Terrain," 18.

21 Ibid., 6.

22 www.kennedy-center.org/about/virtual_tour/ike.html#gifts.

23 Arthur Erickson, "Rationalism and Architecture," www.hillside.ca/rationalism-19-01-2000/AErationalism_1.htm.

24 Ibid.

25 Elizabeth Kimball, "The Company of Young Craftsmen."

26 Anita Aarons, "Three Reviews," 24.

27 Suzanne Morrison, "These Handicrafts Are Designed," *Toronto Star*, 10 March 1967.

28 "Report on the Kingston Craftsmen's Conference," Archives of Ontario.

29 Canadian Craftsmen's Association, "The Kingston Conference August 6–11, 1967." Archives of Ontario.

30 Canadian Craftsmen's Association, *Canadian Craftsmen's Association Newsletter*, May 1967.

31 Canadian Craftsmen's Association, "Press Release," 27 August 1967.

32 These included Jacques Anquetil, director of La Maison des métiers d'art Français, Paris; Arthur Hald, president of the Swedish Society for Arts and Crafts; Anton Nilsen, Representative for Per Tannum PLUS craft cooperative of Denmark; Wendell Castle, a woodworker and instructor from Rochester, New York; Peter Collingwood, a production studio weaver from Colchester, England; Willem Heisen, a glass blower from the Netherlands; Freda Koblick from London's Royal College of Art; Anthony Laws, director of Silver Workshops, Limited, London, England; John Prip a studio and industrial metal designer from Providence, Rhode Island; and Paul Soldner, a studio potter from Aspen, Colorado.

33 Norah McCullough, letter to Joan Slebbin, Southern Alberta Gallery, Lethbridge, 31 September 1980, National Gallery of Canada Archives.

34 Anita Aarons and Merton Chambers, letter to Norah McCullough, 13 January 1966, National Gallery of Canada Archives.

35 Norah McCullough, *Biographical Notes*. MacGillivray was the director of the Edmonton Art Gallery who had coordinated the 1964 travelling exhibition *American Ceramics*.

36 "The Arts: Beauty by Design," *Time*, 23 December 1966.

37 *Memo regarding the Exhibition of Canadian Fine Crafts*, National Gallery of Canada Archives.

38 "Canadian Crafts in Panorama," *Ottawa Citizen*, 16 December 1966; "The Arts: Beauty By Design," *Time*, 23 December 1966.

39 "The Arts: Beauty By Design," *Time*, 23 December 1966.

40 Charlotte Lindgren, "Artist's Statement," *Charlotte Lindgren: Fibre Structures*, 1980.

41 Personal interview, Charlotte Lindgren, Halifax, Nova Scotia, 14 June 2003.

42 See www.jra.org/craftart/awards/2001/larsen.htm.

43 Personal interview, Charlotte Lindgren.

44 Ibid.

45 Lindgren describes the technique employed for "Aedicule" as "... woven in one piece; low warp; mixed technique." Charlotte Lindgren, "Artist's Statement."

46 Daniel Rhodes was heavily involved in the American Craftsmen's Educational Council, the precursor of the American Craft Council, which established the School for American Craftsmen at Alfred University. Rhodes completed his MFA degree at the New York State College of Ceramics at Alfred in 1943 and became a ceramics instructor at Alfred in 1947, where he taught until 1973. The American Craftsmen's Educational Council ran the School for American Craftsmen at Alfred from 1946 to 1950, and although they were affiliated with Alfred University and not the New York State College of Ceramics, Rhodes was nonetheless involved in both organizations. From 1962 to 1963 Rhodes studied in Japan on a Fulbright Scholarship. See Gulacsy, *Daniel Rhodes 1911–1989*, Bernstein, *Art and Design at Alfred: A Chronicle of a Ceramics College*.

47 Rhodes, *Clay and Glazes for the Potter* and *Stoneware and Porcelain: The Art of High-Fired Pottery*.

48 Jean Sutherland Boggs, "Foreword," *Canadian Fine Crafts*, 2; Norah McCullough, letter to Professor Daniel Rhodes, 25 February 1966.

49 Norah McCullough, Memo to Jean-Paul Morrisset.

50 "The Arts: Beauty by Design," *Time*, 23 December 1966.

51 Daniel Rhodes, "Introduction," *Canadian Fine Crafts*, 4.

52 Bernard Chaudron, letter to Norah McCullough, 20 January 1966; Norah McCullough, letter to Bernard Chaudron, 21 January 1966.

53 Cultural Affairs Division, Department of External Affairs, letter to Norah McCullough, 17 August 1966.

54 Williamson, "Escalation in Canadian Crafts."

55 Norah McCullough, letter to Mrs. Vanderbilt Webb, American Craftsmen's Council, 6 December 1966, Mrs. Vanderbilt Webb, letter to Norah McCullough, National Gallery of Canada, 7 September 1967. Aileen Osborn Webb sent McCullough a personal letter of congratulations following the opening of *Canadian Fine Crafts* crediting her with a "truly excellent" catalogue of the exhibition.

56 "$13,000 a Year ... For Two Days Work," *Globe and Mail*, 7 October 1966, 16. The article was reporting the results of a meeting of the Community Planning Association of Canada, where the efficiency of "automation, computers and atomic power" was credited with the ability to dramatically change life for North Americans.

57 Hénaut, "The Moment of Truth," 22.

58 Canadian Guild of Crafts, "National Committee Meeting Report," 5 December 1967, 2.

59 The Guild's Ontario branch's shift towards contemporary fine crafts and professional craftspeople left some of its amateur members feeling marginalized. The Federated Women's Institutes of Canada celebrated the efforts of all Canadian craftspeople during Centennial year when they undertook to write the definitive

book on Canadian craft. *A Heritage of Canadian Handicrafts* examined the traditional crafts of Canada province by province, including objects made by Aboriginal craftspeople. Each chapter had been written by Institute members and betrayed their particular social position by relying on nostalgic references to the glories of traditional crafts that most often occupied an important role in rural Canada. Although the book did not analyze Canadian crafts, it did provide a good index of immigrant craft traditions.

60 Wilson Mellen, "Member's Letter," January 1968.

61 Canadian Guild of Crafts, "Annual Report of the Exhibition Committee," 29 April 1968.

62 The majority of the Aboriginal craftspeople in this particular exhibition were from the Northwest Territories, Ontario, and British Columbia. The Euro-Canadian exhibitors represented every province and territory except Prince Edward Island and the Yukon, with the following percentage breakdown: Ontario, 28 percent; British Columbia, 27 percent; Quebec, 18 percent; Alberta, 9 percent; Manitoba, 5 percent; Nova Scotia, 5 percent; Saskatchewan, 3 percent; New Brunswick, 2 percent; Newfoundland, 2 percent; Northwest Territories, 1 percent.

63 Williamson's catalogue did not specify which of Bill Reid's gold boxes was shown in *Canadian Fine Craft*; however, according to Doris Shadbolt's book *Bill Reid*, production of the boxes most likely began with "Bear Design and Three Dimensional Cast Eagle on Lid" in 1967. Bill Reid had many discussions with Bill Holm, author of the 1965 publication *Northwest Coast Indian Art*, in which Reid outlined his study of the "deep carving" technique and rules leading up to the production of his gold boxes post-1965, Shadbolt, *Bill Reid*, 96. It is interesting to note that Bill Reid can hardly be considered a typical Aboriginal artist in this context.

64 The issue of authenticity has become a major concern in the contemporary period as historians have acknowledged the way in which modern aboriginal art production has been dismissed because it did not easily fit into the parameters of the "imaginary Indian." See Francis, *The Imaginary Indian; The Image of the Indian in Canadian Culture*.

65 The Indian Act of Canada was established in 1876 to deal with three areas: land, membership, and local government. At issue in the Indian Acts was reducing the number of Native people who could "legally" lay claim to the land and its resources. Fewer Natives recognized in law meant fewer people who had to be negotiated with over the land. It was amended in 1884 to outlaw cultural and religious ceremonies such as the potlatch and the Tamanawas Dance. The potlatch was a ceremony to mark special events and confirm social status and was sometimes used for political purposes. The Tamanawas Dance involved the invocation of supernatural forces and initiation rites. Christian missionaries found these activities offensive and supported the new laws of 1884, which threatened jail terms of two to six months for engaging in these cultural events. The rational behind outlawing such activities was to integrate the Native population by denying specific cultural traits. This approach was not perceived as being problematic for most Euro-Canadians. Duncan Campbell Scott, the Deputy Superintendent General of Indian Affairs, stated in 1920 that "Our object is to continue until there is not a single Indian in Canada that has not been absorbed into the body politic and there is no

Indian question and no Indian department." Aboriginal leaders objected to these laws in the nineteenth-century. Chief Maquinna defended potlatches in an 1 April 1896 article in the Victoria, British Columbia, newspaper *The Daily Colonist.* "A white-man told me one day that the white people have also sometimes masquerade balls and white women have feathers on their bonnets and the white chiefs give prizes for those who imitate best, birds or animals. And this is all good when white men do it but very bad when Indians do the same thing." www.ualberta.ca/~esimpson/claims/indianact.htm, www.bloorstreet.com/indact.htm.

66 "Reviews – Montreal Branch of the Women's Art Association of Canada Second Exhibition of Arts and Handicrafts," 147. The Women's Art Association turned over their assets to what was going to become the Guild in 1904.

67 Weinrich, "A Very Short History of Craft." Bronfman Collection Site, www.civilization.ca/arts/bronfman/historye.html.

68 McMaster, "Tenuous Lines of Descent: Indian Art and Craft of the Reservation Period," 93–113.

69 Suzanne Morrison, "Eskimo Art Is Booming," *Toronto Daily Star,* 23 November 1966.

70 "Discoverer Sees Death of Eskimo Art," *Globe and Mail*, 13 October 1966.

71 Phillips, *Trading Identities: The Souvenir in Native North American Art from the Northeast 1700–1900*, 198, 210.

72 Phillips, "'Nuns, Ladies, and the "Queen of the Huron': Appropriating the Savage in Nineteenth-Century Huron Tourist Art," 34–48. Phillips discusses the publication of Canadian ethnologist Marius Barbeau's discovery that the Ursuline nuns had originated the art of bark and moose-hair embroidery, arguing that Barbeau's intervention deauthenticated this category of craft production because "Essentialist discourses hate a hybrid."

73 The importance of nuns in promoting Native crafts continued through the 1960s, when Sister Blanche Matte, a gray nun from Rae, Northwest Territories, was featured in *Chatelaine* for her organization of the Dogrib band craftspeople. Sister Blanche Matte convinced Emile Gautreau, a forestry technician who had been cared for by her in the local hospital after a plane crash, to obtain orders for the mukluks she had encouraged the Dogrib women to make. By 1965 a $20,000 annual income had been created by moccasin sales, employing eight full-time sewers and seventy-six co-op members. Sister Matte turned over the craft project to the women to run themselves in 1967. "Women of Canada: The North," 37.

74 Bol, "Defining Lakota Tourist Art, 1880–1915," 215.

75 Valaskakis, "Postcards of My Past: The Indian as Artefact," 155–69.

76 Ibid., 110. The Ohsweken Art Group held an exhibition at the Academy of Fine Arts in Philadelphia during the 1950s.

77 Jo Carson, "Nimble-Fingered Indian Keeps Crafts Alive," Archives of Ontario. Gladys Taylor described her trips with her mother to the farmers around Curve Lake to trade their quillworks and splint baskets for food.

78 Although the business was owned by Clifford Whetung and his wife Eleanor, the band council signed a resolution backing "a substantial loan" for the new building. "Ojibway Progress Marked by New $50,000 Building – Craft House Built for Booming Business," 2.

79 Ibid., 2.

80 Currell, "Indian Craftsmen Are Skilled Carvers," 34.

81 "Progress, Pride for Curve Lake," *Telegram*, 14 May 1966.

82 For a discussion of imported Native "fakes" made in Japan, see Blundell, "Aboriginal Empowerment and Souvenir Trade in Canada," 64–87; Ettawageshik, "My Father's Business," 20–9; and "Canadian Souvenirs and Giftware – How Can We Improve Design and Quality?" Panel Discussion at the Design Centre, Toronto, 11 May 1966, Archives of Ontario.

83 Blundell, "Aboriginal Empowerment and Souvenir Trade in Canada," 64–87.

84 Price and Barbeau, *National Asset/Native Design*, 1.

85 Abrahamson, "Of Consuming Interest: Indian and Eskimo Art: True and False," 18. *Chatelaine* featured an article on shopping for Centennial Souvenirs in its 1967 special Souvenir Centennial Issue, which urged consumers to look for labels for authenticity when buying Native and Inuit objects. "Chatelaine Shops for Centennial Souvenirs," 66.

86 Stainforth, *Did the Spirit Sing: An Historical Perspective on Canadian Exhibitions of the Other*, MA thesis, 47–9.

87 *Canadian Indian Crafts Limited: A Proposed Program for Developing Indian Art and Craft in Canada*, submitted to Agricultural Rehabilitation and Development Act, Department of Forestry, Ottawa, June 1966, 1–63, Archives of Ontario. The study, focusing only on Ontario and British Columbia, listed Whetung Ojibwa Crafts as employing eighty to one hundred Native craftspeople. Outsider businesses that organized Native craftspeople included Frank Porter of Victoria, British Columbia, who employed eighty-five Native women to knit Cowichan products, and Jack Newcomb of Takla Lake, who sold Native crafts to tourist ships.

88 Art Soloman, "Some Thoughts on Indian Craft Development in Canada," 3. Art Solomon was the craft coordinator for the National Indian Council of Canada.

89 "People Worth Knowing," *Popular Ceramics*, April 1965, 88.

90 "The New Indian," *Photosheet Magazine* (1968).

91 "Gift for the Queen," *Globe and Mail*, 30 June 1967.

92 Valaskakis "Postcards of My Past: The Indian as Artefact," 157–66.

93 Phillips, *Trading Identities*, 265.

94 Schrader, *The Indian Arts and Crafts Board: An Aspect of New Deal Indian Policy*, 79.

95 Ibid., 124–46.

96 René d'Harnoncourt was the curator of the exhibition. The Indian Arts and Crafts Board, established under F.D. Roosevelt's Public Works of Art Project Initiative, hired d'Harnoncourt in 1936 as assistant manager, and later the manager, where he became involved in "a personal crusade to improve all aspects of the Indian Arts and Crafts situation in the United States." In 1945 d'Harnoncourt became director of the new department of Industrial Design at the Museum of Modern Art. Schrader, *The Indian Arts and Crafts Board: An Aspect of New Deal Indian Policy*, 124–46.

97 Berlo and Phillips, *Native North American Art*, 223.

98 The National Gallery of Canada attempted to showcase Native work as art rather than ethnographic artifact as early as 1927 with its exhibition *Canadian West Coast Art, Native and Modern*. The show combined Native and non-Native art and artists. Emily Carr's paintings were juxtaposed with a historical traditional Northwest

Coast woven blanket (Stainforth, *Did the Spirit Sing?*, 50–2); however, it was not until Doris Shadbolt mounted the exhibition *Arts of the Raven* at the Vancouver Art Gallery in 1967 that contemporary modern Native craft would be displayed in a formal fine arts setting. (Glenn Allison, telephone interview, 14 June 2000).

99 Hill, "Canadian Indian Art: Its Death and Rebirth," 11. Both Tom Hill and Alex Janvier created circular exterior murals, based on the pattern of Plains-style quillwork rosettes. Janvier used both his name and treaty number when signing his mural.

100 "Indians Spend Expo Cash to Tell of Poor Deal," *Globe and Mail*, 7 April 1967: 3.

101 *The Memorial Album of the First Category Universal and International Exhibition Held in Montreal from 27 April to 29 October 1967*, 118.

102 Brydon, "The Indians of Canada Pavilion at Expo 67," 59. The regions and crafts in the reception area were a Tsimshian helmet from the North West Coast, a Lilooet Cradle from the Plateau, Slavey snowshoes from the Subarctic, a Blackfoot headdress from the Plains, an Iroquois False Face Mask from the Eastern Woodlands, and an Ojibwa basket from the Woodlands.

103 "Ancient Craft for Expo Igloo: Eskimo Artists Face Biggest Challenge," 53.

CHAPTER FOUR

1 It must be noted here that earlier Canadian craft education often relied heavily on British models, for example, Halifax's Victoria School of Art (now NSCAD University) and Toronto's Ontario School of Art (now Ontario College of Art and Design). For an overview of Canada's early academic craft education see Flood, *Canadian Craft and Museum Practice 1900–1950*, 167–211.

2 Lord, "Canada: After Expo, What?" 94.

3 These guidelines were reiterated in many articles and jurors' statements during this period. In a later piece Kay Kritzwiser of the *Globe and Mail* clearly laid out the criteria for determining how a craft work "failed to achieve a high degree of professionalism" that followed these "rules." She wrote of the 1973 Canadian National Exhibition juried craft show, "The judges considered it vital to encourage craftsmen to consider the content, the meaning of their work, in relation to themselves but to other craftsmen and society as well." Kritzwiser, "Criticism of Quality at CNE Exhibit."

4 Orland Larson, "A Nova Scotia Craftsman's View, 1973," National Archives of Canada.

5 Foucault, *Power/Knowledge: Selected Interviews and Other Writings 1972–1977*, 257.

6 Foucault, "The Discourse on Language," 149.

7 "American Craft Council 1943–1993: A Chronology," 138. Herwin Schaefer, the Museum of Contemporary Crafts' first director, wrote that the museum's "primary aim is to show artistic excellence, to show problems and solutions of design, not as recipes but as inspirations for originality and creative vigor ... What will inspire that craftsman will also help to educate the consumer."

8 Reif, "80 Today and She Can't Wait to Get Back on the Dance Floor."

9 "American Craft Council," *American Craft*, 139.

10 Paul Smith, personal interview, 22 January 2002, New York.

11 Shirey, "Crafting Their Own World," 62.

12 Paul Smith, personal interview, 22 January 2002, New York.

13 Ibid.

14 "Connoisseurs of Crafts," 47–50.

15 O'Brian, *Clement Greenberg: The Collected Essays and Criticism, Volume One: Perceptions and Judgments*, xxiii.

16 Guilbaut, *How New York Stole the Idea of Modern Art: Abstract Expressionism, Freedom and the Cold War*, 20.

17 Quoted in Metcalf, "Replacing the Myth of Modernism," 41.

18 Lord, "Living inside the American Empire of Taste: Canadian Artists Are Struggling to Find a Way Out," 31.

19 Ibid., 29.

20 Jenkner, *Catalogue: 120 Dessert Plates*.

21 Ibid.

22 Stacey and Wylie, *EightyTwenty: 100 years of the Nova Scotia College of Art and Design*, 76.

23 Meredith Filshie et al. *Report on the Canadian Handicraft Situation*.

24 Ricardo Gomez, personal interview, 26 December 2003, Kingston.

25 Jack Sures, email interview, 3 July 2002.

26 Canadian Museum of Civilization, "Air, Earth, Water, Fire."

27 Jack Sures, email interview, 3 July 2002.

28 Ricardo Gomez, personal interview, 23 September 2000, Kingston.

29 McNeil, "A Question of Identity: Twelve Canadians," 28.

30 Strecker, *Sheridan: The Cutting Edge in Crafts*, 157.

31 White, *Donald Lloyd McKinley: A Studio Practice in Furniture*, 2.

32 Dempsey, "Craftsmen's Hands Mould the Good Life," 32.

33 McKinley, "The School of Crafts and Design: A Personal Memoir," 157.

34 Ibid., 146.

35 Helen Worthington, "Potters Pursue Dream in Unique School," 4/49. Mary Jukes, "Student Art Designed to Sell," W9. See also Bonellie, "An Experiment in the Teaching of Crafts," 11.

36 Worthington, "Potters Pursue Dream," 49.

37 Verzuh, *Underground Times: Canada's Flower-Child Revolutionaries*, 213.

38 Westhues, *Society's Shadow: Studies in the Sociology of Counter Cultures*, 183.

39 Barbour and Frost, *The Quakers*, 267.

40 Kansinsky, *Refugees from Militarism: Draft-Age Americans in Canada*, 5. Kansinsky makes a distinction between draft dodgers and deserters. The draft dodgers had higher levels of education and were of the middle class, whereas the deserters had lower levels of education and were of the working class.

41 Westhues, *Society's Shadow*, 190.

42 Flood, *Canadian Craft and Museum Practice 1900–1950*, 262.

43 McCullough, *Biographical Notes*, National Archives of Canada.

44 Peter Tonge, "An Affair to Remember."

45 Kootenay School of Art, "News Release," May 1966.

46 "Kootenay School of Art Wins World Art Award," *Nelson Daily News*, 1. The jury for the exhibition in Faenza consisted of: Argan Guilio Carlo, professor of History of

Art, University of Rome; Artigas Jose Llorens, ceramist, Barcelona, Spain; Dr Frattani Gino, painter; Lindberg Stig, ceramist, Gustavsberg, Sweden; Dr Pecker Andre, Paris; Dr Rossi Filippo, superintendent of the Galleries of Florence; Carlo Zauli, ceramist, Faenza, Italy. Mignosa's student Sara Golling from Alabama was featured on the cover of the *Nelson Daily News* report. Douglas O. MacGregor the director of the Kootenay School of Art claimed that after the school won the silver medal in Italy, applications "started coming in from Great Britain, Germany, Nigeria, South America, Hong Kong, and a wide selection of cities in Canada and the U.S."

47 MacGillivray, "Introduction," *American Ceramics*, exhibition catalogue, November 1964.

48 Rhodes, "Stoneware and Porcelain," *American Ceramics* exhibition catalogue, 6, Nelson Museum and Archives.

49 Chris Freyta, personal interview, 10 August 2000, Nelson.

50 "Kootenay School of Art Faculty List," Nelson Museum and Archives.

51 Lesser, *École du Meuble 1930–1950, La décoration intérieure et les arts décoratifs à Montréal*, 15, 19, 51.

52 Ibid., 89.

53 Lois Moran, letter to Cyril Simard, 20 April 1971.

54 Yvan Gauthier, personal interview, 21 January 2000, Montreal.

55 Filshie et al., *Report on the Canadian Handicraft Situation*, 24, 57.

56 King et al., "Craft Boom."

57 "Interest in Craft Work Booming as Part of Social Revolution," *Owen Sound*, November 1973.

58 Arnheim, "The Form We Seek."

59 Metcalf, "Replacing the Myth of Modernism," 45.

60 The Canadian Craftsmen's Association sponsored Christmas Craft Exhibitions at the Ottawa Civic Centre from 1971 to 1973 and held a Craftsmen's Market at the National Arts Centre in Ottawa during the summer of 1973. National Archives of Canada, Canadian Craftsmen's Association, MG28I222, Vol. 9.

61 Yvan Gauthier, personal interview, 21 January 2000, Montreal.

62 John de Vos, letter to Sheila Stiven, 21 July 1971, National Archives of Canada.

63 Wolff, *The Social Production of Art*, 40.

64 B.S. Ellis, letter to Peter Swann, director, Royal Ontario Museum, 26 September 1969. Peter Swann, who had recently moved to Canada from Britain, was a proponent of crafts and was instrumental in having the Royal Ontario Museum host the exhibition. After leaving the Museum, Swann became director of the Samuel and Saidye Bronfman Family Foundation, which sponsored the Saidye Bronfman award for Canadian craft beginning in 1976.

65 Andrews, "Pelletier Opens Craft Guild Show." The Canada Council contributed $12,000, the Royal Ontario Museum gave $7,000, and the Canadian Guild of Crafts Ontario branch paid $7,000 towards the exhibition.

66 Harold B. Burnham, "Canadian Crafts – Old and New."

67 Memo to Craft Volunteers, Royal Ontario Museum Archives.

68 Joan Chalmers, the president of the Ontario Branch of the Canadian Guild of Crafts, was not entirely pleased with the Royal Ontario Museum's approach to the display of *Craft Dimensions Canada* and was particularly dismayed to see that curators had

fashioned display stands out of disposable materials like plastic coffee cups. She believes that curators possessed little sensitivity to the special needs of craft objects in exhibitions. Joan Chalmers, personal interview, 19 April 2002, Toronto.

69　Taborsky, "The Discursive Object," 59–60.

70　Marjory Wilton, letter to Mrs Hugh Downie, 24 August 1967.

71　Foucault, *The Order of Things: An Archaeology of the Human Sciences.*

72　Canadian Guild of Crafts, "Annual Report of the Exhibition Committee," 29 April 1968.

73　Marjory Wilton, letter to Mrs Hugh Downie, 24 August 1967. As Sandra Flood points out, curators with experience mounting craft exhibitions, which have complex three-dimensional requirements, are rare, and in 1969 Paul Smith would have been one of the only people capable of undertaking such a challenge. Sandra Flood, email interview, 31 August 2002.

74　Memo regarding Paul Smith, July 1968, Royal Ontario Museum Archives.

75　The exhibition committee also sought advice from British sources, bringing in Hugh Wakefield of the Victoria and Albert Museum to give a lecture entitled "Contemporary Crafts in the Museum." During Wakefield's 2 October 1969 lecture he alienated Quebec craftspeople by insisting that "As an Englishman I cannot forebear pointing out that it was Britain, which played a leading part in the early phases of the industrial revolution, that the contemporary craftsman first appeared more than a century ago in the intellectual revolt associated especially with the name of William Morris." While British craftspeople and ideas influenced parts of English Canada, British administrators were turning to Canada for guidance on how to structure an effective national craft organization. Mary Eileen Muff, Canadian representative to the World Crafts Council, received a letter from George Sneed of the Society of Designer Craftsmen in London inquiring about "the position of craftsmen in Canada in relation to the government" and thanking Muff in advance: "British craftsmen will be most grateful to you if you will in this way help them to obtain the Government recognition they feel they require." Wakefield, "Lecture," 2 October 1969, Archives of Ontario; George Sneed, letter to Mary Eileen Muff, 30 October 1969, National Archives of Canada.

76　"Artists Must Fight Apathy – Pelletier," *Toronto Star*, 23 September 1969.

77　Andrews, "Pelletier Opens Craft Guild Show."

78　"Craft Dimensions," *Canadian Interiors*, September 1969; "Jurors for Craft Dimensions Canada Exhibition," Press Release, Royal Ontario Museum Archives.

79　Bourdieu, *The Field of Cultural Production*, 2.

80　Craft Dimensions Canada Award Winners, "memo," 22 September 1969. The awards were distributed as follows: Alberta, 4/23 or 17 percent, Ontario, 13/23 or 57 percent, Quebec, 3/23 or 13 percent, New Brunswick, 1/23 or 4 percent, Nova Scotia, 1/23 or 4 percent, Newfoundland, 1/23 or 4 percent.

81　Jurors' Statements, Royal Ontario Museum Archives.

82　Piper, "Craft Canada Dimensions."

83　Gerard Brett, letter to Robert Fennell, 22 December 1954.

84　Canadian Guild of Crafts, "President's Report, Annual Meeting," 27 April 1970.

85　Andrews, "Pelletier Opens Craft Guild Show."

86　"Art, Artistes, Artisans," *La Presse*, 29.

87 "International Handicraft Exhibition," *Craftsman/L'Artisan*, 4/2, 1971: 6.

88 "Minutes of the Meeting on the International Craftsmanship Touring Exhibition of the Agence de Cooperation Culturelle et Technique, 13 April 1971," Archives of Ontario.

89 Green, *A Heritage of Canadian Handicrafts*, x.

90 Nineteen Canadian representatives attended the meeting, including Mary Eileen Muff, Don McKinley, Jack Sures, Sheila Stiven, Gordon Barnes, and Art Price. Fourteen of the Canadians were from Ontario.

91 "Proceedings of the Formation of a North American Alliance of the World Crafts Council," Shelburne, Vermont, 24 August 1969.

92 Roulston, "World Crafts Council," 2.

93 Aileen Osborn Webb, letter to Prime Minister Pierre Elliott Trudeau, 2 March 1970, National Archives of Canada. This was not the only time Webb had written letters regarding the promotion of Canadian crafts. In 1969 Sheila Stiven, executive secretary of the Canadian Craftsmen's Association, received a letter from Marilyn Stonier of Perth, Ontario, stating "I have just received a letter from Mrs. Webb of the World Crafts Council giving me the name and address of your association ... for I have been having a most difficult time ascertaining an individual or indeed even an organization to which I may write." National Archives of Canada, Canadian Craftsmen's Association, MGI222, Vol. 12.

94 collections.ic.gc.ca/artists/davidson_robert.html

95 *Canadian Craft Council 1974 Report*, 14–15, National Archives of Canada.

96 Edwards, "Made in Canada: Our Craftsmen Turn Out Beautiful Work."

97 Joan Chalmers, letter to James Noel White, 28 September 1971, National Archives of Canada.

98 McCutcheon, "Report of the Indian-Eskimo Committee," Minutes of the Canadian Guild of Crafts, 26 January 1972.

99 Arthur Soloman, "Response to World Crafts Council Questionnaire, 1968," National Archives of Canada.

100 *Native American Arts* was shown at the Institute of American Indian Arts, United States Department of the Interior during 1968. *Aboriginal Art in Paris*, composed of two hundred items from thirteen Canadian Museums, was exhibited in the spring of 1969, opening at the National Gallery of Canada on 20 November 1969. Baronness Alix de Rothschild, president of la Société des Amis du Musée de l'Homme, Paris, opened the exhibition, providing links to the tradition of philanthropic connoisseurs supporting the trade in increasingly valuable traditional craft objects. See *Craftsman/L'Artisan*, 2/2, Summer 1969, 3; and *Craftsman/L'Artisan*, 2/3, 1969, 2.

101 Soloman, "Presentation to the Parliamentary Common, Northern Affairs," 10–11.

102 Soloman, *To the Indian Craft Workers of Ontario*, Archives of Ontario. Soloman's 1969 meeting was unique in that the participation was limited exclusively to First Nations' representatives. This followed the revolutionary 1966 meeting of the conference of Northwestern Ontario Indians, which was described by the *Globe and Mail* as exceptional in that "it was organized entirely by Indians and whites played only a subservient role." "Indians Form New Association," *Globe and Mail*, 8 October 1966, 18.

103 *Telegram*, 16 February 1969, 4:1.
104 *Indian Crafts of Ontario*, Archives of Ontario. The directors of the new organization were Art Soloman, Alma Houston (James Houston's wife), of the Canadian Arctic Producers, and the quillworker Clara Baker.
105 The Archives of Ontario contains a number of handwritten messages and urgent memos between Arthur Soloman, Bunty Muff, and R.F. Lavack of the Youth and Recreation Branch of the Ontario Department of Education. Archives of Ontario, Ontario Crafts Council, MU5781, Box 36, FV-FZ.
106 "Manitou Cultural Teach-In News Release," Saturday, March 1971.
107 Gibson, *A "Desk" Commentary: The Role of Federal Government Departments with Respect to Canadian Handicrafts*, 13.
108 Canadian Craftsmen's Association, "Minutes," 11 December 1971.
109 "Artists Must Fight Apathy – Pelletier," *Toronto Star*, 23 September 1969.
110 Editor Sheila Stiven reported in the second issue of *Craftsman/L'Artisan*, "Among our critics was the Canadian Guild of Crafts who, while appreciating the difficulties implicit in producing a first issue, complicated by a mail strike, thought that the first issue was not too satisfactory" and stopped their financial contribution. *Craftsman/L'Artisan*, no. 1/2, November 1968, 1.
111 Canadian Guild of Crafts, "Becoming Better Known in Ottawa," President's Report, 31 March 1970, 8, 15.
112 Statistics Canada Survey, "News Release," 14 November 1972, National Archives of Canada.
113 Gibson, *A "Desk" Commentary: The Role of Federal Government Departments with Respect to Canadian Handicrafts*, 4.
114 Ibid., 23–4.
115 *Program to Support the Canadian Handicraft Industry*, 1–2.
116 Ibid., 7.
117 Meredith Filshie et al. *Report on the Canadian Handicraft Situation*, 1–2, National Archives of Canada.
118 "Proceedings of the Formation of a North American Alliance of the World Crafts Council," Shelburne, Vermont, August 1969, 3, National Archives of Canada.
119 Ibid., 8, 28, 68. Filshie, Hancox and Orr recommended in their report that the federal government raise the taxation level from $3,000 to $15,000 before requiring sales tax and that the tax structure be changed to remove Federal Sales Tax from finished articles and materials.
120 Ibid., 102.
121 Ibid., 86.
122 Ibid., 90.

CHAPTER FIVE

1 Sutton, "Sutton's Place," 24.
2 James Plaut, "Memo," National Archives of Canada. Designer Taizo Miake's wife is Ann Suzuki, who was involved with the Canadian Craftsmen's Association.

Joan Chalmers knew Taizo Miake from their work together on the 1971 Canadian Guild of Craft's exhibition *Make*, which had been held at the Ontario Science Centre. Personal interview, Joan Chalmers, 19 April 2002, Toronto.

3 J. Chalmers, "The International Scene."

4 Canadian Guild of Crafts, "A Brief to the Secretary of State from the Canadian Committee," July 1972, 1.

5 "This is World Crafts Year and this program looks at three different artisan co-ops in the Maritimes," *Star TV Guide*, 19 June 1974. *Toronto Star* television guides dating from "summer 1974" list shows of First Nations, Inuit, and Ukrainian crafts. Television Ontario (TVO) showed a three-part series in conjunction with the World Crafts Council comprising "In the Making," "Fibres and Clay," and "The Conference," Valerie Hatten, librarian, Ontario Science Centre, personal interview, 30 January 2001, Toronto.

6 "World Craft Show in Toronto in 1974," *Globe and Mail*, 25 April 1972, 18.

7 Aileen Osborn Webb, letter to Mary Eileen Hogg, 21 June 1971.

8 James Plaut, "Resumé," North American Assembly Conference, 10–11 June 1971.

9 North American Assembly Conference, 10–11 June, 1971.

10 Hogg, "World Crafts Council Progress Report, 1974."

11 "World Crafts Council Discussion," 5 July 1974.

12 Reif, "80 Today and She Can't Wait to Get Back on the Dance Floor."

13 Simpson, "The Great Reversal: Selves, Communities, and the Global System," 115–25. See also, Wellman, *Networks in the Global Village: Life in Contemporary Communities*.

14 George Shaw, letter to Herman Voaden, 14 November 1968; Jack Sures, letter to Herman Voaden, 7 January 1969.

15 J. Hugh Faulkner, Secretary of State, letter to Ann Suzuki, chair, Canadian Craftsmen's Association, 14 March 1973.

16 Rei Nakushima, Visual Arts Centre, Montreal, letter to Ann Suzuki, chair, Canadian Craftsmen's Association, 18 January 1973.

17 *Quebec Congress of the Applied Arts*, 25–27 May 1973, Orford, Quebec, 5.

18 "1974 – The Crafts Year in Canada," A Brief to the Secretary of State from the Canadian Committee, World Crafts Council, July 1972, 2.

19 Vidal, "Métiers d'Art du Québec Statement to the Canadian Guild of Crafts (Quebec and Ontario)." Vidal wrote, "Votre organisme semble ignorer que la langue des artisans du Québec est le français et que pour les rejoindre, il faut s'addresser à eux dans leur langue ... Il existe un malaise parmi les artisans québécois face à cette manifestation, et c'est la raison pour laquelle la plupart n'ont pas participé."

20 Sheila Stiven, "Memo to Mary Eileen Hogg," 8 August 1972.

21 "Memorandum from World Crafts Council to all World Crafts Council Directors and Representatives," 8 February 1972.

22 "World Crafts Council Fact Sheet, Toronto, Canada, June 1974," 4.

23 Joan Chalmers, personal interview, 19 April 2002, Toronto.

24 Ibid., Chalmers recounts that her mother, Jean Chalmers, was friends with Mrs Vaughn, wife of the vice-president of Eaton who allowed the Guild shop to operate out of the northeast corner of Toronto's Eaton store. Joan had been under the

impression that the Guild paid her $5 weekly wage during her summer job but found out when she joined the Exhibition Committee in 1970 that her father had paid the Guild her weekly wage.

25 Floyd S. Chalmers was awarded the Order of Canada in 1967, received the Diplôme d'Honneur from the Canadian Council of the Arts in 1974, and was made a Companion of the Order of Canada in 1984. Chalmers, "Biography for Order of Canada"; see also Laine and Winters, "Chalmers, Floyd" (www.thecanadianencyclopedia.com/).

26 Dempsey, "Metro Woman Plans First World Crafts Show"; Reif, "80 Today and She Can't Wait to Get Back on the Dance Floor."

27 For a discussion of the role of the "popular aesthetic," with its emphasis on the continuity between art and life, versus "pure taste" and the "aesthetic disposition," see Bourdieu, *Distinction: A Social Critique of the Judgement of Taste*, 28–50.

28 Strecker, *Sheridan: The Cutting Edge in Crafts*, 20.

29 One of Floyd S. Chalmers's main interests was the theatre. He helped to establish the Stratford Festival, and provided Chalmers Awards for Canadian plays, directors, and young playwrights.

30 "Pioneer Craft Sponsor Gets Honorary Degree," *Toronto Star*, 6 June 1973.

31 Canadian Guild of Crafts (Ontario), "President's Report," 18 April 1974.

32 Newman, "Who Runs Culture in Canada?" 26, 27, 79.

33 Hogg, "Memo to All Members of the Canadian Section of the World Crafts Council, 1972."

34 George Shaw, letter to Herman Voaden, 14 November 1968; Jack Sures, letter to Herman Voaden, 7 January 1969.

35 Campaigne, *Manifesto of the Salon des Refusés*.

36 Hogg, "Memo to All Members of the Canadian Section of the World Crafts Council."

37 "Donation for Crafts," *Globe and Mail*, 27 March 1974. Lombard's glowing statement on the necessity of crafts ("perhaps more than any other human activity, at the heart of every society, reflect the realities and dreams of all men") was tempered by the anonymous author of the article who reminded readers that "still, the donation has practical value for the company."

38 These figures were taken from the *Globe and Mail* article "Donation for Crafts" and the *Canadian Committee of the World Crafts Council 1974 Report*. For a good listing of sources, see Kritzwiser, "In Praise of Hands: The Craftsman's Orbit." The eleven master craftspeople sponsored by the Department of External Affairs were: Magdalena Abakanowicz, Poland; Jagoda Buic, Yugoslavia; Daniel Cobblah, Ghana; Marea Gazzard, Australia; Tony Hepburn, United Kingdom; Mona Hessing, Australia; Ritzi and Peter Jacobi, Germany; Klaus Moje, Germany; John Rimer, Denmark; and Seka Severin Tudja, Venezuela.

39 The Ontario Craft Foundation had been established in April 1965 during the Ontario Crafts Conference at Geneva Park, Lake Couchiching. Organized by Mary Eileen Hogg (née Muff), the chief mandate of the new organization was the establishment of a specialized craft training centre, realized by the Sheridan College of Art and Design. In 1976 the Ontario Craft Foundation and the Canadian Guild of Crafts, Ontario branch joined to form the Ontario Crafts Council.

40 "Paul Bennett's View of Craft Development," *Craft Ontario*, 8 April 1974.

41 Paul Cummings, oral history interview with Mrs Vanderbilt Webb, 47.

42 Shirey, "Crafting Their Own World," 62.

43 "Think Tank Session," Ascot Inn, 6 January 1972, 5.

44 "Craft Exhibit Invites Visitors to Pitch In," *The Detroit Free Press*, 19 May 1974, 18.

45 Carson, "Handmade in Canada," 6.

46 Markowitz, "The Insiders."

47 Alsop, "A Global Holding of Hands," 16.

48 Ibid.

49 Ibid.

50 *In Praise of Hands Entries*, Archives of Ontario.

51 National General Committee of the Canadian Guild of Crafts, *Reports of the Annual Meeting*, 26 April 1973, 20–5.

52 "15 Canadian Works in International Exhibition," *Globe and Mail*, 12 April 1974, 20.

53 Bourdieu, *Distinction*, 12.

54 The Canadian craftspeople selected were: Bailey Leslie, Toronto, porcelain compote and footed porcelain pot; Ruth Gowdy McKinley, Mississauga, porcelain wine server and three piece stoneware tea set; Robert Held, Mississauga, stoppered glass decanter; Mary Keepax, Ballinafad, Ontario, white stoneware table; Haakon Bakken, Mississauga, sterling silver neckpiece with pearls and moonstone; William Reid, Montreal, gold and sterling silver necklace; Mrs Winnie Tatya, Putumiraqtuq, appliqued wool wall hanging; Heidi Koukema, West Montrose, Ontario, black wool wall hanging; Richard Hunter, Victoria, silk hammer; Elin Corneil, Toronto, woven wall hanging; Hilde Schreier, Ottawa, hanging fibre sculpture; and Alan Perkins, Toronto, three silver enamel wine goblets. Interestingly, the two Canadian clay objects featured in the book *In Praise of Hands*, Bailey Leslie's compote and Mary Keepax's table, were both porcelain. This contrasts greatly with the trend towards stoneware that had been experienced since the 1960s.

55 Kritzwiser, "Judges Choose Final Craft Entries," 16.

56 *World Crafts Council News*, Autumn 1973, 1.

57 Edinborough, "How the World's Craftsmen Keep Individuality Alive," 13. Although not all of the accepted pieces by American craft artists were included in the book *In Praise of Hands*, fourteen of the twenty-four shown were listed under "The Maker's Statement" chapter.

58 Yanagi's father admired the simplicity of Leach's pottery, an approach Leach had adopted from Japanese tradition (Edinborough, "How the World's Craftsmen Keep Individuality Alive," 13).

59 Harrod, *The Crafts in Britain in the 20th Century*, 385.

60 Soloman, "Letter to the Editor," 8.

61 A condensed version of James Plaut's catalogue essay was included in the issue.

62 Slivka, "The Object as Poet," 12. Craftspeople trained in Europe and South America frequently acknowledged the apprenticeship system. The United Kingdom, France, Germany, Sweden, Denmark, and Finland had an extensive program of formal craft education within universities and art schools. British schools were similar to North America in their emphasis on developing conceptual craft programs.

63 Block's books included biographies, romance novels, mysteries, nonfiction health books, and articles for popular women's magazines. In 1983 she co-authored *Life with Jackie*, a biography of Jacqueline Susann written with Irving Mansfield, Susann's husband. During the 1980s Block wrote articles on Nancy Reagan and Barbara Bush for *Good Housekeeping*, "My Life in the White House," *Good Housekeeping* (15 September 1981), and "The Best Time in My Life Is Now," *Good Housekeeping* (November 1989).

64 Block, "The Crafts in Canada," 15.

65 Reid, *The Canadian Style*, ix.

66 Smith, "Letter to the Editor," 11.

67 Chalmers, "The International Scene."

68 Swain, "Women Producers of Ethnic Arts," 33-35.

69 Reif, "Toronto Crafts Show Is Enormous ... And So Are Problems World's Craftsmen Face," 50. In the 1990s Rita Reif's writing and personal life have focused on the issue of repatriation. She has written many articles for the *New York Times* on the impact of auctions on the repatriation of Native American art; see Jonathan Beninson's Native American Hope Page (members.aol.com/Stenrude/NatAm.html) for a complete listing of her articles on this subject. In 1998 Rita Reif and Henri Bondi claimed that their families, persecuted in the Holocaust, were the rightful owners of two Egon Schiele paintings on temporary display at New York's Museum of Modern Art. The works were seized from the gallery by the Manhattan District Attorney's Office until they were ordered returned to the Leopold Foundation in Austria. The writing surrounding the case emphasized the importance of resolving repatriation cases in the United States. See Anthony F. Anderson, "The Schiele Affair: Art Loans Gone Awry."

70 The multisensory intentions of the exhibition were present during the conference as well. During the European half-day, a large-scale presentation on European craft, consisting of slides of craft objects synchronized with sounds of craft-making such as potters' wheels and looms, intended to bring the viewer into closer contact with the processes. Demonstrators from all of the participating countries were active every day throughout the exhibition. Donald Winkler's montage film *In Praise of Hands*, produced for the National Film Board of Canada, took a similar approach, excluding commentary in the hopes of replacing language barriers with auditory and visual sensory signs. Mixing scenes of craftspeople from all six areas of the world, Winkler linked the scenes through the cadence of craft, the sounds of spinning, throwing, weaving, and hammering.

71 Kritzweiser, "A Shorn Sheep Cleaves Craft from Art."

72 Lee, "Craftsmen and Museum: Out of Touch."

73 Kritzweiser, "A Shorn Sheep."

74 Alfoldy, *Theory and Craft: The Kootenay Christmas Faire*; Cochrane, *The Crafts Movement in Australia: A History*; Gustafson, "Mapping the Terrain"; Harrod, *The Crafts in Britain in the 20th Century*, 342–55.

75 Taborsky, "The Discursive Object," 59–60.

76 Johnson, "Out of Touch: The Meaning of Making in the Digital Age," 293.

77 These numbers are calculated based on the illustrations provided in the book *In Praise of Hands* and not the actual number of items in the exhibition, which numbered close to one thousand. Western items have been designated as originating from industrially advanced countries. The chapters are divided as follows:

"Apparel and Adornment," named Western, 38 percent, named non-Western, 11 percent, anonymous Western, 2 percent, anonymous non-Western, 49 percent; "The Home: Utility and Embellishment," named Western, 41 percent, named non-Western, 3 percent, anonymous Western, 9 percent, anonymous non-Western, 47 percent; "Play," named Western, 30 percent, named non-Western, 11 percent, anonymous Western, 15 percent, anonymous non-Western, 44 percent; "Ritual and Celebration," named Western, 17 percent, named non-Western, 24 percent, anonymous Western, 6 percent, anonymous non-Western, 53 percent; "The Maker's Statement," named Western, 95 percent, named non-Western, 5 percent.

78 Paz, "Use and Contemplation," 1.

79 J. Wilson, *Octavio Paz*, xi.

80 Paz, "Use and Contemplation," 23.

81 Plaut, "A World Family," 9, 11.

82 The panels were: "The Craftsman in a Changing World," keynote speaker Dr d'Arcy Hayman, head, Section of Arts Education and Cultural Development of the Community, UNESCO, Paris; "Preservation of the Cultural Values of a Society through Craftsmanship," chair, Mme Kamaladevi Chattopadhyay, India Handicrafts Board, New Dehli, India; "Production and Marketing in One World," Keynote speaker Stanley Marcus, president, Neiman-Marcus Co., Dallas, Texas; "Planning an International Association of Craftsmen," keynote speaker Mrs Vanderbilt Webb; "Education through International Communication," panelists from West Pakistan, Venezuela, England, Germany, Italy, the United States, and Thailand; "The Contemporary Scene," keynote speaker René d'Harnoncourt, director, Museum of Modern Art, New York; "Design for Production," keynote speaker, Arthur Hald, president, Swedish Society for the Arts, Crafts and Industrial Design; "Our Changing Environment"; "Art Concepts in Architecture"; "Vistas in the Arts," keynote speaker Harold Rosenberg; "Vistas in the Future," keynote speaker, Mrs Vanderbilt Webb.

83 "World Craft Council Fact Sheet, Toronto, Canada, June 1974." Participants in the panel included: Ruth Dayan, Israel, founder of Naskit, craft marketing organization; Abdoulaye Ba, Senegal, directeur, Office Senegalais de l'artisanat; Tonatiuh Gutierrez, Mexico, Administrator General of the Crafts, Federation of Mexico; Lloyd New, chairman, Indian Arts and Crafts Board, United States Department of the Interior, and director of the Institute of American Indian Arts; Felicity Abraham, director, Craft Enquiry, Australia Council for the Arts; Robert Secord, director, Sports and Recreation Bureau, Government of Ontario; James Noel White, World Crafts Council vice-president for Europe; Andre Guerin, general director of Textiles and General Production, Department of Industry, Trade and Commerce, Canada.

84 A.D. Little Inc., "Marketing Crafts from the Third World."

85 M. Rosenberg, "Craft Exhibitors Share Cuisine," FI.

86 Harrod, *The Crafts in Britain in the 20th Century*, 386.

87 Baumin and Sawih, "The Politics of Participation in Folk Life Festivals," 290–2.

88 Hinsley, "The World as Marketplace: Commodification of the Exotic at the World's Columbian Exposition, Chicago, 1893," 345.

89 Ibid., 349, 362.

90 Many of the attendees from Africa, Asia, and Latin America were either demonstrators or directors of the World Crafts Council. "World Crafts Council Fact Sheet," 3.

91 Hendrickson, "Selling Guatemala: Maya Export Products in U.S. Mail-Order Catalogues," 107, 112–3, 117.

92 Plaut, "A World Family," 11.

93 Kritzwiser, "A Shorn Sheep," 19.

94 Littman, "Prairie Sculptor's Ma and Pa Figures Highlight of Guild of Potters' Exhibition."

95 Reif, "Crafts Show: New and Vigorous, but Tradition's Impact Is Solid," 48.

96 Coleman, "Personal View," 10.

97 Diana McDougall, chair, Indian and Eskimo Committee, letter to Herman Voaden, president, Canadian Guild of Crafts, 25 September 1968.

98 *National General Committee Report of Canadian Indian Arts/Crafts 1970*, York University Archives.

99 Elizabeth McCutcheon, letter to Dr E. Rogers, Royal Ontario Museum, 16 May 1972.

100 Tom Hill, personal interview, 21 February 2002, Brantford Ontario.

101 Elizabeth McCutcheon, "Report of the Indian-Eskimo Committee."

102 E.S. Rodgers and Tom Hill worked well together on the project, and Hill was invited to stay and work at the Royal Ontario Museum. Tom Hill, personal interview, 21 February 2002, Brantford.

103 Canadian Guild of Crafts, "Indian-Eskimo Committee Minutes."

104 "In Praise of Hands," *Collingwood Ontario Enterprise Bulletin*, 14 August 1974.

105 "Indian Art Has International Impact on Native Arts and Crafts in Canada," *Indian News*, March 1974.

106 Hill, "Canadian Indian Art: Its Death and Rebirth," 10.

107 Tom Hill, personal interview, 21 February 2002, Brantford.

108 MacVicar, "Indian Art, Traditional and Modern."

109 Reif, "Toronto Crafts Show is Enormous ... And So Are Problems World's Craftsmen Face."

110 Viscount Eccles, "World Crafts Council Conference Address," 10 June 1974.

111 Paz, "Use and Contemplation, 1.

112 Mary Eileen Hogg, "Speech," 10 June 1974.

113 Ibid., 2.

114 Aileen Osborn Webb, "1974 Address."

CHAPTER SIX

1 Peter Weinrich letter to Barbara Brabec, 10 February 1976.

2 Peter Weinrich, "Background Paper." In this paper, as well as in subsequent writings, Weinrich insists on using the term "craftsman" rather than "craftsperson," arguing "craftsperson is an inhuman word and in most countries more craftsmen are women."

3 M. Chambers, "Formation of a National Crafts Council," 26–8.

4 Weinrich, "Background Paper," 1.

5 Cruickshank, "Craftsman Campaigns for Quality."

6 Ibid., A-5.

7 These provincial craft organizations are the Alberta Craft Council (1980), the Crafts Association of British Columbia (1973), the Manitoba Crafts Council (1978),

the New Brunswick Crafts Council (1972), the Craft Council of Newfoundland and Labrador (1972), the Nova Scotia Designer Crafts Council (1973), the Ontario Crafts Council (1976 – from a merger of the Canadian Guild of Crafts [Ontario] and the Ontario Craft Foundation [1966]), the Prince Edward Island Crafts Council (1965), the Conseil des métiers d'art du Québec (1972 – in 1949 Quebec's first group, L'Association professionnelle des artisans du Québec was established under Jean-Marie Gauvreau), and the Saskatchewan Craft Council (1975).

8 Alan Elder, personal interview, 12 April 2002, Ottawa.
9 Canadian Crafts Council, *The CCC Bulletin*.
10 Jan Waldorf, personal interview, 28 October 1999, Toronto.
11 Robert Jekyll, personal interview, 29 October 1999, Toronto.
12 Ibid.
13 Ibid.
14 Lois Moran, personal interview, 9 December 1999, New York.
15 Cheryl Master, personal interview, 6 July 1999, Vancouver. The provinces not attending were Nova Scotia, New Brunswick, and Prince Edward Island.
16 Robert Jekyll, personal interview, 29 October 1999, Toronto.
17 Yvan Gauthier, personal interview, 21 January 2000, Montreal.
18 The essays are: "Clay Talks," by Susan Jeffries, assistant curator of Contemporary Ceramics at Toronto's Gardiner Museum; "Canadian Textiles Today," by Sarah Quinton, contemporary curator , Textile Museum of Canada, Toronto; "The Book Arts Scene," by Shelagh Smith, managing director, Canadian Bookbinders and Book Artists Guild; "Canadian Metalworking – Diversity and Strength," by Anne Barros, Silversmith; and "Canadian Glassworks," by Rosalyn Morrison, executive director, Ontario Crafts Council, and curator of Canadian Glassworks, 1970-90.
19 Boyle, "Career Self-Management In the Cultural Sector: What Next? CODA Craft Conference and Survey."
20 See Myerson, "Tornadoes, T-Squares and Technology: Can Computing Be a Craft?" 176–86, and Johnson, "Out of Touch: The Meaning of Making in the Digital Age," 292–9.
21 Kitchin, *Cyberspace*, ix.
22 Speech by Russell C. Honey, QC, MP, Parliamentary Secretary to the Honourable Jean Chrétien, Minister of Indian Affairs and Northern Development.
23 Tom Hill, personal interview, 21 February 2002, Brantford, Ontario.
24 Peter Weinrich, letter to Tom Hill, no date, National Archives of Canada.
25 Tom Hill, personal interview, 21 February 2002, Brantford.
26 Stephen Inglis, personal interview, 11 April 2002, Ottawa.
27 Clary, "Barbara Rockefeller Believes Crafts Tell about America."
28 Paul Smith, personal interview, 22 January 2002, New York; and Joan Chalmers, personal interview, 19 April 2002, Toronto.
29 Paul Smith, personal interview, 22 January 2002, New York.
30 Peter Weinrich, "Report of a Meeting on the Future of Crafts."
31 Stephen Inglis, personal interview, 11 April 2002, Ottawa.
32 James S. Plaut, letter to Peter Weinrich, 7 November 1981.
33 "Memorandum Regarding a National Museum of Crafts and Design."
34 "Report to the Board of the Canadian Crafts Council on a National Gallery of Crafts and Design, 24 March 1982."

35 Marianne Heggtveit, telephone interview, 21 July 2002.
36 G. MacDonald, "Foreword," 7.
37 Elder, "Craft at the Border," 6.
38 Winners of the Saidye Bronfman Award are: 1977 – Robin Hopper (potter); 1978 –
 Lois Etherington Betteridge (silversmith); 1979 – Monique Cliché-Spénard (quilt
 artist); 1980 – Doucet-Saito (ceramic artists); 1981 – Joanna Staniszkis (textile artist);
 1982 – Micheline Beauchemin (painter-weaver); 1983 – Wayne Ngan (potter); 1984 –
 William Hazzard (wood carver); 1985 – Michael Wilcox (bookbinder); 1986 –
 Bill Reid (metalsmith, wood carver, jeweller); 1987 – Carole Sabiston (fibre artist);
 1988 – Lutz Haufschild (glass artist); 1989 – Harlan House (potter); 1990 – Dorothy
 Caldwell (textile artist); 1991 – Susan Warner Keene (fibre artist); 1992 – Walter
 Dexter (potter); 1993 – Michael C. Fortune; (furniture designer and maker); 1994 –
 Daniel Crichton (glass artist); 1995 – Louise Genest (bookbinder); 1996 – Steve
 Heinemann (ceramic artist); 1997 – William "Grit" Laskin (guitar maker); 1998 –
 Marcel Marois (tapestry); 1999 – Susan Low-Beer (sculptor); 2000 – Peter Fleming
 (furniture designer and maker); 2001 – Léopold L. Foulem ceramic artist); 2002 –
 Kai Chan (fibre sculptor); 2003 – Walter Ostrom (ceramic artist); 2004 – Maurice
 Savoie (ceramic sculptor).
39 For an excellent analysis of ceramics and landscape, see Surette, *Landscape Imagery in
 Canadian Ceramic Vessels.*
40 D. Webster, *Decorated Stoneware Pottery of North America*, 22.
41 Metcalf, "Replacing the Myth of Modernism," 42.
42 Risatti, "Craft after Modernism: Tracing the Declining Prestige of Craft," 32.
43 Metcalf, "Replacing the Myth of Modernism," 40.
44 Klein, *Interdisciplinarity: History, Theory, Practice*, 66. For writing on interdisciplinarity
 in craft see Gustafson, *Craft Perception and Practice: A Canadian Discourse*; Harrod,
 Obscure Objects of Desire: Reviewing the Crafts in the Twentieth Century; Johnson, *Ideas in the
 Making: Practice in Theory*; and Jordon, *Exploring Contemporary Craft History, Theory and
 Critical Writing.*
45 Mathieu, "The Space of Pottery: An Investigation of the Nature of Craft," 28.
46 Dormer, "The Language and Practical Philosophy of Craft," 219.

CONCLUSION

1 Weinrich, "On Trying to Define Crafts," 1–5.
2 The foreword to *Métier*, an exhibition at the Mary E. Black Gallery in Halifax, Nova
 Scotia, 19 March–2 May 2004, makes this point clear, stating, "... we wanted to
 showcase the work of our members [Visual Arts Nova Scotia] who work in a craft
 medium or technique, but who define themselves as visual artists." Arden,
 "Foreword," *Métier*, 1.
3 Barbara Tober, chair of board, Museum of Art and Design,
 artsnyc.com/museums.html, 29 April 2004.
4 knitting.activist.ca/.

Bibliography

A.D. Little Inc. "Marketing Crafts from the Third World." *World Crafts Council News*, Tenth Anniversary Conference Issue, June 1974. Archives of Ontario, Ontario Crafts Council, Archives of Canadian Craft, MU5783, Box 38, GD-GG4.

Aarons, Anita. "An Absent Minded Attitude." *Architecture Canada* 505, 44/10 (October 1967): 21-2.

– "Canadian Handicrafts and the Architect." *Royal Architectural Institute of Canada Journal* 476, 42/5 (May 1965): 16–17.

– "Three Reviews." *Architecture Canada* 498, 44/3 (March 1967): 23–4.

– "To the Professional – A Challenge!" *The Craftsman/L'Artisan* (June 1966). Archives of Ontario, Ontario Crafts Council, Archives of Canadian Craft, MU5782, Box 37, GA-GC2.

– and Merton Chambers. Letter to Norah McCullough, 13 January 1966. National Gallery of Canada Archives, Canadian Fine Crafts, 12-4-296, Volume 3.

"Aboriginal Art in Paris." *Craftsman/L'Artisan* 2/3 (1969): 2.

"Aboriginal Claims in Canada: Indian Act." www.ualberta.ca/~esimpson/claims/indianact/htm

Abrahamson, Una. *Crafts Canada: The Useful Arts.* Toronto, Vancouver: Clarke, Irwin and Company Limited, 1974.

–. "Of Consuming Interest: Indian and Eskimo Art: True and False." *Chatelaine* 41/6 (June 1968): 18.

"Activities of Deane H. Russell." War Files, Interdepartmental Committee on Canadian Handicraft. National Archives of Canada, RG 17 Agriculture, Vol. 3418, File 1500-40-1.

Adams, Don and Arlene Goldbard. "New Deal Cultural Programs: Experiments in Cultural Democracy." www.wwcd.org/policy/US/newdeal.html

Adamson, Anthony. "Exhibit Sets New Goal for Industrial Design." *Saturday Night* (2 June 1945): 4–6. Royal Ontario Museum Archives, Design in Industry, RG 107, Box 1, File 5.

Aerni, April Laskey. *The Economics of the Crafts Industry.* University of Cincinnati, Doctoral Thesis, 1987.

Agostinone, Faith. *A Postmodern Feminist Text Analysis of the Pedagogy of Popular Crafts.*
　　Oklahoma State University, Doctoral Thesis, 1999.

"Aileen O. Webb, Leading Figure in National Crafts Movement, 87." *New York Times,*
　　17 August 1979: 29.

Alfoldy, Sandra. *Theory and Craft: A Case Study of the Kootenay Christmas Faire.* Concordia
　　University, Masters Thesis, 1997.

Allison, Glenn. Telephone interview. 14 June 2000.

Allyn, Nancy E. *Defining American Design: A History of the Index of American Design
　　1935–1945.* University of Maryland, Masters Thesis, 1982.

Alsop, Kay. "A Global Holding of Hands." *Vancouver Province,* 25 February 1974: 16.

"The Amazing Adventures of Man: Special Issue Expo 67." *Star Weekly,* 11 Febuary 1967:
　　3–28.

"American Craft Council 1943–1993: A Chronology." *American Craft* 53/4 (August/
　　September 1993): 137–44.

An American Sampler: Folk Art from the Shelburne Museum. Washington: National Gallery of
　　Art, 1987.

"Ancient Craft for Expo Igloo: Eskimo Artists Face Biggest Challenge." *The Montreal Star,*
　　22 September 1966: 53.

Anderson, Anthony F. "The Schiele Affair: Art Loans Gone Awry."
　　www.thecityreview.com/schiele.html

Andrews, Bernadette. "Pelletier Opens Craft Guild Show." *Toronto Telegram,* 23 September
　　1969: 32.

Arden, Storme, "Foreword." Svava Juliusson. *Métier.* Halifax: Mary E. Black Gallery
　　19 March–2 May 2004.

Arnheim, Rudolf. "The Form We Seek." *Fourth National Conference of the American
　　Craftsmen's Council,* 26–29 August 1961, University of Washington, Seattle. American
　　Craft Council Archives, American Craft Council, Box 1.

"Art, Artistes, Artisans." *La Presse,* 27 September 1969: 29.

Art Gallery of Nova Scotia. *Charlotte Lindgren: Fibre Structures.* Halifax: Art Gallery of Nova
　　Scotia 17 April – 2 June 1980.

The Artisans of Crawford Bay: Janet Wallace, John Smith, Lorin Robin, Rob Schwieger,
　　Janet Schwieger, Tim Elias, Gina Medhurst. Personal interview. 25 August 1999,
　　Crawford Bay.

"Artist Ed Drahanchuk." *The Windsor Viter* 8/6 (December 1998).
　　www2.uwindsor.ca/~hlynka/eight63.html

"Artists Must Fight Apathy – Pelletier." *Toronto Star,* 23 September 1969: 2/11.

"The Arts: Beauty by Design." *Time* (December 23, 1966). National Gallery of Canada
　　Archives, DOC/CLWT, McCullough, Norah.

Association Professionelle des Artisans du Québec, *Brochure,* 1965. Archives of Ontario,
　　Ontario Crafts Council, Archives of Canadian Craft, MU5752, Box 7, BW8-CB2.

Backer, Noelle. "Arts and Crafts in the U.S. Army: The Quiet Side of Military Life."
　　The Crafts Report Online. www.craftsreport.com/december96/army.html

Ballantyne, Michael. *Expo 67 Art.* Montreal: Tundra Books, 1967.

Barbour, Hugh and J. William Frost. *The Quakers.* New York: Greenwood Press, 1988.

Barnes, Gordon. "History of Canadian Crafts." National Archives of Canada, Canadian
　　Crafts Council/World Crafts Council, MG281274, Volume 34.

Barnhard, Dorothy. "A Centennial Quilt: An Hierloom for Your Daughter." *Family Herald* 24 (November 1966): 17.

Barros, Anne. *Ornament and Object: Canadian Jewellery and Metal Art.* Toronto: Boston Mills Press, 1997.

Bata, Sonja. "Foreword." *National Design Council Annual Report 1974–1975.* Ottawa: National Design Council, 1975.

Baumin, Richard and Patricia Sawih. "The Politics of Participation in Folk Life Festivals." Ivan Karp and Steven D. Lavine, eds. *Exhibiting Cultures: The Poetics and Politics of Museum Display.* Washington, London: Smithsonian Institution Press, 1991.

Beninson, Jonathan. "Native American Hope Page." members.aol.com/stenrude/NatAm.html

Beriau, Oscar A. "Craft Revival in Quebec." *Craft Horizons* 1/1 (May 1942): 23–6.

– Letter to Mrs E. W. Brownell, 30 May 1946. Archives of Ontario, Department of Education, Crafts Section, 1946 – 1949, RG2 – 76, No. 1.

– Letter to Mrs Vanderbilt Webb, 10 January 1947. Archives of Ontario, Department of Education, Crafts Section 1946 – 1949, RG2 – 76, No. 1.

Berlo, Janet, ed. *The Early Years of Native American Art History: The Politics of Scholarship and Collecting.* Seattle: University of Washington Press, 1992.

Berlo, Janet Catherine and Ruth Phillips. *Native North American Art.* Oxford, New York: Oxford University Press, 1998.

Bernstein, Melvin Herbert. *Art and Design at Alfred: A Chronicle of a Ceramics College.* Philadelphia: Art Alliance Press, 1986.

Black, Mary E. Letter to Galt Durnfurd, 3 August 1964. Archives of Ontario, Ontario Crafts Council, Archives of Canadian Craft, MU5756, Box 11, CK3 – CK7.

Block, Jean Libman. "The Crafts in Canada." *Craft Horizons,* 34/3 (June 1974): 15–17.

Blundell, Valda. "Aboriginal Empowerment and Souvenir Trade in Canada." Erik Cohen, ed. *Annals of Tourism Research 20* (1993): 64–87.

Boggs, Jean Sutherland. "Foreword." *Canadian Fine Crafts Catalogue 1966–1967.* National Gallery of Canada Archives, Canadian Fine Crafts 12-4-296, Volume 3.

Bol, Marsha C. "Defining Lakota Tourist Art, 1880–1915." Ruth B. Phillips and Christopher Steiner, eds. *Unpacking Culture: Art and Commodity in Colonial and Postcolonial Worlds.* Berkeley, Los Angeles, London: University of California Press, 1999.

Bonellie, Janet. "An Experiment in the Teaching of Crafts." *The Telegram,* 21 February 1970: 11.

Bourdieu, Pierre. *Distinction: A Social Critique of the Judgement of Taste.* Trans. Richard Nice. Cambridge, Massachusetts: Harvard University Press, 1984.

– *The Field of Cultural Production.* Ed. Randal Johnson. New York: Columbia University Press, 1993.

Boyanoski, Christine. *Loring and Wyle: Sculptors' Legacy.* Toronto: Art Gallery of Ontario, 1987.

Boyle, Dana. "Career Self-Management in the Cultural Sector: What Next?" CODA Craft Conference and Survey 2001. www.canadiancraftsfederation.ca/html/advocate_ccf.html

Brett, Gerard. "Notes on a Possible Canadian Modern Design Exhibition." February 1955. Royal Ontario Museum Archives, Designer-Craftsmen, 22 May–22 June 1955, RG 107, Box 1, File 14.

– Letter to Robert Fennell, 22 December 1954. Royal Ontario Museum Archives, Designer-Craftsmen, 22 May–22 June 1955, RG 107, Box 1, File 14.

Brydon, Sherry. "The Indians of Canada Pavilion at Expo 67." *American Indian Art Magazine* 22/3 (Summer 1997): 52–9.

Buchanan, Donald. *Canadian Fine Crafts 1957 Catalogue.* National Gallery of Canada Archives, Exhibitions in Gallery 5.5 c., Box 1, File 2.

– "Design in Industry – A Misnomer." *Canadian Art* 10/2 (Summer 1945): 194–7.

– "Design in Industry: The Canadian Picture." *Journal, Royal Architectural Institute of Canada* 26/7 (July 1947): 234–9.

– "Memo from Donald W. Buchanan, 29 June 1956." National Gallery of Canada Archives, Canadian Fine Crafts 1957, Box 1, File 2.

"Buchanan, Donald William." National Gallery of Canada Archives, DOC/CLWT, Buchanan, Donald.

Burnham, Bob. "Specialized Knowledge, Professionalism and the Discipline of Architecture." *Journal of Architectural Education* 41 (Winter 1988): 53–5.

Burnham, Harold. "Canadian Crafts – Old and New." *Canadian Antiques Collector* (January 1970). Royal Ontario Museum Archives, Craft Dimensions Canada, RG 107, Box 5, File 20a.

– "Crafts and Craftsmen." *The Craftsman/L'Artisan* (1965). Archives of Ontario, Ontario Crafts Council, Archives of Canadian Craft, MU5791, Box 46, HZ-1H2.

– "Report of the Winnipeg Conference." Archives of Ontario, Ontario Crafts Council, Archives of Canadian Craft, MU5750, Box 5, BU-BW2.

Burrage, Michael and Rolf Torstendahl. *Professions in Theory and History: Rethinking the Study of the Professions.* London, Newberry Park: Sage Publications, 1990.

Bustard, Bruce I. *A New Deal for the Arts.* Seattle: University of Washington Press, 1997.

Campaigne, Alan. *Manifesto of the Salon des Refusés.* National Archives of Canada, Canadian Craftsmen's Association, MG281222, Volume 9.

Campbell, David. "Designer-Craftsmen U.S.A. 1960." *Craft Horizons* 20/4 (July/August 1960): 12–27.

Canadian Committee of the World Crafts Council 1974 Report. National Archives of Canada, Canadian Craftsmen's Association, MG281222, Volume 1.

Canadian Crafts Council. *The CCC Bulletin.* CCMA, Special Bulletin, March 1995.

Canadian Crafts Council 1974 Report. National Archives of Canada, Canadian Craftsmen's Association, MG281222, Volume 1.

"Canadian Crafts in Panorama." *Ottawa Citizen,* 16 December 1966. National Gallery of Canada Archives, DOC/CLWT, McCullough, Norah.

Canadian Craftsmen's Association. *Canadian Craftsmen's Association Newsletter.* May 1967. Archives of Ontario, Ontario Crafts Council, Archives of Canadian Craft, MU5782, Box 37, GA-GC2.

Canadian Craftsmen's Association. "The Kingston Conference August 6–11, 1967." Pamphlet. Archives of Ontario, Ontario Crafts Council, Archives of Canadian Craft, MU5750, Box 5, BU-BW.

Canadian Craftsmen's Association. "Minutes." Meeting of 11 December 1971, Hotel Bonaventure, Montreal. Archives of Ontario, Ontario Crafts Council, Archives of Canadian Craft, MU5782, Box 37, GA-GC2.

Canadian Craftsmen's Association. "Press Release." 27 August 1967. Archives of Ontario, Ontario Crafts Council, Archives of Canadian Craft, MU5770, Box 25, PZ-EH.

Canadian Designs for Everyday Living 1948, Catalogue. National Gallery of Canada Archives, Exhibitions in Gallery 5.5 c., Box 1.

"Canadian Fine Crafts 1967." *Canadian Art.* Archives of Ontario, Ontario Crafts Council, Archives of Canadian Craft, MU5769, Box 24, DQ3-D4.

Canadian Guild of Crafts. "Annual Report of the Exhibition Committee." 29 April 1968. Archives of Ontario, Ontario Crafts Council, Archives of Canadian Craft, MU5750, Box 5, BU-BW.

– "A Brief to the Secretary of State from the Canadian Committee." July 1972. National Archives of Canada, World Crafts Council/Canadian Crafts Council, MG28I274, Volume 34.

– "Indian-Eskimo Committee Minutes, April 16, 1973." Archives of Ontario, Ontario Crafts Council, Archives of Canadian Craft, MU5782, Box 37, GA-GC2.

– "National Committee Meeting Report." 5 December 1967. National Archives of Canada, DGAC4000-C47, RG 97, Volume 1, Associations, Clubs and Societies, Canadian Guild of Crafts.

– "President's Report, Annual Meeting." 27 April 1970. Archives of Ontario, Ontario Crafts Council, Archives of Canadian Craft, MU5756, Box 11, CK3-CK7.

– "Becoming Better Known in Ottawa." President's report, 31 March 1970. Archives of Ontario, Ontario Crafts Council, Archives of Canadian Craft, MU5756, Box 11, CK3-CK7.

Canadian Guild of Crafts (Ontario). "President's Report." 18 April 1974. York University Archives, Herman Voaden Fonds, 1991 – 020/011, File 4.

Canadian Handicrafts Guild. "Handicrafts/L'Artisanat." *Canada: Royal Commission on National Development in the Arts, Letters and Sciences.* Ottawa: King's Printers, 1951.

Canadian Handicrafts Guild Bulletin, no. 53, March 1964. Archives of Ontario, Ontario Crafts Council, Archives of Canadian Craft, MU5750, Box 5, BU-BW.

"Canadian Handicrafts Guild Presentation to Seminar 65." January 1965. Archives of Ontario, Archives of Canadian Craft, MU5756, Box 11, CK3-CK7.

Canadian Handicrafts Guild Questionnaire to Craftsmen. 1964. Archives of Ontario, Ontario Crafts Council, Archives of Canadian Craft, MU5756, Box 11, CK3-CK7.

Canadian Indian Crafts Limited: A Proposed Program for Developing Indian Art and Craft in Canada. Ottawa: Agricultural Rehabilitation and Development Act, Department of Forestry, June 1966.

Canadian Museum of Civilization. "Air, Earth, Water, Fire." File, artist's description. 08: communication artifcats, H040: art, LH993.27.1.

"Canadian Souvenirs and Giftware – How Can We Improve Design and Quality?" Panel Discussion at Design Centre, 11 May 1966. Archives of Ontario, Ontario Crafts Council, Archives of Canadian Craft, MU5757, Box 12, CK10 – CL6.

Canadian YMCA War Services. *Make Your Own.* Archives of Ontario, Ontario Crafts Council, Archives of Canadian Craft, MU5769, Box 24, DQ3-D4.

Carnegie, Andrew. *Gospel of Wealth and Other Timely Essays.* New York: The Century Co., 1889.

Carson, Jo. "Handmade in Canada." *Globe and Mail,* 4 July 1974: 6.

– "Nimble-Fingered Indian Keeps Crafts Alive." Archives of Ontario, Ontario Crafts Council, Archives of Canadian Craft, MU5772, Box 27, EK-EL3.

Case, Josephine Young and Everett Needham Case. *Owen D. Young and American Enterprise.* Boston: David R. Godine, 1982.

Catlin, Daniel. *Good Work Well Done: The Sugar Business Career of Horace Havemeyer, 1903–1956.* New York: D. Catlin, 1988.

Chadwick, Whitney. *Women, Art and Society*. London: Thames and Hudson, 1990.

Chalmers, Floyd S. "Biography for Order of Canada, 1967." York University Archives, Herman Voaden Fonds, 1991-020/011, File 12.

– "Sales of Canadian Handicrafts Products in the United States." 29 August 1939. Archives of Ontario, Ontario Crafts Council, Archives of Canadian Craft, MU5752, Box 7, BW8-CB2.

Chalmers, Joan. Letter to James Noel White, 28 September 1971. National Archives of Canada, Canadian Crafts Council/World Crafts Council, MG281274, Volume 34.

– "The International Scene." National General Committee of the Canadian Guild of Crafts, Report of the Annual Meeting 26 April 1972. Archives of Ontario, Ontario Crafts Council, Archives of Canadian Craft, MU5756, Box 11, CK3-CK7.

– Personal interview. 19 April 2002, Toronto.

Chambers, Merton. "Formation of a National Crafts Council." *Royal Architectural Institute of Canada Journal* 477, 42/6 (June 1965): 26–8.

– Letter to Harold Burnham, 13 February 1965. Archives of Ontario, Ontario Crafts Council, Archives of Canadian Craft, MU5750, Box 5, BU-BW.

Charles, Evelyn M. Letter to Donald Buchanan, 26 June 1957. National Gallery of Canada Archives, Exhibitions in Gallery 5.5C, Canadian Fine Crafts 1957, Box 1, File 2.

"Chatelaine Shops for Centennial Souvenirs." *Chatelaine Souvenir Centennial Issue* 14/7 (July 1967): 66.

Chaudron, Bernard. Letter to Norah McCullough, 20 January 1966. National Gallery of Canada Archives, Canadian Fine Crafts, 12-4-296, Volume 3.

Cheeseborough, Mrs. "Canadian Handicrafts Guild – Past, Present and Future." *Junior League Magazine* (1964). Archives of Ontario, Ontario Crafts Council, Archives of Canadian Craft, MU5756, Box 11, CK3-CK7.

Christensen, Erwin Ottmar. *The Index of American Design*. New York: Macmillan, 1950.

Clary, Velma Jean. "Barbara Rockefeller Believes Crafts Tell about America," *Winston-Salem Sentinel*, 10 June 1977. National Archives of Canada, Canadian Crafts Council, MG281274, Volume 46, 83/338, File: American Craft Council.

Coatts, Margo, ed. *Pioneers of Modern Craft*. Manchester, New York: Manchester University Press, 1997.

Cochrane, Grace. *The Crafts Movement in Australia: A History*. Kensington, New South Wales: New South Wales University Press, 1992.

Coleman, Marigold. "Personal View." *Crafts* 10 (September/October 1974): 10.

Colwell, Mary Anna Culleton. *Private Foundations and Public Policy: The Political Role of Philanthropy*. New York, London: Garland Publishing, 1993.

Cook, Blanche Wiesen. *Eleanor Roosevelt: Volume One 1884–1933*. New York: Viking Press, 1992.

"Connoisseurs of Crafts." *Woman's Day* 11 (August 1969): 47–50.

Conseil des métiers d'art du Québec for the Canadian Crafts Federation. "Profile and Development Strategy for Craft in Canada." October 2003.

"Craft Dimensions." *Canadian Interiors* (September 1969). Royal Ontario Museum Archives, Craft Dimensions Canada, RG 107, Box 5, No. 20a.

Craft Dimensions Canada Award Winners. "Memo." 22 September 1969. Royal Ontario Museum Archives, Craft Dimensions Canada, RG107, Box 5, No. 20a.

"Craft Exhibit Invites Visitors to Pitch In." *The Detroit Free Press*, 19 May 1974: 18.

Cragg, Margaret. "About the House: Homemakers Will Enjoy Craft Show at Museum." *Globe and Mail*, 19 May 1955. Royal Ontario Museum Archives, Designer-Craftsmen, 22 May–22 June, 1955, RG 107, Box 1, File 14.

Crawford, Alan. "The Object Is Not the Object: C.R. Ashbee and the Guild of Handicraft," Margot Coatts, ed. *Pioneers of Modern Craft*. Manchester, New York: Manchester University Press, 1997.

Crawford, Gail. *A Fine Line: Studio Crafts in Ontario from 1930 to the Present*. Toronto, Oxford: Dundurn Press, 1998.

– Letter, 8 August 2002.

– Personal interview with Merton Chambers. 16 June 2002.

Cruickshank, John. "Craftsman Campaigns for Quality," *The Whig-Standard*, 18 February 1978: A-5. National Archives of Canada, Canadian Crafts Council, MG281274, Vol. 13, 79/206.

Cultural Affairs Division, Department of External Affairs. Letter to Norah McCullough, 17 August 1966. National Gallery of Canada Archives, Canadian Fine Crafts, 12-4-296, Volume 3.

Cummings, Paul. Oral history interview with Mrs. Vanderbilt Webb. Archives of American Art, Smithsonian Institution, Washington, DC, mq 24004.

Currell, Harvey. "Indian Craftsmen Are Skilled Carvers." *The Telegram*, 23 November 1966: 34.

Delorme, Jean-Claude. Letter to George Shaw, 10 March 1966. National Archives of Canada, Canadian Crafsmen's Association, MG281222, Volume 1.

Dempsey, Lotta. "Craftsmen's Hands Mould the Good Life." *Toronto Star*, 18 May 1974: 32.

– "Is Past Ruining Present?" *Toronto Star* 19 July 1966: 15.

– "Metro Woman Plans First World Crafts Show." *Toronto Star*, 22 May 1974. Archives of Ontario, Ontario Crafts Council, Archives of Canadian Craft, MU5757, Box 12, CK10-CL6.

– "The Non-Collaboration of Artists and Architects." *Toronto Star*, 8 August 1966: 23.

DeSève, Andrée-Anne. *Hommage à Jean-Marie Gauvreau*. Montréal: Conseil des métiers d'art du Québec, 1995.

"Designer-Craftsmen U.S.A. 1953." *Craft Horizons* 13/6 (November/December 1953): 13–15.

De Vos, John. Letter to Sheila Stiven, n.d. National Archives of Canada, Canadian Craftsmen's Association, MG281222, Volume 9.

"Discoverer Sees Death of Eskimo Art." *Globe and Mail*, 13 October 1966. Archives of Ontario, Ontario Crafts Council, Archives of Canadian Craft, MU5771, Box 26, EH2-EJ.

"Donation for Crafts." *Globe and Mail*, 27 March 1974. Archives of Ontario, Ontario Crafts Council, Archives of Canadian Craft, MU5757, Box 12, CK10-CL6.

"Dora Billington Biography." www.aber.ac.uk/ceramics/makers/dorabillington.htm

Dormer, Peter, ed. *The Culture of Craft: Status and future*. Manchester, New York: Manchester University Press, 1997.

– "The Language and Practical Philosophy of Craft." Peter Dormer, ed. *The Culture of Craft*. Manchester: Manchester University Press, 1999.

Durkheim, Emile. *The Division of Labor in Society*. Trans. George Simpson. New York: The Free Press, 1964.

Eccles, Viscount. "World Crafts Council Conference Address." 10 June 1974. Archives of Ontario, Ontario Crafts Council, Archives of Canadian Craft, MU5783, Box 38, GD-GG4.

Edinborough, Arnold. "Chalmers and Arts: Time, Thought and Money." *Financial Post*, 15 September 1979: 73:7.

– "How the World's Craftsmen Keep Individuality Alive." *Financial Post*, 22 June 1974: 13.

Edwards, Natalie. "Made in Canada: Our Craftsmen Turn Out Beautiful Work." *Starweek* (25 November–2 December 1972). Archives of Ontario, Ontario Crafts Council, Archives of Canadian Craft, MU5757, Box 12, CK10-CL6.

Ehmer, Josef. "The Artisan Family in Nineteenth-Century Austria: *Embourgeoisement* of the Petite Bourgeoisie?" Geoffrey Crossick and Heinz-Gerhard Haupt, eds. *Shopkeepers and Master Artisans in Nineteenth-Century Europe*. London, New York: Methuen, 1984.

Elder, Alan. "Craft at the Border." Paper presented at the American Craft Museum, New York, November 1998.

– "Curator's Statement." *Transformations*. 1996.

– *Designing a Modern Identity: The New Spirit of British Columbia 1945– 1960*. Kelowna: Kelowna Art Gallery, 2001.

– Personal interview. 12 April 2002, Ottawa.

– "Reflecting and Affecting Craft: Federal Policy and Contemporary Canadian Craft." Betty Ann Jordan, ed. *The Past and the Future: Exploring Contemporary Craft History, Theory and Critical Writing*. Toronto: Coach House Press, 2002.

Ellis, B.S. Letter to Peter Swann, 26 September 1969. Royal Ontario Museum Archives, Craft Dimensions Canada, RG107, Box 5, No. 20a.

Erickson, Arthur. "Rationalism and Architecture." www.hillside.ca/rationalism-19-01-2000/Aerationalism._1.htm

Ettawageshik, Frank. "My Father's Business." Ruth B. Phillips and Christopher B. Steiner, eds. *Unpacking Culture: Art and Commodity in Colonial and Postcolonial Worlds*. Berkeley, Los Angeles, London: University of California Press, 1999.

Evans-Pritchard, Dierdre. "How 'They' See 'Us': Native American Images of Tourists." *Annals of Tourism Research* 16/1 (1989): 89–103.

"Expo a Storehouse of World's Treasure." *The Montreal Star*, 28 April 1967: 66.

Faulkner, J. Hugh. Letter to Ann Suzuki, 14 March 1973. National Archives of Canada, Canadian Craftsmen's Association, MG281222, Volume 7.

Felinghuysen, Alice Cooney. *Splendid Legacy: The Havemeyer Collection*. New York: Metropolitan Museum of Art, 1993.

"15 Canadian Works in International Exhibition." *Globe and Mail*, 12 April 1974: 20.

Filshie, Meredith et al. *Report on the Canadian Handicraft Situation*. Ottawa: Materials Branch, Department of Industry, Trade and Commerce, 1972. National Archives of Canada, RG97, Volume 441, DGAC 4530 – J:2, Volume 12.

"First Craft Conference Lake Couchiching April 23–25, 1965." Archives of Ontario, Ontario Crafts Council, Archives of Canadian Craft, MU 5776, Box 31, EX2-FA.

"First Nations Art. An Introduction to Contemporary Native Artists in Canada: Robert Davidson." www.collections.ic.gc.ca/artists/davidson_robert.html

"First World Congress of Craftsmen." *Craft Horizons* 24/5 (September/October 1964): 8.

Flood, Sandra. *Canadian Craft and Museum Practice 1900–1950*. Hull: Canadian Museum of Civilization, 2001.

– "Craft in Canada: Overview and Points from *Canadian Craft and Museum Practice 1900–1950*." Jean Johnson, ed. *Exploring Contemporary Craft: History, Theory and Critical Writing*. Toronto: Coach House Books, 2002.

– Email correspondence. 6 August 2002.

– Email correspondence. 31 August 2002.

Foreman, John. *The Vanderbilts and the Gilded Age: Architectural Aspirations 1879–1901*. New York: St Martin's Press, 1991.

"The Formation of a National Association of Craftsmen." Report, 4 March 1965. National Archives of Canada, Canadian Craftsmen's Association, MG281222, Volume 1.

Foucault, Michel. *Power/Knowledge: Selected Interviews and Other Writings 1972–1977*. Ed. Colin Gordon. New York: Pantheon Books, 1980.

– *The Birth of the Clinic: An Archaeology of Medical Perception*. Trans. A.M. Sheridan Smith. New York: Vintage Books, 1975.

– "The Discourse on Language." Trans. Rupert Swyer. *Social Science Information* (10). London: Sage Publications, Inc., 1971.

– *The Order of Things: An Archaeology of the Human Sciences*. New York: Vintage Books, 1970, 1994.

Francis, Daniel. *The Imaginary Indian: The Image of the Indian in Canadian Culture*. Vancouver: Arsenal Pulp Press, 1992.

Frelinghuysen, Alice Cooney. *Splendid Legacy: the Havemeyer Collection*. New York: Metropolitan Museum of Art, 1993.

Freyta, Chris. Personal interview. 10 August 2000, Nelson.

Frye, Northrop. *Mythologizing Canada: Essays on the Canadian Literary Imagination*. Ed. Branko Gorjup. Toronto: Legas, 1997.

Fulford, Robert. "The Glory of Expo May Weld Us into One Canada." *Toronto Daily Star Special Section Salute to Expo*, 22 April 1967: 2.

– "Some Hard Truths about Public Art." *Toronto Star*, 7 February 1967: 34.

– *This Was Expo*. Toronto: McClelland and Stewart Limited, 1968.

Gauthier, Yvan. Personal interview. 21 January 2000, Montreal.

"George Eggleston Dodge." *New York Times*, 15 April 1904: 9.

Gibson, John W. *A "Desk" Commentary: The Role of Federal Government Departments with Respect to Canadian Handicrafts*. Ottawa: Travel Industry Branch, Office of Tourism, Department of Industry, Trade and Commerce, February 1972.

"Gift for the Queen." *Globe and Mail*, 30 June 1967. Archives of Ontario, Ontario Crafts Council, Archives of Canadian Craft, MU5771, Box 26, EH2-EJ.

Giles, Dorothy. *Designer-Craftsmen U.S.A. Catalogue*. New York: American Craftsmen's Educational Council, 1953. American Craft Council Archives, World Crafts Council, Box 2.

Gomaz, Ricardo. Personal interview. 23 September 2000, Kingston.

Gotlieb, Rachel and Cora Golden. *Design in Canada: Fifty Years from Teakettles to Task Chairs*. Toronto: Alfred A. Knopf Canada, 2001.

"A Good Life-Work Ended." *New York Times*, 10 February 1883: 8.

"Grace Hoadley Dodge." *New York Times*, 28 December 1914: 9.

Green, H. Gordon, ed. *A Heritage of Canadian Handicrafts*. Toronto, Montreal: McClelland and Stewart Limited, 1967.

Green, Harvey. "Culture and Crisis: Americans and the Craft Revival." *Revivals! Diverse Traditions 1920–1945: The History of 20th Century American Craft*. Ed. Janet Kardon. New York: American Craft Museum and Harry N. Abrams, 1994.

Greenhalgh, Paul, ed. *The Persistence of Craft*. London: A&C Black, 2002.

Guilbaut, Serge. *How New York Stole the Idea of Modern Art: Abstract Expressionism, Freedom and the Cold War*. Trans. Arthur Goldhammer. Chicago: University of Chicago Press, 1983.

Gulacsy, Elizabeth. *Daniel Rhodes 1911–1989*. Alfred, New York: Scholes Library, n.d.

Gustafson, Paula, ed. *Craft Perception and Practice: A Canadian Discourse*. Vancouver: Ronsdale Press, 2002.

Gustafson, Paula. "Mapping the Terrain." *Made by Hand*. Vancouver: Crafts Association of British Columbia, 1998.

Gwyn, Sandra. "Guild at the Crossroads." *Canadian Art* 20/5 (September/October 1963): 274–9.

Hale, Barrie. "Perspective 67 Opens at AGO." *The Telegram*, 8 July 1967: 14.

Hall, Stuart. "The Local and the Global: Globalization and Ethnicity." Anne McClintock et al *Dangerous Liaisons: Gender, Nation and Postcolonial Perspectives*. Minneapolis: University of Minnesota Press, 1997.

"Handicraft Expert Guest at Luncheons." *Globe and Mail*, 16 May 1955. Royal Ontario Museum Archives, Designer-Craftsmen, 22 May–22 June 1955, RG 107, Box 1, File 14.

Harrod, Tanya. *The Crafts in Britain in the 20th Century*. Yale: Yale University Press, 1999.

– "Herbert Read." *Crafts* 36 (July/August 1993): 14.

– *Obscure Objects of Desire: Reviewing the Crafts in the Twentieth Century*. London: Crafts Council, 1997.

Hatten, Valerie. Personal interview. 30 January 2001.

Hawthorn, Harry. "Bill Reid – Metalsmith, Wood Carver, Jeweller." www.civilization.ca/arts/bronfman/reid1e.html

Heggtveit, Marianne. Telephone interview. 21 July 2002.

Hénaut, Dorothy Todd. "1967 – The Moment of Truth for Canadian Crafts." *Arts/Canada* 24/104 (January 1967): 20–2.

Henderson, Bill. "Notes on the Indian Act." www.bloorstreet.com/indact.htm

Hendrickson, Carol. "Selling Guatemala: Maya Exports Products in U.S. Mail-Order Catalogues." David Howes, ed. *Cross-Cultural Consumption: Global Markets, Local Realities*. London, New York: Routledge, 1996.

Herem, Barry. "Remembering Bill Reid." www.civilization/ca/aborig/reid/reid08e.html

Hickey, Gloria A., ed. *Common Ground: Contemporary Craft, Architecture and the Decorative Arts*. Hull: Canadian Museum of Civilization, 1999.

– *Making and Metaphor: A Discussion of Meaning in Contemporary Craft*. Hull: Canadian Museum of Civilization, 1994.

Hill, Tom. "Canadian Indian Art: Its Death and Rebirth." *Art Magazine* 5/18 (Summer 1974): 10–12.

– Personal interview. 21 February 2002, Brantford.

Hinsley, Curtis. "The World as Marketplace: Commodification of the Exotic at the World's Columbian Exposition, Chicago, 1893." Ivan Karp and Steven D. Levine, eds. *Exhibiting Cultures: The Poetics and Politics of Museum Display*. Washington, London: Smithsonian Institution Press, 1991.

Hodges, Margaret. *Sigrun Bulow-Hube: Scandinavian Modernism in Canada*. Concordia University, Masters Thesis, 1996.

Hogg, Mary Eileen. "Memo to All Members of the Canadian Section of the World Crafts Council, 1972." York University Archives, Herman Voaden Fonds, 1991-020/011, File 3.

– "Obituary, Aileen Osborn Webb." *Craftsman* 4/5 (October 1979): 16.

- "Speech." Monday, 10 June 1974. Archives of Ontario, Ontario Crafts Council, Archives of Canadian Craft, MU5783, Box 38, GD-GG4.
- "World Crafts Council Progress Report, 1974." National Archives of Canada, Canadian Crafts Council/World Crafts Council, MG281274, Volume 35.

Holm, Bill. *Northwest Coast Indian Art: An Analysis of Form.* Seattle: University of Washington Press, 1965.

Honey, Russell C., QC, MP, Parliamentary Secretary to the Honourable Jean Chrétien, Minister of Indian Affairs and Northern Development. "Speech, First National Indian Cultural Conference, Ottawa, Ontario, 24 March 1970," 6. National Archives of Canada, Canadian Crafts Council, MG281274, Volume 9, 79/206, File: Education Native.

Hornung, Clarence Pearson. *Treasury of American Design: A Pictoral Survey of Popular Folk Arts Based upon Watercolour Renderings.* New York: Harry N. Abrams, 1972.

Howard, Richard. "Tawney," *Craft Horizons* 35/1 (February 1975): 69–72.

Hutchinson, John. *Modern Nationalism.* London: HarperCollins, 1994.

Hyett, Paul. "What Truly Makes a 'professional.'" *Architect's Journal* 208/5 (30 July 1998): 21.

"In Praise of Hands." *Collingwood Ontario Enterprise Bulletin.* 14 August 1974. Archives of Ontario, Ontario Crafts Council, Archives of Canadian Craft, MU5757, Box 12, CK10-CL6.

In Praise of Hands Entries. Archives of Ontario, Ontario Crafts Council, Archives of Canadian Craft, MU5780, Box 35, FN-FU.

"Indian Art Has International Impact on Native Arts and Crafts in Canada." *Indian News* (March 1974). Royal Ontario Museum Archives, Canadian Indian Art 10 June – 31 August 1974, RG 107, Box 9, No. 12.

Indian Crafts of Ontario. Archives of Ontario, Ontario Crafts Council, Archives of Canadian Craft, MU5781, Box 36, FV-FZ.

"Indians Form New Association." *Globe and Mail,* 8 October 1966: 18.

"Indians Spend Expo Cash to Tell of Poor Deal." *Globe and Mail,* 7 April 1967: 3.

Inglis, Stephen. Personal interview. 11 April 2002, Ottawa.

"Interest in Craft Work Booming as Part of Social Revolution." *Owen Sound,* November 1973. Archives of Ontario, Ontario Crafts Council, Archives of Canadian Craft, MU5757, Box 12, CK10-CL6.

"International Handicraft Exhibition." *Craftsman/L'Artisan* 4/2 (1971): 6.

Interview with Mr Archie F. Key, Canadian Museums Association. 23 January 1965. Archives of Ontario, Ontario Crafts Council, Archives of Canadian Craft, MU5750, BU-BW2, Box 5.

Jarvis, Alan. Letter to Adelaide Marriott, 4 February 1965. Archives of Ontario, Ontario Crafts Council, Archives of Canadian Craft, MU5756, Box 11, CK3 – CK7.

Jekyll, Robert. Personal interview. 29 October 1999, Toronto.

Jenkner, Ingrid. *Catalogue: 120 Dessert Plates.* Halifax: Mount Saint Vincent University Art Gallery, 18 May–14 July 2002.

Johnson, Pamela. *Ideas in the Making: Practice in Theory.* London: Crafts Council, 1998.
- "Out of Touch: The Meaning of Making in the Digital Age." Tanya Harrod, ed. *Obscure Objects of Desire: Reviewing the Crafts in the Twentieth Century.* London: Crafts Council, 1997.

Jordon, Betty Ann, ed. *Exploring Contemporary Craft History, Theory and Critical Writing.* Toronto: Coach House Press, 2002.

Jordon, Rachel. "Osborn and Dodge Family Papers 1726–1983: A Finding Aid."

Manuscripts Division, Department of Rare Books and Special Collections, Princeton University Library, 2004.
libweb.princeton.edu/libraries/firestone/rbsc/aids/osborn-dodge.htm

Jukes, Mary. "Student Art Designed to Sell." *The Women's Globe and Mail*, 8 May 1969: w9.

"Jurors for Craft Dimensions Canada Exhibition." Press Release. Royal Ontario Museum Archives, Craft Dimensions Canada, RG 107, Box 5, No. 20a.

Jurors' Statements. Royal Ontario Museum Archives, Craft Dimensions Canada, RG107, Box 5, No. 20a.

Kansinsky, Renee, G. *Refugees from Militarism: Draft-Age Americans in Canada*. New Jersey: Transaction Books, 1976.

Kardon, Janet, ed. *Craft in the Machine Age 1920–1945: The History of 20th Century American Craft*. New York; American Craft Museum and Harry N. Abrams, 1995.

– *The Ideal Home 1900–1920: The History of 20th Century American Craft*. New York: American Craft Museum and Harry N. Abrams, 1994.

– *Revivals! Diverse Traditions 1920–1945: The History of 20th Century American Craft*. New York: American Craft Museum and Harry N. Abrams, 1994.

Kimball, Elizabeth. "The Company of Young Craftsmen." *sw Magazine* (1 July 1967). Archives of Ontario, Ontario Crafts Council, Archives of Canadian Craft, MU5771, Box 26, EH2-EJ.

King, Annabelle et al. "Craft Boom." *Chatelaine* (October 1973). Archives of Ontario, Ontario Crafts Council, Archives of Canadian Craft, MU5756, Box 11, CK3-CK7.

Kitchin, Rob. *Cyberspace*. Chichester, New York, Weinheim, Brisbane, Singapore, Toronto: John Wiley and Sons, 1998.

Klein, Julie Thompson. *Interdisciplinarity: History, Theory, Practice*. Detroit: Wayne State University Press, 1990.

Kling, Alice Jane. *American Contemporary Craftsmen: A Way of Work, A Way of Life*. George Washington University, Doctoral Thesis, 1987.

Kootenay School of Art. "News Release, May 1966." Nelson Museum and Archives, Kootenay School of Art (3), Accession #1997.057, Series 2 / Subseries 1/ File 14 / Box 2, Bay 6, Shelf 1.

"Kootenay School of Art Faculty List." Nelson Museum and Archives, Kootenay School of Art (3), Accession #1997.057, Series 2/ Subseries 1/ File 14/ Box 2, Bay 6, Shelf 1.

"Kootenay School of Art Wins World Art Award." *Nelson Daily News*, 17 June 1966: 1.

Krause, Elliott A. *Death of the Guilds: Professions, States, and the Advance of Capitalism, 1930 to the Present*. New Haven and London: Yale University Press, 1996.

Kritzwiser, Kay. "Criticism of quality at CNE exhibit." *Globe and Mail* (15 August 1973). Archives of Ontario, Ontario Crafts Council, Archives of Canadian Craft, MU5757, Box 12, CK10-CL6.

– "In Praise of Hands: The Craftsman's Orbit." *Globe and Mail*, 31 May 1974: 41.

– "Judges Choose Final Craft Entries." *Globe and Mail* 11 December 1973: 16.

– "A Shorn Sheep Cleaves Craft from Art." *Globe and Mail*, 15 June 1974: 19.

Laine, Mabel H. and Kenneth Winters. "Chalmers, Floyd." *The Encyclopedia of Music in Canada*.
www.thecanadianencyclopedia.com/index.cfm?PgNm=TCE&Params=U1ARTU0000654

Lansbury, George. *Looking Backwards – And Forwards*. London: Blackie, 1935.

Larson, Magali. *The Rise of Professionalism: A Sociological Perspective*. Berkeley: University of California Press, 1977.

Larson, Orland. "A Nova Scotia Craftsman's View, 1973." National Archives of Canada, Canadian Craftsmen's Association, MG281222, Volume 1.

Lawless, H.J. "A Girl against the Veldt." *The Star Weekly*, Toronto, 5 January 1946. National Archives of Canada, McCullough, Norah and Family, MG30D317, Volume 7.

Leach, Bernard. *A Potter's Book*. London: Faber and Faber, 1940, 1969.

Lee, Virginia. "Craftsmen and Museum: Out of Touch." *New York Times* 4 August 1974: 53.

Leitch, Alexander. "Dodge-Osborn Hall." *A Princeton Companion*. etc.princeton.edu/Campuswww/companion/dodgeosborn_hall.html

Lesser, Gloria. "Biography and Bibliography of the Writings of D.W. Buchanan (1908–1966)." *Journal of Canadian Art History* 5/2 (1981): 32.

– *École du Meuble 1930–1950, la décoration intérieure et les arts décoratifs à Montréal*. Montréal: Musée des arts décoratifs de Montréal, 1989.

Lewis, Alfred Allan. *Ladies and Not so Gentle Women*. New York: Viking, 2000.

Lighthall, Alice. *The Canadian Handicrafts Guild: A History*. May 1966. Archives of Ontario, Ontario Crafts Council, Archives of Canadian Craft, MU5756, Box 11, CK3-CK7.

Lindgren, Charlotte. "Artist's Statement." *Charlotte Lindgren: Fibre Structures*. Halifax: Art Gallery of Nova Scotia, 1980.

– Personal interview. 14 June 2003, Halifax.

Lippard, Lucy. *Mixed Blessings: New Art in a Multi Cultural America*. New York: Pantheon Books, 1990.

Littman, Sol. "Prairie Sculptor's Ma and Pa Figures Highlight of Guild of Potter's Exhibition." *Toronto Star*, 24 May 1974: 14.

Littrell, Mary Ann et al. "What Makes a Craft Souvenir Authentic?" Erik Cohen, ed. *Annals of Tourism Research* 20/1 (1993): 197–215.

Lord, Barry. "Canada: After Expo, What?" *Art in America* 56/2 (March/April 1968): 94–6.

– "Living inside the American Empire of Taste: Canadian Artists Are Struggling to Find a Way Out." *Saturday Night* 86/12 (December 1971): 31.

Luffman, Jacqueline. "Earnings of Selected Culture Workers: What the 1996 Census Can Tell Us." *Focus on Culture* 12/1 (First Quarter 2000): 1–2.

MacDonald, George F. "Foreword," *Masters of the Crafts: Recipients of the Saidye Bronfman Award for Excellence in the Crafts, 1977–1986*. Hull: Canadian Museum of Civilization, 1989.

MacDonald, Keith. *The Sociology of the Professions*. London: Sage Publications, 1995.

MacGillivray, John. "Introduction." *American Ceramics Exhibition Catalogue*, November 1964. Nelson Museum and Archives, Kootenay School of Art (3), Accession #1997.057, Series 2 / Subseries 1/ File 14 / Box 2, Bay 6, Shelf 1.

MacVicar, William. "Indian Art, Traditional and Modern." *Globe and Mail*, 11 June 1974: 8.

Mainzer, Janet C. *The Relation between the Crafts and the Fine Arts in the United States from 1876–1980*. New York University, doctoral thesis, 1988.

Mangan, Kathleen Nugent. "Lenore Tawney." www.jra.org/craftart/awards/1999/tawney.htm

"Manitou Cultural Teach-In News Release." March 1971. Archives of Ontario, Ontario Crafts Council, Archives of Canadian Craft, MU5757, Box 12, CK10-CL6.

Markowitz, Ruth. "The Insiders." *Craft Dimensions* (7 July 1974). National Archives of Canada, Canadian Crafts Council/World Crafts Council, MG281274, Volume 39, ff.

Marriott, Adelaide. *History: The Canadian Guild of Crafts*. Archives of Ontario, Ontario Crafts Council, Archives of Canadian Craft, MU5756, Box 11, CK3-CK7.

Masters, Cherryl. Personal interview. 6 July 1999, Vancouver.

Mathieu, Paul. "The Space of Pottery: An Investigation of the Nature of Craft." Gloria Hickey, ed. *Making and Metaphor: A Discussion of Meaning in Contemporary Craft.* Hull: Canadian Museum of Civilization, 1994.

McCarthy, Pearl. "Art and Artists." *Globe and Mail,* 4 January 1938.

– "Designer-Craftsmen Coming with a Display of Exploratory Ideas." *Globe and Mail,* 15 May 1955. Royal Ontario Museum Archives, Designer-Craftsmen, 22 May–22 June 1955, RG 107, Box 1, File 14.

– "Designer-Craftsmen U.S.A. Coming with Honest Appraisal Its Motive." *Globe and Mail,* 26 March 1955. Royal Ontario Museum Archives, Designer-Craftsmen, 22 May – 22 June, 1955, RG 107, Box 1, File 14.

– "Two-Way Surprises at Fine Craft Show." *Globe and Mail,* 8 June 1957: 24. Archives of Ontario, Ontario Crafts Council, Archives of Canadian Craft, MU 5780, Box 35, FN-FU.

McClintock, Anne, et al. *Dangerous Liasons: Gender, Nation and Postcolonial Perspectives.* Minneapolis: University of Minnesota Press, 1997.

McCullough, Norah. *Arthur Lismer Watercolours.* Guelph: Macdonald Stewart Art Centre, 1987.

– *Biographical Notes.* National Archives of Canada, McCullough, Norah and Family, MG30D317, Volume 6.

– "Handicraft in Denmark Suggests a Fresh Approach to Canadian Crafts." National Archives of Canada, McCullough, Norah and Family, MG30D317, Volume 7.

– Letter to Alan E. Blakney, 6 July 1965. National Archives of Canada, Canadian Craftsmen's Association, MG28I222, Volume 1.

– Letter to Bernard Chaudron, 21 January 1966. National Gallery of Canada Archives, Canadian Fine Crafts, 12-4-296, Volume 3.

– Letter to Daniel Rhodes, 25 February 1966. National Gallery of Canada Archives, Canadian Fine Crafts, 12-4-296, Volume 3.

– Letter to Glen Lewis, 26 August 1965. National Archives of Canada, Canadian Craftsmen's Association, MG28I222, Volume 1.

– Letter to Jean-Paul Morrisset, n.d. National Gallery of Canada Archives, Canadian Fine Crafts, 12-4-296, Volume 3.

– Letter to Joan Slebbin, 31 October 1980. National Gallery of Canada Archives. DOC/CLWT McCullough, Norah.

– Letter to Molly and Bruno Bobak, 21 February 1957. National Archives of Canada, McCullough, Norah and Family, MG30D317, Volume 7.

– Letter to Mrs H. Reidl-Ursin, 9 February 1966. National Archives of Canada, World Crafts Council, MG38I274, Volume 34.

– Letter to Mrs Vanderbilt Webb, 6 December 1966. National Archives of Canada, McCullough, Norah and Family, MG30D317, Volume 7.

– *Looking Back to My Early Days in Regina.* National Archives of Canada, McCullough, Norah and Family, MG30D317, Volume 6.

– *Newsletter to the Craftsmen of Canada from Miss Norah McCullough, Regina.* 16 September 1964. National Archives of Canada, Canadian Craftsmen's Association, MG28I222, Volume 1.

– "Report to Craftsmen." Memo for *World Crafts Council Newsletter,* 31 August 1967. National Archives of Canada, Canadian Crafts Council/World Crafts Council, MG28I274, Volume 33.

McCutcheon, Elizabeth. Letter to Dr E. Rogers, 16 May 1972. Royal Ontario Museum Archives, Canadian Indian Art, 10 June–31 August 1974, RG 107, Box 9, No. 12.

– "Report of the Indian-Eskimo Committee." Minutes of the Canadian Guild of Crafts, 26 January 1972. Archives of Ontario, Ontario Crafts Council, Archives of Canadian Craft, MU5756, Box 11, CK3-CK7.

McDougall, Diana. Letter to Herman Voaden, 25 September 1968. York University Archives, Herman Voaden Fonds, 1991-020/011, File 3.

McKay, Ian. *The Quest of the Folk: Antimodernism and Cultural Selection in Twentieth-Century Nova Scotia.* Montreal and Kingston: McGill-Queen's University Press, 1994.

McKinley, Donald. "The School of Crafts and Design: A Personal Memoir." James Strecker, ed. *Sheridan: The Cutting Edge in Crafts.* Erin, Ontario: Boston Mills Press, 1999.

McLeod, Ellen Easton. *In Good Hands: The Women of the Canadian Handicrafts Guild.* Montreal and Kingston: Carleton University by Queen's University Press, 1999.

McMaster, Gerald. "Tenuous Lines of Descent: Indian Art and Craft of the Reservation Period." Canadian Museum of Civilization, ed. *In the Shadow of the Sun.* Hull: Canadian Museum of Civilization Canadian Ethnology Service Mercury Series Paper 124, 1993.

McNeil, Joan. "A Question of Identity: Twelve Canadians." Ann Roberts, ed. *A Question of Identity: Ceramics at the End of the Twentieth Century.* Waterloo: The Canadian Clay and Glass Gallery, 1998.

McPherson, Hugo. "Culture Planning, Canadian Style." *Canadian Art* 99/22 (September/October 1965): 40-3.

Mellen, Wilson. Letter to Adelaide Marriott, 25 January 1965. Archives of Ontario, Ontario Crafts Council, Archives of Canadian Craft, MU5752, Box 7, BW8-CB2.

– "Member's Letter." January 1968. Archives of Ontario, Ontario Crafts Council, Archives of Canadian Craft, MU5752, Box 7, BW8-CB2.

"Memo Regarding Paul Smith." Royal Ontario Museum Archives, Craft Dimensions Canada, RG 107, Box 5, No. 20a.

"Memo Regarding the Exhibition of Canadian Fine Crafts." National Gallery of Canada Archives, Canadian Fine Crafts, 12-4-296, Volume 10.

"Memo to Craft Volunteers." Royal Ontario Museum Archives, Craft Dimensions Canada, RG 107, Box 5, No 20b.

"Memorandum from World Crafts Council to all World Crafts Council directors and representatives." 8 February 1972. National Archives of Canada, Canadian Crafts Council/World Crafts Council, MG281274, Volume 34.

"Memorandum Regarding a National Museum of Crafts and Design." Canadian Crafts Council, 1 September 1982. National Archives of Canada, Canadian Crafts Council, MG281274, Volume 87, File: Special Projects Committee – 1022-6, National Gallery of Crafts and Design.

The Memorial Album of the First Category Universal and International Exhibition held in Montreal from 27 April to 29 October 1967. Toronto: Thomas Nelson and Sons Ltd, 1968.

Metcalf, Bruce. "Replacing the Myth of Modernism." *American Craft* 1/53 (February/March 1993): 40-7.

Michner, Sally. "VSA to ECIAD 1964 – 1994: A Faculty Perspective." *64/94 Contemporary Decades.* Vancouver: Emily Carr Institute of Art and Design, 1994.

"Minutes of the Meeting on International Craftsmanship Touring Exhibition of the Agence de Cooperation Culturelle et Technique, April 13, 1971." Archives of Ontario, Ontario Crafts Council, Archives of Canadian Craft, MU5781, Box 36, FV-FZ.

Moogk, Peter. "In the Darkness of a Basement: Craftsmen's Associations in Early French Canada." *Canadian Historical Review* 72/4 (December 1976): 399–438.

Moore, Mavor. "Cultural Wasteland: We Splurge on Superhighways, but Scrimp on the Arts." *Maclean's Magazine* 79/6 (4 June 1966): 14–15, 38.

– "Lives Lived: Moncrieff Williamson." *Globe and Mail*, 2 September 1996. National Gallery of Canada Archives, DOC/CLWT, Williamson, Moncrieff, 1915–1996.

Moran, Lois. Letter to Cyril Simard, 20 April 1971. Archives of Ontario, Department of Education, Crafts Section. RG2-76, No. 3.

– Personal interview. 9 December 1999, New York.

Moritsuga, Frank. "At Last! An Ambitious Dream Becomes Magic in Reality." *The Montreal Star*, 28 April 1967: 2–3.

Morrison, Suzanne. "Eskimo Art Is Booming." *Toronto Daily Star*, 23 November 1966: 21.

– "These Handicrafts Are Designed." *Toronto Star*, 10 March 1967: 17.

Muff, Mary Eileen. "Report from the Meeting of Canadian Craftsmen, Winnipeg, February 5–7, 1965." Archives of Ontario, Ontario Crafts Council, Archives of Canadian Craft, MU5750, Box 5, BU-BW2.

Mullick, Nancy. *The Transfer of the Northern Affairs (NA) and Indian and Northern Affairs of Canada (INAC) Collection of Inuit Art: 1985–1992.* Concordia University, masters thesis, 1998.

Museum of Modern Art, 1945. "The Museum of Modern Art New York Appoints Rene d'Harnoncourt Director of New Department." Royal Ontario Museum Archives, Design in Industry, RG 107, Box 1, File 5.

Myerson, Jeremy. "Tornadoes, T-Squares and Technology: Can Computing Be a Craft?" Peter Dormer, ed. *The Culture of Craft* (Manchester: Manchester University Press, 1999), 176–86.

Nakushima, Rei. Letter to Ann Suzuki, 18 January 1973. National Archives of Canada, Canadian Craftsmen's Association, MG281222, Volume 7.

National Design Council. "Annual Report 1974–1975." Ottawa: National Design Council, 1975.

National Gallery of Canada and Canadian Corporation for the 1967 World Exhibition. *Man and His World International Fine Arts Exhibition.* Ottawa: Queen's Printers, 1967.

National General Committee of the Canadian Guild of Crafts. "Reports of the Annual Meeting, April 26, 1973, Montreal." National Archives of Canada, DGAC4000 – C47, RG97, Volume 1, Associations, Clubs and Societies, Canadian Guild of Crafts.

National General Committee Report of Canadian Indian Art/Craft 1970. York University Archives, Herman Voaden Fonds, 1982-019/013, File 7.

National Industrial Design Council. *The Story behind the Design Centre.* Royal Ontario Museum Archives, Designer-Craftsmen U.S.A. RG 107, Box 1, File 14.

"Native American Arts." *Craftsman/L'Artisan* 2/2 (Summer 1969): 3.

"New Arts Board for Saskatchewan." *Regina Leader Post*, 2 February 1948: 3.

"New Cultural Vistas Open to Rural Areas." *Regina Leader Post*, 10 February 1948: 7.

"The New Indian." *Photosheet Magazine* (1968). Archives of Ontario, Ontario Crafts Council, Archives of Canadian Craft, MU 5772, Box 27, EK-EL3.

Newman, Christina. "Who Runs Culture in Canada?" *Chatelaine* 43/6 (June 1970): 26–7, 79.

Nicks, Trudy. "Indian Handicrafts: The Marketing of an Image." *Rotunda* 23/1 (Summer 1990): 14–20.

- "Indian Villages and Entertainments: Setting the Stage for Tourist Souvenir Sales."
 Ruth B. Phillips and Christopher B. Steiner, eds. *Unpacking Culture: Art and Commodity in
 Colonial and Postcolonial Worlds*. Berkeley, Los Angeles, London: University of California
 Press, 1999.
Nielson, Waldemar A. *Inside American Philanthropy: The Dramas of Donorship*. Norman:
 University of Oklahoma Press, 1996.
"1974 – The Crafts Year in Canada." A Brief to the Secretary of State from the Canadian
 Committee, World Crafts Council, July 1972. National Archives of Canada, Canadian
 Crafts Council/World Crafts Council, MG28I274, Volume 33.
"North American Assembly Conference, 10–11 June 1971." National Archives of Canada,
 Canadian Crafts Council/World Crafts Council, MG28I274, Volume 35.
O'Brian, John. *Clement Greenberg: The Collected Essays and Criticism, Volume One: Perceptions and
 Judgments*. Chicago: University of Chicago Press, 1986.
O'Conner, Francis, ed. *The New Deal Art Projects: An Anthology of Memoirs*. Washington, DC:
 Smithsonian Institution Press, 1972.
"Obituary: Aileen Osborn Webb." *Craftsman* 4/5 (October 1979): 16.
"Ojibway Progress Marked by New $50,000 Building – Craft House Built for Booming
 Business." *The Indian News* 9/3 (October 1966): 2–3.
Ong, Walter. "The Human Nature of Professionalism." *PMLA* 115/7 (December 2000):
 1906–16.
Ontario College of Art Alumni Association Alumnus. Spring 1983. National Archives of Canada,
 McCullough, Norah and Family, MG30D317, Volume 8.
Parr, Joy. *Domestic Goods: The Material, the Moral, and the Economic in the Postwar Years*.
 Toronto: University of Toronto Press, 1999.
"Past Leaders: Owen D. Young."
 www.ge.com/en/company/companyinfo/at_a_glance/bio_young.htm
"Paul Bennett's View of Craft Development." *Craft Ontario* (April 1974): 8. Archives of
 Ontario, Ontario Crafts Council, Archives of Canadian Craft, MU5757, Box 12, CK10-CL6.
Paz, Octavio. "Use and Contemplation." Octavio Paz and James S. Plaut, eds. *In Praise of
 Hands: Contemporary Crafts of the World*. Greenwich, Connecticut: New York Graphic
 Society and World Crafts Council, 1974.
"People Worth Knowing." *Popular Ceramics* (April 1965): 88. Archives of Ontario, Ontario
 Crafts Council, Archives of Canadian Craft, MU5773, Box 28, EL4-EO.
Perkin, Harold. *The Third Revolution: Professional Elites in the Modern World*. London and
 New York: Routledge, 1996.
Phillips, Ruth. "Nuns, Ladies, and the 'Queen of the Huron': Appropriating the Savage
 in Nineteenth Century Huron Tourist Art. Ruth B. Phillips and Christopher B. Steiner,
 eds. *Unpacking Culture: Art and Commodity in Colonial and Postcolonial Worlds*. Berkeley,
 Los Angeles, London: University of California Press, 1999.
- *Trading Identities: The Souvenir in Native North American Art from the Northeast 1700–1900*.
 Seattle, London, Montreal, Kingston: University of Washington Press and McGill-
 Queen's University Press, 1998.
"Pioneer Craft Sponsor gets Honorary Degree." *Toronto Star*, 6 June 1973. Archives of
 Ontario, Ontario Crafts Council, Archives of Canadian Craft, MU5757, Box 12, CK10-CL6.
Piper, David. "Craft Dimensions Canada." *Craft Horizons* (September 1969). Royal Ontario
 Museum Archives, Craft Dimensions Canada, RG107, Box 5, No. 20a.

Plaut, James S. Letter to Peter Weinrich, 7 November 1981. National Archives of Canada, Canadian Crafts Council, MG281274, Volume 87, File: Special Projects Committee – 1022-6, National Gallery of Crafts and Design.

– "Memo." National Archives of Canada, Canadian Crafts Council/World Crafts Council, MG281274, Volume 38.

– "Resumé." North American Assembly Conference 10–11 June 1971. National Archives of Canada, Canadian Crafts Council/World Crafts Council, MG281274, Volume 35

– "A World Family." Octavio Paz and James S. Plaut, eds. *In Praise of Hands: Contemporary Crafts of the World.* Greenwich, Connecticut: New York Graphic Society and World Crafts Council, 1974.

Price, Arthur. Letter. 23 February 2000.

– and Marius Barbeau. *National Asset/Native Design.* Montreal: Pulp and Paper Industry Commission of Canada, November 1956.

Prochaska, F.K. *Women and Philanthropy in 19th Century England.* Oxford: Clarendon Press, 1980.

"Proceedings of the Formation of a North American Alliance of the World Crafts Council." Shelburne, Vermont, 24 August 1969. National Archives of Canada, World Crafts Council, MG281222, Volume 15.

Program to Support the Canadian Handicraft Industry. Ottawa: Materials Branch, Department of Industry, Trade and Commerce, 20 March 1972. National Archives of Canada, RG 97, Volume 441, File 4530 – J:2, Volume 2, DGAG 4530 – J:2, Volume 2.

"Progress, Pride for Curve Lake." *The Telegram,* 14 May 1966: 27.

"Province of Ontario Council for the Arts Press Release, 10 April 1965." Archives of Ontario, Ontario Crafts Council, Archives of Canadian Craft, MU5770, Box 25, DZ-EH.

Quebec Congress of the Applied Arts, 25–27 May 1973, Orford, Quebec. National Archives of Canada, Canadian Craftsmen's Association, MG281222, Volume 1.

Reid, Dennis. *A Concise History of Canadian Painting.* Toronto: Oxford University Press, 1988.

Reid, Raymond. *The Canadian Style.* Toronto, Montreal, Winnipeg, Vancouver: Fitzhenry and Whiteside Ltd., 1973.

Reid, William. Letter to Donald Buchanan, 21 May 1957. National Gallery of Canada Archives, Exhibitions in Gallery 5.5 c, Canadian Fine Crafts 1957, Box 1, File 2.

Reif, Rita. "Crafts Show: New and Vigorous, but Tradition's Impact Is Solid." *New York Times,* 16 June 1974: 48.

– "80 Today and She Can't Wait to Get Back on the Dance Floor." *New York Times,* 17 July 1972. National Archives of Canada, Canadian Crafts Council/World Crafts Council, MG281274, Volume 38, ee.

– "Toronto Crafts Show Is Enormous … And So Are Problems World's Craftmen Face." *New York Times* 12 June 1974: 50.

"Report, Canadian Guild of Crafts National Committee Meeting, December 5, 1967." Archives of Ontario, Ontario Crafts Council, Archives of Canadian Craft, MU5750, Box 5, BU-BW.

"Report 4 March 1965. The Formation of a National Association of Craftsmen." National Archives of Canada, Canadian Craftsmen's Association, MG281222, Volume 1.

Report of the Meeting of the Pro-Tem Committee to Establish a Council of Craftsmen, February 5–7, 1965. Archives of Ontario, Ontario Crafts Council, Archives of Canadian Craft, MU5750, Box 5, BU-BW2.

"Report of the Royal Commission on Aboriginal Peoples." Volume 1: Looking Forward
Looking Back; Part One: The Relationship in Historical Perspective; Chapter 6 –
Stage Three: Displacement and Assimilation; 8. Extending Measures of Control and
Assimilation. www.ainc-inac.gc.ca/ch/rcap/sg/sg17_e.html

"Report on the Design in Industry Exhibition." July 1945. Royal Ontario Museum
Archives, Design in Industry, RG 107, Box 1, File 5.

"Report on the Kingston Craftsmen's Conference." August 1967. Archives of Ontario,
Ontario Crafts Council, Archives of Canadian Craft, MU5782, Box 37, GA-GC2.

"Report Prepared for the Province of Ontario Conference on the Arts Meeting with
Community Programmes Branch." Toronto: Department of Education, March 20,
1964. Archives of Ontario, Ontario Crafts Council, Archives of Canadian Craft, MU5770,
Box 25, DZ-EH.

"Report to the Board of the Canadian Crafts Council on a National Gallery of Crafts
and Design, 24 March 1982." National Archives of Canada, Canadian Crafts Council,
MG281274, Volume 87, File: Special Projects Committee – 1022-6, National Gallery of
Crafts and Design.

"Reviews – Montreal Branch of the Women's Art Association of Canada Second
Exhibition of Arts and Handicrafts." *The Studio* 26 (July 1902): 147.

"Revolutionary Knitting Circle." knitting.activist.ca/

Rhodes, Daniel. *Clay and Glazes for the Potter.* New York: Greenberg, 1957.

– "Introduction." *Canadian Fine Crafts Catalogue, 1966–1967.* National Gallery of Canada
Archives, Canadian Fine Crafts, 12-4-296, Volume 3.

– "Stoneware and Porcelain." *American Ceramics Exhibition Catalogue,* November 1964.
Nelson Museum and Archives, Kootenay School of Art (3), Accession #1997.057,
Series 2 / Subseries 1 / File 14 / Box 2, Bay 6, Shelf 1.

– *Stoneware and Porcelain: The Art of High-Fired Pottery.* Philadelphia: Chilton Book, 1959.

Rice, Jacqueline, ed. *The First World Congress of Craftsmen, June 8–19, 1964.* New York:
American Craft Council, 1965. American Craft Council Archives, First World Congress
of Craftsmen, Box 2.

Risatti, Howard. "Craft after Modernism: Tracing the Declining Prestige of Vraft."
New Art Examiner 17 (March 1990): 31–4.

– "Protesting Professionalism." *New Art Examiner* 18 (February 1991): 22–4.

Rockman, Arnold. "Editorial." *Canadian Art* 22/97 (May/June 1965): 7.

Rogers, Randal Arthur. *Man and His World: An Indian, a Secretary and a Queer Child. Expo 67
and the Nation in Canada.* Concordia University, masters thesis, 1999.

Rosen, Wendy. *Crafting as Business.* New York: Chilton Books, 1994.

Rosenberg, Harold. *The Anxious Object: Art Today and Its Audience.* New York: Horizon Press,
1964.

– *The Tradition of the New.* London: Thames and Hudson, 1962.

Rosenberg, Monda. "Craft Exhibitors Share Cuisine." *Toronto Star,* 24 July 1974: F1.

Rossides, Daniel W. *Professions and Disciplines: Function and Conflict.* New York: Perspectives,
1998.

Roulston, E.N. "World Crafts Council." *Handcrafts* 28/3 (July 1971): 2.

Rowley, Sue, ed. *Craft and Contemporary Theory.* St Leonards Australia: Allen & Unwin,
1997.

Russell, Deane H. "Handcraft Activities in Canada." *Craft Horizons* 1/1 (May 1942): 19–21.

Schrader, Robert Fay. *The Indian Arts and Crafts Board: An Aspect of New Deal Indian Policy.*
 Albuquerque: University of New Mexico Press, 1983.

Shadbolt, Doris. *Bill Reid.* Vancouver: Douglas and McIntyre, 1986.

Shaw, George. "A Brief to Request Relief to Artists of Federal Sales and Excise Tax."
 Archives of Ontario, Ontario Crafts Council, Archives of Canadian Craft, MU5782,
 Box 37, GA-GC2.

– Letter to Herman Voaden, 14 November 1968. York University Archives, Herman
 Voaden Fonds, 1991-020/011, File 3.

"Shelburne Museum: The Museum History."
 www.shelburnemuseum.org/htm/museum/MU_hist.htm#hist_top

Shirey, David L. "Crafting Their Own World." *Newsweek* (21 July 1969): 62. Archives of
 Ontario, Ontario Crafts Council, Archives of Canadian Craft, MU5782, Box 37, GA-GC2.

Short Guide to World Crafts. June 1964. American Craft Council Archives, World Crafts
 Council, Box 2.

Sibun, Piers Seton. *Ceramics in Quebec: Past, Present, Projected.* Concordia University, Masters
 Thesis, 1976.

Simpson, John H. "The Great Reversal: Selves, Communities, and the Global System."
 Sociology of Religion 57/2 (1996): 115–25.

Slivka, Rose. "Aileen Osborn Webb, David Campbell: A Reminiscence." *American Craft*
 53/4 (August/September 1993): 132–6.

– "The Object as Poet." *Craft Horizons* 34/3 (June 1974): 12–14.

–, Slivka, Rose, Aileen Webb, and Margaret Patch. *The Crafts of the Modern World.* New
 York: Bramhall House, 1968.

Smith, Allan. *Canada: American Nation? Essays on Continentalism, Identity, and the Canadian
 Frame of Mind.* Montreal, Kingston: McGill-Queen's University Press, 1994.

Smith, David. "Letter to the Editor." *Craft Horizons* 34/3 (June 1974): 11.

Smith, Paul, ed. *Objects for Use: Handmade by Design.* New York: Harry N. Abrams and
 American Craft Museum, 2001.

Smith, Paul. Personal interview. 22 January 2002, New York.

Sneed, George. Letter to Mary Eileen Muff, 30 October 1969. National Archives of
 Canada, World Crafts Council MG281274, Volume 34.

Soloman, Arthur. "Letter to the Editor." *Craftsman/L'Artisan* 1/2 (November 1968): 8.

– "Presentation to the Parliamentary Common, Northern Affairs." *Craftsman/L'Artisan*
 2/2 (Summer 1969): 10–11.

– "Response to the World Crafts Council Questionnaire, 1968." National Archives of
 Canada, World Crafts Council, MG281274, Volume 34.

– "Some Thoughts on Indian Craft Development in Canada." *Canadian Craftsmen's
 Association Newsletter*, April 1967. Archives of Ontario, Ontario Crafts Council, Archives
 of Canadian Craft, MU5782, Box 37, GA-GC2.

– "To the Indian Craft Workers of Ontario." Archives of Ontario, Ontario Crafts Council,
 Archives of Canadian Craft, MU5781, Box 36, FU-FZ.

"Special Events Flyer." Royal Ontario Museum Archives, Designer-Craftsmen, 22 May–
 22 June 1955, RG 107, Box 1, File 14.

Stacey, Robert and Liz Wylie. *EightyTwenty: 100 years of the Nova Scotia College of Art and
 Design.* Halifax: Art Gallery of Nova Scotia, 1988.

Stainforth, Lis Smidt. *Did the Spirit Sing: An Historical Perspective on Canadian Exhibitions of the
 Other.* Carleton University, Masters Thesis, 1990.

Stair, Julian. "Dora Billington." *Crafts* 154 (September/October 1998): 24–5.

Star TV Guide, 19 June 1974. Archives of Ontario, Ontario Crafts Council, Archives of Canadian Craft, MU5757, Box 12, CK10-CL6.

Statistics Canada Education Division, Cultural Information Section. *Canadian Crafts Survey and Membership Plebiscite*. Ottawa: Education Division, Cultural Information Section, November 1972. National Archives of Canada, Canadian Craftsmen's Association, MG28I222, Volume 1.

Statistics Canada. "Monthly Survey of Retailers." *The Daily*, 28 October 1999.

Statistics Canada Survey. "News Release." 14 November 1972. National Archives of Canada, Canadian Craftsmen's Association, MG28I222, Volume 1.

Steele, Betty. *The League of New Hampshire Craftsmen's First Fifty Years*. Concord: League of New Hampshire Craftsmen, 1982.

Stiven, Sheila. "Editorial." *Craftsman/L'Artisan* 1/2 (November 1968): 1.

– "Memo to Mary Eileen Hogg. 8 August 1972. National Archives of Canada, Canadian Crafts Council/World Crafts Council, MG28I274, Volume 35.

Stonier, Marilyn. Letter to Sheila Stiven, 1969. National Archives of Canada, Canadian Craftsmen's Association, MGI222, Volume 12.

"The Story behind the Design Centre." Royal Ontario Museum Archives, Designer-Craftsmen 22 May – 22 June 1955, RG 107, Box 1, File 14.

Strecker, James, ed. *Sheridan: The Cutting Edge in Crafts*. Erin, Ontario: Boston Mills Press, 1999.

"Stress Excellence of Design." *Windsor Daily*, 8 April 1965. National Gallery of Canada Archives, Exhibits in Canada 12-4-296, Volume 3.

Strychacz, Thomas. *Modernism, Mass Culture and Professionalism*. Cambridge, New York: Cambridge University Press, 1987.

Sures, Jack. Canadian Museum of Civilization File: Artist's Description, "Air, Earth, Water, Fire." O8 Communication Artifacts, H040: art, LH993.27.1.

– Email correspondence. 3 July 2002.

– Letter to Herman Voaden, 7 January 1969. York University Library, Herman Voaden Fonds. 1982-019/013, File 8.

Surette, Susan. *Landscape Imagery in Canadian Ceramic Vessels*. Concordia University, Masters thesis, 2003.

Sutton, Joan. "Sutton's Place." *Toronto Star*, 25 April 1972: 24.

Swain, Margaret B. "Women Producers of Ethnic Arts." Erik Cohen, d. *Annals of Tourism Research* 20 (1993): 23–38.

Taafe, Gerald. "Man and His World at Expo 67." *New York Times* 28 April 1967: 3.

Taborsky, Edwina. "The Discursive Object." Susan Pearce, ed. *Objects of Knowledge*. London and Atlantic Highlands: The Athlone Press, 1990.

Tawney, Lenore. Individual Artist's Files. American Craft Council Archives.

"Think Tank Session." Ascot Inn, Toronto, 6 January 1972. National Archives of Canada, Canadian Crafts Council/World Crafts Council, MG28I274, Volume 36, kk.

"$13,000 a Year … For Two Days Work." *Globe and Mail*, 7 October 1966: 16.

Thompson, Hugh. "Stress Fine Simplicity in United States Craftsmen Show." *Toronto Daily Star*, 18 May 1955: 4.

Thompson, Kenneth W., ed. *Philanthropy: Private Means, Public Ends*. Lanham: University Press of America, 1987.

Tinkl, Judith. *Craft Directory*. Toronto: Ontario Department of Education, 1965. Archives of Ontario, Ontario Crafts Council, Archives of Canadian Craft, MU5770, Box 25, DZ-EH.

Tober, Barbara. "Museum of Arts and Design formerly American Craft Museum."
 artsnyc.com/museums.html

Tonge, Peter. "An Affair to Remember." *Focus* (April 1969). Nelson Museum and Archives,
 Kootenay School of Art (3), Accession #1997.057, Series 2 / Subseries 1/ File 14 / Box 2,
 Bay 6, Shelf 1.

Trolander, Judith. *Professionalism and Social Change.* New York: Columbia University Press,
 1987.

Tuohy, Carolyn and Patricia O'Reilly. "Professionalism in the Welfare State." *Journal of
 Canadian Studies* 27 (Spring 1992): 73–92.

Turner, Margaret E. *Imagining Culture: New World Narrative and the Writing of Canada.*
 Montreal, Kingston: McGill-Queen's University Press, 1995.

Ullrich, Polly. "The Workmanship of Risk: The Re-Emergence of Handcraft in
 Postmodern Art." *New Art Examiner* 25/7 (April 1998): 25–9.

Valaskakis, Gail Guthrie. "Postcards of My Past: The Indian as Artefact." Valda Blundell,
 John Shepherd, Ian Taylor, eds. *Relocating Cultural Studies: Developments in Theory and
 Research.* London, New York: Routledge, 1993.

"Vast Change Noted in Island Handcrafts." *Charlottetown Guardian*, 16 May 1972.
 National Gallery of Canada Archives, DOC/CLWT, Williamson, Moncrieff, 1915–1996.

Veblen, Thorstein. *The Theory of the Leisure Class.* New York: Macmillan, 1899.

Verzuh, Ron. *Underground Times: Canada's Flower-Child Revolutionaries.* Toronto: Deneau
 Publishers, 1989.

Vidal, Guy. "Métiers d'Art du Québec Statement to the Canadian Guild of Crafts
 (Quebec and Ontario)." 19 January 1973. National Archives of Canada, DGAC4000 –
 C47, RG 97, Volume 1.

Wakefield, Hugh. "Lecture." 2 October 1969. Archives of Ontario, Ontario Crafts
 Council, Archives of Canadian Craft, MU5772, Box 27, EK-EL3.

Waldorf, Jan. Personal interview. 28 October 1999, Toronto.

Wall, Joseph Frazier. *Andrew Carnegie.* Pittsburgh: University of Pittsburgh Press, 1989.

Walpole, Mary. "Around the Town." *Globe and Mail*, 1 April 1965: w8.

Webb, Aileen Osborn. *Almost a Century.* American Craft Council Archives, unpublished
 autobiography, 1977.

– Letter to Mary Eileen Hogg, 21 June 1971. National Archives of Canada, Canadian
 Crafts Council/World Crafts Council, MG281274, Volume 34.

– Letter to Norah McCullough, 7 September 1967. National Archvies of Canada,
 McCullough, Norah and Family, MG30 D317, Volume 7.

– Letter to Norah McCullough, 20 December 1966. National Archives of Canada,
 World Crafts Council, MG281274, Volume 34.

– Letter to Sherman Burbank, 7 February 1966. National Archives of Canada,
 World Crafts Council, MG281274, Volume 34.

– "1974 Address." National Archives of Canada, Canadian Craftsmen's
 Association/World Crafts Council MG281274, Volume 35.

– *World Crafts Council Newsletter.* August 1964. National Archives of Canada, World Crafts
 Council, MG281274, AC 1986/00S9, Volume 67, dd2.

Webster, Donald Blake. *Decorated Stoneware Pottery of North America.* Rutland, Vermont:
 Charles E. Tuttle Co., 1971.

Webster, Judith. *Voices of Canada: An Introduction to Canadian Culture.* Burlington, Vermont:
 Association for Canadian Studies in the United States, 1977.

Weinrich, Peter. "Background Paper," 2. October 1974. National Archives of Canada, Canadian Crafts Council, MG281274, Volume 7, 79/206.
– Letter to Barbara Brabec, 10 February 1976. National Archives of Canada, Canadian Crafts Council, MG281274, Volume 7, 79/206, File: 1975 – 1976 Acts and Legislation: Working Definition of Crafts.
– Letter to Tom Hill, n.d. National Archives of Canada, Canadian Crafts Council, MG281274, Volume 9, 79/206. File: Education Native.
– "On Trying to Define Crafts," National Archives of Canada, Canadian Crafts Council, MG281274, Volume 7, 79/206, File: 1975 – 1976 Acts and Legislation: Working Definition of Crafts, 1–5.
– *Report and Recommendations to the Department of Canadian Heritage and the Canadian Crafts Council on Crafts Policy.* Ottawa: Canadian Crafts Council, 12 May 1994.
– "Report of a Meeting on the Future of Crafts held at Stanley House, New Richmond, Quebec, Commencing Monday 29 August to Friday 2 September 1982, 8 September 1982." National Archives of Canada, Canadian Crafts Council, MG281274, Volume 90, File: Special Briefs – Applebaum-Hébert Commission.
– "A Very Short History of Craft." *Masters of the Crafts; Recipients of the Saidye Bronfman Award for Excellence in the Crafts, 1977–1986.* Hull, Quebec: Canadian Museum of Civilization, 1989.
Weitzenhoffer, Francis. *The Havemeyers: Impressionism Comes to America.* New York: Harry N. Abrams, 1986.
Wellman, Barry, ed. *Networks in the Global Village: Life in Contemporary Communities.* Boulder, Colorado: Westview Press, 1999.
Westhues, Kenneth. *Society's Shadow: Studies in the Sociology of Counter Cultures.* Toronto: McGraw-Hill Ryerson Limited, 1972.
What's the Conseil des métiers d'art du Québec? Montreal: Conseil des métiers d'art du Québec, 1997.
White, Karen R. *Donald Lloyd McKinley: A Studio Practice in Furniture.* Oakville: Oakville Galleries, 2001.
"William Church Osborn." *The New York Times,* 5 January 1951: 20:3.
Williamson, Moncrieff. *Canadian Fine Crafts.* Ottawa: Queen's Printers, 1967. Thomas Fisher Rare Book Library, University of Toronto, T-1015 Collection of Miscellaneous Material on Expo 67.
– "Escalation in Canadian Crafts." *The Craftsman/L'Artisan* (June 1966). Archives of Ontario, Ontario Crafts Council, Archives of Canadian Craft, MU5782, Box 37, GA-GC2.
Wilson, Jason. *Octavio Paz.* Boston: Twayne Publishers, 1986.
Wilson, Marjory. Letter to Mrs Hugh Downie, 29 August 1967. Royal Ontario Museum Archvies, Craft Dimensions Canada, RG 107, Box 5, No. 20a.
Wilson, Murray. Letter to Mrs Louis E. Johnson, 22 October 1964. Archives of Ontario, Ontario Crafts Council, Archives of Canadian Craft, MU5750, Box 5, BU-BW.
Wolff, Janet. *The Social Production of Art.* New York: New York University Press, 1981, 1993.
"Women of Canada: The North." *Chatelaine* 41/6 (June 1968): 37.
"World Crafts Council Discussion." 5 July 1974. National Archives of Canada, Canadian Crafts Council/World Crafts Council, MG281274, Volume 35.
"World Crafts Council Fact Sheet, Toronto, Canada, June 1974." Archives of Ontario, Ontario Crafts Council, Archives of Canadian Craft, MU5783, Box 38, GD-GG4.

World Crafts Council News, Autumn 1973. Archives of Ontario, Ontario Crafts Council, Archives of Canadian Craft, MU5783, Box 38, GD-GG4.

"World Craft Show in Toronto in 1974." *Globe and Mail* 25 April 1972: 18.

Worthington, Helen. "Potters Pursue Dream in Unique School." *Toronto Star*, 24 February 1969: 4/49.

Wry, William G. "Uniting the World's Craftsmen." *New York Herald Tribune*, 7 June 1964: 11.

Index

Joan Chalmers, 168; and Kingston conference, 96; and modern art 7; and modernism, 53, 224; and Native craft, 112, 118, 153; in relation to professionalism, 83; at Sheridan College of Crafts and Design, 146; and Vancouver Art Gallery, 69; at Winnipeg conference, 41–6; and World Crafts Council, 167
Statistics Canada, 14
Stiven, Sheila, apprentice program, 143; Canadian Crafts Council, 165; Canadian Craftsmen's Association, 154, 155, 165; Centennial Commission, 49; Craftsman/L'Artisan, 171; Expo 67, 91, 94; and World Crafts Council, 163
stoneware, 88, 90, 99, 139, 216
suffrage, 64
Sures, Jack, 91, 131–4, 143, 171
Suzuki, Ann, 165, 170
Swann, Peter, 144, 249n64
symbolic capital: and Aileen Osborn Webb, 31, 63; and Daniel Rhodes, 102; and the First World Congress of Craftsmen, 81; and jurors, 146; and the United States, 107;
symbolism, 111

T. Eaton Company, Canadian Handicrafts Guild shop, 47, 68, 69; In Praise of Hands, 161; Royal Ontario Museum, 75, 230n25, 232n58
Tawney, Lenore, 66, 67
taxes, 252n119
Taylor, Ashley, 112
Taylor, Gladys, 112, 121
technical skill: and computer technology, 207; and concept, 9, 55; and Daniel Rhodes, 102; at Kingston conference, 96; and modernist ideology, 124, 224; and technology, 84, 105
Time magazine, 85, 98, 103
Toronto, 161, 173
Town, Harold, 172, 187
tradition, 47, 73; and abstract expressionism, 128; and authenticity, 147; and the conceptual, 178–9; in education,

141; at In Praise of Hands, 184, 187, 191–2; Indigenous Crafts, 103, 108–9, 116; Inuit carving, 110
Transformations, 214
Tripetti, J.T., 107
Trudeau, Pierre Elliott, 137, 149, 212
Turner, Robert, 145, 146
The Turning Point: Deichmann Pottery 1935–1953, 214

Uhthoff, Ina Campbell, 138
UNESCO, 163, 164
United States instructors, 123, 129
Unity in Diversity (Exposition internationale d'artisanat: mille arts une solidarité), 147
university education: and American Craft Council, 56, 58–9; American ideologies, 11; and Canadian Handicrafts Guild, 26; and Canadian universities, 11, 30, and class, 13; and conceptual art practices, 11; and craftspeople, 14; and discourse, 157; and distinction from amateurs, 9; and fine arts, 141; and First World Congress of Craftsmen, 29; and gender, 11; and interdiscplinarity, 223; and opportunities, 10; and professionalism, 174; and School for American Craftsmen, 31
University of Manitoba, 35, 100, 132
University of Saskatchewan, Regina, 131–4, 223
university professors, 35
Ursuline Nuns, 111

Val-Kill Industries, 62
Van Horne Kitchens, 235n12
Van Koert, John, 77, 78, 80, 240n87
Vancouver Art Gallery, 69, 180
Vancouver School of Art, 139, 149
Varr, Grace, 93
Vergette, Nicholas, 37
veterans, 72
Vidal, Guy, 166, 176, 253n19
Vietnam war, 137
Vistas in the Arts panel, 31
Voaden, Herman, 171, 193

audience, 175; and Quebec, 167; and
Tom Hill, 194; traditional vs concep-
tual craft, 179; unity, 164; and
Winnipeg conference, 41, 42, 230n34
world peace, 28, 29, 65
world's fairs, 73, 190
Wyle, Florence, 18, 19

Yanagi, Soetsu, 187
Yanagi, Sori, 178, 179
York University, 160
Young, Owen D., 59, 235n12
Young Americans 1969, 127